# READINGS
# IN ART HISTORY
## Second Edition

### VOLUME I

# Readings

# in Art History

## Second Edition

VOLUME I · ANCIENT EGYPT
THROUGH THE MIDDLE AGES

*Edited by Harold Spencer*

Charles Scribner's Sons, New York

Library of Congress Cataloging in Publication Data
Spencer, Harold, 1920–      comp.
    Readings in art history.
    Includes bibliographical references and indexes.
    CONTENTS: v. 1.   Ancient Egypt through the Middle
Ages.—v. 2.   The Renaissance to the present.
    1.   Art–History–Addresses, essays, lectures.
I.   Title.
N5303.S63   1976            709              76-7404
ISBN 0-684-14617-7 (v. 1)
ISBN 0-684-14618-5 (v. 2)

"Egyptian Art" is reprinted from the Introduction in W. S. Smith, *The Art and Architecture of Ancient Egypt* (1958), with the permission of the publishers, Penguin Books Ltd., and the author. Copyright © W. Stevenson Smith, 1958.
"Dramatic and Scenic Coherence in Assyrian Art" is reprinted from H. A. Groenewegen-Frankfort, *Arrest and Movement: An Essay on Space and Time in the Representational Art of the Ancient Near East* (1950), with the permission of the publishers, Faber and Faber Ltd., London.
"The General Characteristics of Greek Sculpture" is reprinted from Chapter II in Gisela M. A. Richter, *The Sculpture and Sculptors of the Greeks,* Rev. ed. (1950). Copyright © 1929, 1930, 1950 by Yale University Press.
"Greek Geometric and Archaic Art" is reprinted from sections I–VII in J. D. Beazley and Bernard Ashmole, *Greek Sculpture and Painting to the End of the Hellenistic Period,* Rev. ed. (1966), with the permission of the publishers, Cambridge University Press.
"Greek Temple Pediments" is reprinted from Chapter V in Rhys Carpenter, *Greek Sculpture,* by permission of The University of Chicago Press. © 1960 by The University of Chicago.
"The Aesthetics of Greek Architecture" is reprinted from Chapter IV in Rhys Carpenter, *The Esthetic Basis of Greek Art* (1959), with the permission of the publishers, Indiana University Press.
"Hellenistic Art" is reprinted from George M. A. Hanfmann, "Hellenistic Art," *Dumbarton Oaks Papers,* XVII (1963), pp. 83–94, by permission of the author. Several passages, footnotes, and illustrations have been omitted in this reprint. Footnotes and illustrations have been renumbered.
"Roman Architecture" is reprinted from William L. MacDonald, *The Architecture of the Roman Empire,* I (1965), by permission of Yale University Press. Copyright © 1965 by Yale University.
"Roman Wall Paintings from Boscoreale" is reprinted in abridged form from Chapter III in Phyllis Williams Lehmann, *Roman Wall Paintings from Boscoreale in the Metropolitan Museum of Art* (1953), Monographs on Archaeology and Fine Arts, V, by permission of the author and the publishers, The Archeological Institute of America and the College Art Association of America.
"Byzantine Mosaics" is reprinted from Otto Demus, *Byzantine Mosaic Decoration: Aspects of Monumental Art in Byzantium* (1948), by permission of the publishers, Routledge & Kegan Paul Ltd., London.
"The Origins of the Bay System" is reprinted from Walter Horn, "On the Origins of the Mediaeval Bay System," *Journal of the Society of Architectural Historians,* XVII (1958), by permission of the author.
"The Eleventh Century and the Romanesque Church" is reprinted from Henri Focillon, *The Art of the West in the Middle Ages,* I, edited and revised by Jean Bony, translated by Donald King (1963). Published by Phaidon Press Ltd., London, New York. Footnotes marked with an asterisk indicate additions by Jean Bony.
"The Iconography of a Romanesque Tympanum at Vézelay" is reprinted from Adolf Katzenel-lenbogen, "The Central Tympanum at Vézelay: Its Encyclopedic Meaning and Its Relation to the First Crusade," *The Art Bulletin,* XXVI (1944), by permission of Elisabeth Katzenel-lenbogen (Mrs. A.).
"Medieval Iconography" is reprinted from Emile Mâle, *The Gothic Image: Religious Art in the Thirteenth Century* (1913). Translated by Dora Nussey. Published in the United States by E. P. Dutton & Co., Inc., and reprinted with their permission.
"The Byzantine Contribution to Western Art of the Twelfth and Thirteenth Centuries" is reprinted from Ernst Kitzinger, "The Byzantine Contribution to Western Art of the Twelfth and Thirteenth Centuries," *Dumbarton Oaks Papers,* XX (1966), pp. 25–47, by permission of the author.
"The General Problems of the Gothic Style" is reprinted from Paul Frankl, *Gothic Architecture* (Pelican History of Art, 1962), pp. 217–240, Copyright © Paul Frankl, 1962. Reprinted in abridged form by permission of Penguin Books Ltd.
"Painting in Florence and Siena after the Black Death" is reprinted from Millard Meiss, *Painting in Florence and Siena After the Black Death* (1951), by permission of Princeton University Press, Copyright, 1951, by Princeton University Press.
"Jan van Eyck and Roger van der Weyden" is reprinted by permission of the publishers from Erwin Panofsky, *Early Netherlandish Painting,* Cambridge, Mass.: Harvard University Press, Copyright, 1953, by the President and Fellows of Harvard College.

# Contents

INTRODUCTION    3

1. *Egyptian Art*
   WILLIAM STEVENSON SMITH    7

2. *Dramatic and Scenic Coherence in Assyrian Art*    21
   HENRIETTE A. GROENEWEGEN-FRANKFORT

3. *The General Characteristics of Greek Sculpture*    35
   GISELA M. A. RICHTER

4. *Greek Geometric and Archaic Art*    51
   SIR JOHN D. BEAZLEY

5. *Greek Temple Pediments*    71
   RHYS CARPENTER

6. *The Aesthetics of Greek Architecture*    87
   RHYS CARPENTER

7. *Hellenistic Art*    105
   GEORGE M. A. HANFMANN

8. *Roman Architecture*    125
   WILLIAM L. MAC DONALD

9. *Roman Wall Paintings from Boscoreale*    149
   PHYLLIS WILLIAMS LEHMANN

# CONTENTS

10. *Byzantine Mosaics*    167
    OTTO DEMUS

11. *The Origins of the Bay System*    187
    WALTER HORN

12. *The Eleventh Century and the Romanesque Church*    221
    HENRI FOCILLON

13. *The Iconography of a Romanesque Tympanum at Vézelay*    251
    ADOLF KATZENELLENBOGEN

14. *Medieval Iconography*    265
    EMILE MÂLE

15. *The Byzantine Contribution to Western Art of the Twelfth and Thirteenth Centuries*    293
    ERNST KITZINGER

16. *The General Problems of the Gothic Style*    325
    PAUL FRANKL

17. *Painting in Florence and Siena after the Black Death*    353
    MILLARD MEISS

18. *Jan van Eyck and Roger van der Weyden*    383
    ERWIN PANOFSKY

    INDEX    398

# READINGS
# IN ART HISTORY
## Second Edition

### VOLUME I

# INTRODUCTION

The aim of this anthology is to assemble a convenient and use-ful series of modern writings on several aspects of the his-tory of art in the Western world. It is intended primarily, but not exclusively, as a supplement to the texts usually assigned in introductory courses in the history of Western art. To this extent it is a practical measure: the problem of providing multiple copies of supplementary readings on library reserve shelves has, at one time or another, haunted all who teach such courses. The paper-bound anthology seems a reasonable answer, however partial the solution it offers. But this anthology's usefulness is not limited to introductory surveys of Western art. These selections provide a valuable set of readings for any student of Western civilization or of the creativeness of man; and although art history is not always presented in fine literary style, there are examples here of precision of expression and even of eloquence.

The selections in this anthology range from problems of style, technique, iconography, and theories of art, to the relevant stylistic and socioeconomic context within which a work of art acquires its form and performs its function. The sequence of the selections approximates customary chronology, so that the readings correlate with traditional periods. Some selections, however, reach beyond the limits of a single period or movement.

This first volume of the anthology covers the long period from ancient Egypt to the beginnings of the Renaissance, and attempts to achieve a reasonable balance between the ancient and medieval worlds while giving proportionate attention to sculpture, architec-ture, and painting. If the emphasis with respect to ancient art has been lavished on Greece and Rome it is not meant to imply for them a greater artistic accomplishment than the older civilizations of the Near East, but simply to recognize the preeminent role that classical antiquity has played in the subsequent history of Western art. If the art of the classical world can no longer exercise the claims

3

it once made on the heart and mind of Western man, its survival as an exemplar of beauty or grandeur for many periods of art can scarcely be denied. Variations on antique themes have sprung up again and again in generations grown aware of their inheritance or self-consciously seeking identity through the authority of their ancient roots. Other traditions, growing out of the institution of Christianity and the culture of the barbarian north, are the predominant ones in the selections from the latter half of this volume, and complete the major lines of influence that have lent their force to the shape and substance of Western art before the age of political and industrial revolutions.

Phyllis Lehmann's study is a thorough analysis of the impressive mural decorations found in a Roman villa near Pompeii. The excerpts from this study evoke the breadth of scholarship that was applied to the problem of relating these paintings to the life and thought of that era while, at the same time, revealing the intensive focus brought to bear on the visual evidence in the works of art themselves that makes those relationships convincing. This integrative thrust is apparent, too, in the selection from Millard Meiss, *Painting in Florence and Siena after the Black Death,* which examines with fine discrimination the correlations between art and the religious and socioeconomic contexts of late medieval Italy.

The selections by Henriette Groenewegen-Frankfort and Otto Demus, on Assyrian and Byzantine art respectively, not only define the essential visual features of these traditions but emphasize the vital bond between form and content. Of special interest in the selection by Demus is the commentary on the relationship between the Byzantine image and its beholder.

The excerpts from Émile Mâle's classic work on Gothic art deal with iconographical interpretations, as do those from Adolf Katzenellenbogen's fine study of the meaning of the tympanum at Vézelay, whereas the selections by Rhys Carpenter on Greek architecture and sculpture emphasize aesthetic and formal considerations.

There is yet another aspect to the variety encountered in this anthology. The editor has deliberately selected articles that range widely in the degree of difficulty they present to the reader, thereby increasing the flexibility of the anthology in meeting the diverse needs it must surely encounter in fulfilling its functions.

In many instances the footnotes that accompanied the original

4

publication have been reduced or eliminated, sacrifices to the requirements of available space. In such cases, the function of this anthology as a series of supplementary readings in undergraduate courses of a generalized nature has been the guiding principle, but many footnotes leading to specialized study have been retained.

Although illustrations were limited by necessity, the editor has included as many as possible in an effort to enhance the usefulness of the anthology. They have been placed wherever possible adjacent to the relevant portions of the text, a welcome convenience. In some instances an illustration from one selection will be found to relate directly or peripherally to another reading. The choice of illustrations also permits comparisons and suggests problems of art history that lie outside the subject matter of the selections they illustrate.

The headnotes accompanying individual selections or groups of selections serve chiefly as bibliographical devices, and have been kept somewhat austere so as not to impinge on space better served by the selected readings than by pedagogical intrusions. Furthermore, each instructor who uses this anthology will have his own contextual devices for presenting problems in art history. The anthologist would, therefore, defer to the reader by allowing the selections to speak for themselves. The bibliographical references cited in the headnotes are limited to works in English since this anthology is intended primarily for the undergraduate audience.

Decisions as to what should be included were often difficult to make; and much important and attractive material was excluded when it appeared impossible to excerpt it without destroying the writer's purpose or the flow of his argument. In these selections every effort has been made to retain them as they originally appeared except in such cases where a lack of uniformity in spelling, capitalization, or punctuation might be confusing to the reader. Wherever a selection has been edited, the deletions are clearly indicated by ellipses. It was necessary to omit some of the illustrations and footnotes; the remaining ones have been renumbered.

No anthology can hope to serve fully the needs of every situation in which it might be used. There is a peculiar inevitability about this condition, manifest in the dilemma of the anthologist and in the refrain of his critics.

It would be ungracious to end this introduction without acknowledging my debt to the scholarship of others too numerous to mention, and to the contributions of my teachers, colleagues, and

students over the years; to Thomas McCormick and James R. Johnson for their valued advice on the revision; to Elsie Kearns and Kati Boland at Scribners for their help in piecing it together; to Eleanor Kuhar for her labors of typing; and to my wife whose sensitive perceptions have been constant resources beyond measure.

HAROLD SPENCER

# 1. EGYPTIAN ART

## William Stevenson Smith

### INTRODUCTION

From the edge of the eastern plateau that overlooks the modern city of Cairo the panorama that stretches far to the north and south and westward across the Nile to the desert can be read as a symbolic triad: the river which of old gave life to the valley, the great city affirming the continuity of that life, and far to the west on the edge of the desert, the eternal geometry of the Old Kingdom's pyramids. This heraldic confrontation of past and present to the axis of the Nile is a reminder that permanence was a basic dimension of ancient Egypt and the art it produced. So much of this art comes from the ancient tombs that the impulse is strong to view it as an art obsessed with death. But the statues of the dead do not close their eyes, servant statues administer to their needs, and the walls of the tombs celebrate the activities of life—the hunt, the harvest, and the feast. The life in the world of the tombs goes on like the unending cycle of the river's seasons.

The selection that follows, by an eminent Egyptologist, is an excellent introduction to both the forms and content of Egyptian art; but, more than that, the selection joins this art to the wider context of the eastern Mediterranean world, a direction the author explored in detail in a later work, *Interconnections in the Ancient Near East* (1965).

For a general survey of the Egyptian civilization the best work is John A. Wilson, *The Burden of Egypt* (1951), available in a paperbound edition as *The Culture of Ancient Egypt*. An excellent brief survey of Egyptian art is Cyril Aldred, *Development of Ancient Egyptian Art 3200–1315 B.C.*, 3 Vols. (1949–1962). Other works are W. Stevenson Smith, *A History of Egyptian Sculpture and Painting in the Old Kingdom*, 2nd ed. (1949); Alexander Badawy, *A History of Egyptian Architecture*, Vol. I (1954), Vol. II (1966); E. Baldwin Smith, *Egyptian Architecture as Cultural Expression* (1938);

7

Irmgard Woldering, *The Art of Egypt* (1967); Kazimierz Michalowski, *Art of Ancient Egypt* (1969), a well-illustrated work; E. Iversen, *Canon and Proportion in Egyptian Art* (1955); Ahmed Fakhry, *The Pyramids* (1962); Henri Frankfort (ed.), *The Mural Painting of El-'Amarneh* (1929); Arpag Mekhitarian, *Egyptian Painting*, translated by Stuart Gilbert (1956), a popular text especially useful for its colorplates; Henri Frankfort, *Kingship and the Gods* (1948); and H. A. Groenewegen-Frankfort, *Arrest and Movement* (1951). K. Lange and M. Hirmer, *Egypt* (1968), is a handsomely illustrated picture book, and W. Westendorf, *Painting, Sculpture, and Architecture of Ancient Egypt* (1968), is a small picture book with numerous color illustrations. Heinrich Schäfer's 1919 classic is now translated and revised as *Principles of Egyptian Art* (1974).

Ancient Egypt was protected by formidable desert barriers and confined to a narrow river valley. It was less subject to outside influences than the other great early civilization in Mesopotamia, and its culture presents, as one of its salient characteristics, a long, virtually unbroken continuity. In an almost rainless country the regular rise of the Nile every year provided the striking example of a renewal of life with each annual flood and gave the Egyptian a cheerful assurance of the permanence of established things, suggesting the acceptance that life would somehow continue after death in the same way. The peculiarly Egyptian concern with the continuity of life after death in a form similar to that which had been experienced upon earth provided an element in the development of the arts which was not present to such an extent in other countries. Thus, while architecture, painting, and sculpture ordinarily appeared in the service of the cult of a god or to glorify the wealth and power of a ruler, in Egypt we find emphasis laid upon providing a lasting dwelling-place for the dead, the re-creation of life magically in pictures to serve him, and lastly the provision of a substitute in stone for his perishable body.

This striving of the literal-minded and keenly observant Egyptian towards the re-creation of life for the dead man would seem to be intimately connected with the naturalistic elements in Egyptian art, and is primarily responsible for the impulse to produce portraiture which is a feature of the best of Egyptian sculpture (Fig. 1). This worked against the formalizing tendencies which, particularly in Mesopotamia, led more towards the stylization of forms and the employment of geometric shapes. Its naturalistic elements lend a familiar quality to Egyptian art which never seems a wholly oriental creation, although it displays the same approach to representation which is common to all other ancient peoples before Greek times. All pre-Greek peoples give us a kind of diagram of a thing as man knew it to be, not as it appears to the eye under transitory circumstances. In spite of this attitude towards visual impressions, the Egyptian had an instinct to imitate closely what he saw about him. His natural disposition towards balance and proportion, combined

9

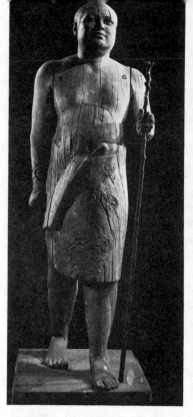
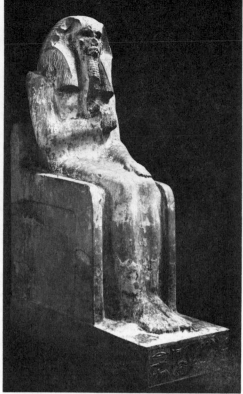

1. Ka-aper, called "Sheikh-el-Beled," Wood, 3′7″ High, Dynasty V, 2565–2420 B.C. (Egyptian Museum, Cairo)

2. Limestone statue of Zoser, Dynasty III, 2780–2680 B.C., Old Kingdom, 55″ High (Egyptian Museum, Cairo)

with a long-maintained tradition of orderly craftsmanship, strikes a sympathetic note for the Westerner.

The availability of working materials is an influential factor which must be taken into consideration. The abundance of good stone was an advantage the Egyptian had over his contemporaries in southern Mesopotamia, who had to import their stone. The shape and small size of the slabs and boulders available to the Sumerian conditioned the rounded forms and somewhat uneven quality of his sculpture. The Egyptian early learned to cut blocks for building-stone, and the sculptor had a plentiful supply of rectangular blocks from the quarry for his work. This may well be a practical reason for his pre-disposition towards cubical form (Fig. 2) in contrast to the rounded, conical shapes preferred by the Mesopotamian. It certainly allowed for the largeness of scale which is another outstanding feature of Egyptian work both in sculpture and architecture.

## Egyptian Art

One is always conscious that the Egyptian has hewed his forms from the stone block and not modelled them from softer materials, as in Crete, where the only large-scale work that has survived is in plaster relief which assumes a plastic form in contrast to the stone-cutter's technique. This has a modelled projection from the surface which is opposed to the Egyptian tendency to maintain a flat plane in reliefs. In contrast to the timeless, static permanence of Egyptian statues, the instinct of the Cretan, who excelled in the fashioning of delicate small figures of ivory, metal, and faience, was to catch an impression of movement and lively action. The Cretan might be said to see things with a painter's eye. The modelling of his reliefs produces the same impressionistic results as does his painting.

The Mesopotamian, on the other hand, tends away from natural forms in his sculpture and towards formal patterns. There is nothing in Egypt like the way in which the surfaces of the human face of one of the great Assyrian bulls are enlivened by unrealistic but superbly decorative undercuttings and contrasts in planes. It is as though the craftsman's preoccupation with seal engraving impelled him to approach larger works with the formal equipment developed in that craft as well as in textile-making and metal-work. Metal seems to have been a particularly congenial medium, and it is probably no accident that one of the Mesopotamian's finest early creations in sculpture is the magnificent Akkadian copper head from Nineveh.[1]

The marvellous facility with which huge stones were handled became one of the outstanding characteristics of Egyptian architecture. Enduring stone forms were chiefly reserved for the building of temples and tombs, while secular architecture continued to employ sun-dried bricks and wood. This lighter construction has largely disappeared with the destruction of the cities in the Nile valley and the gradual accumulation of silt from the river's annual flood. More has survived of the domestic architecture of the New Kingdom than of other periods, particularly in the Palace of Amenhotep III and at Tell el Amarna. This material, much of which is not well known, helps to balance the impression gained from the overwhelming mass of evidence which is derived from tombs. The excellent preservation of so much which represents the peculiarly Egyptian emphasis upon tomb architecture might have produced a distorted picture if it were not for the beliefs which caused so

11

many personal possessions to be buried in the tombs and so much of the daily life to be represented on the walls of the tomb chapel. A great deal is reflected of what must once have existed in the cities and on the country estates. In the stone buildings, as well as in the pictures, there is evident a particularly happy facility for the adaptation of plant-forms to conventionalized design, especially in the shapes of columnar support. The palaces of the New Kingdom have preserved also something of a purely decorative use of naturalistically represented plant and animal life in ceiling- and floor-paintings, as well as on minor wall-spaces. Something of this sort must have occurred earlier in house decoration.

The covering of wall-surfaces with scenes representing the ruler's relationship with the gods of the temple of the glorification of his acts on earth seems to have been common to all ancient peoples. However, the Egyptian's impulse to re-create life for the dead man, which caused him to make statues for the tomb, also suggested that he cover the walls of the chapel with representations of life on earth (Fig. 3). A desire for permanence early led to the use of low relief carvings on the stone-lined walls of a tomb chapel or temple. Like the statues, these were painted to complete their life-like aspect. In praising the beauty of these carvings there has been a tendency to overlook the fine quality of the painted detail or the work in paint alone which sometimes takes the place of these reliefs. The usual Egyptian practice, which combined the skills of the sculptor and the painter in creating one unified whole in painted relief, has to a certain extent obscured the Egyptian's very real contribution purely as a painter. In early times he was rivalled in this respect only by the Cretan. Egypt has provided us with an amazingly preserved series of examples in the field of wall-painting which range over the whole long period of Egyptian history. The finest examples of Cretan work are limited to a fairly short range of time at the beginning of the Egyptian New Kingdom, while accidents of preservation have confined our knowledge of the painting of Western Asia to a few examples widely separated in time. Thus Egypt provides by far the largest body of evidence for the development of early painting. Moreover, the Egyptian, with his naturalistic approach and meticulous interest in recording the details of what he saw about him, developed an extraordinary dexterity of brushwork and a manipulation of a wide range of color which is hard to match in ancient times. This is most evident in the breaking up of flat

surfaces of color by fine brush-strokes of different hues to suggest the fur of an animal or the feathering of a bird. The success achieved in indicating texture is immediately clear if one examines a rare example of such an attempt outside Egypt in the bull's head from the wall-paintings of the palace of Mari in northern Syria[2] or another head of a bull from the Cretan palace of Knossos.[3] In these the detail is indicated summarily by rather coarse dark lines. The emphasis on the thick outlines of the Mesopotamian example is even more apparent in the paintings of the early Assyrian palace[4] of Tukulti-Ninurta, where the strongly marked bordering of the different parts of the composition has been compared to the isolation of the various elements in the design of an oriental carpet. In contrast to this tendency to reduce forms to a decorative pattern, the Egyptian was interested in the outward look of living and inanimate things, and consequently endeavored to perfect his skill in indicating their surface details. He never loses, however, his sense of the clarity of their form or the use that can be made of line for this purpose. The Cretan, on the other hand, seems impatient with such detailed rendering of an animal or a plant form. He presents us with a creature instinct with life and movement, but his lively, instantaneous, impressionistic treatment will not bear too close analysis as to the accuracy of its details.

Thus, within certain limits of his conventions, the Egyptian approaches his subject with careful, painstaking attention to detail. He has a matter-of-fact rather than an imaginative attitude to the world about him, and when he deals with supernatural things manages with a kind of cheerful assurance to give them a familiar, everyday look. Even the most remarkable monsters are rather dryly conceived, and one of his most surprising achievements was the convincing naturalness with which were combined human and animal parts in composite form for the representation of his gods. The Egyptian mind did not run riot in imagining such strange and frightening spirits as appear on the seal designs of Mesopotamia or Crete. Instead there is an almost complacent acceptance of the orderliness and continuity of existence in a mild climate which was spared a good many of the more frightening caprices of nature. There is no expression of that anxiety with which the Mesopotamian regarded the harshness of nature, nor did the Egyptian's surroundings provide him with the broken mountain crags and seascapes that stirred the imagination of the inhabitants of the Aegean.

The rationalized approach to visual impressions developed by the Greeks was foreign to earlier peoples. The Greeks first contrived a consistent way of drawing figures so that their different parts were related to one another in the manner in which they appear to the eye. They then began to experiment with the placing of these figures against a background in which the lines correspond to a series of receding planes which appear natural to the observer. They ended by developing a system of aerial perspective. The absence of a desire on the part of the Egyptian to suggest depth and volume in his painting and reliefs is only one aspect of an attitude towards representation which prevailed throughout the ancient world. It tends to generalization according to the characteristics of the people who employ it, whether this takes the form of avoiding movement, as in Egypt, or crystallizes a typical aspect of lively action, as in Crete.

Specific historical events, if represented at all, are treated as the symbolical memorial of a victory or some other action of the ruler. Often when a battle is actually represented it is given a form which might be considered an enlarged hieroglyph signifying the idea. This is perfectly illustrated by the complementary use of early word-signs and figure representation on the Narmer palette at the beginning of Dynasty I, but the intimate connection between writing and drawing continues throughout all Egyptian monuments. The beautifully made hieroglyphs are small drawings in themselves and form an integral part of larger compositions, while the wall-scenes are really an extension of the written signs. Inscriptions are also a necessary part of the statues. They provided the essential identity of the owner by giving his titles and name, although the portrayal of his outward appearance is usually generalized without individual characteristics, except in certain outstanding works that we shall see appear throughout Egyptian history at periods of remarkable creative effort. Similarly, the subject-matter of the wall-scenes is restricted to typical aspects of Egyptian life which ordinarily lack the narrative element in the sense that they seldom refer to specific happenings. Backgrounds are summarized, with a few trees, a vineyard, the selected parts of a building, or the upright stems of a papyrus thicket to suggest the setting of a scene. At first there is little attempt to deal with the spatial relationship between these simple stage-props and the men and animals which they accompany. Emotion or individual feeling, and the dramatic relationship

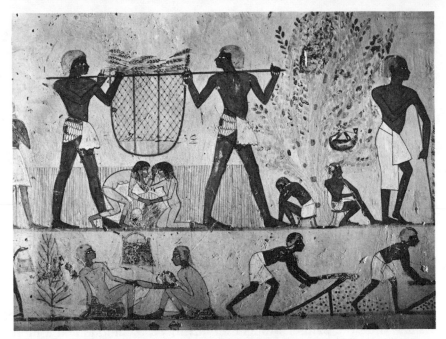

3. Harvest scene, Tomb of Mene-na (No. 69), Thebes, Egyptian, Dynasty XVIII, *c.* 1412–1402 B.C. (Photography by Egyptian Expedition, The Metropolitan Museum of Art)

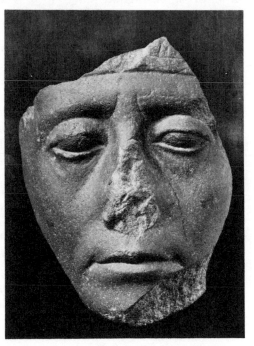

4. Fragment of head of King Sesostris III (Se'n Wosret III), 1878–1842 B.C., Quartzite, 6½″ High (The Metropolitan Museum of Art, New York, Carnarvon Collection, Gift of Edward S. Harkness, 1926)

15

between the figures which this might engender, had little place, although we may find certain typified exceptions such as the mourners at a funeral or the dying forms of animals.

However, within this general framework we shall find a constant enlivening of the whole by freshly observed detail and an increasing interest in the treatment of landscape and architectural backgrounds with experiments in the more complicated grouping of figures and their relationships in space. This reached its most advanced stage in the huge compositions of the Ramesside temple reliefs, where topographical and even historical elements, which had first made their appearance in the Eighteenth Dynasty, are handled in a fashion paralleled only by the later Assyrian reliefs. The royal sculpture of the Twelfth Dynasty also shows a first attempt to portray something of man's inner feeling in the somber, careworn faces of Sesostris III (Fig. 4) and Amenemhat III. At the same time the painter brought an advanced technique and a more subtle color sense to the treatment of textures which had already interested the artists of the Old Kingdom. This was to be carried to a most sophisticated stage in the very extensive work of the Eighteenth-Dynasty painters.

Of course it is the significant changes which appear against the background of the long continuity of Egyptian civilization that quicken our interest. One of the fascinations of the study of Egyptian art is in learning to distinguish the variations in a style which is easily recognizable as belonging to that country over a vast length of time from the fourth millennium down to 332 B.C., when the conquest of Alexander the Great brought Dynastic Egypt to an end. Initially one may have the impression of an endless repetition of forms, but closer examination reveals definite characteristics of the Old, Middle, and New Kingdoms. Then we begin to realize the special qualities of the formative stages which led up to these great periods of achievement. First came that brilliant Archaic Period in Dynasties I–III, when civilization was developing out of the primitive conditions of Predynastic times towards a culmination in the Old Kingdom. This so-called Pyramid Age of Dynasties IV–VI began about 2680 B.C. and lasted for some four hundred years. The freshness of a new beginning appears again about 2100 B.C. in Dynasty XI, and shortly after 1600 B.C. in early Dynasty XVIII, when the Middle and New Kingdoms respectively emerged from the darkness of those times of political disintegration

known as the First and Second Intermediate Periods. Once again, towards the end of the eighth century B.C. and after a long period of decline, we find new life poured into the old forms. This renewal was stimulated by the invasion of the Kushite kings of the Sudan (which the Greeks called Ethiopia and the Romans Nubia). It strikes us as a more conscious, archaizing effort, lacking in the spontaneity of earlier national revivals. . . .

In looking back over the tremendous span of Egyptian civilization, it should be remembered that from the beginning of historic times the king was always referred to as a god. He was sometimes simply termed the Good God. As Horus he was considered the earthly embodiment of an ancient deity of the sky whose worship was preeminent at the time of the establishment of united rule over the two lands of Upper and Lower Egypt in Dynasty I. As Son of Ra the king represented the direct descent of royalty from the creator sun god. Finally in his assimilation with Osiris he would continue to reign over the realm of the dead; for he was repeating the cycle of the god who was thought to be an ancient king who had passed through death to resurrection. Such a drastic simplification of the Egyptian conception of divine kingship presents ideas which were developed in succeeding periods, but which had been accepted by the end of Dynasty V when the earliest preserved body of religious literature, known as the Pyramid Texts, appears first on the walls of the burial-chambers of King Unas. These potent spells were compiled in order to assist in the king's translation from his earthly body into the world of the gods, and imply the recognition of his human qualities which must undergo transformation after death.

The manifold nature of Egyptian religious beliefs defies summary treatment.[5] We are accustomed to the attempt to resolve opposing views, but we must expect instead a many-sided approach to a phenomenon, with the result that unrelated explanations are accepted side by side. Formidable difficulties are presented by the accumulation of beliefs over the centuries through an additive process which was reluctant to replace one idea wholly with another or to discard the old. There is both continuity and extraordinary fluidity in this. Two gods may be assimilated with one another without losing their separate entities. Likewise there may be various manifestations of the same god, as in the case of Horus, who as avenger of his father Osiris, or the infant son of Isis, is quite a

17

different being from the sky god whose wings span the heavens and whose eyes are the sun and the moon.

We find a mixture of popular beliefs and the attempts of learned men to explain the emergence out of chaos of that order which was personified by the Goddess Maat, who stood for justice, truth, and right. From the beginning the Egyptian felt that he was surrounded not only by friendly but also by hostile spirits which had to be propitiated. He also sensed the more remote and impersonal quality of the great forces of nature whose personifications were revered as well as the gods of each locality. The local deities had at first appeared in the shape of animals, or more rarely were represented by a plant or inanimate object. Later, when they assumed human form, the animal head was frequently retained, or else the original animal, plant, or object was borne as a symbol on the head. The Goddess Nekhbet wore a vulture headdress, and Hathor was shown with the horns of a cow, although she might still manifest herself in the form of that animal. There were a number of different Hathors, although these were generally associated with the idea of a mother goddess. Her worship was accompanied by dancing and sistra-playing, and she came to be thought of as the goddess of love and joy. As Mistress of the Sycamore she was identified with a tree-spirit in an old sanctuary near the Giza Pyramids and became the patroness of the royal family of Dynasty IV. In similar guise she is later found dispensing food and cool drink to the dead. Through an interchange of functions with the sky goddess Nut and the Goddess of the West she was associated with the western mountain at Thebes, where she received the sun at its setting.

In historic times the term "city god" describes what must have been an early conception of a local deity who presided over a community. Generally he formed the head of a family triad, such as we have in the case of Ptah of Memphis with his consort the lioness Sekhmet and their son Nefertem, whose symbol was a lotus flower. As one of the primitive villages assumed leadership over neighboring communities, its local god acquired supremacy in that district. Later political fluctuations might replace the god of such a district by another, or they might bring about his rise to national importance. In this process one god might take on the attributes of his predecessor or, if his worship spread throughout the country, he might assume the qualities of one of the great cosmic deities. In the latter case he was still associated with a particular place,

of which he was considered the lord and in which lay his principal sanctuary. Something of this process can be learned from the sacred emblems on the standards of the Nomes or provinces which evidently reflect the independent districts of prehistoric times. Thus in Hermopolis the ibis-headed Thoth, the god of wisdom, had long supplanted Wenut, but her symbol, the hare, continued to be used on the standard of this Fifteenth Nome of Upper Egypt. Neith, on the other hand, always remained mistress of Sais, the capital of the Fifth Nome of Lower Egypt, whose standard bore her arms, a shield and crossed arrows.

The assimilation of one divine being with another is easier to understand if we can grasp something of the Egyptian's conception of a vital force which was present to a varying degree in all things animate and even inanimate. When, in the creation according to the doctrine of Heliopolis, the sun, Atum-Ra, brought into being Shu (air) and Tefnut (moisture), he spread his arms about them and his Ka entered into them. Here is suggested the transmission of a life-force which remained in continuous operation from the beginning of the world. It was thus that divine nature was imparted to the king, although its full potentialities could not be realized until after death. Lesser mortals were able to share some part of this force.

The Ka was one of three emanations of the spirit. It was related to, but separate from, the Akh and the Ba. These had all originally belonged only to the gods. They approximate to what we think of as the soul and were all associated with the personality of the individual. One could only become an Akh, a transfigured spirit, after death. Its place was in the heavens remote from the body. The Ba, on the other hand, was an animated aspect of the soul which could move back and forth from the dead body. From the Eighteenth Dynasty onward it is pictured as a human-headed bird, drinking cool water from a pool, perched in the branches of a tree, or fluttering down to join the body in the tomb chamber. The Ka is best viewed as a person's vital force which accompanied him both in life and in death. Certain of its qualities were intensified in the person of the king and they were fully possessed only by supreme beings. The Ka had a separate existence and in one sense can be thought of as a double or as a protective genius. It was closely associated with the tomb statue and with nourishment. Through it the dead man was able to avail himself of the food and drink that

19

he had contracted with his funerary priest to present on stipulated occasions at the false-door of his tomb chapel, and which could be supplemented by the offerings pictured on the walls of this chapel.

*NOTES*

[1] H. Frankfort, *The Art and Architecture of the Ancient Orient*, Pelican History of Art (Harmondsworth, 1954), plates 42 and 43.

[2] Frankfort, *op. cit.,* plate 69A.

[3] Sir Arthur Evans, *The Palace of Minos*, 1 (London, 1921), 529, Figure 385.

[4] Frankfort, *op. cit.,* plate 74.

[5] See H. Frankfort, *Kingship and the Gods* (Chicago, 1948); *Ancient Egyptian Religion* (New York, 1948); J. Vandier, *La Religion égyptienne*, 2nd ed. (Paris, 1949).

# 2. DRAMATIC AND SCENIC

# COHERENCE IN ASSYRIAN ART

*Henriette A. Groenewegen-Frankfort*

## INTRODUCTION

When we extract from the long history of representational art the question
of how mankind's experience of the space in which it exists has been
interpreted, implied, or to what degree ignored in works of art down
through the centuries, we are confronted with many answers. One of these
has proved particularly persuasive for the past five hundred years. It has
conditioned the Western world to a view through space from a fixed
point-of-sight, either through the projection of a perspective system de-
veloped in the Renaissance, or, more recently, through the optics of a
camera lens. The cubist break with this tradition early in the twentieth
century, its various offspring, and the mobility of the motion-picture camera
notwithstanding, the post-Renaissance fixed point-of-view persists as a norm.
That other modes of representation have achieved efficient ends in harmony
with the ritual, commemorative, symbolic, or narrative purposes of repre-
sentational art is, however, confirmed by the example of ancient Near
Eastern art and the art of the Middle Ages.

A desire to account for "the eccentricities of spatial rendering" in the art
of the ancient Near East was cited by Henriette A. Groenewegen-Frankfort
as the stimulus for the study that resulted in the publication of her book,
*Arrest and Movement: An Essay on Space and Time in the Representational
Art of the Ancient Near East* (1951). The bulk of the text deals with
Egyptian art, followed by two shorter sections on Mesopotamian and Cretan
art. Apart from analysis of spatial devices in relief sculpture and painting,
this study is a particularly fine presentation of ideas concerning the inter-

relationship of form and content in ancient art, and it bears significantly on the related subject of visual narrative. This latter aspect of ancient art was the theme of a symposium in 1955, papers from which were published in *American Journal of Archaeology*, LXI, 2 (1957). For the student of art history, these works provide, collectively, an excellent introduction to the genesis of narrative composition. The selection from *Arrest and Movement* that follows analyzes the Assyrian modes of depicting human and animal images in dramatic and scenic contexts.

On the general field of art in the Asian Near East the reader should consult the convenient survey by Seton Lloyd, *The Art of the Ancient Near East* (1961). More detailed information can be found in Henri Frankfort, *The Art and Architecture of the Ancient Orient* (1955); Eva Strommenger and Max Hirmer, *5000 Years of the Art of Mesopotamia,* exceptionally well-illustrated (1964); André Parrot, *Sumer: The Dawn of Art* (1961), and, by the same author, *The Arts of Assyria* (1961); Ekrem Akurgal, *Art of the Hittites* (1962); and for the Persian region, Edith Porada and R. H. Dyson, *The Art of Ancient Iran* (1965).

A good survey of the general subject of spatiality in Western respresentational art is provided by the following works, in addition to the book by H. A. Groenewegen-Frankfort: G. M. A. Richter, *Perspective in Greek and Roman Art* (1971); Miriam Bunim, *Space in Medieval Painting and the Forerunners of Perspective* (1929); Ingvar Bergström, *Revival of Antique Illusionistic Wall Painting in Renaissance Art* (1957); John White, *The Birth and Rebirth of Pictorial Space,* rev. ed. (1967); and two articles, Beaumont Newhall, "Photography and the Development of Kinetic Visualization," *Journal of the Warburg and Courtauld Institutes,* VII (1944), 40–45; and Winthrop Judkins, "Toward a Reinterpretation of Cubism," *The Art Bulletin,* XXX (1948), 270–278.

In addition, there are a number of works that can profitably be consulted on the subject of visual perception, namely: J. J. Gibson, *The Perception of the Visual World* (1950); Ernst Kris (with E. H. Gombrich), *Psychoanalytical Explorations in Art* (1952); W. H. Ittelson, *The Ames Demonstrations in Perception* (1952); E. H. Gombrich, *Art and Illusion* (1960, 1961); and Rudolf Arnheim, *Art and Visual Perception* (1954). In connection with the latter one should read Gombrich, *Art and Illusion,* pp. 26–27, and Arnheim's review of this book in *The Art Bulletin,* XLIV (1962).

Assyrian art, baffling and full of contradictions like so much that pertains to Assyrian culture, brings one most striking innovation: the commemorative reliefs of the royal palaces are entirely secular and narrative. To see this fact in its true perspective more than a mere sketch of historical events and cultural changes would be needed. The shift of power to a northern centre after a period in which Syrian, Indo-European, and other north-eastern influences prevailed in Mesopotamia under Kassite and Mitannian rule, presents a historical problem that bristles with unanswered and perhaps unanswerable questions. Moreover, the archaeological material from the Middle Assyrian period is so fragmentary that we cannot trace even a formal development which would lead up to the reliefs of Assurnasirpal and the surprising boldness of this new artistic venture. All we can do at present is to point out some significant changes in the few extant reliefs and the glyptic of the Middle Assyrian period which appear to have cultural implications and then to see if these new trends can be tentatively correlated with a changed attitude where the rendering of event in space and time is concerned.

Both Frankfort and Moortgat have discussed the degenerate glyptic of Kassite and Mitannian origin and stressed the remarkable freshness of the Assyrian seals which mark a new beginning.[1] The main points of interest for our problem are a new delight in dynamic scenes such as animals on the move or hunters attacking quarry—actual or mythical—and a vigorous naturalism which even affects the traditional antithetical groups of animals, so that their attitudes appear contingent rather than heraldic. Most remarkable is that this interest in animals and hunting develops at the expense of religious subjects. Presentation scenes are altogether absent, such adoration scenes as occur have least pronounced Assyrian characteristics and are stylistically close to Babylonian ones, while the few reliefs of the period which we possess seem to avoid likewise the well-worn scheme of divine and human confrontation. On the earliest one known, an 'obelisk' showing a number of captives being brought before the king, the epiphany of the god Assur consists of a pair of hands emerging from a cloud and handing down a bow as symbol

of the king's power.[2] Here divinity was for the first time shown quite literally transcending the realm of man. In the faïence tile of Tukulti Ninurta we find the same god in a more emblematic form—a winged disk containing his feathered figure—in the act of shooting a bow, floating above the royal figure in a battle scene.[3] On two roughly contemporaneous altar stones we see in the one instance the king flanked by the symbols of the sun—not facing its image—and on the other two royal figures, one kneeling, one standing before an altar which again only supports a symbol.[4]

All the available material of the Middle Assyrian period would therefore confirm Frankfort's observation, which he based mainly on later Assyrian glyptic, that: 'the higher power has become inaccessible and direct contact apparently ceased.'[5]

It would be rash to draw the conclusion that the presence of historical scenes on palace walls and a remarkable absence of religious scenes in the temples could be entirely explained by a changing concept of divinity and a different relation between a more transcendent god and man. The part the god Assur played in fertility rites and his connection with the sacred tree[6] are too obvious and at the same time too obscure than that the transcendence of this lord of hosts could be taken for granted. There does indeed appear to be a curious hesitancy in confronting god and man. There is also, as we shall find, cleavage between secular and non-secular—that is mostly ritual—representation, even within the scope of the palace reliefs. For the secular scenes delight in rendering concrete detail, the religious ones shun actuality—if we may use this term to denote a type of religious imagery in which gods appear and act in human form and in situations analogous to actual life. This same cleavage finds expression in yet another way: the textual recording of the king's achievement on building inscriptions loses its character of a religious dedication, which it had had throughout Mesopotamian history and becomes a purely historical record. We find therefore that at a moment when secular art on a large scale makes its first appearance in history, significant changes had already occurred both in religious pictorial idiom and in texts, and that these seem symptomatic of a widening gulf between the world of man and of the divine.

But before we turn to the battle and hunting scenes on the palace reliefs we must discuss yet another innovation which accentuates the distance between secular and non-secular art: a host of winged

monsters in various beneficial functions invades the ritual scenes. Now we cannot discuss here the problem of monsters in Mesopotamia nor speculate on the reasons why these should have appeared throughout such remarkably convincing entities, whether they were composite animals, bullmen or merely fantastic creatures. It is a fact that they occur mostly in semi-decorative context and especially in popular glyptic art, so that we may assume that they were at home in the realm of folk religion. The Assyrian winged creatures which appear on the seals have been fully discussed by Frankfort,[7] those on the reliefs are either in human form or animal headed, for the human-headed bull which in gigantic form guarded the palace entrance occurs only once in an actual scene sporting among fishes in a naval battle.[8] These monsters apparently filled a gap produced by a less concrete religious imagination, yet they failed to inspire the artists of the reliefs. Whether or not they emerged from remoter layers of religious awareness, they gained in the hands of subtle and sophisticated craftsmen an—for monstrous form—almost absurd concreteness in muscular detail. Yet, arranged in stereotyped postures on either side of a formalized tree in a ritual act they lose whatever demonic life they may have had originally and are impressive only through sheer size and workmanship. We shall in our discussion of the late Assyrian reliefs ignore all ritual scenes because they are entirely formal and have no bearing on our problem.

The palace reliefs of Assurnasirpal (885–860) present the first narrative art we possess in Mesopotamia.[9] It has been suggested that they might have been inspired by either first or second-hand knowledge of the Egyptian New Kingdom reliefs;[10] this is at least a possibility, but even so the differences between the two would be more significant than any hypothetical plagiarism and we shall only refer to the Egyptian ones in order to throw into relief the peculiar and consistent character of the Assyrian work. It is, for instance, very striking that nowhere in the actual battle reliefs the king should dominate the scene either by his size or by his action; the king looks and acts like any of his soldiers. Fighting is throughout at close quarters and slain victims are strewn about the scene; but the defeat of the enemy is not a foregone conclusion: enemy soldiers striding away from the royal chariot turn back and shoot at the king and repeatedly one of them grabs at a horse's mouth in an effort to halt them. The enemy, moreover, never shows abject terror; the fight is

fierce and virile. It is also entirely episodic, not a single battle scene contains a clue to its outcome; consequently, the spectator is held in suspense till he moves on to the next episode, where rows of prisoners or a city in flames complete the story. Such scenes lack entirely the symbolical character which made the Egyptian ones a timeless assertion of inevitable royal victory; they show ephemeral events changing before the spectator's eyes from one phase to another. There are no clear breaks in this pictorial epic, nor is action ever suspended; the movement of figures in one direction always seems purposeful even if no explicit aim is indicated; rows of prisoners seem on the march towards their destination, not displayed in a formal aimless stride. Movement is rarely met by counter-movement except in the case of a siege where the town formed the centre of action (in the reliefs of Seti I at Karnak this was never the case) and the attackers were arranged antithetically. In chariot scenes the galloping horses are not tilted diagonally, although the extended forefeet are off the ground. In fact, all horizontals are usually stressed in this case, the reins, the arrows, the prostrate figures under the horse's belly, so that the level movement is unchecked.

The drawing of the horses, in a surprising variety of gait and posture, is throughout superb. The draughtsmen must have known and lived with them as no Egyptian artist ever did, and with a delicate observation—completely absent in their human figures—could render shades of mood and temperament in sensitive horses' heads, beautifully coordinated movement of neck and body in horses starting to pull up, horses swimming, horses straining up a mountain slope when the rider slackens his rein. These creatures move in a scenic space which, if the register groundline is adhered to, will lack all suggestion of topographical recession, but the register acts as horizon so that the scenes appear as real as life. Frequently, however, the horizon line is ignored and figures superimposed without apparent concern about their spatial relation. The effect may vary but the action is usually so closely knit that such 'floating' figures seem part of a coherent group in space. . . . We have one interesting example of true scenic background, though not yet of stage space (Fig. 5), where the royal cortege is seen passing below the city walls. Figures do not yet always appear in pure profile, there is frequently an awkward twist in the shoulder region, though the burly rather amorphous bodies, almost entirely hidden in long garments, do not

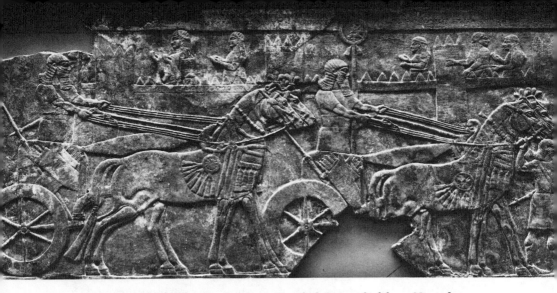

5. King Assurnasirpal II's Chariots Passing a Fortified City, relief from Nimrud, Assyrian, 9th Century B.C., 3′4½″ by 7′1″ (The British Museum, London)

make the non-functional drawing so obvious that it interferes with the impression of organic corporeality which they convey.

Apart from these details of spatial rendering the following facts stand out: the narrative scheme of consecutive scenes in fairly narrow strips has nowhere been abandoned in favour of one which would allow for a dramatic climax, a summing-up of complex event in one pregnant situation; nor can we observe anywhere a tendency to transcend actuality in the manner of monumental art. The story told remains discursive. This may explain the limitations of the experiments made in the rendering of space: scenic space was intended throughout but it merely depended on the choice of episode whether the horizon line of the register sufficed or whether—especially when the action took place on or near water or was spread out over a large terrain—the problem of the disposition of figures in space had to be faced. Topographical coherence then began to form a new preoccupation for the artist.

Under the reign of Assurnasirpal's successor Shalmaneser an important innovation was made which enhanced the character of scenic space: from now on human figures nearly always appear in pure profile, that is, in a definite relation to the spectator's viewpoint. The remains of this period consist mostly of bronze reliefs which covered the palace gates at Balawat.[11] They are narrow scenes arranged in double strips in such a way that the movement of the figures in the upper row is in opposite direction to that of the lower one. This work, obviously decorative in intention, is strictly

27

narrative in character, but though technically bold it is artistically rather dull. The monotony of the depicted horrors, the records of a series of campaigns, is practically unrelieved and the work is on too small a scale to allow for much experiment. In one instance when a non-military event was depicted topographical scenery was ventured on and the attempt made to represent the head of a valley surrounded by mountains on both sides with a subterranean stream visible through 'windows' in the mountainside. Here some kind of recession has been aimed at in rendering the mountains on the far side of the valley; usually, however, all scenes run parallel to the surface.

The rather fragmentary remains from the reign of Tiglathpilesar III, and the reliefs of Sargon show a continuation and further development of earlier trends. Profile rendering is maintained and the superposition of figures in the now slightly wider registers is more frequent. Groups without groundline are put in at different levels . . . so that the general impression is that of a coherent scene in space although the figures are not yet topographically related. . . .

The reliefs of Sennacherib,[12] less subtle, less dramatic than those of his successor Assurbanipal, are full of experiment in the rendering of scenic space and especially in the disposition of figures in depth. The interest is largely focused on complicated activities involving large groups of people and the relation between these and their local setting. It is interesting to see how persistent efforts were made to emphasize spatial coherence as well as unity of action. In a mountain assault, for instance, soldiers are scattered among trees over a wide area marked with the conventional [scaly] pattern of a mountain side, which can only be conceived as receding. One might be tempted to use the term cavalier perspective here, but strictly speaking both it and 'bird's eye view' presuppose a definite, if unusual, spatial relation between observer and things observed, which is totally absent here. It is true that the receding surface of the mountain side has been made more or less concrete by the conventional pattern and that thereby the scattered human figures and trees could be definitely fixed in relation to it and to each other. Yet they give no clue to the observer's viewpoint, because from a high viewpoint which might reveal their disposition as clearly as the picture shows, the trees could not appear in plain front view. It is, however, undeniable that some sort of spatial coherence of figures

and objects, and some illusion of recession has been achieved. How important this coherence of receding space was considered can be gauged by the almost absurd insistence on a patterned background which the reliefs show; trees stuck into such a background must of necessity be conceived as spatially related, and if they are super-imposed this can only mean also related in depth.

The same holds good for the marsh scene [in a relief of Sennacherib] where the superimposed islands are so carefully joined by well-drawn strips of water that there is no loophole for spatial ambiguity, each figure, each object is definitely fixed in relation to every other and yet the viewpoint has not been clarified. Again the illusion of a bird's eye view strengthened by the centrifugal arrangement of some of the reed bushes, is destroyed by the front view rendering of others. But nowhere . . . has any of the surface been left blank. The full consequences of illusionistic scenic render-ing, with its challenge of complete spatial coherence, had been accepted.

More ambitious if rather less successful are the attempts to picture the transport of colossi or the making of artificial mounds for Sennacherib's palace. We are far removed indeed from the first Egyptian effort at such a scene. Here the action is very lively and in each of the different versions we possess a definite moment, a definite place has been chosen to mark the actual phase of the event. The most remarkable is that where the colossus has to cross a dip in the ground near a strip of water. While in some other renderings the rows of figures straining at the ropes have the support of a ground-line; here they are merely spread out on an amorphous plain from which the hillock rises where the king in his chariot overlooks the scene. Here again the river in the foreground with its narrow dams and shadufs at work (all given in straight elevation) are incompatible with a high viewpoint which part of the scene would suggest; and the relation between plain and hill on the right is not clear.

Yet the same passionate interest in receding space leads to another curious experiment. The sieges of hill towns or mountain strongholds had already become livelier and livelier, they were now frequently offset against a mountain background which in some cases rose above the town or castle walls. Diagonal scaling ladders had often lent a dramatic touch to the event,[13] now however it became a matter of ambition to render the actual approach of the attacking army on the mountain side. Such an approach is of necessity in a

diagonal line and so we suddenly see, instead of ladders, solid paved diagonal paths leading up to the strongholds, and that means, at any rate conceptually, away from the spectator. The effect is weird in the extreme, the more so because in a misguided effort at realism the angle of ninety degrees between these paths and the climbing figures has been maintained so that the soldiers appear to be falling backward. The wild pattern of diagonals nowhere achieves the illusion of recession or of topographical coherence, but the boldness of this attempted short cut at landscape perspective on a vast scale is astounding and unsurpassed till Hellenistic times.

Sennacherib's innovations must have been considered aesthetically barbarous by those who planned the Assurbanipal reliefs, for they did not venture any further in the direction of illusionistic recession. With the restraint of true and very great artists they did not pursue a naturalism already run wild along topographical lines. The most gifted of them either brought their figures back to the relief surface in fairly narrow parallel scenes or bound them by subtle means in a dramatic situation that could dispense with locality altogether. It is true that some of the motifs survived, but it is interesting to note that when an artist indulges in topographical scenes, as when an aqueduct in its setting is rendered and the strange diagonal rivers are obviously inspired by the diagonal paths, the scene is empty of figures and is therefore much more plausible. In [one example][14] the fleeing Elamites are arranged in parallel registers as of old, but the deserted town walls looming above them tier upon tier, reminders of the threat they must have held, make the implicit victory appear an even more formidable achievement than if a lively siege were given. The new restraint is thus dramatically most effective. One other motif in which an attempt at rendering recession had been made before, namely, that of fugitives or looting soldiers leaving a town, has been developed further. Already on a remarkable relief of Sennacherib two superimposed town walls and a vertical row of soldiers leaving the buildings suggest recession. On another fragment[15] fugitives appear to be walking on a mountain contour line. This motif is repeated more plausibly in an Assurbanipal relief.[16] In Fig. 6, however, the looting soldiers are leaving the gate on a road, clearly indicated by a double line, which widens toward the spectator. The figures, it is true, are clinging rather timidly to the boundary line, not walking in the middle of the road, but the effect of their marching downhill and *toward* the spectator

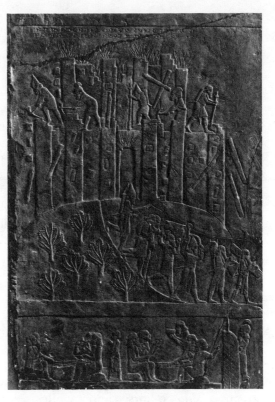

6. Sack of the City of Hamanu in Elam, relief from Nineveh (Kuyunjik), Assyrian, c. 650 B.C., Gypseous alabaster, 36″ by 25″ (The British Museum, London)

has been unmistakably achieved by what is virtually true perspective.

However, as we said before, the greatest artists of the period merely arranged their scenes parallel with the observer; they also were great innovators in the matter of rendering space but not recession; dramatic space was what they aimed at and paradoxically this aim was not achieved with human figures in action, but with animals. There is only one extremely 'human' scene of the king on his couch and a queen or concubine sitting upright on a chair at his feet, which also has an odd if restrained dramatic quality. The head of a slain enemy hanging in a tree near the musicians destroys the illusion of domestic bliss and gives to the festivity an overtone of cruel sensuousness.[17]

Otherwise it would appear as if commemoration of the same human, if unhumane, pursuits, the same patterns of warfare, repeated and elaborated now for centuries, must have wearied at least one artist whom we must consider the greatest of all. The historical epic was, as we saw, discursive and though astonishingly inventive in

31

matters of detail, it lacked the very quality of all great art; being time-bound and space-bound, it never transcended the purely episodic. Throughout a period in which the violence of one small nation brought a staggering amount of suffering on countless peoples, pictorial art recorded battle after battle in a scenic display unhampered by metaphysical considerations with a brutal secularity which, for all its freshness and vigour, had something shallow and naïve. Victory was a man-made thing, it was devoid of the symbolical quality which it had had before both in Egyptian and Mesopotamian art, and which it was to gain later on in Greece in a mythical form. And since victory was man-made and ephemeral, defeat also was a contingency; it lacked that touch of the tragic which gave to the Seti reliefs their peculiar dignity. The artist of the hunting scenes took up a motif as old as mankind and as unchanging; in doing so he not only displayed an astounding virtuosity in the handling of animal form, but showed that he possessed the emotional depth which could convey the tragedy of suffering and defeat, of desperate courage and broken pride.

There is nothing in these scenes to detract from the actual or imminent disaster that befalls those who provide sport for the powerful. There is no indication of localty or background for these groups of hunted horses and gazelles, yet they form a coherent unit in a space we must conceive as a receding plain. The very emptiness makes them appear more vulnerable, more exposed. The gazelles grazing restlessly, warily, appear under the threat of imminent danger; the backward glance of the male leader gives a peculiar tenseness to their movement. In the group of wild horses the possible escape heightens the tension and lends a horrible poignancy to the mare looking back at her young. In the lion hunt disaster is inevitable; here the group on the right has no dramatic unity, each dying creature is alone in his agony, and this lack of spatial as well as emotional coherence is emphasized by the separate groundlines of the superimposed figures. The greatest dramatic intensity is reached not in the group where the royal chariot is attacked with mad fury, but on the right, where the battle is as yet undecided (Fig. 7); a crouching lion and the terrified horse and his rider are separated by the most dramatic of 'significant voids' ever achieved in Near Eastern Art.

It is strange to consider that shortly before the disastrous finale of the Assyrian Empire, the same people under whose dominion the

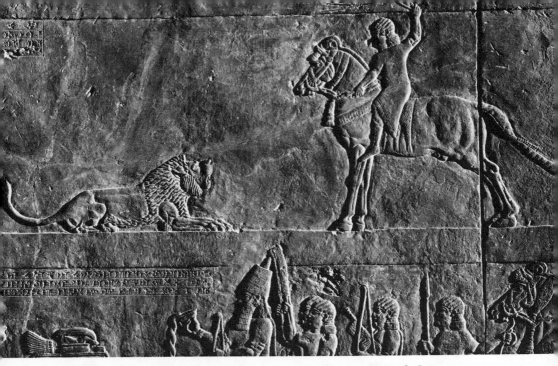

7. Lion Facing Horseman, relief from Nineveh (Kuyunjik), Assyrian, 7th Century
B.C., 5′3″ by 8′9″ (The British Museum, London)

world had shuddered brought forth an artist who revealed the depth
of his fear and pity for these doomed creatures and raised his scenes
to the stature of tragedy.

Assyrian art, flowering on the periphery of Mesopotamia proper,
occurred on the very brink of a new era. Alien to the predominantly
religious character of older Mesopotamian work, and bound, as no
other form of art, to the secular power of single monarchs whose
achievements it recorded, it vanished when this power was exter-
minated. One may well ask if not a vestige of its influence could be
traced in westerly direction, toward the Greek world. So far this
question can only be answered in the negative.

*NOTES*

[1] H. Frankfort, *Cylinder Seals*, 186–191; A. Moortgat, 'Assyrische Glyptik des
dreizehnten Jahrhundert's', in *Zeitschrift für Assyriologie*, XLVII.
[2] Sidney Smith, *Early History of Assyria*, Pl. XVII.
[3] W. Andrae, *Farbige Keramik von Assur*, Pls. 7, 8.
[4] W. Andrae, *Die Jungeren Ischtartempel in Assur*, Pl. 29–30.
[5] H. Frankfort, *loc. cit.*, 196.

[6] Sidney Smith in *Bulletin of the School of Oriental Studies*, IV (London, 1926–1928), 69–76.

[7] H. Frankfort, *loc. cit.*, p. 198, also *Archiv für Orientforschung*, XII (1937–1939), 128–135.

[8] *Encyclopédie photographique de l'art*, Tome II, Pl. 2, 3.

[9] E. A. Wallis Budge, *Assyrian Sculpture in the British Museum. Reign of Assurnasirpal* (London, 1914).

[10] J. H. Breasted in *Studies Presented to E. Ll. Griffith*, pp. 267–271.

[11] L. W. King, *Bronze reliefs from the Gates of Shalmaneser* (London, 1915).

[12] 705–681 B.C. See A. Paterson, *Assyrian Sculpture in the Palace of Sinacherib* (The Hague, 1915).

[13] Paterson, *loc. cit.*, Pl. 15.

[14] H. R. Hall, *Babylonian and Assyrian Sculpture in the British Museum* (Brussels, 1928), Pl. XLII.

[15] Paterson, *loc. cit.*, Pl. 39.

[16] H. R. Hall, *op. cit.*, Pl. XL.

[17] H. R. Hall, *loc. cit.*, Pl. XLI.

# 3. THE GENERAL CHARACTERISTICS OF GREEK SCULPTURE

## Gisela M. A. Richter

### INTRODUCTION

Gisela Richter's *The Sculpture and Sculptors of the Greeks* has been one of the most useful studies of Greek sculpture since its initial publication in 1929. For years, students of Greek art have benefited from her research, published in such works as *Red-Figured Athenian Vases* (1936), *Kouroi* (1942, 1960), *Archaic Greek Art Against its Historical Background* (1949), *Three Critical Periods in Greek Sculpture* (1951), *Ancient Italy* (1955), and *A Handbook of Greek Art*, 4th rev. ed. (1965), which contains a fine selected bibliography on all phases of Greek art.

Miss Richter was one of those scholars who did not recoil from the risks of generalization. The selection in this anthology accepts such risks, and the result is surely one of the best introductory essays on the nature of Greek sculpture.

Other recommended readings on the sculpture would include Rhys Carpenter, *Greek Sculpture* (1960), which is not strictly speaking a history of Greek sculpture but a study of the techniques in their relationship to style; portions of his *The Esthetic Basis of Greek Art,* rev. ed. (1959), especially Chapter III; the well-illustrated volume by Reinhard Lulliès with photographs by Max Hirmer, *Greek Sculpture* (1960); J. Charbonneaux, *Greek Bronzes* (1962); E. Langlotz and M. Hirmer, *Ancient Greek Sculpture*

*of South Italy and Sicily* (1965); and Humfry Payne and G. M. Young, *Archaic Marble Sculpture from the Acropolis* (1936). For material on the techniques of sculpture one should mention, in addition to the above works, Stanley Casson, *The Technique of Early Greek Sculpture* (1933); C. Bluemel, *Greek Sculptors at Work* (1955); and, for a discussion of Graeco-Roman copies, Miss Richter's *Ancient Italy* (1955).

We must remember that when the Greeks of classical times began their career civilization was still young. Everything that has happened in the last three thousand years was to them nonexistent. It is difficult to realize at once what this implies. It means that their artistic background was confined to the products of Egypt, Western Asia, and, in part, of Crete; and even of these their knowledge was limited, especially in literature, for what existed of Eastern writings was not easily accessible. Their own past was dimly remembered in the form of myths and legends. So practically the only literature they knew was Homer; the only history they were cognizant of was the Trojan war. In religion they had come in contact in the East with beliefs in heterogeneous gods and monsters, and from this they had developed the anthropomorphic religion found in Homer and Hesiod. In other words, most of the influences—artistic, intellectual, and religious—which act upon the modern man were as yet unformed. The background was simpler and the human mind had the freshness of youth.

In the centuries in which the classical Greek civilization was developed great changes happened. From its primitive beginning it passed through many stages to a more complicated outlook, and during this time it created a large part of what constitutes our Western culture. Nevertheless, it is possible to view the Greek mind as a whole. We will endeavor to do so and to see how its quality determined the character of Greek sculpture.

The three outstanding characteristics which strike us when we analyze the Greek mentality applied to art are directness, agility, and a feeling for beauty.

The directness was no doubt largely the result of a simpler outlook. It is a quality which we with our more complicated natures have lost; and when we come in contact with it, it affects us like a fresh breeze on a sultry day. It enabled the Greeks to keep their eyes on the essentials without the distraction of superfluous details. In literature this shows itself in their vivid similes, their keen observation, and also in a bald sincerity in stating facts.[1] Take such a description as Aeschylus': . . . ταχύπτεροι πνοαί, . . . ποντίων τε

37

κυμάτων ἀνήριθμον γέλασμα, παμμῆτόρ τε γῆ,[2] "Swift winged winds
. . . , and numberless laughter of waves, and earth the mother of
all." Could there be a truer and more beautiful description of the
much-besung wind and sea and earth? It reaches out to the chief
quality of each, transforms it into poetry, and creates thereby
something fundamental and permanent. Or take Clytaemnestra's
analysis of her emotions (in Sophocles' Electra[3]) when she hears of
the death of her son Orestes, whose vengeance she dreaded: "Are
these glad tidings? Rather would I say sad but of profit." It is a
simple statement of the case, without pretense or blinking of facts;
and perfectly concise. Greek literature is full of these pregnant,
clear-eyed sayings. The much-quoted epitaph, "His father Philip
laid here to rest his twelve-year-old son Nicoteles, his high hope,"[4]
is another example of this combination of sincerity and conciseness.
What could be added to the essential facts conveyed in "laid to
rest," "twelve-year-old," and "high hope" which would not be a
superfluity? And let us remember Aristotle's definition of super-
fluities, "That which makes no perceptible difference by its presence
or its absence is no real part of the whole."[5]

It is this feeling for the whole unencumbered by superfluities
which gives Greek art its peculiar greatness. At the very beginning
of his career the Greek sculptor went straight to the essentials. In
the early "Apollo" statues why is it that in spite of their stiffness
and faulty construction they are full of life? Because the important
functional parts of the body are properly accented, the details are
omitted, and each and every part passes into and connects with
the adjoining part. . . . The rendering is simplified; the important
parts are made to stand out and there are no incidents, no super-
fluities. The result is that we have the impression of an organic
whole which can function and live (Fig. 8). And this is true of all
Greek sculpture during its best periods.

The second outstanding characteristic of the Greeks we may take
to be their agility. It was stimulated doubtless by the geography
of the country. For the combination of mountains and sea tended
both to separate the Greek peoples from one another and to stimu-
late emigration. The mountains acted as barriers and the sea invited
adventures. Hence the formation of a number of separate communi-
ties distributed over a large area including Greece, western Asia
Minor, the Aegean Islands, southern Italy, and a few outlying places
in Spain and France. This double circumstance insured on the one

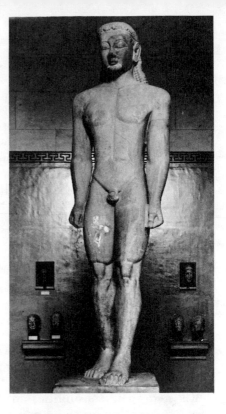

8. Kouros of Sounion, Archaic Greek, *c.* 600 B.C. (Marburg-Art Reference Bureau)

hand compact community life in small city states, on the other the variety of stimulus derived from heterogeneous peoples; all of which made for lively activity, because individual responsibility in a small state and rivalry with other states are apt to invite energy. This striving for adventure and for knowledge led the Greeks into many untried paths. It is responsible for the amazing number of their discoveries in almost every field of intellectual activity. "To be learning something is the greatest of pleasures, not only to the philosopher but also to the rest of mankind, however small their capacity for it," is Aristotle's definition of happiness[6] of which Plato's more imaginative rendering is, "He whose heart has been set on the love of learning and on true wisdom and has chiefly exercised this part of himself, this man must without fail have thoughts that are immortal and divine."[7]

In sculpture this agility of mind and this love of knowledge are likewise responsible for a great deal. They meant progress and development. Without them Greek sculpture might have remained stationary, never surpassing the attainments of Oriental artists. The Egyptian sculptor, for instance, with all his wonderful feeling for the value of essentials, practiced his art for thousands of years

39

without solving some of its difficulties. He followed throughout the old law of frontality,[8] his knowledge of anatomy remained primitive, and in his reliefs proper perspective was never attained. The agile mind of the Greek determined to wrestle with these problems. Not content with what had been accomplished before him, he was eager to solve new problems, and so he started out on his adventure of representing a human body in all manner of postures, constructed according to nature, with its parts in proper relation and perspective, both in the round and in relief. To a pioneer in the field it was a formidable task. But with remarkable perseverance the Greek artist accomplished it, and his solution of these problems was like the removal of shackles which had hampered the free development of art for generations. The human figure, by its movements and gestures, could henceforth express action and emotion. . . .

A love of truth and of knowledge could easily have made realists of the Greeks; but their realism was transformed into idealism by their third great characteristic—their feeling for beauty. Beauty to them was not something apart from daily life but interwoven into every phase of it. The beauty of their own landscape undoubtedly quickened their sensibilities in this direction. Its grandeur and suavity, its rich colors and fine contours, its elusive, subtle quality would inevitably influence a young, impressionable people. It would incline them to regard beauty as an integral part of their lives and to find their happiness in the loveliness of their immediate surroundings. And their sense for beauty grew so strong that it became the underlying principle in their lives. For they made a great discovery—one that we have lost since, perhaps through Puritan interpretations, but are beginning to realize again—that goodness and beauty are identical, not only figuratively but actually. "Virtue it appears will be a kind of health and beauty and good habit of the soul; and vice will be a disease and deformity and sickness of it," says Plato in his Republic;[9] and with the Greeks it was a generally accepted principle. "Then good language and good harmony and grace and good rhythm all depend upon a good nature, by which I mean a mind that is really well and nobly constituted in its moral character," Plato says again in his Republic;[10] and in his Symposion:[11] "From the love of the beautiful has sprung every good in heaven and earth." Most eloquent of all is the current Greek expression for a "gentleman"—καλός κἀγαθός, "beautiful and good." Greek and especially Athenian education was planned di-

rectly with this end in view; and athletics and music were given the most prominent places, one to foster the beauty of the body, the other of the mind. That exercise develops the body is easily accepted by us today; but that art and music make men good is not so generally believed. Yet the Athenians practised this creed with good results; at least they won a reputation, Plato tells us, "throughout Europe and Asia" "for the beauties of their bodies and the various virtues of their souls."[12] Let us learn from Plato how this can be accomplished. In dealing with the education of his guardians in his Republic,[13] he gives us a specific account. Socrates asks: "Ought we not to seek out artists who by the power of genius can trace out the nature of the fair and the graceful, that our young men, dwelling as it were in a healthful region, may drink in good from every quarter, whence any emanation from noble works may strike upon their eye or their ear, like a gale wafting health from salubrious lands, and win them imperceptibly from their earliest childhood into resemblance, love, and harmony with the true beauty of reason?" And when Glaucon assents Socrates continues: "Is it then on these accounts that we attach such supreme importance to a musical education, because rhythm and harmony sink most deeply into the recesses of the soul, and take most powerful hold of it, bringing gracefulness in their train, and making a man graceful if he be rightly nurtured?" And finally he sums up, "There can be no fairer spectacle than that of a man who combines the possession of moral beauty in his soul with outward beauty of form, corresponding and harmonizing with the former, because the same great pattern enters into both." Translated into conduct this aesthetic ideal became a reverence for sobriety and temperance. As an imaginative, southern people the Greeks no doubt had strong feelings difficult to control; but they recognized that temperance was a kind of harmony, and therefore desirable. So μηδέν ἄγαν, "nothing too much," became their motto, and ὕβρις "insolence," their abomination.

Naturally in the art of sculpture the Greek sense of beauty found a fruitful field. It is directly responsible for the most characteristic quality, idealism. The creation of beauty was the sculptor's chief interest and his types are selected with this end in view. "But when you want to represent beautiful figures," says Socrates to the artist Parrhasius, "since it is not easy to find everything without a flaw in a single human being, do you not then collect from a number

what is beautiful in each, so that the whole body may appear beautiful?" And Parrhasius admits that such is their practice. This sums up very simply the Greek point of view. It is not realism and truth to nature but perfection of form that the Greeks consciously strove for. And this beauty of form was further enhanced by their feeling for design, which gave to their work a highly decorative quality. It is particularly strong in the archaic period when stylization took the place of correctness of modeling, but it was not lost even in the more naturalistic periods, and always gives style to the whole—the style which distinguishes art from nature. Indeed it is this sense of composition which the Greek regarded as perhaps the most important element in a work of art. It is clearly brought out in the definition of beauty quoted by Plotinus (as the opinion of some):[14]

> What is it that impresses you when you look at something, attracts you, captivates you, and fills you with joy?
> The general opinion, I may say, is that it is the interrelation of parts toward one another and toward the whole, with the added element of good color, which constitutes beauty as perceived by the eye; in other words, that beauty in visible things as in everything else consists of symmetry and proportion. In their eyes, nothing simple and devoid of parts can be beautiful, only a composite.

This joy in "symmetry and proportion" can be clearly detected in all Greek art.

Another important factor in the "idealism" of Greek sculpture is its simplification. The Greek sculptor felt that to translate the human body into a work of art he must harmonize the multiformity and restlessness of nature and create a unity. We have spoken of his subordination of parts to the whole, his elimination of superfluous details, his restriction to the essentials. Equally important was his simplification of the design. His statue was contained in a unified space,[15] that is, a space with restricted depth. . . . It is important to understand and realize this characteristic of Greek sculpture; for it is very largely through this conception of space that a Greek statue acquires its dignity and grandeur. A figure thus carved can be taken in by the human eye without distraction, and thereby attains that sense of quiet and detachment which makes art a refreshment to the spirit.

This "relief conception," as it has been called by Hildebrand, was inherited by the Greeks from the Egyptians; it was stimulated

by the universal practice of stone carving, in which both the figure and the space surrounding it were potentially enclosed in the block, by the demand for architectural sculpture with its uniform depths of pediments and metopes. That the Greeks recognized its importance from an artistic point of view is shown by their practice of it even when working in bronze or with figures in which no background had to be considered. It is not until the very latest period, in such creations as the Dirke monument, that this conception is given up, and the result is, we feel immediately, a certain restlessness.

Still another determining element in the idealistic impression of Greek sculpture is beauty of contour. So much of Greek sculpture was out in the open to be viewed from a distance that the outline counted for much; and it is the lovely undulating outline of a Greek statue which impresses us from the first. Indeed this feeling for contour was so strong in the Greek artist that it shows itself in all his work, not only in the design of the whole figure, but in every part of it—the oval of the face, the swing of the eyelids, the curve of the lips, the drawing of the muscles and of the folds of the drapery. It is an extraordinarily strong sensitivity for rhythmic line—which found expression also in the shapes of vases and in vase painting.

It is, then, sense of structure, simplification of form and design, harmonious proportion, and rhythmic contour that stand out as the salient features of Greek sculpture. By them it acquires the grandeur which we feel in its presence. They give it its spiritual quality. And since art is a spiritualization of nature it is this spiritualizing quality which is fundamental, and without which representation is not art. And so Greek sculpture, throughout its development, has the distinguishing trait of great art.

From our analysis of the Greek mind and its influence on Greek sculpture we must pass to the chief uses of sculpture in Greece; for the nature of the demand of course affects the character of the supply.

Sculpture in Greece was largely religious. Its chief use was for the decoration of temples either as pediment groups, friezes, or acroteria, for the cult statues of deities placed in the cella, and for votive statues and reliefs dedicated in sanctuaries. A large proportion of the sculpture that has survived is therefore architectural. This demand early developed the technique of relief as well as the

43

composition of large groups. We should never have had the superb creations of the western pediment of the Olympia temple or the Parthenon frieze but for the long history which preceded them and which gave the sculptor ample opportunities of development. But these pediments and friezes could not vie in importance with the cult statues placed in the interiors of temples. It was round them that the popular worship centered and it was by them that the people obtained a concrete realization of their gods. And so to embody his vision of the deity in a great temple statue was the highest task of a Greek sculptor. Unfortunately hardly any of these statues have survived. We have only descriptions and small reproductions by which to visualize the colossal chryselephantine statues by Phidias, Polyclitus, and Alcamenes. In every estimate of Greek sculpture, therefore, we must remember that its finest creations have been irretrievably lost.

Another important demand for sculpture in Greek times was created by the custom of erecting statues of the victors in the athletic contests given in honor of Zeus, Poseidon, Hera, etc. The statues stood in the public places and in the sacred enclosures in which the games had taken place, and the young athletes were mostly represented nude, for that is how they had engaged in their contests. This practice and the athletic ideal which prompted it led to the development of the nude male type as a favorite form. Not only athletes but gods and heroes were so represented. In this series of nude male figures the ideal human form was gradually worked out and became one of the greatest achievements of Greek sculpture (Fig. 9).

Commemorative sculptures which are so popular today also played an important part in Greece. A significant victory would be celebrated by the erection of a statue or group, like the Nike of Paionios at Olympia, or the bronze Athena of Phidias on the Acropolis which was an offering "from the spoils of the Persians who landed at Marathon." The group of the Tyrannicides set up on the marketplace would remind Athenians every day of their liberation from the tyrants and of the value of their democratic institutions. We hear also of large groups of several figures, e.g., statues of Athena, Apollo, Miltiades, Erechtheus, Cecrops, Pandion, Aegeus, and five other heroes, another offering "from the spoils of Marathon" by Phidias. Such groups in the round must have been remarkable achievements, and it is a grievous loss that they have

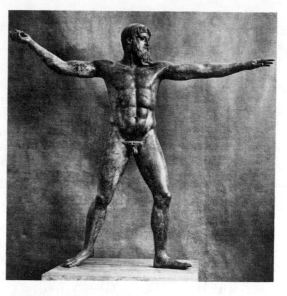

9. Poseidon, Greek, Early Classical, *c.* 460–450 B.C., Bronze, 82″ High (National Museum, Athens; Alison Frantz)

disappeared. The erection of portraits of distinguished men became increasingly popular as time went on.

Besides these more or less public uses of sculpture there was a large private demand for grave monuments. The chief forms adopted in Athens were slabs with reliefs representing the departed, either alone or with sorrowing relatives, statues in the round, slabs crowned by finials, and vases decorated with reliefs. They supply us with some of the most touching and most "personal" representations we have in Greek art. These sculptured grave monuments remained in vogue until the end of the fourth century B.C. when the "anti-luxury" decree of Demetrius put a sudden stop to this artistic expression. Their constant use during three centuries greatly furthered the development of relief technique.

It is important to become familiar also with the subjects represented in Greek sculpture; for the Greek artist had an entirely different repertoire from our own. Early Christian, medieval, and Renaissance art are from this point of view much nearer to us, since they need little explanation; but when we enter the Greek field we are stepping into an unknown land; and we must be careful to leave behind us any preconceptions we may have.

We have seen how the athletic ideal helped to concentrate interest in the human figure. It accustomed people to seeing the human body in all manner of postures and to appreciating its beauty. Moreover, the Greek with his love of the normal had a tendency

45

to humanize everything. His gods and goddesses are no longer monsters, as often in Eastern art, but assume human form; so do the Nymphs, Satyrs, Centaurs, Tritons, and the other personifications of nature. Even when these start with hybrid shapes they soon lose their animal characteristics and gradually become more and more human. And so Greek sculpture consists largely of figures of human beings representing divinities, heroes, and athletes. Animals and decorative motives find a place and an important one, but they are nevertheless secondary. The human figure is the theme par excellence.

Joined to this humanizing tendency the Greeks had a love for storytelling. Much of Greek religion consists of stories about gods and goddesses and heroes; and these manifold imaginative tales would naturally make a great appeal to the artist. They supplied him with the most varied material, which he used so constantly that definite standardized types soon emerged. Plato's words about literature apply also to sculpture and painting—that art must eschew novelty and be framed after the pattern of those foundation myths which the poets have made familiar. So we must become conversant with these foundation myths. And a delightful process it is; for these stories have the freshness and imaginative quality of a poetic people. In entering this world of Greek fiction with its contests of Lapiths and Centaurs and Amazons, its wonderful deeds of heroes, and its manifold adventures of gods and goddesses, we feel very near the beginning of civilization. We sense the vivaciousness and naïveté of youth. No doubt some of the myths have a historical background; some are certainly rooted in actual experience; but the poet when he took his material transformed fact into fancy and then the artist translated this fancy into a beautiful picture. And so in our interpretation of Greek mythology in Greek art let us endeavor to catch the lovely simplicity of these spirited stories directly and concretely told. It is easy for us with our modern, complicated minds to read our own thoughts into these representations and endow them with farfetched symbolic significance. But thereby we lose the early Greek flavor and become more like the late Latin commentators. . . . To the Greek artist the hero was always Heracles with his lion's skin and club or Theseus with his little chiton and his sword or Perseus with his distinctive paraphernalia, tackling in various ways these dangerous creatures. The whole interest lies in the contest, in the story, and in its artistic rendering. Its subjective significance was outside the artist's scope.

In this connection we may again quote Plato;[16] for in his analytical time a few learned people were beginning to lose the childlikeness of earlier days and search for farfetched interpretations. When Socrates is asked by young Phaedrus whether he believes in the story that Boreas carried off Orithyia he gives an illuminating answer, which it may be well to quote at length, for it states the case admirably: "If I disbelieved," Socrates says, "as the wise men do, I should not be extraordinary; then I might give a rational explanation, that a blast of Boreas, the north wind, pushed her off the neighboring rocks as she was playing with Pharmaceia, and that when she had died in this manner she was said to have been carried off by Boreas. I think, however, such explanations are very pretty in general, but are the inventions of a very clever and laborious and not altogether enviable man, for no other reason than because after this he must explain the forms of the Centaurs, and then that of the Chimaera, and there presses in upon him a whole crowd of such creatures, Gorgons, Pegasoi, and multitudes of strange, inconceivable, portentous natures. If anyone disbelieves in these, and with a rustic sort of wisdom, undertakes to explain each in accordance with probability, he will need a great deal of leisure. Now I have no leisure for them at all. . . . And so I dismiss these matters and accept the customary belief about them."

Surely our interest also lies in these customary beliefs of the people who produced and enjoyed the art which we are endeavoring to understand. So we cannot do better than follow Socrates' advice and not spoil a fairy tale with a laborious mind. We must remember, then, that the only symbolism we shall find in Greek art is the concrete one by which pebbles suggest the beach, a fish the sea, a growing plant the meadow, a pine tree the mountain, a reed the river bank, and a column the house. This practical symbolism was freely used, for such shorthand methods were useful and easily understood, and were thoroughly in line with the Greek tendency to simplification.

The large mass of architectural sculptures—the pediments of the temples, the continuous friezes, the metopes—have almost invariably mythological representations—either legends directly associated with the deity to whom the temple was dedicated (e.g., the birth of Athena and her strife with Poseidon in the pediments of the Parthenon), or the familiar contest scenes of Heracles, Theseus, Lapiths, etc. Only occasionally is there a scene from actual life, for instance, the Panathenaic procession in the Parthenon frieze;

47

though here too the subject is lifted to a higher plane by the actual presence of the gods on the eastern side. The almost total absence of historical representations is striking. Even in single sculptures erected to celebrate a specific victory such subjects are rare; when Miltiades is introduced in Phidias' group commemorative of the battle of Marathon[17] he is associated with Athena, Apollo, and various heroes; the representation of Greeks and Persians on the frieze of the temple of Athena Nike is exceptional. We have not a single representation of the battles of Thermopylae or Salamis, of the Peloponnesian war, of the great plague, of the Sicilian expedition; in short, of the outstanding events which formed the chief preoccupation of the Greeks of the fifth century. How different the Romans or the Egyptians and Assyrians with their endless friezes recording their triumphs over their enemies; how different we ourselves with some of our war monuments and realistic pictures of contemporary battles! The Greeks, in order to convey the strife and stress of their time, had recourse to mythological contests, or to the semi-legendary events of the Trojan war.[18] These were far enough removed to admit of safe treatment, which with the constantly changing alignment of the Greek states was probably an important point. At all events, the Greeks knew that history with the strong partisan and bitter feeling it arouses is not an appropriate subject for sculpture. The same is true of contemporary political events. The Greek was distinctly a "political animal." Of all his contributions to mankind he prided himself most on his civic ideal. Every Athenian citizen was a representative in Congress and a legislator in the law courts. But that part of his life was passed over by the artist. And probably for the same reason for which contemporary wars were omitted—that controversial subjects do not belong to the realm of art.

There were some other aspects of daily life, however, which found a place in Greek sculpture. Not only single statues of athletes but chariot groups were popular dedications; and occasionally even in the fifth century we hear of such "genre" subjects as the statue by Styppax of "a slave roasting entrails and kindling a fire with a blast from his swollen cheeks."[19] In the Hellenistic period such themes greatly gained in vogue, especially in bronze and terracotta statuettes. But the most frequent representations of daily life occur on the grave monuments where the departed were shown in their favorite occupations, as their families liked to remember them. To

us these pictures of Greek life are singularly precious; for they are contemporary illustrations of familiar happenings and as such eloquent and trustworthy. We see here men represented as warriors or athletes; women busy with their spinning or putting on their jewelry; children playing ball or caressing their pet animals; and in the family groups we gain a realization of a happy and affectionate family life. And, always, these renderings are simple and direct—with no trace of sentimentality or exaggeration, but with the Greek note of serenity which makes of them something typical and permanent. We are reminded of Nietzsche's famous saying: "Die Griechen sind, wie das Genie, einfach: deshalb sind sie die unsterblichen Lehrer."

*NOTES*

[1] For an excellent discussion of this subject, cf. Livingstone, *The Greek Genius and Its Meaning to Us.*

[2] *Prometheus Bound* 88 ff.

[3] 766.

[4] Callimachus, *Epigr.* 19.

[5] *Poetics* 8. 4.

[6] *Poetics* IV 4.

[7] *Timaius* 90 A.

[8] Frontality I take to mean a perfect symmetry in the two sides of the body, i.e., the equal distribution of weight on the two legs. This admits of the torsion of the body which we find adequately rendered in some Egyptian sculptures.

[9] IV. 444.

[10] III. 400.

[11] 197.

[12] *Timaius* 21 A–25 D.

[13] III. 401–402.

[14] *Ennead* I. VI. i. Though Plotinus lived in the third century A.D. his teachings are often borrowed from Plato and other philosophers of the fifth and fourth centuries B.C.

[15] Cf. on this subject Hildebrand's remarks in his illuminating book, *Das Problem der Form.*

[16] *Phaidrus* 229 D.

[17] Pausanias X. 10. 1. In Mikon's famous painting of the battle of Marathon, Athena and some popular heroes (Theseus, Heracles, and Echetlus) are likewise introduced (Pausanias I. 16).

[18] We have a few exceptions to this general rule in Greek paintings, for instance in the representation of the battle of Oinoe in the Poikile (Pausanias I. 15).

[19] Pliny, *N. H.* XXXIV. 81.

# 4. GREEK GEOMETRIC AND ARCHAIC ART

## Sir John D. Beazley

### INTRODUCTION

*Greek Sculpture and Painting,* initially the chapters on Greek art in the *Cambridge Ancient History,* has long enjoyed a reputation as an exemplary survey of Greek art from its Geometric beginnings to the Hellenistic period. The selections on the painting and sculpture of the Geometric and Archaic periods are the work of J. D. Beazley, whose prose style, like his analyses of the art, is as fine as it is precise. The early centuries of Greek art have seldom been better summarized than in this selection—and nowhere more memorably.

*The Development of Attic Black-Figure* (1951), by the same author, can be recommended for further reading on the subject of Archaic vase-painting. For vase-painting in general there is Ernst Pfuhl, *Masterpieces of Greek Drawing and Painting,* tr. by J. D. Beazley (1955); Ernst Buschor, *Greek Vase-Painting,* tr. G. C. Richards (1922); and Mary Hamilton Swindler, *Ancient Painting* (1929). R. S. Young, *Hesperia,* Supplement II (1939) is a valuable source for information on Geometric pottery, and for red-figure vase-painting one should consult Richter, *Red-Figured Athenian Vases* (1936), and her *Attic Red-Figured Vases, A Survey* (1946, 1958). The following contain useful discussions on the techniques of Greek pottery: Richter, *The Craft of Athenian Pottery* (1923); Beazley, *Potter and Painter in Ancient Athens* (1944); and Joseph V. Noble's article "The Technique of Attic Vase-Painting" in *American Journal of Archaeology,* LXIV, 4 (1960), and his book, *The Technique of Painted Attic Pottery* (1965). Other books relevant to the subject of early Greek art are J. W. Coldstream, *Greek Geometric Pottery* (1968); R. M. Cook, *Greek Painted Pottery,* 2nd ed. (1972),

a good all-around handbook; Humfry Payne and G. M. Young, *Archaic Marble Sculpture from the Acropolis* (1936); Sheila Adam, *The Technique of Greek Sculpture in the Archaic and Classical Periods* (1967); Ernst Homann-Wedeking, *Archaic Greece* (1968); G. M. A. Richter, *Korai, Archaic Greek Maidens,* with excellent photographs by Alison Frantz (1968); J. Charbonneaux and others, *Archaic Greek Art* (1971), a well-illustrated volume. An elaborately illustrated work of a general nature, with photographs by Max Hirmer, is J. Boardman and others, *Greek Art and Architecture* (1967).

## I. EARLY GREEK ART

The early story of Greek art is concerned with three phenomena: the reign of a primitive Geometric art from the tenth century to the eighth; the assimilation of Oriental influences toward and after the close of that period; and the formation, assisted at first by these Oriental models, of a new national style, the Greek Archaic, in the seventh and sixth centuries. The culmination of this style, at the end of the sixth century and the beginning of the fifth, is attended by the collapse, for the first time in the world's history, of certain age-long conventions, and the way is thus prepared for an art of unprecedented freedom, the classical Greek art of the fifth and fourth centuries.

The literary sources for the history of sixth-century art are extremely scanty, and for the art of the preceding centuries there is hardly any direct literary testimony. Inscriptional evidence begins in the seventh century. But most of our knowledge is derived from the stylistic and other peculiarities of the objects themselves, and from the circumstances of their discovery. Sometimes an object can be connected closely or loosely with a datable person or event; and other objects can be dated relatively to the first.

Of the vast number of objects produced in antiquity, some had a better chance of surviving to our times than others. Some substances are perishable (wood, plaster, textiles), others comparatively durable but convertible (marble, bronze), others comparatively durable and comparatively inconvertible (well-baked clay, gemstones). Thus painted clay vessels must take the place, for us, of paintings on wood or wall; small bronzes, lost or discarded, for the most part, in antiquity, of the large bronze statues which remained in place to be melted down; and only a small proportion of marble statues has escaped utter defacement or the lime-kiln. For these reasons, and for others, such as the lack of exploration in many areas, there are great gaps in our monumental evidence. In the early period, however, our sources, though scanty, are untroubled: the

53

objects to be dealt with are almost exclusively originals, and not, as in subsequent periods, largely later copies or imitations: unearthed but lately, they have suffered little at the restorer's hands: lastly, we may feel confident that, on the whole, the best of them, whether sculptures or paintings, are equal in quality to the best of their time: for the Archaic sculptures of the Acropolis were buried in an age which paid little respect to the work of the past, and were not disinterred until our own days; and it was not till well after the Persian Wars that painting took such a leap as to leave the decoration of vases far behind: "the vases of the Classical period are but a reflection of classical beauty; the vases of the Archaic period are archaic beauty itself."

## II. GEOMETRIC ART

Between the flourishing of the Creto-Mycenaean civilization, and the geometric period proper, there lies a long period which has been named, not very happily, the Proto-Geometric: a period of cultural decay, doubtless of invasions and incessant conflict. The remains are chiefly ceramic. The shapes and decoration of the vessels are commonplace. The material which the painter uses is still that lustrous black glaze which was invented by Middle Minoan potters, but his repertory is limited to groups of semi-circles and circles, triangles, straight and wavy lines.

Somewhere about the end of the tenth century, a new style arose, the Geometric style proper, which in the course of the ninth and eighth centuries conquered the Greek world. Its triumph was more complete in some districts than in others: in Crete and eastward, Proto-Geometric and even late Aegean elements lingered; old shapes, and old ornaments, such as the concentric circle, persisted; and old principles of decoration.

The analogies between Greek geometric work and the products of the Northern Balkans and Central Europe point to the rudiments of the style having been brought to Greece by Northern invaders. When life in Greece became a little more settled, the seed ripened: and the rudiments were formed into a distinctive Greek style. That this Greek style originated in a single center seems likely from the uniform character of early Geometric decoration in places so far apart as Crete and Thessaly, Athens and Rhodes. Where the center

was is doubtful, but seeing that the development of the style is more consistent in Old Greece, especially in Attica, than elsewhere, its home probably lay in that quarter.

Geometric pottery reached its highest point in Attica, and the progress of the style can be traced better there than anywhere else. The earliest Attic Geometric vases are decorated with horizontal bands, row over row, of simple rectilinear patterns—meander, lozenge, chain, zigzag; a broader band being set between narrower, and the narrower symmetrically disposed. New shapes of vase came in with the new style of decoration, and others were added later. These shapes differ widely from the harmonious forms of sixth- or fifth-century vases; but they please by their strength, clarity, and sedateness. The early Geometric system of decoration was elaborated in two ways: first by a structural alteration in the ornamental scheme—the division of the main zone by means of verticals into rectangular fields; and secondly by the introduction of animal and human figures. A row of animals in single file is substituted for a pattern zone; the antithetic group, two animals facing, with or without a central object, is used to adorn a rectangular field; freer compositions appear, scenes of a general character from everyday life. The chief animals are birds, horses, deer: the scenes are mostly battles, often at sea or on the seashore, and funerals. The figures are schematized silhouettes. The men, for example, are very tall and thin, the trunk a triangle tapering to the waist, the head a knob with a mere excrescence for the face: toward the end of the style the head is lit up—the head-knob is drawn in outline, and a dot signifies the eye. The background of the picture is toned down by copious filling-ornaments.

The metalwork which has survived from the Geometric period consists mainly of bronze bands, incised with patterns, which formed part of vessels; gold diadems with embossed designs; incised fibulae; further, of small bronze statuettes, some of them votive offerings each standing on its own base, others portions of larger objects (staves, pins, vessels, stands). The engraved and embossed decoration resembles that of the vases. The statuettes are small figures of animals or of men, sometimes simple groups, mare and foal, rider, chariot. The best show artistic intention, decision, and some skill. The men are mainly arms and legs, but by the end of the period, the forms begin to round out a little and grow shapely: and in a small group of ivories found with geometric vases in an Attic grave,

10. Attic Dipylon Amphora, Late Geometric Style, 8th Century B.C. (National Museum, Athens)

the greater corporeity, and the studied symmetry of the attitude, give a presage of Greek Archaic sculpture.

This art of thin lines and sharp corners, this small, bleak, thrifty art, presents a strange contrast to the rich swell and swing of Mycenaean forms. But its achievement should not be underrated. Take one of those huge monumental vases (Fig. 10) which stood over Athenian graves: we cannot fail to admire the simple firm lines of the shape; the careful arrangement of the decorative elements to suit their places; and the clear, compact composition of the main picture—a dead man lying in state, with mourners to left and mourners to right of him, and mourners seated and kneeling beside the bier.

## III. ORIENTAL INFLUENCES: AND THE EARLIEST ARCHAIC ART

Even in the Geometric period, the Greek world shows occasional signs of contact with the more ancient and far more highly developed art of the East: if more were known about early Ionia these signs would no doubt be more frequent. Toward the end of the eighth century foreign import and foreign influence increase greatly, and eventually contribute to the transformation of the aspect of Greek art. Products of Hittite and Syrian art, and of the mixed art created out of Syrian, Mesopotamian and Egyptian elements by the Phoenicians, reached the Greeks both overland and by sea. Few

56

of these products were of fine quality; but they served to place the artistic experience of ages at the disposal of the untutored Greek craftsman. The Homeric poems bear witness to a general admiration for the works of art made or peddled by the Phoenician: and the old belief that the shield of Achilles is based upon Eastern metalwork, though often assailed, holds the field. Side by side with this Oriental influence, there are traces, but much fainter traces, of another: Creto-Mycenaean traditions may have lingered in some districts after fading out elsewhere: and it is always possible that in various parts of Greece, Cretan or Mycenaean objects, remaining in view, or discovered from time to time, contributed at least the decayed nobleman's mite towards the formation not only of the Greek system of ornament but of the Greek figure style as well.

Oriental motives find their way into Attica, as into Sparta, before the end of the Geometric period. Lion and griffin appear on diadems found with Geometric vases: a man fights with a rampant lion; two lions devour a hunter: and from time to time an Oriental creature strays into pottery, like a prospector before the rush. . . .

The pottery of the late eighth and the seventh century, from its plentifulness and variety, throws more light upon the history of Greek art during the period than any other class of object. The technique of vase-painting changes towards the end of the eighth century. The face, or parts of it, are now drawn in black outline, with black lines for inner details. The "reserved" spaces (those enclosed by the black outline) are often uncolored; but female flesh is sometimes filled in with white, male with white or brown. White and red are used for details as well as black. An alternative process was to retain the old silhouette of the Geometric period, but transformed by the use of incised lines for inner markings: the black is usually enlivened by touches of red. Both processes, "outline" and "black-figure," may occur on the same vase, even in the same picture; further, in the black-figured pictures, the female flesh is regularly "reserved," and the male sometimes brown.

Geometric painting was monochrome: the new art contrasts light with dark, and one color with another. The Geometric painter divided his field into many small areas, and decorated each with small oft-repeated units: the new art enlarges the areas by reducing their number; decorates them with bigger and bolder elements, connected by an ampler rhythm; lays more stress on the chief area; achieves unity of design by subordination not by diffusion.

57

In patterns and in figures the straight line gives place to the curved. Lotus-flower, lotus-bud, and other motives floral and spiral were borrowed from the East, and out of these borrowed elements new and complex patterns were constituted, the ancestors of classical Greek ornament. For a long time animals are no less, even more, popular than before; but the choice changes; the favorites are now the ferocious or fantastic creatures of the East, lion, griffin, sphinx, and new monsters invented to keep these company. Turning to the human figure, we find the meager schematic forms swelling out and acquiring volume. The arms are no longer match-like; thighs, buttocks and calves are big and strong: the joints are defined, breast, knee and ankle indicated, the facial features emphasized. In the Geometric period legs and head were always in profile, breast always frontal: now the breast may be either frontal or in profile: frontal if the arms are extended to left and right of the body, in profile if the arms are close to the body or both stretched forward. The head can now look back. The movement of the legs is freer and truer: Geometric figures are unsteady, especially when they would run: but seventh-century figures, standing, running or striding, have the steadiness of later Greek art. An interlocked group is hardly representable in the simple silhouette style: if two Geometric figures were in contact, they touched but gingerly: the seventh century, by its inner delineation and its color contrasts, can demarcate one figure from another in an intertwined group: animal can close with animal, man with monster or man. "Congruent" groups can also be formed, two figures side by side, one overlapping the other. The subjects alter: the battle pictures become more disciplined; hoplite faces hoplite in the prescribed attitude; in good order, a detachment advances at the double, or the victors follow up their success; the fallen are no longer ranged, one higher than the other, like specimens on a board, but lie grovelling or supine each on his own piece of groundline. The chariot-race supplants the slow funeral procession. Lastly, the Greek artist now sets himself to represent, on clay, metal or other material, the stories of the gods and the great men of old: and by the sixth century these "myths" will have become his favorite theme. Old types are enriched and defined by a mythical content, new figures created to embody a particular story. The scenes are still confined to the barest necessaries: and the passions represented are the simplest: the desire to kill or to escape death, the delight at the sight of a friend.

58

## Greek Geometric and Archaic Art

The vases of this period divide themselves into two groups, an eastern, comprising the vases of Greek Asia Minor, of the adjacent islands, especially Rhodes, and of Naukratis; and a less homogeneous western. The contrast between the two groups is instructive. The east uses the outline technique, and long avoids incision: the black-figure technique arises in the west. The east is conservative, the west experimental. The east is content with the ancient monsters of the Orient, the west devises new: the east likes uniform rows of animals, a whole row of goats, another of deer, the west mixes its animals: the western patterns are now wilder, now more complex than the eastern: the west is narrative, the east decorative: the east, having no tale to tell, retains the filling-ornaments, and needs no inscriptions: the west ends by clearing the ground for action and for word.

Geometric pottery, though exported was not exported widely, and beyond the Greek world hardly at all: the potter worked mainly for local demand: but by the seventh century pottery was one of the principal articles of Greek export trade. Eastern Greek pottery was sent north to the Black Sea colonies, south to Egypt, west to Sicily and Etruria. The circulation of Corinthian pottery was even wider. . . .

At the end of the seventh century, the black-figure takes the place of the outline technique in Attica: the exuberant ornament is

11. "Nessos" Amphora, Attic, *c.* 610–600 B.C. Heracles Killing the Centaur Nessos, Gorgons (National Museum, Athens)

59

reduced, the animals are powerfully stylized; the eccentricity disappears. The change is partly due to influence from Proto-Corinthian art. The chief example of this stage is the Nessos amphora in Athens (Fig. 11), where the group of Heracles and the Centaur yields to fine Proto-Corinthian work in deftness, surpasses it in force. Other works by the same painter have been preserved: he is perhaps the earliest Greek artist whose personality we can grasp.

## IV. THE SIXTH CENTURY, TO 520 B.C.: EARLY AND MIDDLE ARCHAIC SCULPTURE

The figures and scenes with which we have hitherto been dealing were all small. In the later part of the seventh century large stone statues appear in Greece. The idea of making life-size or colossal statues came to Greece from Egypt, the home of grandeur, now open to the Greeks. There is no reason to suppose that the period of big stone figures was preceded by a period of big wooden figures: the material was probably stone from the beginning. Soft limestone could be shaped with the knife: marble needed hammer, punch, chisel, emery; but its clearness and brightness, and the high finish it would take, repaid the labor. Limestone is used by the sixth-century sculptor, but chiefly for the figures decorating buildings: free sculpture prefers marble. Large bronze statues could be constructed by attaching metal plaques to a wooden core: but in the second half of the sixth century improvements in the process of hollow casting enabled the Greek artist to *cast* large figures in bronze. Few such figures remain from antiquity: but from the late sixth century onwards, bronze was the favorite material for free statuary. Terracotta was used not only for metopes and other ornaments of buildings, but also for statuettes and even for larger figures.

There was plenty of work for sculptors. The custom of giving representations of living things to the gods was a very old one. The new figures, so large, so life-like, so handsome, yet so durable, would be bound to delight the divinity and make him love the donor: and so the Greek sanctuaries became peopled with men, women and animals in marble or bronze. The image of the god himself is installed in his stone house. The effigy of the dead man is set over his grave. Moreover, the development of the stone temple leads to a great extension in the range of decorative sculpture. Certain parts

of the building call for decoration: the frieze is adorned with figures in low relief: a new kind of work, high relief, enlivens pediment and metope: the pedimental figures tend to become detached in part or wholly from the background, and thus to approximate to the nature of free statuary. Besides this applied relief-work, there are substantive reliefs, funerary and votive. For work on a smaller scale there was great demand: for metal statuettes—parts of vessels and other furniture, or dedications each complete in itself; and for engraved seals, and engraved dies to make coins with: the sixth century revived the old art of engraving in hard gemstones, and the practice of issuing coins had already reached the Greek world.

Free sculpture long confines itself to a few simple types, and its repertory is very small compared with that of painting or relief. The chief types are the upright male figure, usually naked, one leg, the left, set well forward; the draped female figure, with legs close together, or the left slightly advanced; the draped seated figure. The statue is intended to be viewed directly from the front: two side views are also contemplated, and usually a back view. Each side view is a complete profile, corresponding to the complete profile in painting. The transition from side view to front view is more or less abrupt, and the stone figure retains a measure of the quadrature of the block from which it was hewn. The attitude of the statue is rigid: one leg may be set forward, the arms have a certain limited freedom of movement, and in draped statues the lines of the clothing may cut across the figure: but trunk does not twist or bend, legs are alike in posture, head looks straight forward, inclining neither up nor down nor sideways. The main mass of the statue, now as before, is bilaterally symmetrical, the plane of symmetry being the median plane, that is the plane which passes through crown, nose, navel and fork.

The leading type is that of the naked upright man with left leg advanced, the "kouros." The kouros did not develop out of early Greek statuettes: it is something new in Greece, and the model was Egyptian. The hands may hold objects, but the arms usually hang down along the sides, with the fists clenched. The figure is fully corporeal. The main divisions of the body are clearly marked: broad shoulders, big buttocks, big thighs, and muscular calves are emphasized by wasp waist and neat hard knees: the trunk remains summary. The figure becomes lighter with time, the limbs more refined, the facial features smaller and more vivacious.

61

The earlier female figures ("korai") stand with legs pressed close together, the later take a little step forward with the left. In early western women, the drapery encloses the figure in a quasi-rectangular case, which may be diversified by patterns. The germs of a subtler system of drapery are observable in the Ephesian ivories, in which the lower part of the thin chiton is either covered with dense vertical lines, or divided by a plain central band or a group of central vertical folds in relief. In the sixth century, these devices were elaborated in eastern Greece and in the islands. In an Ionian bronze of the seventh century one of the hands grasps the central strip:[1] the motive found favor; but still more popular motive was that of the hand grasping the central strip and bearing it to the side of the body, thus drawing the chiton tight so that the legs show through, and setting up a system of long curving folds. For the upper part of chiton we must turn once more to Ephesus: here the upper part is sometimes drawn down over the belt at the sides, so that the lower line of the chiton is an arc, not a straight line. Later, the chiton is pulled farther down at one side of the belt than at the other, making the two sides of the garment uneven: later still, the unevenness is increased by the Ionic himation, the upper line of which cuts across the figure diagonally from shoulder to waist. Dense groups of rippled lines render the crinkling of the chiton, and both garments terminate below in series of step-like folds. The rendering of drapery thus developed is a complex one: it diversifies the surface by dividing it into a number of areas, each with its own system of curved or straight lines; and it vivifies the mass by revealing the bodily forms beneath.

Kouros and kore, to give them their conventional names, remain the principal types of free statue throughout the archaic period. It is not until about 480 B.C. that the two legs and the two sides of the body come to be differentiated, the weight resting on one leg, the axis of the trunk being thrown out of the straight, and the head beginning to bend to one side. Then we shall no longer be able to speak of kouros and kore: but that time is far hence. The scheme of the kouros is so simple, intelligible, and compact, that no kouros will ever be quite ugly: οὔποτε πάγκακον ἔσται. But we shall find great differences in quality as well as in execution, and the later will not necessarily be better than the earlier. Among the earlier kouroi, to which we are confining ourselves for the present, two stand out: the huge and very early kouros of Sunium [see Fig.

8], in his rude majesty, like Otus, the child giant who challenged the gods, or like Adam the first man; and the kouros of Tenea, spruce and fine.

The uniformity of substantive statuary does not extend to relief-work. Here subjects and attitudes are far more varied. In many of its uses, the relief is an alternative to the picture: the chief theme is narrative, and the figures have nearly the same rules as the figures of painting. In the decorations of metope and pediment the relief is often very high indeed, and pedimental figures are sometimes partly or wholly detached from the background: but however high the relief, it remains flattish: the artist long hesitates to avail himself of the opportunity which the depth of the block affords of rendering the third dimension: the modelling is confined, for the most part, to the neighborhood of the front plane, and the sculpture has something of a drawing on stone with the contours emphasized by being worked back from the surface. . . .

The effect of the stone figure was completed by the application of color, the predominant colors being a bright red and a merry blue. In limestone figures, male flesh was painted red or red-brown, and blue and red, occasionally other colors, used for the garments; backgrounds were now plain, now colored. In marble the colors, though bright, were used more discretely: the flesh was commonly left plain, with colored details—hair, lips, eyes; part of the drapery might be colored, but most of it was plain, with colored borders or a sprinkling of little patterns: in reliefs the background was dark, blue or red. Bronze was left in its natural tone; details sometimes inlaid in other material. . . .

## V. THE SIXTH CENTURY, TO 520 B.C.: EARLY AND MIDDLE ARCHAIC PAINTING

What were the materials of sixth-century painting? The clay metopes from Thermon are virtually pictures, and votive pictures on clay tablets are common in the sixth century at Athens as well as at Corinth. A few paintings on marble slabs have survived from the later part of the century. Wooden panels we may take for granted, though no examples have reached us: but whether mural painting was already practiced in Greece is an open question. It was practiced in Etruria; moreover, the Etruscan tomb-paintings

63

show overwhelming Greek influence: but of Archaic Greek wall-painting we have no fragment remaining, nor any mention in our scanty records. The black-figure method of vase-painting reached Attica, as we saw, at the end of the seventh century, and even penetrated into eastern Greece. During the greater part of the sixth century, the sway of the black-figure technique is almost undisputed: it is not till about 530 B.C. that a new method, the so-called red-figure, arises in Athens and gradually supplants the old. During the black-figure period, the outline method forms, as far as one can see, but an undercurrent: but our impression would no doubt be different, if our non-ceramic evidence were more abundant.

The drawing of the earliest red-figure vases does not differ, in essentials, from that of the black-figured work which preceded them: and the style of the black-figured work changed but slowly. New features appear between 600 and 525 B.C.: but what goes on is mainly the fulfillment of ideas initiated in the seventh century, and the refinement and systematization of older forms. Filling-ornaments, which declined in the seventh century, disappear by the middle of the sixth. The friezes of animals fall into comparative neglect. Narrative engrosses the painters: mythical or heroic pictures acquire greater volume and greater variety than before. . . . The emotions expressed by the figures are more varied than in the seventh century: the tragic dejection of the seer who knows that Amphiaraus will not return; the joy of Theseus' crew at the sight of land and home; the incorrigible impudence of the satyrs who form the bodyguard of Dionysus and his bride. If there are more moods than there used to be, there are also more kinds of people. The world no longer consists of bearded men, beardless youths, women, animals and monsters. The old man and the child become more frequent; the workman appears, and with him the capitalist; the foreigner also, the eastern or northern barbarian in trousers and quaint hat, the flimsy Egyptian, the . . . negro; the lover; the man of pleasure; and most important of all, the wild man, the satyr, with horse's ears and horse's tail, the incarnation of our less serious moods, and one of the chief vehicles of Greek humor for many a day.

In the drawing of the figure, and even in the shapes of the vases, there is a tendency to make the forms more precise, and usually, to refine them: to proceed from the ideal expressed by Kleobis and Biton to that of the kouros of Tenea. The types of figure are the same as before, full profile, or profile legs joined to frontal breast;

but a step is sometimes taken towards the three-quarter view of the succeeding period. . . .

Not long after 600 B.C., Attic vases appear in Naukratis, in south Russia and in Etruria: by the middle of the sixth century they have penetrated everywhere, and above all, the great Etrurian market is in the hands of the Athenians. Their monopoly of fine pottery

12. Attic Amphora by Exekias, *c.* 550–540 B.C. (Vatican Museum)

a) Dioskouroi welcomed home

b) Achilles and Ajax playing draughts

remained almost unchallenged for over a hundred years. Signatures of artists and of potters and owners of fabrics, hitherto rare in Greece, now become common in Athens. The earliest Attic artist whose name we know is the vase-painter Sophilos. Sophilos was by no means a dolt: but it was not such men as he who beat the Corinthians forever from the field. It was men like Ergotimos and Klitias, the maker and the painter of the François vase, a nobly-shaped crater decorated with row upon row of pictures, chiefly scenes from myth, comprising hundreds of thin, angular, extra-ordinarily varied, elegant and expressive figures: a marvel of minute yet masculine work. The François vase was found in the far west, at Chiusi in Etruria: a cup signed by Klitias has been found far in the east at Phrygian Gordion. It is on cups that the style and the spirit of Klitias continue: in the "little-master cups" with their tiny exquisite figures. Larger pictures were painted side by side with these, and the black-figure technique may be said to culminate in the Vatican amphora signed by Exekias (Fig. 12). The technique: for the style is already past its prime: the spirit which is able to express itself through silhouette and incision is departing, and the time has come for a new and freer means of expression, the red-figure style.

## VI. LATE ARCHAIC SCULPTURE

In considering the sculpture of the Late Archaic period, we may begin, for the sake of simplicity, with the naked male figure and the clothed female figure of the types which we have learned to know as kouros and kore; for it is not until the time of the Persian Wars that these two simple but happy creations cease to be the dominant types of substantive statue. . . .

For all the beauty and variety of the Late Archaic kouroi and korai, it is not in these that Late Archaic sculpture finds its most perfect expression, but in the action-figures—men not being but doing—common as before in groups, especially in decoration of buildings, and becoming common now as substantive statues. . . .

The west pediment [of the Temple of Aphaia at Aegina] is dis-tinctly less advanced in style than the east, and it is plausibly conjectured that the west belongs to the years just before 490, the east to the years just after. The excellence of the several figures has long been recognized, and wonder expressed, that the Aeginetan

sculptors, best known in antiquity as bronze-casters, should have been masters of marble as well: but not until the new excavations of 1901 was it possible to form an accurate idea of the composition. Many-figured battle-scenes, dense yet clear; each man eager, light of foot, and trained to the last ounce; and all the freedom of a picture in the attitudes—darting, dying, and even falling. The theme of the pediments is one upon which Pindar loved to dwell in his Aeginetan odes: how the sons of Aiakos had twice taken Troy: once with Heracles, and again with the Atreidai. . . . If a single figure had to be chosen to represent ripe Archaic sculpture, would it not be the archer Heracles, himself tense as a drawn bow, from the east pediment at Aegina?

## VII. LATE ARCHAIC PAINTING

. . . In the course of the sixth century the Attic potters drove their competitors from the field. About 525, a new technique came in. The old black-figure method long survived, never quite died out, and produced masterpieces down to the end of the sixth century, but it waned gradually before the new red-figure method, in which the figures are not painted in black on the clay of the vase, but left in the color of the clay, and the background painted black: the minor details are in brown lines; a purplish-red is used very sparingly; and the color-effect is thus very sober. That manly precision, which is one of the chief characteristics of Greek vase-painting, is now imparted not by incised lines as previously, but by the wiry unerring "relief-line." In its relation to nature, the drawing of the earliest red-figure vases does not differ in essentials from that of the black-figured vases signed by Exekias or Amasis. The great change sets in fully about ten years after the introduction of the red-figure technique. The characteristics of the new style are first, a profound interest in the individual forms of the human body, and second, a new conception of the body in space, a conception of which the most obvious manifestation is the love of certain violent yet definite foreshortenings. The first of these characteristics we know from the sculpture of the time: in painting it may be illustrated by the Antaios of Euphronius (Fig. 13), which stands at the beginning of the movement, and is full of the enthusiasm of the pioneer: the artist delights in collecting and recording the very smallest facts. Such extreme

profusion of detail is hardly found in later works: by the end of the Archaic period the knowledge now being amassed is common property, and though used is not displayed. The second characteristic has no exact equivalent in sculpture in the round, but it naturally occurs in low relief, and to some extent in high relief. Hitherto the figures making up a picture had moved past the beholder on a plane parallel to the plane of his eyes: either the legs had been in profile and the breast frontal, or the whole figure had been in profile. In the new style of the later sixth century the figures are apt to turn towards the spectator and front him, partly or mainly: there are figures in which one leg is in profile and the other leg and the trunk frontal;

13. Attic Krater Painted by Euphronius, *c.* 510–500 B.C. Heracles Wrestling with Antaios (Louvre, Paris)

and figures in which both legs are in profile and the trunk three-quartered. Such figures do not merely make more variety in the representation: the foreshortenings lead the eye onward beyond the surface of the picture, and by suggesting the third dimension give the bodies more solidity and substance. The frontal figure is not a mere vehicle of action: it invites the beholder to contemplate its mass. The Thorykion of Euthymides is a good example; in which we notice further that the two halves of the body are differentiated by the frontal leg, that the head, though still in profile, no longer perches rigid on a rigid neck, but bends on to the shoulder, that one hip is higher than the other, and the trunk on the eve of turning with the bend of the head. Thus, and by the turn toward us, the figure falls into line, in some degree, with the new kind of statue which we shall find taking the place of the kouros at the beginning of the next period: an earlier manifestation of the same revolutionary idea.

Besides figures seen from the front, we have figures seen from behind: with profile legs and the back three-quartered; or with one leg in profile, and trunk and the other leg in full back-view. The head is still nearly always in profile: the full face remains rare, and three-quarter faces are not attempted till after the beginning of the fifth century, and then only occasionally and for a long time unsuccessfully. Three-quartered hands add life to the gesture; the foot may make a three-quarter turn. Finally, the artist no longer shrinks from obscuring important parts of the body: the thigh of Antaios occludes the lower half of his leg.

Thus, by purely linear devices, the painter contrives to give his picture a certain depth in space. Toward the end of the Archaic period, a device of different kind but with a kindred tendency makes its first appearance: shading. It is used very seldom and very sparingly: a flat wash of brown to give the hollow of a hat or of folds, hatched brown brush-strokes to model the rotundity of a vessel or a shield. But it is the first step towards the abolition of the linear contour and towards the replacement of outline drawing by what the modern world calls painting.

The chief interest of the vase-painter remains action. Narrative subjects—mythical and heroic—are as popular as ever, but pictures from everyday life become commoner than before, and there is a special love of athletic scenes with their straining muscles, intense movements, and countless postures; for scenes of revelry, the

"komos," where men rush, dance, quarrel, lust, vomit, shout, and sing; and for the counterpart of the komos in the ideal sphere—the thiasos, Dionysus with his satyrs and maenads. For all its variety, humor and unconcern, this art is not naturalistic: apart from some very old persons, crookbacked and borne-over, from a fat belly or so, a wrinkled brow, a bald head, a bad beard, or a blobby nose; god and man, Greek and barbarian, athlete, drinker and amorist, have the same well-formed bodies and the same untainted vigor.

*NOTES*

[1] A. Furtwängler, *Olympia* 4, pl. VII, 74.

# 5. GREEK TEMPLE PEDIMENTS

### Rhys Carpenter

## INTRODUCTION

The selection from Carpenter's *Greek Sculpture* was chosen for the emphasis it places on two key monuments of pedimental sculpture, the warriors from the Temple of Aphaia at Aegina (too enthusiastically restored by Thorwaldsen) and the fine marbles from the Temple of Zeus at Olympia, together representing the crucial era of Late Archaic and Early Classical sculpture. Carpenter's observations in this selection on the development of pedimental sculpture weave together three significant phenomena: the relationship pedimental sculpture bears to both painted and relief decoration, the connections between bronze and marble statuary suggested by the Aegina groups, and the mimetic aspects of Greek sculpture. It is instructive to read, in conjunction with this selection, Gisela Richter's *Three Critical Periods in Greek Sculpture* (1951), which highlights other significant turning points in the evolution of Greek sculpture, and Carpenter's article "Tradition and Invention in Attic Reliefs," *American Journal of Archaeology*, LIV, 4 (1950).

Other works relating to the subject of this selection are Adolf Furtwängler and others, *Aegina* (1906); Walter Hege and Gerhart Rodenwaldt, *Olympia* (1936); Bernard Ashmole and Nicholas Yalouris, *Olympia: The Sculptures of the Temple of Zeus* (1967); and Marie-Louis Säflund, *East Pediment of the Temple of Zeus at Olympia: A Reconstruction and Interpretation of Its Composition* (1970).

In ancient Greece as in later Europe during the Romanesque and Gothic period and, for that matter, in any age when the major contribution to building was the stonemason's concern, sculpture and architecture were intimately allied. In Greece, both arts employed the same material medium of white finely crystaled marble, trimmed and carved with the same tools, finished in equally exact precision, and with brightly colored detail added in the same wax-base pigments. The Greek architect conceived his task in the same visual terms and aimed at the same artistic effects as did his sculptural fellow. Indeed, sculptors and architects were often one—Scopas and the younger Polyclitus being conspicuous examples of this dual role. In consequence, it is not far wide of the truth to say that a Greek temple such as the Parthenon, with its perfection of jointing and coherence of contour and organic unity of structural form, would have seemed not so much assembled out of separate blocks as carved in a single huge mass of marble. It is not surprising that Greek architecture (again like Romanesque and Gothic) relied greatly on sculpture for decorative aid.

Apart from the carved and colored moldings which were introduced to crown and separate the various structural elements, the sculptural adjuncts to the Greek orders had their origin in two unrelated types of ornamentation. One of these was painted design applied to blank surfaces; the other was modeled clay for finial plaques and figurines along gutters and gabled ridges. Since roofs were covered in terracotta tile, their decoration with terracotta figurines or modeled plaques along their eaves and against the sky line was a wholly appropriate invention. In another category, the smooth surfaces of the marble walls and the various other blank elements incident to a temple structure presented panels to attract the painter's art. But glyptic monumental sculpture in-the-round had originally no congenial place on a Greek building. Here it was carving in relief which acted as the intermediary in converting the painter's contribution into sculptural enterprise.

In timber construction, a framework of parallel beams laid horizontally carries the ceilings, and sloping (or "raking") beams are

73

set as rafters to support the roof. In the horizontal rack, the open intervals at the outer end of the ceiling beams could be closed with thin slabs to keep out the weather. These slabs might be made either of thin wooden plank or of terracotta when that material was in use for sheathing exposed woodwork. On either of these the application of a whitewash slip would provide a suitable ground for painted design. It was from such painted panels that the carved metopes of the Doric order were evolved.

Along the flanks, where the horizontal ceiling beams and the sloping rafters converge, there were only the overhanging eaves above the metopes; but at the narrow ends of the building the sloping rafters, rising from either side to a central ridgepole, formed a large gaping triangle above the ceiling level. Since this opening, too, needed to be closed against the weather, a screen wall was inserted—the *tympanon* of Greek architectural parlance—and this presented an attractive field for painted design. It was not the open space under the sloping roof but the closing wall behind it, not the pedimental gable but the tympanon screen, which at first received decoration. From the reinforcement of such tympanon designs by carving them in relief, pedimental sculpture was initiated on the Doric temple. But it was not until relief gave place to fully detached statuary that the shallow shelf in front of the closing wall was utilized. In this manner the Greek tradition for pedimental sculpture was evolved.

This is not a theoretical reconstruction of an assumed series of events; for the earliest pedimental sculpture which has survived is all relief-work; and the earlier its date, the shallower is its carving and the more dependent is it on drawn outline and flat, colored surfaces. The tiny pediment showing Heracles' combat with the Hydra, from the Athenian acropolis, is very faithfully a carved-out Attic black-figure vase design. And the transition from tympanon relief to detached sculpture in-the-round is convincingly demonstrated on the Siphnian Treasury at Delphi, where the upper half of the various pedimental figures is fully cut away from the ground while their lower portion remains imbedded in it, carved only in relief.

By all odds, the most spectacular relief-pediment to survive is the well-preserved series of tympanon blocks from an early sixth-century temple to the local Artemis of Corcyra, the island today generally known as Corfu. In utter disregard of consistent scale, the

carved figures swell from tiny prostrate or seated figures in the corners of the gable to huge spotted leopards flanking an enormous, hideous-faced Gorgon at the center. The available height of wall under the sloping roof has alone determined the varying sizes of the occupants of a common spatial frame. The artist's mind was seemingly undisturbed by any suspicion that such a loftily set and sharply isolated situation demarcated a spatial world of its own, which imposed a self-contained orderliness of coherent size, pertinent action, and relevant meaning. All this the Greek sense of artistic fitness might be expected to reason out fully and find for all its problems of scale and composition and subject matter their appropriate solutions—not abruptly and at a single cast, but only after repeated trial and effort.

What explanation can be offered for the substitution of sculptural for pictorial decoration on the Greek temple?

On the blank rear walls of public colonnades such as lined the open plaza (or *agora*) of a typical Greek city or enclosed a sheltered porch (or *leschē*), paintings were often executed in wax pigment upon the polished or stuccoed marble surface. This tradition was not altered in favor of adornment in carved relief for such a location, nor were statues set to embellish such a background wall. Similarly, within the temples and public buildings, painted designs were applied to the stone screens and perhaps to the interior faces of the walls (as seems to have been the original intent for the Hephaisteion in Athens). Was it merely the danger of impairment by sunlight, wind, and rain which deterred a similar pictorial treatment of the exposed exterior surfaces of a building? Such an explanation would hardly apply to a tympanon, where heavy eaves offered adequate protection for painted decoration. In order to explain the shift from pictorial to sculptural decoration in Greek architecture, which produced the carved metopes and the pedimental statuary of the classic temple norm, we must postulate a powerful, though perhaps not wholly conscious, preference for sculpture as against pictorial representation, the very reverse of the condition in Renaissance Italy when painting was the favored art, with sculpture by and large a poor second. In Greek appraisal, painting was more appropriate to interiors with low illumination, sculpture in-the-round to the full light of out-of-doors, while relief (the intermediary between the two arts) was cut in greater salience when intended to be seen in strong daylight and more weakly

limned where the light was less. So, on the Parthenon, the figures on the exterior metopes were as completely detached from their ground as the medium permitted, whereas the sheltered frieze within the colonnade, dimmed by the ceiling above it, was carved in much slighter projection. The technical reasoning here is sound. The higher the protrusion of relief carving, the deeper will be the shadow cast by and upon the figures and the greater will be the illumination required to dispel it. *Per contra*, where diffused shade prevails and daylight is dimmed, relief must avoid adding to the obscurity and must therefore use only low-projecting masses devoid of heavy shadow. For the harsh, sun-struck reality of a Greek temple standing in the open against a Grecian sky, although flat color could profitably be added to clarify the individual structural members, any painted composition spread flat upon an exposed surface would have possessed insufficient spatial actuality, in contrast with the vividly real structure of the building. Here only solid sculpture had adequate material existence. Likewise, a carved and colored relief upon a tympanon, viewed from far below and at a considerable distance, would appear scarcely more than a painting on a shadowed screen, too weak for the heavy frame of roof and cornice.

Yet the introduction of solidly substantial figures in the niche of built-in space between entablature and roof, while it better suited the architectural environment of sharply defined structural shapes, entailed an esthetic objection of a different order. Whereas painted representations were only visual evocations as unreal as the incidents in a storyteller's tale, statues in their full and firmly solid actuality must seem as real as the temple on which they were stationed. The Aeginetan warriors, fighting and stumbling and lying wounded on their corniced shelf high up above unclimbable columns within a starkly uncomfortable triangle beneath an irrelevant roof, could hardly fail to suggest something illogical and even ludicrous in their embattled presence, encamped on a temple front (Fig. 14).

We have no way of knowing whether the irrationality of thus representing convincingly human beings in a setting manifestly impossible to them ever disturbed the Greek artist or his public. But it raises the interesting query whether the Greeks' insistence on visual realism had not here led them astray. And it is perhaps pertinent that the architects addicted to the Ionic order, though they ultimately accepted the Attic practice of setting between

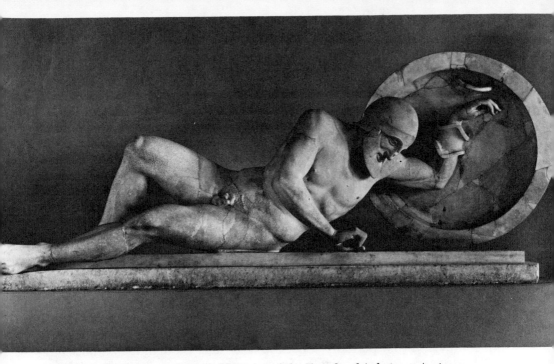

14. Fallen Warrior, from the east pediment of the Temple of Aphaia on Aegina, Archaic Greek, Late, *c.* 490 B.C., Parian marble, Length 72″ (Glyptothek, Munich; Hirmer Fotoarchiv)

epistyle and cornice a frieze of sculptured figures in relief, resolutely resisted the introduction *more Dorico* of statues in their pediments.

Because the roofs of temples were carried on central ridgepoles running the length of the building to form symmetrical gables at either end, sculptors were confronted with the task of filling two triangular fields of identical shape and size. For this reason, Greek pedimental sculpture was produced in twin sets of closely contemporary execution and hence, it is to be expected, of comparable style and similar composition.

This being the norm, it was extremely surprising and no less bewildering to discover on closer study of the remains of the early fifth-century sanctuary of the deity Aphaia on the island of Aegina opposite the Attic shore that not two but *three* series of pedimental figures were represented, with no other possible source than the one isolated Doric temple. The most plausible explanation for this anomaly assumes that, during the Persian invasion and at the time of the enemy's naval blockade of the Saronic Gulf before Salamis, a hostile landing party severely damaged the statuary on the eastern

front of the newly erected temple but did no harm to the western gable, whose figures may not yet have been set in place. After the Persian defeat, the Aeginetans would have replaced the damaged statues with a new set of figures and buried the discarded series within the sanctuary, just as the Athenians at that time interred the shattered dedications on their acropolis. Such an explanation, if correct, lends new importance to the Aegina statues. Despite the havoc which Persian rage, the indifference of time, and the over-sanguine restorations of Thorwaldsen have inflicted on them, their contribution to the chronology of stylistic development during a crucial phase goes far to compensate for the disappointments attendant on a visit to the famous *Aeginetensaal* in Munich.

Although the correct restoration of many of the figures is debatable and their arrangement within their respective pediments is still by no means entirely certain, there is much to be learned from them. Compared with any known marble work from the period (even if that period is a decade later than the handbooks on sculpture assume), the variety of poses is surprisingly great. This richness of compositional resource must have been derived from the Aeginetan bronze-casters' experimentation with piece-cast figures. There is abundant evidence for an important school of sculpture in bronze on Aegina by the close of the sixth century, but little or nothing to suggest a flourishing industry in marble. Yet for the sculptural adornment of a marble temple there was no other choice than marble, since it was seemingly unthinkable to the Greek mind that bronze should be employed. The compulsion to essay a branch of the sculptor's art with which the Aeginetans were not conversant explains their adherence to technical procedures from working in metal. This is revealed not only by the highly active poses such as could with difficulty be cut from single blocks or kept in balance or insured from breakage when made of solid stone, but also by the abundant recourse to metal accessories for the statues. Spears and shields, bows and arrows, helmets and plumed crests, all occur as separately cast additions to the marble hands and heads of the warriors. A further borrowing from bronze technique, which greatly affected the stylistic quality of the work, is the sharp, shallow engraving for the hair of head and beard and for the detailed elaboration of such costume and armor as had not been supplied in metal.

It should be remarked that this intrusion of actual armor and

weapons into a make-believe company of stone was entirely con-
sonant with the realistic ambition of the Greek sculptors, whether
Archaic or not, who saw no logical objection to putting genuine
swords and spears in the hands and helmets on the heads of figures
intended to be seen so accoutered. The resultant "mixed metaphor,"
which confused physical reality with artistic imagery, was greatly
mitigated where the addition of bronze, whether left blank, arti-
ficially patinated, or gilded over, produced no further visual effect
than that of an éxtra color in the palette of bright hues habitual
to Greek marble sculpture.

A significant advantage in borrowing from the bronze-caster's
more extensive repertory of poses was the unity of scale and subject
matter which could be achieved—probably for the first time in
sculptural history—within the awkward spatial limitations of a
full-size temple gable. By judicious choice of attitudes—reclining,
kneeling, stooping, falling, lunging, striding, or standing erect—the
designer could meet all the exigencies of pedimental headroom
without introducing any discrepant size in the figures. It was of
course incumbent to choose some applicable theme to justify the
simultaneous occurrence of so many different postures. But such a
theme was ready at hand in the combat scenes of contemporary
pictorial tradition. The melee of battle included every moment for
such a scene. That the arrangement which resulted was wholly
impossible in actual combat hardly weighed against the sculptural
coherence and visual harmony attained. Whatever else might be
said against such a carefully ordered display of arbitrary action in
conflict, at least it solved the formal problem of pedimental composi-
tion with exemplary consistency and without any surrender of
artistic sense or fitness.

It is hardly sound aesthetic criticism to object that in such a
situation it is the pre-established external frame which has supplied
the unifying bond to the composition; for the frame belongs to the
architecture, and if this dominates the sculpture, it correctly em-
phasizes the subordination of decoration to structural design. Even
so, it must be the sculptor's task to compose so adroitly that the
figures seem to determine the shape of the frame rather than to
allow it to be apparent that, in fact, the reverse is the case. Herein
the Aeginetan masters signally succeeded.

Greek temples faced the sunrise, toward which the cult statue
of the enshrined divinity looked out through a great doorway and

the eastern row of exterior columns. In consequence, the eastern pediment crowned the open entrance front while the western pediment adorned the rear of the god's dwelling. At Aphaia's temple on Aegina the absorbed interest of the sculptors in their new formula of composition seems to have precluded any thought of distinguishing sculpturally between the two façades. But at Olympia (Fig. 15), with the next great commission for temple pediment statues only a decade later than the last of the Aegina triad, east and west were emphatically and brilliantly contrasted. This finely conceived distinction might well have become an accepted tradition for the Doric temple; yet it seems to have been an isolated trait of Greek artistic inventiveness. No comparable difference of mode between front and rear pediment is discernible in the later temples, whether in the Parthenon at Athens or the rebuilt shrines for Apollo at Delphi and Athena Alea at Tegea in Arcadia. However, since the last two are known to us by little more than a description of their statues, no dogmatic statement may be made.

In Elis beside the river Alpheus, where the foremost of the Greek athletic festival contests were ceremoniously celebrated every fourth summer, Zeus, lord of the games, had long held his sanctuary

15. Apollo (center) and Lapith Women Struggling with Centaurs, from the west pediment of the Temple of Zeus at Olympia, Greek, Early Classical, c. 460 B.C., Parian marble, Height of Apollo 10'3" (Museum, Olympia. Reprinted from Bernard Ashmole, Nicholas Yalouris, and Alison Frantz, *Olympia* [1967], Phaidon Press Ltd., by permission of the publisher)

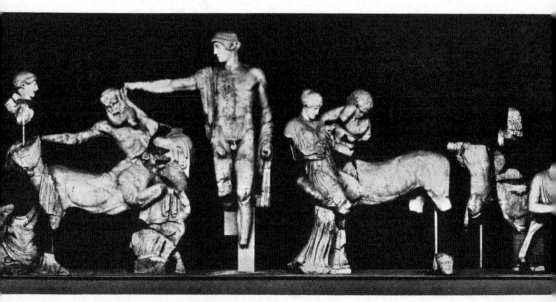

yet possessed no proper temple of his own. He shared with his wife
Hera an old-fashioned, squat-columned, but in no sense mean or
unworthy building. The god's share in the booty from the richly
caparisoned Persian host in the great defeat at Platea provided the
funds, as the tremendous victory provided the moral incentive, for
building an ambitious new temple. (At Athens, where a sadly ruined
town had first to be rebuilt and adequately fortified with encompass-
ing walls, the city goddess' new temple had to wait forty years
for its dedication; the Parthenon, following at an appreciable inter-
val the temple of Zeus, is the next great sculptural undertaking.)
At Olympia the funds seem to have been exhausted before crowning
statues had been set against the sky line for acroteria above the
pediments or a worthily rich and duly impressive cult statue of
the god could be placed in the interior chamber. In consequence,
the completion of the sculpture for the temple lagged for more than
thirty years. The twelve metope reliefs for the front and rear
vestibules—the exterior order was left blank—were the first to be
finished; next, the two pediments were filled with statuary by
masters unidentified; thereafter, but not immediately, the enormous
gold and ivory cult statue of the seated Zeus was fashioned by
Phidias and installed within the temple; and, last of all, the
acroterial figures of Victory were carved by Paeonius, an Ionian-
born sculptor resident in Athens. Of this splendor of sculptural
adornment, several of the metopes and most of the pediment statues
have survived in intelligible condition; but of the acroteria and the
great chryselephantine statue no fragments remain. Thanks to the
clean river sand in which the marble has lain embedded, whatever
has been recovered preserves a surface texture such as few ancient
statues can rival. Most of the classical marbles now on display in
museums were found encrusted with a lime deposit or otherwise
discolored and damaged from century-long repose under rain-soaked
soil. Because they were thoroughly cleaned, often with acid to
loosen the crust, scoured, and burnished without pity during the
Renaissance and in even quite recent times without due regard, the
original texture is usually lost. But from this misfortune the marbles
from the Zeus temple at Olympia are exempt. Broken as they are,
whatever remains has lost nothing save its coloring in wax and still
shows the original touch of the stonecutter's hands. And since these
pediments mark the highest surviving achievement of a particularly
inventive phase in stylistic progress and self-conscious artistry, a

pilgrimage to Olympia today is as obligatory on the lover of Greek art as ever it was in the past on the enthusiast for athletic contests.

As immediate successors to the artists of Aphaia's temple on Aegina, the sculptors at Olympia might be expected to have followed the excellent Aeginetan formula for pedimental composition, but in fact it would be difficult to imagine nearly contemporaneous productions more profoundly different in mood and manner than those which adorned the two sanctuaries.

It is completely uncertain who were the masters charged with the metopes and pediments at Olympia or even from what part of Greece they and their helpers were called to Elis. To be sure, Pausanias in describing the famous temple, still standing undamaged in his day six centuries after it was erected, records two familiar names of the Attic school, Alcamenes and Paeonius, as masters of the two pediments. But the proven date and apparent style of these sculptors render his testimony unacceptable. Yet he may have correctly indicated the home land of the sculptural school responsible for the work. It is mistaken to suppose that there were a great many important centers of sculptural activity in Greece at this time or many workshops equipped and experienced to execute so great a commission in marble (just as, in this same period, statues in bronze were probably being produced at only a comparatively small number of foundries—at Samos, Aegina, Argos, Athens, and perhaps Chalcis, as well as at Rhegion on the Sicilian strait, to name those for which we have most certain evidence). Of this much at least we may feel convinced, that the artists who carved the statues for the Olympia pediments had been apprenticed and schooled to work in marble, not bronze, and that they were intimately familiar with the Attic sculpture of their day. The head of the huge Apollo who stood protectingly in the center of the western pediment has often been likened to that of the *Blond Boy* of Athens; the heroic nudes on either side of the god, striding with weapons raised, are reminiscent of the Attic *Tyrannicides,* the famous bronze pair made to replace Antenor's figures carried off by the Persians; beyond these, the centaurs assaulting Lapith women and boys resemble those of the earlier metopes which were (perhaps) even then being carved at Athens to await emplacement on the great new temple projected for Athena Parthenos; and finally some of the attendant figures in the east pediment show contracted poses of much the same silhouetted character as Myron's *Discobolus.*

At Olympia the two pediments are deliberately and dramatically contrasted one with the other. On the entrance façade the ordering of the figures is calm and tranquil with each statue set openly apart from its neighbors, whereas the rear gable is filled with a remarkably agitated arrangement of symmetrically balanced groups tightly interlocked. It is presumably an accidental result of such a disposition of the figures rather than the deliberate intent of a geometrically minded artist that, when projected, the axes of all the major figures in the east gable run vertically parallel without intersecting or converging, while in the west the projected axes converge toward two rather vaguely defined areas situated about forty feet above and below the pedimental floor level (the latter convergence agreeing, by coincidence, perhaps, with the location of a spectator standing before the temple front). When examining Greek art, and most especially that of the fifth century, it is difficult to decide how many of its geometrical and other mathematical qualities were deliberately introduced by the artist; for, as already noted, there can be no question that the sculptors and architects of the period were highly sensitive to numerical and geometrical relationships of form and much concerned to employ them in their work.

Certainly, there is a deliberately contrived contrast in mood and manner between the two pediments at Olympia. In the ceremonially aloof poses of the east gable the central statues continue the *kouros* tradition of the motionless pier-hewn figure, while the attendants crouch or otherwise contract themselves into immobile blocks, humanly articulated rectangles surmounted by slumbering heads; and in the corners, recumbent youths, interpreted by Pausanias as divinities of the two nearby rivers, emerge from tightly wrapped sheaths of clothing, as slow-moving as mollusks in their shells. A local legend fraught with violence and threat of murderous disaster—the tale of the chariot pursuit of Pelops by his grim, unwilling father-in-law—has been drained of all incident and action in order to transmute it into changeless statuary. It is as though, before acting out a drama of deceit and flight and lovers' triumph, a company of players had aligned themselves at the footlights to bow to their audience. Those who incline to esthetic dogma in the spirit of Lessing may detect herein a fundamental aversion to pictorial narrative which properly distinguishes the sculptor's from the painter's art. But to conclude that Greek sculpture avoided the immediate representation of dramatic action is to overlook the rear

pediment of the same temple where all is turmoil and impassioned strife.

Perhaps it will be objected that here, in this astonishing array of interlaced bodies, sculpture has become pictorial narrative; but if so, it constitutes a peculiarly Greek sort of pictured presentation, since there is no indication of scenery or setting, of spatial or material environment, but only living actors upon an empty stage, set side by side against a common ground. It is true that Greek painters might have portrayed a centauromachy in similar terms of vivid silhouettes against a blank background; but this would suggest either that Greek painting had a strong sculptural bias or that Greek sculpture drew on graphic precedent, but not that Greek sculpture had here transcended its proper domain and trespassed on painting's legitimate preserve. If in the east pediment all action has dropped from the myth and no story is being told, and in the west the incidents of a drama of violent struggle are displayed in vivid detail, in neither case is there transgression beyond the representation of sculptural themes in sculptural terms. Architectural space—the solid triangle on the shallow shelf between horizontal and raking cornice—has been accepted and utilized as sculptural space without conversion into pictorial illusion of inactual depth and distance. It is the supreme logic of Greek sculpture and the best proof of its sound artistic sense that it confines itself to sculptural space.

If it be inquired what may be meant by "sculptural space" and what warrant there is for its existence, a straightforward answer can be given:

Whenever we concentrate our attention on a piece of sculpture, we deliberately segregate it mentally (and hence visually) from its objective environment. Amid the depth and distance in which our visual world extends, a sufficient amount of these commodities will accrue to the sculptured solid; and, in addition, it will attract to itself enough of the surrounding aerial vacancy to insulate itself from the rest of the visual scene. It demands adequate living-room for its activities. According as it is seen to be thin or thick, flat or cylindrical, cubical or otherwise constituted, it will occupy varying amounts of visual space; and according as it presents motion or implies any similar reaching-out beyond itself, it will assimilate sufficient enveloping space for action. There is thus a subjective factor in sculptural space which differentiates it from the meas-

84

urable volume which a physicist would assign to the configured material mass of a statue. The material mass is never identical with the apparent volume as seen—and still less so if we add the sculpture's attracted environment, its spatial "aura." Sculptural space is accordingly definable in terms of apparent volume and assimilated surrounding "aura," and hence is not fully identical with physical or (as we are apt to call it) "real" space.

On inquiry it will be found that architectural space has a similar subjective character; but it is sufficient for our present understanding to note that sculptural space may coincide with architectural space accurately enough to prevent any sensible discrepancy; whereas pictorial space, because it is created through the substitution of an artificial visual field with its own presentation of depth and distance, cannot be made coextensive with either architectural or sculptural space, both of which partake of the spatial world of our normal waking sense-experience. There is nothing recondite in such a formulation, which corresponds to everyone's awareness that buildings and statues are spatially real while that which we see in a painting is spatially illusionary. But it is less generally appreciated that the spatial structure of sculptural representation depends primarily on vision and not on physical measurements. It is what it is *seen* to be; and since it is also seen as something other than its material self—being, for instance, the god Apollo as well as a nine-foot mass of marble—how it seems to be shaped is greatly affected by visual presentation and suggestion. It is this distinction between the carved block and the seen statue which the fifth-century sculptors were beginning to appreciate. At Olympia we may see them working their way to an optically effective solution to an extremely subtle visual problem.

On this problem—if we are not to misapprehend or miss completely one of the most extraordinary properties of Greek sculptural art—we must concentrate our attention.

The Greeks understood sculpture as an art of direct visual presentation; what one saw, when one looked attentively and intelligently, was the entire intent. Statues were not meant to be symbolic suggestions of something other than themselves, illusive and allusive in their impact on the imagination of the spectator. They were fully objectified existants in the same world of sense as the rest of the spectator's sensuous experience (even if some mental concession had to be made to explain their immobile presence out-of-doors in a

85

temple precinct or a public market place). This should not be construed to imply that the Greeks had no recognition of a statue's independent status as a work of art or were unaware of its essential unreality as a block of carved marble or a piece of cast bronze; they cannot be accused of thus confusing subject matter with esthetic experience. But it serves to justify the struggle for mimetic truth which through six centuries of seldom-diverted effort determined the course of their sculpture's stylistic development.

# $6.$ THE AESTHETICS OF GREEK ARCHITECTURE

## Rhys Carpenter

### INTRODUCTION

When it was first published in 1921, *The Esthetic Basis of Greek Art* was cited by one eminent reviewer as possibly the best study in English on the aesthetics of Greek art. Revised in 1959, it continues to occupy an attractive place in the literature. Its author's interest in the psychology of visual perception has often led him into controversial regions, but always he guides the reader to fresh—and delightful—insights into ancient art.

The standard books in English on Greek architecture are W. B. Dinsmoor, *The Architecture of Ancient Greece* (1950); Donald S. Robertson, *A Handbook of Greek and Roman Architecture* (1954); and A. W. Lawrence, *Greek Architecture* (1957). See also J. A. Bungaard, *Mnesicles, a Greek Architect at Work* (1957); H. Berve, G. Gruben, and M. Hirmer, *Greek Temples, Theatres, and Shrines* (1962); Robert L. Scranton, *Greek Architecture* (1962); Rhys Carpenter, *The Architects of the Parthenon* (1970), a stimulating study especially interesting for its reconstruction of the career of Kallikrates. A recent and controversial study of the meaning of Aegean and Greek architecture is the eloquent work by Vincent J. Scully, *The Earth, the Temple, and the Gods*, 2nd ed. (1969). One should read, in conjunction with it, the review of the first edition by Homer A. Thompson in *The Art Bulletin*, XLV, 3 (1963), to fix the outlines of the controversy.

I must presuppose that the history and achievements of Greek architecture are sufficiently familiar to the reader. He will know, for example, that the dominant form or theme is the colonnaded temple; that this is built with wall, column, and horizontal beam; and that the structural elements are the square-hewn, close-fitting, mortarless ashlar block, and the various members of two distinct and characteristic "Orders," the Doric and the Ionic, to the latter of which is allied a sub-Order, the Corinthian, scarcely differing from the Ionic save in the form of its capital (Fig. 16). He will know, further, that there are temple remains dating from the sixth century B.C. and remarkable for their vigor and simplicity; that in the fifth century were achieved the refined and powerful buildings on the Athenian acropolis, in which the Doric Order reached its formal perfection and the Ionic its first flowering on Attic soil; and that in the two succeeding centuries the Ionic style was perfected by Pythius and Hermogenes and their respective schools, on the west shores of Asia Minor in such notable exemplars as the Mausoleum, the Athena temple at Priene, the Artemis temples at Ephesus and at Magnesia on the Meander, and the long-travailled but never-complete giant temple of Didymean Apollo.

I must also assume that most of the technical vocabulary of the architect will convey its legitimate meaning to the reader, and that he has already noticed the obvious and salient virtues or limitations of the Greek style.

Thus he will know that it is a current precept that Greek buildings always express their purpose and the mechanics of their construction. A temple-plan is self-explanatory; its elevation never misleads us with any pretence—although it must be granted that it rather effectually disguises the building's interior conformation by spreading a flatly aligned colonnade in front of it. The entablature is not carved or molded to produce a merely decorative façade: the epistyle has horizontal stressings to show its function; we may guess that ceiling beams bed behind the frieze; the cornice is unashamedly a watershed; the pediment occurs of necessity because a sloping roof can end in no simpler or more obvious manner. The acroteria are the only structural nonessentials—and I am not altogether sure

89

that these may not have been survivals of weights to hold down the roof, like the stones on Swiss chalets, or the interlacing of rafters.

We can scarcely acquit the Greek architects of having followed a third popular modern precept by making their architecture express its material, since they not merely painted their marble, but in the members of the two Orders carved forms (such as triglyphs, dentils, guttae, regulae) which were clearly imitative presentations of timber construction. Yet they exploited the good qualities of their building material, by giving their marble walls that lustrous finish which still endures upon them, and by carving designs whose sharpness of line and shadow-free shallows emphasized those beauties which reside more in fine marble than in any other stone. On the other hand, they could not tolerate rustication or ruggedness (except for fortification walls and similar uses) but covered their coarser materials with a stucco of powdered marble which effectively gave the lie to its native qualities. That they sheathed exposed timber with terracotta or bronze cannot be instanced against them, since it was done not so much to disguise the material as to protect and preserve the wood.

There is a fourth precept to which good architecture is generally supposed to conform. It must express (it is said) the mentality and civilization of its builders—as though whatever man consciously makes could fail to be eloquent of himself! Even a Moorish tower upon a Renaissance palace built for the servants' hall of an American millionaire's countryplace is eloquent of its age and culture. Eclecticism is as much a style as any other—and as significant of its attendant civilization. The skyline of Fifth Avenue is very eloquent of the perturbed and composite culture that made it and enjoys it. But it is intended to assert by this particular precept, that the spiritual qualities of an age should somehow be deducible from the buildings which it produces; and it is clearly true of Greek architecture that it is ordered and logical, that it harmonizes part with part, and parts with whole, and that, to a most remarkable degree, it is unfantastic and, in all its elements and proportions, always implies a human use or service, and a mortal eye and a rational mind to observe and approve it (Fig. 17).

There are no structural irrelevancies in Greek building, such as columns which are not the true supports of their superstructures, or façades which merely mask with decorative additions the dispar-

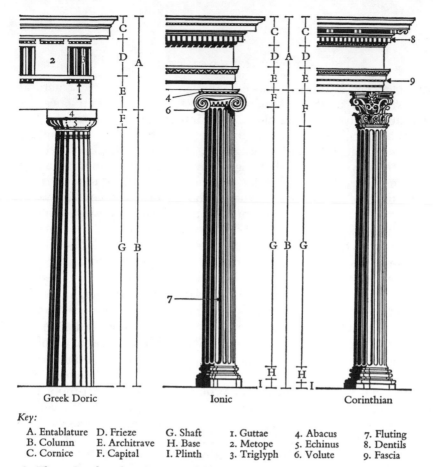

| | | |
|---|---|---|
| Greek Doric | Ionic | Corinthian |

*Key:*

| | | | | |
|---|---|---|---|---|
| A. Entablature | D. Frieze | G. Shaft | 1. Guttae | 4. Abacus | 7. Fluting |
| B. Column | E. Architrave | H. Base | 2. Metope | 5. Echinus | 8. Dentils |
| C. Cornice | F. Capital | I. Plinth | 3. Triglyph | 6. Volute | 9. Fascia |

16. Three Greek orders (Reprinted by permission of Penguin Books, Ltd., from John Fleming, Hugh Honour, and Nikolaus Pevsner: *The Penguin Dictionary of Architecture* [1966], Fig. 64. *Order*, p. 206. Copyright © John Fleming, Hugh Honour, Nikolaus Pevsner, 1966)

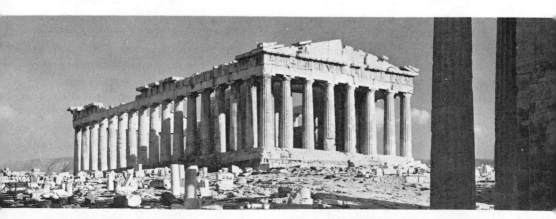

17. Parthenon, view from the northwest, with corner of Propylaea at right, 448–432 B.C. (Propylaea, 437–432 B.C.) (Acropolis, Athens; Martin Hürlimann)

ate structure behind them. But though there are no structural irrelevancies, neither is there much structural inventiveness or ambition. The Greek temple is, in its intent, a one-story affair. The superposed colonnades in its interior were forced on the builder by the physical necessity of supporting the roofbeams and the aesthetic impossibility of doing so by means of a single story of columns (since these would have to be taller and so more massive than those of the exterior order). The two-story colonnade with ground floor and gallery, thus produced, was often employed to line marketplaces and open squares, but seems not to have incited builders to attempt a third or fourth stage of columns. The tower-like superposition of the Orders was reserved for Roman façades and the restless Renaissance to achieve. The stoa, thus limited by custom to two stages, was further restrained in its height by the characteristically Greek consideration that a column more than 12 feet high would seem out of proportion to the human beings for whose service and convenience it was intended. Here, as so often in things Greek, it seemed that "man is of all things the measure." The temples, being houses of gods or at least their images, were not cribbed and cabined by these demands of human proportion: their single story of columns (you would imagine) could swell to any height. But here another proportion stepped in to check their rise toward the colossal: the distance from column to column always bore some sort of established relation to the height of the shafts, and columns could not be too widely spaced lest they could no longer be safely bridged with horizontal beams of stone. The Greeks were timid engineers:[1] a 15-foot air-span gave them pause, and the lintel of Diana's temple at Ephesus was a gigantic achievement. And so when they strove toward the colossal in height, their columns were allowed but barely sixty feet.[2] Except for such exceptional forms as the lighthouse of Alexandria and the Mausoleum of Halicarnassus, how many Greek buildings (like the Zeus temple at Girgenti) overpassed a height of one hundred feet? The theaters, to be sure, stretched up till their topmost rows might be more than this distance above the dancers' circle; but the seats were all bedded safely on the sloping hillside. For the Greeks before the Roman era, no hillside—no theater. Nothing is more surprising than to sketch the elevation of one of the great French Gothic cathedrals and to the same scale superpose upon it the façade of any of the greater Greek temples. Where the two buildings chance to agree in width,

as do the Parthenon and the cathedral of Chartres, it is all the more astonishing to see the Gothic pushing its nave to twice the Greek temple's height before ever it begins to stretch its tower and spires toward the sky.

Nor were plans varied or complex or ambitious.[3] The temple was the god's house and the depository for his possessions. What then should a god do with more than two rooms? When the cult-statue was housed and the dedications and sacred treasures were safely sheltered, nothing remained to do. A surrounding colonnade to accommodate the god's worshippers, perhaps; but nothing more. The altar, if only because of its smoke and fire, was in the open air and escaped housing. A peribolos wall, marking out the god's acreage, often shut in indiscriminately temple, altar, and *ex voto* dedications. The Greek architect had no idea of the mysterious in setting or approach; a few chthonian shrines in caverns is all that can be cited. Nor did it occur to him that his god might house, dark and inaccessible, beyond great walls and many rooms, approached through courtyard and hallway and stair, as the gods of the Pharaohs lived in the penetralia of Karnak or Luxor. Nor were there kings to dwell in magnificent palaces. Even a sixth century tyrant was a man among men. Pisistratus might take the Acropolis for his house, and Dionysius might have his dwelling on Ortygia; but these were fortresses, not palaces. Even the princes of Hellenistic Pergamon have only a paltry bit of the great hillslope for their private places. The "palace" of Pericles? There was none. And the great fifth century Athens, which was responsible for the masterpieces of the Acropolis, was only "a poorly laid-out town"[4] of small mud-brick houses and crooked narrow streets. The greatness of Greek architecture is certainly not domestic, but lies in temples and public buildings of the *polis*. Yet how monotonous are the plans of the Greek temples! and although their settings are often wonderful—on the windy sunrise cape of Sunium, among the waste grey folds of Arcadian Bassae, under the shining frown of the Delphic cliffs—how much reliance is placed on Nature and how little does Art contribute! Delphi is as idly and irrelevantly marshalled as the accretions of a cemetery; Delos is an architectural pepperpot; Olympia is unconsidered and fortuitous; the Athenian acropolis—a crown of splendor upon a head of tangled hair—owes much of its effectiveness to the lofty, clear-shining aloofness of its site. Neither in the planning of the individual building nor in its relation to other

buildings does the Greek architect show invention or artistic imagination. I do not feel confident that he even considered this latter relation until the fourth century: the symmetry *à peu prés* in the arrangement of the buildings on the Acropolis may be very subtle—or very haphazard.

Mnesicles' unfulfilled design for the Propylaea, the town-plan of Halicarnassus and perhaps Rhodes, the carven giants against the gigantic masses of the Zeus temple of Acragas, the Erechtheum plan with its imperfect reaching-out toward a freer form[5]—a list of six or seven such items seems to exhaust the instances of original and powerful departures from the lucid but easy perfection of an established tradition. Two "Orders" and a variant—only that to show for the activity of centuries! Two entablatures and three kinds of capital—is that fecundity? is that inspiration? Is it then so hard for the human brain to invent, so impossible for it to create, that one of the most intelligent and aesthetically most sensitive of races should have only this to show? They are very fine of their kind, these Orders and these temple-, colonnade, tholos-, and theater-forms; but under what limitations and abnegation of originality was their perfection wrought! And how could so many generations of active architects remain content to copy and recopy from the same meager repertory, as though there were no other way to build, no other plans or forms, nor even any other moldings to be imagined, and as though to alter a proportion or to refine a subsidiary outline were achievement enough for any master?

How can we explain such absence of individual invention and artistic variety? Only by referring it to a deep-seated prejudice of the Greek mind. . . .

The impression that the Greek architects were merely seeking the right form, not striving to be original or emotionally expressive, occurs insistently. The proportions of the Doric Order change rapidly but consistently during the sixth and fifth centuries B.C. With the attainment of the right form in the Athenian Propylaea the process of development is almost entirely arrested. Later, the decidence of the Order from favor for temple-construction and the obvious need of a lightened entablature in the use of this Order for colonnades, entirely altered the ratios: the form was no longer right, an altered use had modified it. The profile of the Doric capital changes greatly during the sixth and fifth centuries; but after the time of the Propylaea the only important change is the slight

straightening of the top of the echinus which makes the capital so much easier to cut—and entirely robs it of beauty. When the architects no longer appreciate rightness of form, the Practical and the Labor-saving are allowed to announce their wishes.

Until Hellenistic times there was only one important innovation among architectural forms—the Corinthian capital—and that was produced under logical pressure because of the inadequacy of the existing forms. The Ionic capital posed an insoluble problem at the point where a colonnade changed direction (as at the corner of a temple), while the Doric capital could not be extricated from its use with the Doric entablature whose triglyph was a tyrannous nuisance with its interference in the free spacing of columns. Moreover neither the Doric nor the Ionic capital strictly satisfied the logical requirements for the right form. The capital's function is to take the entablature weight and transmit it to the column-shaft. As an intermediary its shape should be consonant with those which it serves: it should be rectangular above and circular below in its cross section, and in the intervening part it must perform without effort the transition from rectangle to circle. The Ionic capital does not meet these requirements; the Doric lacks the transition; but the Corinthian will withstand the most rigorous criticism. It is a marvellous metamorphosis of a circle into a rectangle by a conventional device of leaves tied around a shaft.

The development of the Ionic column-base from the crude and unfelt forms of the Samian Heraion to the Attic or the fourth-century Asia Minor types is a coherent and gradual process. Contemplating it, we have the impression of beholding in operation that which the metaphysicians call a Final Cause, as though it were not each term in the series which occasioned the next, but the ultimate and perfect form like a magnet exerting its attraction through all the attempts of all the earlier builders. Compare, in particular, the Ionic bases of the Propylaea, of the east porch of the Erechtheum, and the north porch of the same building: the last form lies in the first, and progress is as unhesitant as though the path were known and the goal sighted in advance. Equally impressive is the abrupt cessation of experiments and changes as soon as the right form has been attained. The profile of the north porch bases recurs some eighty years later on the monument of Lysicrates, almost unmodified, and the form seems to have imposed itself upon the ancient builders almost as authoritatively as upon their modern imitators. The

Corinthian capital has much the same history; its form, once reached, undergoes little further change until late Hellenistic times.

This explanation for the extraordinary tyranny of the canonic form is manifestly inapplicable to all the elements of the Orders. The shape of a triglyph or mutule could not be deduced from the necessities of a roofed two-room shrine in trabeated stone or from any other intellectual formula or requirement. One could derive the column logically, but not its diminution; the capital, but not its profile; the architrave and perhaps the frieze, but not their scheme of decoration; the cornice, but not its profile. With the substitution of stone for timber in early times (for however much one may differ as to the detail of this timber prototype, it is impossible to refuse credence to it in some form or other) the structural justification for the appearance and pattern of regula, guttae, triglyph, mutule, fasciae, and dentils is their pretence of representing in conventionalized form the beam ends, planks, cleats, and even the nail-heads of timber-work transmuted into stone. Once established, these conventions survived through universal recognition of their artistic usefulness for articulating a structure which otherwise would possess little intelligible appearance. However inappropriate to limestone or marble for their material embodiment, and however irrelevant to the structural demands of squared and fitted blocks of stone, they supplied a recognizable norm for imparting to an assemblage of walls, ceilings, roofs, rooms, and corridors a unified, coherent, and shapely appearance—in short, they transformed mere masonry into a stoa or a temple. Precisely because strict architectural logic made no demand for the presence of most of the elements which composed the Orders and could not dictate to them either their shape or size or surface pattern, they escaped criticism, censure, or attack. They had come into existence in the early days of Greek architectural thinking and thereafter persisted in their own right as established species—much as there might be no discoverable inherent necessity for owls or weasels, but there they were, and each had its distinctive and established form. . . .

It is an impressive discovery when the human mind first catches glimpse of the eternal supersensuous laws ruling the seemingly casual appearances of the world of sense. This moment came to the Greeks early in their career in the course of Pythagorean and other geometric investigations. In musical theory its appearance was

most striking. Sounds—those intangible and invisible occurrences, seemingly unruled by anything but a fortuitous concordance among themselves—suddenly admitted their allegiance to the tyranny of geometry and number. The consonance of two notes was shown to depend on the presence of a simple integral numerical ratio between the lengths of the strings which produced them. Beauty and ugliness of sound were but functions of Number and ratio, and therefore founded on something measurable, something intelligible. Everywhere, order showed its control within the universe—in the paths of the stars, in the structure of material things—and everywhere, order seemed to be traceable to the influence of Number. If the right and wrong in something seemingly so elusive and unmeasurable as musical tone was based on Number, was it not even more probable that a similar geometric or arithmetic basis should determine right and wrong in the appearance of seen objects, which were material things, measurable and directly amenable to geometric notions? Nature is orderly. The forms for which she strives are strikingly symmetrical and numerically rational. The accidents of matter obscure and confuse the simple geometry of her intentions; but if we compare enough specimens of any species, we can eliminate the individual accidents and construct the true form. Here then is a cardinal assumption of Greek aesthetic practice—that there is a true form for every class of objects and that such a true form is characterized by its geometric simplicity, by the commensurability of its component members. For if its parts be not simply commensurable, then complex and therefore less perfect numbers will enter and take the place of the more perfect ones which might have been employed. Commensurability of parts, συμμετρία, is consequently a test of rightness of form, and it behooves the architect to work by the aid of its precepts.

The generative ratio of the Doric Order was fixed as 2 to 1 in the earliest times of which we have knowledge. In the round building whose architrave was discovered in the foundations of the Sikyonian treasury at Delphi this ratio was apparently not followed: in Hellenistic times the entablature (because so diminished in height) is frequently poly-triglyphal. But between these limits of time, the ratio of 2 to 1 served for what may be termed the generative formula of the Order in its horizontal extension. To every normal column span we find (enumerating the elements as they lie one above the other)

1 column,
2 regulae,
2 triglyphs + 2 metopes,
4 mutules,
4 lion's-heads,
(8 rows of cover-tiles?)

so that an ordinary Doric colonnade beats out a rhythm of full-notes in the columns, half and quarter notes in the entablature, and (frequently) eighth notes on the sloping roof, and even sixteenth notes in the floral ornamentation of the sima between the lion's-head water-spouts. In the Zeus temple at Olympia the measurements in ancient feet show how thoroughly and coherently the ratio was applied: the width of the roof-tile is taken as two feet, twice this measure gives us the width of a mutule with its *via* as well as the distance from lion's-head to lion's-head on the roof gutter, twice this latter measure gives the width of a triglyph with its metope, as well as the length of an abacus block, twice this measure gives the width from column center to column center, which is also the length of an epistyle block, and twice this last measure gives the height of a column. Finally, if the central acroterion of Nike was life-size, the total height stylobate to peak of gable-figure may very probably have equalled twice this last measurement. And so with $2 \times 2 \times 2 \times 2 \times 2$ ($\times$ 2?) the exterior of the temple is built up, and the tacit assumption seems to be that the eye, contemplating these forms, will be rhythmically affected by the simple numerical ratios inherent in them.

A more sophisticated employment of numerical ratio occurs in the colonnaded portico which the late fourth century architect Philon added to the Hall of Mysteries at Eleusis. There—as building inscriptions state and existing fragments of the architectural elements confirm—the columns' lower diameter was set at six feet while the open floor-space between the columns was set at nine feet; half of the former dimension was assigned to the triglyph width, half of the latter to the metope width; and half of this last measure was given to the overhang of the cornice over the frieze.

The giant columns of Persepolis clearly betray Greek influence, and not least in their careful observation of numerical symmetry. The two fore-parts of bulls which carry the rafters are supported by a four-sided theme, each side of which has four scrolls or volutes

(each decorated with sixteen-petalled rosettes) into which a four-filleted band has been wound; this in turn is supported by a capital whose upper portion shows eight, while its lower portion shows sixteen, floral divisions; below, a shaft with forty-eight flutings is supported on a base whose petal forms number twenty-four.

There can of course be no doubt of the conscious use of this simplest of all numerical ratios as a generative formula in the Doric Order, but it should not be imagined that all the measurements therefore will be found to be mathematically exact—all equal or double or quadruple—in the ancient Doric temples. In the Sicilian temples[6] especially there occur the greatest irregularities in the spacing of the columns and the size of the various members. Much of this may be attributed to indifferent workmanship, since the eye really exacts only very general approximations to the mathematically correct in architectural ratios. But in the classic instance of the Parthenon it is a very difficult thesis to maintain that the irregularities are attributable to mason's errors or the architect's indifference to exactness. Rather it appears that the builders deliberately sought to temper the mathematically correct by slight departures from the "true" measurements, even carrying this ideal so far that they left no straight line straight nor any spacing equal.[7] We cannot fail to recall the practice of the sculptors contemporary to the Periclean architects, and particularly that reputedly Polyclitan saying concerning the "many numbers" which "*almost*" give perfection. The so-called "refinements" of Periclean architecture, the slight deviations from perfect regularity and symmetry, are not optical corrections for untrue illusions,[8] but are added in order to give life to the rigid mathematical correctness of the standard norm; they are departures from the "many numbers," out of which arises perfection. Certainly it is a very surprising thing that the Parthenon measurements cannot be reduced to feet and dactyls according to any common scale. A foot of .2957 meters will do fairly well; a foot of .3362 meters will apply with nearly equal success; but neither these nor any other unitary lengths will fit all the measurements, because they are integrally incommensurable. We can only conclude that the builders of the Parthenon (whether by intelligent imitation or by intuitive artistic taste) had applied to architecture the same secret of beauty which governs natural forms—the tempering of geometric accuracy by minute deviations in the interest of irregularity. I need only refer to the extraordinary mathematical precision

which underlies natural forms in the vegetable and animal worlds[9] and to the patent observation that in any given individual of the species the precision of the underlying form is always tempered by the irregularities attendant upon the chance elements of environment and growth, and add that we are apt to find the actual slightly irregularized flower or shell more real, more "living," and more artistically moving than the cold geometrical perfection of the underlying form. The form only lives when it is irregularized in matter. In architecture the forms are man-devised; but if they are harmonized with mathematical precision and then irregularized in their material presentation, they will acquire a status analogous to that of a living thing in nature. . . .

I have dwelt a good deal on this numerical aspect of Greek architecture not only because it is philosophically interesting in its own right, but also because of certain remarkable implications which it involves. Out of Number come commensurability of lengths and surfaces and, by repetition, architectural beat and rhythm. But all these in Greek architecture are only effective upon the spectator if the matter in which they are embodied is seen as in one and the same plane.

The rhythm of a Doric colonnade with its measured recurrence of columns moving past, while the triglyphs double and the cornice and roof quadruple the same steady beat—all this is effective, indeed exists for the beholder, only if all these elements are felt to be on a single surface or area or plane. Theirs is an art of related lines and surfaces, not of solids. . . .

Instead of true depth, Greek architecture gives us successive and usually parallel planes. The stoa or colonnade presents the front plane of the exterior order, the middle plane of the columns which support the roof-beam, and the rear plane of the wall at the back. There is no sense of depth or enclosed space. Rather, the true depth has been converted into a succession of nearly flat and wholly disconnected surfaces—precisely as in Archaic Greek relief sculpture. Even the roof, thanks to the straight mounting lines of the cover-tiles, joins in the vertical planes. The human beings moving in this colonnade appear to the exterior spectator like bas-relief on the rear plane.

With the temple it is, of course, the same. On the long sides there are two parallel planes, that of the colonnade and that of the naos wall; on the short sides there are three planes, that of the exterior

colonnade, that of the vestibule colonnade and that of the rear wall of the vestibule (with or without its doorway with door or hanging). More complicated vistas in agora or temenos only add other planes. In glimpses across angles of colonnaded squares, or through corners of dipteral temples, the masses are all presented at intervals so that the eye sees a series of superimposed surfaces sharply divided by an intervening break of perfectly indeterminate extent. It should be added that the Greek atmosphere encourages this impression by eating up the air's appearance of solidity, so that space loses its density and surfaces seem directly superimposed. . . .

And so there follows the most remarkable property of all in Greek architecture. Since its appearances all lie in parallel or perpendicular planes, it can only *define or bound solid space, and cannot enclose it.*

Just as there is no true depth to a Greek colonnade, but only the specious depth of Greek sculptured relief, so there is no sense of space shut in and contained in anything that the Greek builders made. Even the temple-interiors offered only more colonnades and walls in parallel planes, topped by a flat ceiling which was only another plane at right angles. Such a procedure bounds space, defines it; but though mechanically it contains space because it shuts it off, it is powerless to impart any such feeling to the human mind. Whereas a vault closes down upon space and makes space sensible, a panel ceiling merely ties the walls. In the terms of relief-carving, it acts like the straight edge or step between successive planes.

That these temple interiors were but half-lighted is perhaps an indication that artistically they were but half-felt or half-considered. They were but the space enclosed by the inner faces of the walls; they were the inside of the treasure-chest, serving to shut in the gold and the sacred heirlooms; and just as the outside of a chest has the craftsman's favor and gets the carving and gilding, so it was the exterior aspect of these enclosing walls which appealed to the ancient builder.

No doubt this is somewhat fanciful, and there exists a better reason for the opinion that interiors were the least successful aspect of Greek architecture. For it is of the utmost importance to note that Greek architecture had almost no need (of a direct practical kind) for trying to shut space in. Greek life was out-of-doors. The houses were mere sleeping-cells about a central patio, the theaters were unroofed gathering-places of the people upon the hillside; the

marketplaces were open; even the shops were mere storehouses from which goods for the day's trade could be brought out to be spread in the open bazaar; the colonnades were but casual out-of-door shelters from wind and rain and sun; the schools were out-of-door palaestrae; the hospitals were colonnades in the sacred precinct of Aesclepius. Only the temples and the council-rooms so much as put the problem of enclosing airspace with encompassing masonry. Before the late Hellenistic age, domestic architecture hardly existed. It is not remarkable, therefore, that the architects devoted themselves wholly to external appearances or that, given the Greek conditions of atmosphere and light, they learned, as no other race has done, the secret of surface and line, but got no farther in the aesthetics of their art than the expression of support in vertical parallel planes.

We may assert, therefore, that the Greek architects had no comprehension of the artistic handling of space in interiors. That vast preoccupation of Gothic and modern designers was to them a book unopened. If a paradox is permissible, their only interior compositions were out-of-doors, where the roof was the blue sky. In town-square and temple-precinct they composed spatial complexities; but the picture is always made of overlapping surfaces moving across one another as the spectator moves. The intervening depths are lost, just as they were lost for the ridges and gulleys and forests of their own beloved mountains which still today show like flat bas-reliefs against the Grecian sky. . . .

Upon this two-dimensional character of its visual presentation Greek architecture based its artistic effects. Since support in the immediate vertical plane was all that such an art could present to the eye, all expression of weight sustained and held aloft must appear in the arrangement of lines and surfaces in the frontal plane of the Order. The entablature presses flat upon the columns and therefore can tolerate only horizontal or vertical lines in its decoration, since in this way the heavy uncomprising mass can be made directly intelligible. Our eyes follow the horizontal lines and our emotions instinctively interpret such lines in terms of mass in a state of rest. We have experienced just such a sweep of line in looking at the horizon of plains or of the ocean: it is the line of things outspread, heavy and immovable and enduring, held by gravity, but in no danger of falling. The columns express in their contour successful but not effortless resistance to this downward pressure, which weighs

102

squarely and heavily upon them until they bulge with the pressure. Here presumably is the psychology of entasis: it is the visible yielding to compression until a stable condition of resistance is reached. It establishes an analogy with human muscular effort and presents it directly to our emotional sensibility.

*N O T E S*

[1] *The Greeks were timid engineers.* Consider the elaborate precautions taken with the central span of the Propylaea (W. B. Dinsmoor in *American Journal of Archaelogy,* [1910], pp. 145 ff). By applying the modern engineering formulae given in Kidder's *Architect's and Builder's Pocketbook,* I find that these precautions were superfluous.

[2] *These columns were . . . but barely sixty feet.* Cf. Athens, Olympieum; Miletos, Didymeum; Ephesos, "fifth" or Hellenistic temple of Artemis.

[3] Contrast the rich inventions of plan in late Roman times (Montano, *Scielti di varii tempietti antichi,* and *Raccolta di tempii,* etc.).

[4] πόλις κακῶς ερρυμοτομημένη Dicaearchos I. 1.12.

[5] I do not accept Dörpfeld's suggestion of an original symmetrical plan doubled on a north-south axis.

[6] Cf. Koldewey and Puchstein, *die griechischen Tempel in Unteritalien und Sicilien.*

[7] *. . . they left no straight line straight.* The material for the study of this question is to be found in Penrose, *Principles of Athenian Architecture* and Goodyear, *Greek Refinements.*

[8] *. . . not optical corrections.* Goodyear has abundantly proved this point in the book referred to in the previous note.

[9] Cf. T. A. Cook, *The Curves of Life;* d'Arcy Thompson, *Growth and Form;* A. H. Church, *Relation of Phyllotaxis to Mechanical Laws;* and the two (very popularly written) books by S. Colman and C. A. Coan, *Nature's Harmonic Unity* and *Proportional Form.*

# 7. HELLENISTIC ART

## George M. A. Hanfmann

### INTRODUCTION

George M. A. Hanfmann's article "Hellenistic Art" was written in conjunction with Ernst Kitzinger's "Hellenistic Heritage of Byzantine Art," papers presented at an exploratory symposium on the Hellenistic origins of Byzantine civilization held at Dumbarton Oaks in May 1962. Quite apart from its original purpose of providing background for Professor Kitzinger's discussion of Hellenistic elements in Byzantine art, the selection that follows can stand alone as an excellent introduction to Hellenistic art, its thematic range, and stylistic variety; and, as the reader will soon discover, it is not without considerable relevance to developments in Roman art.

The standard work in English on Hellenistic sculpture is Margarete Bieber, *The Sculpture of the Hellenistic Age*, rev. ed. (1961). Chapter II of Gisela M. A. Richter's *Three Critical Periods in Greek Sculpture* (1951) surveys the various trends of the last third of the fourth century B.C. which saw the formation of Hellenistic (as distinct from Hellenic) art. E. Schmidt, *The Great Altar of Pergamon* (1962) and D. Thimme, "The Masters of the Pergamon Gigantomachy," *The American Journal of Archaeology*, L (1946) examine a key monument of Hellenistic art. Other aspects of Hellenistic art, further emphasizing its international character, are discussed in W. A. Lawrence, "Rhodes and Hellenistic Sculpture," *Annual of the British School at Athens*, XXVI (1923–25), and, by the same author, "Greek Sculpture in Ptolemaic Egypt," *Journal of Egyptian Archaeology*, XI (1925). Other works are Margarete Bieber, *Laocoön: The Influence of the Group Since Its Rediscovery*, 2nd ed. (1967); Peter H. von Blanckenhagen, "Narration in Hellenistic and Roman Art," *American Journal of Archaeology*, LXI (1957), 78–83; and Christine Havelock, *Hellenistic Art* (1971), a survey.

# FACTORS LIMITING A COMPARISON OF
# HELLENISTIC AND BYZANTINE ART.
# ESSENTIAL TRAITS OF HELLENISTIC ART

In an attempt to make the vast subject manageable, Professor Kitzinger and I have agreed to limit our discussion to certain major themes. I shall try to combine this attempt to seek out what was and what was not of interest to Byzantine artists with some intimation of what I conceive to be some of the essential traits of Hellenistic art. Thus we may hope to avoid an undue displacement of emphasis. Nevertheless, some of the major limitations of this procedure must be indicated. To make any useful comparisons with Byzantine art, we must emphasize pictorial media; yet the basic intuition of Hellenistic art was still plastic, and the plastic, three-dimensional human figure held the center of the stage. Then again, the focal themes of Byzantine art are the Sacred Image and the Sacred Cycles of the Old and New Testament. Neither the cult image nor the mythological, biographical cycle are the most expressive vehicles of Hellenistic creativity. Its full grandeur and splendor revealed itself in divinely hallowed, sacral but not sacred, atmosphere of heroic myth, and, on a more comprehensive scale, in complexes in which nature, architecture, sculpture, and probably painting were united for the sake of the total effect in a new sense of an immediate (as against the Classic distanced) nature-given reality. The Victory of Samothrace (Fig. 18) sweeping down from a mountain to alight on a "real" ship over the real water of a fountain pool, the Gauls of the great Attalid dedication fighting their defiant battle against the backdrop of the grand vistas of the eagle eyrie of Pergamon, and the Eros, asleep on his "real" rock, these seem to me to represent the essence of Hellenistic achievement.[1] If we look for their common denominator, it is vitality, *vis vitalis*, heroic or idyllic, manifesting itself within the framework of the vast diversity of nature, which is the true hero of Hellenistic art.

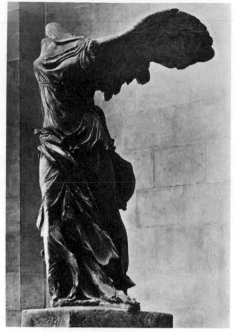

18. Nike of Samothrace, Hellenistic, *c.* 200–190 B.C., Marble, 8' High (The Louvre, Paris; Marburg-Art Reference Bureau)

## EROTICISM

Eroticism pervades Hellenistic art. If any divine powers other than Tyche enjoyed universal and popular interest, it was Eros, Aphrodite, and Dionysus. Hellenistic poetry played countless variations on the theme of the mischievous god of love, sometimes baby, sometimes a small boy, who hits indiscriminately with his arrows, burns lovers with his torch, and is in turn punished, his bow broken, his wings clipped.[2]

A world of infantile fantasies transforms myth and daily life, as when erotes play at adult work.[3] Starting from the theme *omnia vincit Amor,* the erotic invasion of myth brings before us erotes who take away the armor of the god of war and the club of the strongest of mortals, Heracles.[4] In myth after myth, heroic couples are turned into sentimental lovers.[5] . . .

There is frank and joyous love-play, especially among satyrs and maenads, now interpreted as nature's children;[6] but in much of Hellenistic art we sense an overtone of sophisticated perversion. It is the only art which has openly glorified the hermaphrodite.[7] . . .

108

## Hellenistic Art

### HUMOR AND LAUGHTER

From Archaic times on, the burlesque, the fantastic exaggeration, the parody was the great vehicle of Greek humor. It is the essence of the gusty, lusty, riproaring laughter of the Old Comedy. In the Late Classical age, this tradition lived on in the Phlyax.[8] Hellenistic humor is first and foremost an extension of this theatrical humor into the reality of daily life. In an amazing outburst of caricature, Hellenistic artists portrayed slaves, dwarfs, misshapen people, and barbarians as real-life cousins of the fantastically ugly and ridiculous people of theatrical comedy. These grotesques combine the traditional satyric approach of the comedy with keen observation, replace the stylized exaggeration of the masks with nature's quirks, and bring the new naturalistic and scientific approach to bear upon the traditional types and situations. This humor is not always good-natured. The Hellenistic world thought funny what we may consider cruel and brutal.

Laughter and smile, on the other hand, were glorified as expressions of an uninhibited, desirable natural state best embodied in Dionysiac beings and children. Laughter as an expression of ebullient vitality achieved a positive value which was not, however, permitted to invade the traditional solemnity of heroic myth—except in little byplays involving satyrs or erotes.[9]

### GENRE

With the grotesques, we have already touched upon one kind of Hellenistic genre. Let us consider briefly some examples of other types. Despite their intensive observation of "low life" the "Street Musicians" by Dioscurides of Samos are conceived in the spirit of the satyric grotesque.[10] The brilliantly painted "Woman and Shepherd" on the other hand, have been conjectured to represent a mythological scene from the Wanderings of Demeter.[11] Daily life or humanized myth?—that this question can arise is characteristic of the Hellenistic age. Certainly humanization of myth was progressing in the arts. This desire to make the divine tangible, detailed, and concrete need not lead to lack of belief. Thus it has been said of Dionysus that while the divine child becomes ever more sacred, its representations become ever more human.[12]

109

The theme of mother and child, on which Professor Kitzinger will touch in his paper, discloses something of the Hellenistic approach to humanization of myth and, at the same time, reveals some interesting traits of the attitude of the artists toward the theme of motherhood. There is genuine human appeal in such pictures as that of Danae nursing little Perseus[13] after she and her baby have been rescued from their floating box by the two fishermen, who look on with astonishment and sympathy; but the picture is not primarily a symbol of tender relation between Mother and Child. Rather it is a humanized visualization of a certain incident important for the mythological story. That nursing mothers are often figures of the Dionysiac thiasos, that tender scenes of women fondling babies show not mothers but benevolent nymphs, that Eros and Aphrodite are the son and mother most frequently shown, that scenes of tenderness sometimes turn out to be erotic—as in the baby cupid sitting in Psyche's lap[14]—all of this suggests that motherhood as such was not being glorified. Indeed, in a recent study on Birth and Childhood of Divine Children[15] J. Laager has concluded that in the Olympian mythology the mother-child relationship tends to fade into the background in favor of a male protector of the child—a Hermes, a Silenus. Hellenistic art impartially humanizes and sentimentalizes both—the mother as well as the male protector.

## ENLARGEMENT OF THE PHYSICAL WORLD: LANDSCAPES AND ARCHITECTURAL SETTINGS

One of the most striking creations of Hellenistic art are the so-called "sacral-idyllic landscapes" which lie in a border land between genre and myth. Here the mythical and sacral overtones are an integral part of the vision of an idyllic land of shepherds and wanderers, not the real shepherds and wanderers but the shepherds of the Theocritean idylls. Sometimes this idyllic land is shown for its own sake.[16] Sometimes it forms the setting for a mythological narration such as Odysseus' wanderings through the countryside, the portrayal of which became fashionable in Late Hellenistic Rome. The very sketchiness of the pictorial technique enhances the dreamlike quality which is still ideal in a thoroughly Greek—but not in a Classical—way. What is missing here from the point of view of genre is not naturalistic observation but the direct, factual statement

such as we encounter in untutored Roman folk art and in the Vienna Genesis where camels behave like real camels, sturdy and mean, in contrast to the evanescent vision of a camel as seen in the Yellow Frieze of the House of Livia.

The "sacral-idyllic" landscapes bring us to the problem of Hellenistic landscape in general. No subject is more controversial. This discussion must center on the famous Odyssey landscapes, certainly the most highly developed renderings of landscape which have come down to us from antiquity. P. H. von Blanckenhagen has argued that these pictures are derived from an earlier frieze-like Hellenistic painting which was not interrupted by columns or pilasters; the Yellow Frieze in the House of Livia and some other "sacral-idyllic" landscapes have been cited in support of this view.[17]

These putative Early Hellenistic landscapes remain phantoms. We must, I believe, accept this astonishing performance for what it is—a monument of the Hellenistic landscape painting in its latest, Roman phase. The most significant aspect of the Odyssey pictures is the sense of pantheistic vastness of nature, a nature which achieves importance equal, if not superior to the myth. This nature still receives its final animation from men; but the heroic mood is now nature's, not man's. The perennial life of the universe will go on, even when the Odyssey has ended.

In their comprehensive scope and sweep, the Odyssey landscapes are unique; but something of the same marriage of myth and nature in a poetic mode occurs in the various "sacral-idyllic" or "idyllic-mythological" paintings. In literature a similar chord, struck first in the descriptions of the Isles of the Blest, echoes in the "Blessed Landscapes" of Hellenistic romances.[18] In the celebrated picture of Paris on Mount Ida the theme is "an ideal shepherd in hallowed solitude of the mountains," not the hero or the villain of the tragedy of Troy. It is this overtone of ideality of a dreamland as remote as Paradise which seems to have inspired Byzantine artists in Ravenna to adopt such a "Landscape with Shepherd" for the portrayal of the Good Shepherd;[19] but as may be readily seen by the Roman rendering of the subject in Hadrian's Villa, the Christian mosaicists drew their inspiration not from the pantheistic interpretations of Hellenism, with their small figures and large, panoramic landscape, but from the simplified "middle-scale" interpretations of the Roman period.[20]

In other Late Hellenistic representations, the ideality of the

111

framework is less obvious and the specific character of the setting is elaborated, with some borrowings from the cartographic tradition. Civilized urban life is made part of this picture of the *oikoumene* when the so-called "city formula"[21] is added to panoramic vistas of sea and rock. Here again, in varying degree, the setting is more prominent than the action. The fall of Icarus is only an incident in the continuous life cycle of man and nature (Fig. 19).[22]

Potentially, this kind of animated landscape was adaptable to historic narration. In the Jonah scene of the Paris Psalter (Fig. 20), the artist seems to have been strongly impressed by the vision of an ancient "city by the sea" (Fig. 19). Indeed, the miraculous delivery from the belly of the whale becomes almost incidental. There are other striking resemblances; the little boat with the spectators here turned into boatmen who throw a sacklike Jonah overboard, the upward thrusts of gesturing hands transformed from astonished comment into pious urgency of prayer, the lofty place of the luminous divinity in the upper regions of the picture—in one Helios, in the other the hand of God in sunlike orb. Here, for once, one feels that a Hellenistic model may have been the immediate source.[23]

We can recall here only briefly the great variety of other Hellenistic experiments in suggesting spatial, physical setting. What we know of Greek geometry and optics confirms the ancient tradition that architectural drawing applied to theater backgrounds was the primary vehicle for the only consistent optic constructions which ancient painting had achieved. We are fortunate in having a Tarentine vase of the Late Classical period a reflection of an early stage in this process.[24] Its final phase is seen in such pictures as that of Iphigeneia on Tauris set against a magnificently Baroque stage background in the house of Pinarius Cerialis.[25] Other solutions show cities climbing up mountains, and bird's-eye views of cities (Fig. 21), intimate close-ups of civilized nature in Roman villas, and rising rocks peopled with heroic, monumental figures as in the Orpheus painting from Pompeii—which is rather strikingly related in its composition to the rendering of Moses on Sinai in the Paris and Vatican Psalters. This experimentation also comprises architectural backgrounds for narrative friezes such as are shown in scenes from the Iliad on the jug from Bernay and in the stucco frieze from Casa del Criptoportico in Pompeii.

Enlargement of the physical world was thus, in the main, a

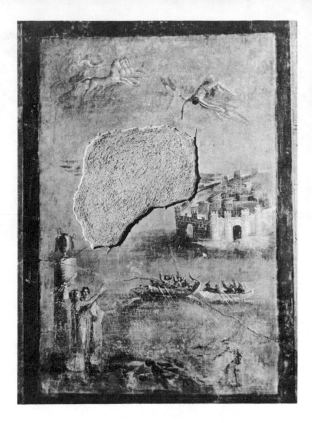

19. Pompeii, House of Amandus, Wall Painting, *Fall of Icarus*, First Century A.D.

Hellenistic achievement.[26] It remains to point out its obvious limitations. Despite their knowledge of axial perspective, Hellenistic painters never managed to detach this geometric construction from the representations of architecture and to apply it consistently to nature-made elements of landscape. The relation of landscape and figures remains in a kind of labile flux which enhances the sense

20. Paris Psalter, *Jonah, c.* 900 A.D. (Bibliothèque Nationale, Paris, after H. Omont, Fac-similés des miniatures des manuscrits grecs de la Bibliothèque Nationale, 1902, pl. 12)

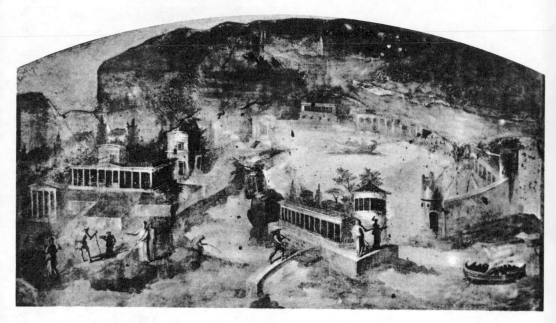

21. Pompeii, House of the Little Fountain, Wall Painting, *View of Imaginary Town and Landscape*

of unreality. It is the unity of coloristic treatment, the dynamic play of highlights, and the sustained harmony of moods that holds this world together.

## ILLUSIONISM

"Illusionism" is a term often used to describe the great advance made by the Hellenistic painters in conveying the impression of a world rich with color, spread out in space, and enlivened with light and shade. The term is not unambiguous—ever since Plato antiquity had felt that there is involved in pictorial representation on a two-dimensional surface an element of illusion in the sense of delusion and deceit, of showing what is not. On the whole, Hellenistic art took a positive attitude toward this deceit. To ancient critics, the pictorial achievements of what we would term Late Classical and Early Hellenistic painting were nothing short of miraculous. To understand their enthusiasm, we must not forget that these were discoveries made for the first time in the history of

mankind. A Late Hellenistic theorist, whose views are preserved by Pliny (XXXV:29), states that painting at long last differentiated itself from other arts, discovered light and shade, explored hue, value, and gradations as well as contrasts of colors, and then added something described as *splendor* and specifically said to be different from light (*splendor, alius hic quam lumen*). This is usually translated as "glow"; what it appears to mean is the general heightening of optical effect attained by the use of highlights as well as by coloristic devices.

From our vantage point of Post-Impressionism and highly developed color photography, the achievements of Hellenistic painters seem curiously incomplete. Yet, even in the provincial reflection by Pompeian wall painters, such is the somnambulistic certainty in the evocative handling of the brush that a critic of the rank of a J. Burckhardt felt himself "seduced into impieties toward the Renaissance" by the brilliance and brio of the ancient Campanians. In their best work, the new pictorial means are utilized to endow the human body, by color and highlight, with a pulsating life and a juicy opulence which sculpture cannot attain.

"If there are any first-rate paintings in Pompeii, they are these," says a sensitive critic of this famous picture of Heracles and Omphale (Fig. 22), part of a triptych or trilogy celebrating the power of Dionysus. The picture is quite certainly by one of the best Pompeian painters of the Fourth Style. It is equally certainly a close rendering of a Hellenistic composition of the third century B.C. At the very least it is a testimonial for the ability of painters in the Late Hellenistic-Early Roman phase of illusionism to create an effect of rich coloristic contrasts modelled in broad strokes and enhanced by generalized light. . . .

Ancient painters never accomplished what Correggio and Rembrandt were to achieve—the visualization of vaporous atmosphere and the completely unified rendering of chiaroscuro. That they attempted night scenes at all was a revolutionary venture. What they did manage to convey with their strange and inconsistent flashing white lights is the drama of the night. The picture of the Trojan horse[27] with its ghostly little silhouettes and vague masses of people is perhaps the most far-reaching attempt of antiquity to dissolve its usually plastic figures; and in the moving rendering of Priam guarding the body of Hector, the dark quiet of the night is used to enhance the mood of the sad vigil.[28]

22. Pompeian Wall Painting, Detail: Head of Omphale, First Century A.D. (Museo Nazionale, Naples)

That landscape and still life emerge as independent if subsidiary themes is characteristic of the interpenetration of the scientific interest in nature and the vitalistic attitude of Hellenistic painters. The sunlit solitude of heroic mountains was perhaps never more charmingly evoked than in the picture of the shepherd and ram; the very sketchiness of the landscape, the insubstantiality of the figures in the background emphasize its poetic unreality.[29]

To find that close-up segments of nature were considered subjects valid in their own right is even more remarkable in an art which was still anthropomorphic in essence. Hellenistic painting interprets still life not as *nature-morte* but as nature alive with a pantheistic life of which the carriers are light and color. Thus in a typical Pompeian "still life"[30] the glass, with its miraculous property of responding to light, is even more alive than the animate bird. This truly is "glow and shimmer."

Such Hellenistic splendor, however, is always a heightening of the natural, not a quest for the radiance of the supernatural. Hellenistic monarchs were noted for luxury and the kings of Pergamon had a monopoly on gold-woven textiles, *Attalicae vestes*. Gold was used to depict gold objects and to increase effects of ornamental details; but to my knowledge neither gold nor silver was ever used to produce the effect of unearthly light, not even in representations

of the halo which in Pompeian paintings was already used as a symbol of divine effulgence.[31]

## EMOTION

The Classical art of Greece had inaugurated a new approach to the portrayal of emotion which was made possible by the discovery of organic art and the resultant ability to establish a convincing relation between the soul and the body. Following up this break-through in many directions, Hellenistic artists enormously enlarged the scope and diversity of emotional situations which art might portray. Their precise observation of physical appearances and their careful studies of the relation between somatic and psychological factors enabled them to diversify the portrayal of emotions to an extent which, at first glance, appears infinite. Relaxed sleep[32] and blazing breathlessness[33] are as much within the power of Hellenistic artists as are the skillfully graduated responses in the crowd of spectators commenting on the expiring Minotaur.[34] Nevertheless, within and underneath this seemingly realistic precision, there is always present a typical element, a belief that the general transcends the specific. Apart from the province of the grotesque, Hellenism continues to uphold the Classical belief in the beauty of man—only the human body is now fleshly and sensuously rather than neutrally and ideally beautiful. The heroic gesture still dominates, even when the emotional situation calls for brutality, suffering, and anguish (Laocoön, Sacrifice of Iphigeneia),[35] subjects the ancient critics would describe as scenes of pathos, *pathe, animi perturbationes.*

For Byzantine art, the treatment of the scenes of death, grief, and lament is of particular significance; and for this reason, it may be relevant to end this discussion with some Hellenistic interpretations of the same theme. Following the precedent set by Classical art, the great majority of sepulchral monuments was concerned not with scenes of grief and lament but with perpetuation of the memory of life.[36] The exception—and this is of interest for Byzantine art—are memorials of women who died in childbirth, as did Hediste, commemorated on the Hellenistic stele from Pagasai.[37] It is not impossible that such funerary scenes influenced the portrayals of death and burial in mythological illustrations; in an Ilias cycle, the

117

corpse of Patroclus swathed in a shroud seems to echo the prostrate forms of dying women—and to anticipate curiously scenes of both death and nativity in Early Christian art.[38] From literary sources we learn that the pathetic contrast of an infant and a dead or dying mother was emphatically presented in famous Hellenistic paintings and sculptures.[39] This, however, is only an extension of that theatrical spirit of pathetic tragedy which Hellenism introduced into such legends as the myth of Pyramus and Thisbe. In general, the heroic and mythical sphere interprets death in the spirit of life defiantly ebbing away or as transition to eternal sleep.[40] This grandiose, pathetic tradition is in Roman art transformed into scenes made urgent and drastic to the point of grief-torn ugliness; and it is from this less formalized, "drastic" tradition that some of the Early Christian artists may have drawn their inspiration.[41]

One type of mythological situation, however, did evoke a more "internalized," subdued, and moving interpretation. On an Etruscan urn from Volterra,[42] there is preserved the reflection of a great Hellenistic composition showing the dead and broken but still beautiful Patroclus being lifted from the chariot. Compassion and pity speak eloquently in the group of Patroclus and the two warriors who gently lower the body of the fallen hero. A comparison with Byzantine representations of the Descent from the Cross, as for instance with the fresco of Nerezi,[43] underlines both the common denominator in the motif and the difference in the treatment—the quietly beautiful, subdued, in a sense objective, approach in the Hellenistic work, which excludes the spectator from immediate participation, and the poignantly expressive but also symbolically demonstrative power of the Byzantine masterpiece.

EPILOGUE

In these perfunctory remarks I have sought to indicate something of the range of Hellenistic art which made it such a treasure house for the Romans and the Byzantines. Elaborating and enlarging the anthropomorphic art created by the artists of Classical Greece, Hellenistic art extended the potential of the Classical tradition by searching observation of the variety and diversity of human types and experience. Going beyond the Classic, Hellenistic artists discovered for the ancient world the largeness of nature and the

possibility of envisaging a universe in which humanity is but a small part of a larger order. To this expanded cosmos, Hellenism added the new dimensions of textured local color, of light and shade, of splendor designed to heighten the feeling of life. Hellenistic art is a world of realistic unrealities—its major concerns are the defiant heroism of mythical and semi-mythical supermen, the sensuous and sentimental delights of love, the dream of a children's world where children play with gods and heroes; of grotesques uglier but also more exuberant than life; and—perhaps most comprehensively—the image of a sacral-idyllic world of pantheistic landscapes peopled with simple folk, whose worship of their rustic gods is uncorrupted by philosophic doubt, and whose peaceful, natural existence knows neither ambition nor strife. Religion in Hellenistic art is diffused and dispersed through all phases of existence, its myth is an afterglow which, like poetry, serves to elevate man's view of his past and his present. With all this yearning for the Golden Age of innocence and for escape to bucolic nature, the general tenor of Hellenistic art is life-affirming; even death is sleep, not decay. The hedonistic view of *KTO KHRO* parades its skeletons to encourage the spectator to live, not to die.[44] In contrast to Byzantine art, Hellenistic art is entirely and enthusiastically of this world, *huius mundi*, with all the good and evil this might imply for devout Christians.

This Hellenistic art, authentically Greek in essence,[45] was doomed even without the Roman conquest—artistically, by the limits set to any naturalistic cycle; psychologically, by the lack of any powerful religious impetus; biologically, by its enormous geographical expansion from India to Spain, with the resultant thinning out of its carriers and the increasing erosive impact of the native attitudes and traditions. Its Roman heirs understood much of it, but not that *élan vital* which was the unifying idea of Hellenistic creativity. In the three centuries when the Roman Empire prospered (A.D. 100–400) and held sway over men's thoughts, the entire vision of life and the world changed from the heroic superman to the *civis Romanus;* and he in turn was transformed into a citizen of the City of God, as the *interpretatio Romana* of Hellenistic heritage was succeeded by *interpretatio Christiana.* Yet Hellenistic art "dying died not." To assess the share of Hellenistic elements in the medieval image of the Classical world and to trace the persistence of Hellenistic art as a latent force which, especially in the Eastern part

of the former Roman Empire, could stimulate creative revivals, is a task which presents fascinating challenges to students of Byzantine art and culture.

*NOTES*

[1] Gauls: as proposed by A. Schober, *RM*, 51 (1936), pp. 104 ff., and *Die Kunst von Pergamon* (1951), pp. 46, 54, pls. 20 f., 80. Bieber, pp. 108 ff., Figs. 281–283, 424–427. Sleeping Eros: Bieber, p. 145, Figs. 616–618. G. M. A. Richter, *AJA*, 47 (1943), pp. 365 ff., Figs. 1 ff. R. Martin rightly notes that the "monumental urbanism" of Pergamon, which is of one piece with the Pergamene style in sculpture, works toward the heightening of nature rather than against nature, *L'urbanisme dans la Grece antique* (1956), chap. 3.

[2] On poetry, F. Lasserre, *La figure d'Eros dans la poésie grecque* (1946), pp. 150 ff. A. Furtwängler, in Roscher, *Myth. Lex.* (1884), Vol. 1 : 1, pp. 1365 ff., and *Antike Gemmen* (1900), III, pp. 167 f., 280 f.

[3] Best known from the amorini paintings of the Casa dei Vettii, Herrmann-Bruckmann, *Denkmäler der Malerei*, pls. 22 ff., 35. Their Hellenistic character is discussed in detail by F. Matz, *Ein römisches Meisterwerk* (1958), pp. 169 ff., pl. 36. Cf. those shown in Delos, Curtius, p. 78, Fig. 45.

[4] Although the purpose is different, much material has been collected by F. Matz, *op. cit.*, pp. 62 ff., which also includes amorini with thunderbolt of Zeus, trident of Poseidon, and quiver of Apollo. Amorini and Ares, Curtius, pl. 1., Matz, pl. 7b.

[5] As in groups of Ares and Aphrodite, Perseus and Andromeda, Dionysus and Ariadne, Curtius, Figs. 149 f., pl. 1. E. Simon, *Jahrbuch d. k. d. arch. Inst.*, 76 (1961), pp. 130 f., Fig. 15. L. Richardson, *Mem. of the Amer. Acad. in Rome*, 23 (1955), pl. 20.

[6] Alinari 28 080. Museo Comunale, Antiquarium. Bieber, p. 147, Fig. 627.

[7] Sleeping hermaphrodite, Louvre. Cf. Vigneau, *TEL: Encyclopédie photographique*, III, p. 231; B and C. J. Charbonneaux, *La sculpture du Louvre*, (1936), pl. 45 f.; Bieber, pp. 146 f., Figs. 623, 625 ff., and p. 124, Fig. 492.

[8] Ample illustrations in M. Bieber, *The History of the Greek and Roman Theater*, 2nd ed. (1961), chaps. 3, 7, 8, 10.

[9] Cf. H. Kenner, *Weinen und Lachen in der griechischen Kunst* (Oesterreich: Akademie der Wissenschaften, Philosophisch-Historische Klasse, *Sitzungsberichte* 234 : 2 [1960]), p. 89, Fig. 21. Kenner, pp. 93 f., emphasizes the rarity of laughing figures and concludes that only satyrs, centaurs, comedy masks, and children—non-human, or not-yet-human beings—were permitted to display laughing faces because an ideal of emotional restraint dominated Greek art. This does not quite do justice to the situation in the Hellenistic age.

[10] Curtius, pp. 337 ff., pl. 9, considers it a theatrical scene. Fig. 14 is after E. Pfuhl, *Malerei und Zeichnung der Griechen*, 3, Fig. 684.

[11] Richardson, *MAAR*, 23 (1955), p. 126, pl. 23 : 2, "Io Painter." Cf. Curtius, p. 316, Fig. 181.

[12] By M. Seiger in her report on Birth and Childhood of a God in Hellenistic Art.

[13] Richardson, pl. 49 : 1, "Iphigeneia Painter."

[14] A. S. Arvanitopoulos, *Athenische Mitteilungen,* 37 (1912), pp. 76 ff., pls. 2–3. H. Fuhrmann, *JdI,* 65–66 (1951), pp. 103 ff. L. Leschi, *MonPiot,* 35 (1936), pp. 139 ff. A. Maiuri, *La Casa del Menandro* (1932), pp. 335 ff. Morgoulieff, *Monuments antiques representant les scènes d'accouchement* (1893), and the literature quoted by J. Laager, cf. note 39. For the bathing scene, much discussed since the discovery of the Baalbek mosaic, there are not only Hellenistic but even Archaic forerunners. Cf. M. Lawrence, *De Artibus Opuscula XL: Essays in Honor of Erwin Panofsky* (1961), I, pp. 323–334, II, Fig. 13. K. Weitzmann, *Ancient Book Illumination* (1959), pp. 55 ff., Figs. 62 ff., Achilles. E. Simon, *JdI,* 76 (1961), pp. 160 f., Figs. 32, 34 f. For a typical Dionysiac "mother" who is actually a nymph, cf. the Farnesina painting, Curtius, Figs. 64 f.

[15] J. Laager, *Geburt und Kindheit des Gottes in der griechischen Mythologie* (1957).

[16] Yellow frieze, House of Livia, after P. Marconi, *La pittura dei Romani* (1929), Fig. 78. Cf. *Monumenti della pittura antica scoperti in Italia,* Sez. III: III, pl. 7 (color plate). The most recent, sensitive appreciation of "idyllic" landscapes is at hand in P. H. von Blanckenhagen and Chr. Alexander's *The Paintings from Boscotrecase, RM,* Suppl. 6 (1962). Von Blanckenhagen's evaluation, pp. 60 f., agrees so closely with mine that it is perhaps relevant to observe that neither of us had an opportunity to consult the work of the other.

[17] Rizzo, *Le pittura ellenistico-romana* (1929), pl. 163. P. H. von Blanckenhagen, *AJA,* 61 (1957), pp. 79 f. K. Schefold, *AM,* 71 (1956), pp. 211 ff.

[18] M. Hadas, *Hellenistic Culture* (1959), chap. 16, "Blessed Landscapes and Havens," pp. 212 ff.

[19] Curtius, Fig. 208. Ravenna: C. R. Morey, *Early Christian Art* (1942), pp. 158 f., Fig. 168 (Galla Placidia).

[20] E. Pfuhl, *Malerei und Zeichnung,* 3, Fig. 695. Color plate in S. Aurigemma, *Villa Adriana* (1961), p. 169, pl. 18.

[21] F. M. Biebel, *Gerasa* (ed. by C. H. Kraeling) (1938), pp. 341–351, pls. 67b, c; 68 a, b; 75a, 86 ff.

[22] Fig. 9 after Alinari 39 387. P. H. von Blanckenhagen, *AJA,* 61 (1957), p. 82, pl. 32, Fig. 11.

[23] Fig. 10 after H. Omont, *Fac-similés des miniatures et des manuscrits grecs de la Bibliothèque Nationale* (1902), p. 9, pl. 12, MS graec. 139, fol. 431. For the motif of figures emerging from the door, cf. Curtius, p. 250, Fig. 145. and K. Weitzmann, *Ancient Book Illumination* (1959), p. 61, pl. 31, Fig. 69.

[24] H. Bulle, "Eine Skenographie" 94. *Winckelmannsprogramm Berlin* (1934), pl. 2. M. Bieber, *History of the Greek and Roman Theater,* 2nd ed. (1961), p. 68, Fig. 266.

[25] Pinarius Cerialis: Bieber, *op. cit.,* p. 231, Fig. 774.

[26] For the situation in Classical Greek art, cf. G. M. A. Hanfmann, *AJA,* 61 (1957), pp. 75 ff.

[27] Made famous as an example of illusionism by F. Wickhoff, *Roman Art* (1900), pp. 149 f., pl. 12.

[28] House of C. Decimus Octavius Quartio. Spinazzola, *Pompeii,* 2 (1953), Fig. 1049.

[29] Alinari 39 135, Curtius, Fig. 213. Color: B. Maiuri, *Museo Nazionale di Napoli* (1957), p. 108.

GEORGE M. A. HANFMANN

[30] From Herculaneum. B. Maiuri, *op. cit.*, p. 134.

[31] On the use of gold, cf. E. Pfuhl, *Malerei und Zeichnung*, 2 (1923), pp. 582, 586, 591, 710, 712. For early empire, cf. A. Boëthius, *The Golden House of Nero* (1960), pp. 102 f., 112. Halo: cf. G. M. A. Hanfmann, *AJA*, 43 (1939), pp. 234 f.

[32] Sleeping Eros, n. 1 . . . Metropolitan Museum, New York, neg. 131094, cf. Bieber, p. 145, Figs. 616–618.

[33] Jockey from the sea near Cape Artemision, E. Buschor, *Vom Sinn der griechischen Standbilder* (1942), pl. 25. Cf. Bieber, p. 151, Fig. 645.

[34] B. Maiuri, *Museo Nazionale di Napoli* (1957), pl. 95, cf. L. Richardson, *MAAR*, 23 (1955), p. 121, pls. 21 f., "Dioscuri Painter." Curtius, pp. 213 f., Fig. 126, thought, probably rightly, that the spectator group goes back to a Late Hellenistic version derived from the same Late Classical original as the superior painting from the Basilica of Herculaneum . . . ; Curtius, Figs. 7 f.

[35] Laocoön in new reconstruction, after F. Magi, *Il ripristino del Laocoonte*, Pontif. Accademia Romana di Archeologia, *Memorie*, 9 (1960), pl. 41. Sacrifice of Iphigeneia, . . . Curtius, pp. 290 ff., pl. 5. Richardson, *MAAR*, 23 (1955), p. 148, pl. 47 : 1, "Iphigeneia Painter." The "beautiful" concept may have been modified to some extent by psychological associations of the kind indicated by references to color of skin and hair as reflections of character in Pseudo-Aristotelian *Physiognomica* and Pollux's catalogue of masks.

[36] For the Classical tradition, cf. K. Friis Johansen, *The Attic Grave-Reliefs of the Classical Period* (1951).

[37] Hediste: Pfuhl, *Malerei und Zeichnung* (1923), pp. 902 f., 907, Fig. 748.

[38] The corpse of Patroclus: House of C. Decimus Octavius Quartio, Spinazzola, *Pompeii*, 2, Figs. 1030, 1032 f. Cf. K. Weitzmann, *The Fresco Cycle of S. Maria di Castelseprio* (1951), pls. 5, 27, Nativity; pls. 3, 29, Joseph's dream; P. Buberl, *Illuminierte Handschriften in Wien* (1937), pl. 34 : 27, death of Isaac; pl. 44 : 48, death of Jacob.

[39] Aristeides of Thebes, painter, Pliny, XXXV : 98, "a mother lying wounded to death in the sack of a city; she appears conscious that her babe is creeping towards her breast." The picture was taken by Alexander the Great to Pella. Epigonus, Pergamene sculptor, Pliny, XXXIV : 88, "infant piteously caressing its dead mother."

[40] . . . Head of giant from copies of "Small Attalid Dedications," German Archaeological Institute, Rome, 36. 1150. Bieber, Figs. 434 f. Sleep—Bieber, Figs. 425, 432.

[41] Meleager sarcophagus Louvre-Borghese. Cf. A. Paoletti, *Materiali archeologici nelle chiese dell' Umbria, Sarcofago con il mito di Meleagro* (1961), pp. 44 ff., where other examples of drastic, "ugly" scenes of grief on Meleager sarcophagi are reproduced. I owe the reference to C. C. Vermeule. On the increase of drastic, desperate grief in rendering of mourners in Roman art, cf. H. Kenner, *Weinen und Lachen* (1960), pp. 57 f. For Early Christian art, cf. Vienna Genesis, Buberl, *Illuminierte Handschriften* . . . (Wien, 1937), pl. 33 : 26, death of Deborah.

[42] Photograph, Soprintendenza Antichità, Firenze, no. 5463, Cf. D. Levi, *Rivista del R. Istituto di Archeologia e Storia dell'Arte*, 4 (1932–3), pp. 7 ff., pl. 2b.

[43] P. Muratoff, *La peinture Byzantine* (1928), pl. 153. UNESCO, *Yugoslavia: Mediaeval Frescoes* (1955), pl. 9.

[44] K. Schefold, *Die Bildnisse der antiken Dichter, Redner, und Denker*, (1943),

pp. 166 f., 216 (goblets from Boscoreale) with references. Photograph, M. Chuzeville. This side shows Zenon (left) pointing at Epicure, who is taking a cake from the table. The scene is inscribed: *to telos hedone,* "pleasure is the [highest] end."

[45] I do not wish for a moment to deny the historic significance and aesthetic potential of forms developed in Egypt, Syria, Mesopotamia, and India through fusion of Hellenistic with native elements, but the center of gravity, the artistic leadership remained in a small area—essentially the Greek islands and the Greek cities in the coastal areas of Asia Minor, with a wider "secondary" zone taking in Athens, Sikyon, Tarentum, Syracuse, Antioch, and Alexandria.

# 8. ROMAN ARCHITECTURE

## William L. MacDonald

### INTRODUCTION

During the course of the first and second centuries A.D. a new vaulted architecture, predominantly secular in function, developed in the Mediterranean world. In all parts of the Empire it became a testimony of the Roman presence. Unlike the architecture of the Greeks, this Roman style emphasized enclosure, the interior hollow, thus providing a principle from which later centuries would continue to draw precedent.

William L. MacDonald's volume on Roman architecture, concentrating on four monuments, the Pantheon, the markets of Trajan, and the palaces of Nero and Domitian, is a detailed study of the major forms that define the Imperial architecture. The portions selected for this anthology discuss the materials and methods of construction as well as general characteristics of this new architecture of Imperial Rome.

Other works on Roman architecture are W. J. Anderson and R. P. Spiers, *The Architecture of Greece and Rome*, 2 Vols., rev. by Thomas Ashby (1927), G. T. Rivoira, *Roman Architecture*, translated by G. McN. Rushforth (1930); A. Boëthius and J. B. Ward-Perkins, *Etruscan and Roman Architecture* (1970); and, on the relationship between Roman and Early Christian architecture, see J. B. Ward-Perkins, "The Italian Element in Late Roman and Early Medieval Architecture," *Proceedings of the British Academy*, XXXIII (1947), 163 ff.; and, by the same author, "Constantine and the Origins of the Christian Basilica," *Papers of the British School in Rome*, XXII (1954), 69 ff.

Footnotes in the selections that follow cite, in abbreviated form, the following works:

| | |
|---|---|
| *AJA* | *American Journal of Archaeology* |
| *Atti* | *Atti del . . . congresso* (sometimes *convegno*) *nazionale di storia dell' architettura.* |

BC              *Bulletino della commissione archeologica communale di Roma.*
Blake *1*        M.E. Blake, *Ancient Roman Construction in Italy from the Prehistoric Period to Augustus* (1947).
Blake *2*        M.E. Blake, *Roman Construction in Italy from Tiberius through the Flavians* (1959).
BollCentro      *Bolletino del centro di studi per la storia dell' architettura.*
CIL             *Corpus Inscriptionum Latinarium.*
Durm            J. Durm, *Die Baukunst der Etrusker. Die Baukunst der Römer,* 2nd ed. (1905).
EncIt           *Enciclopedia Italiana.*
ESAR            *Economic Survey of Ancient Rome,* ed. T. Frank, 6 vols. (1933–40), reprinted in 1959.
Meiggs          R. Meiggs, *Roman Ostia* (1960).
Middleton       J.H. Middleton, *The Remains of Ancient Rome* (1892).
NS              *Notizie degli scavi di antichità*
Rostovtzeff     M.I. Rostovtzeff, *Social and Economic History of the Roman Empire,* 2nd ed., 2 Vols. (1957).

## ECONOMY OF CONSTRUCTION

Architecture properly includes the art of building, and to omit it would be to suggest a division of knowledge and responsibility that Roman imperial architects would not have recognized. Labor, materials, and methods of building were efficiently organized in an economy of construction second only to principles of design in the formation of the new architecture. Roman attitudes toward making, assembling, and using materials produced the orderly rhythms of preparation and construction essential to success in large buildings of brick and concrete. The great architects had at their disposal ready trains of supply and assembly that reached from the distant clay pits and quarries to the tops of their towering scaffolds, where brick and aggregate, by reversing the processes of nature, were bound by mortar into rock-like structure. . . .

The labor force formed the base of this economy. Unskilled workmen were enrolled or impressed in gangs, and craftsmen and semiskilled workers were organized according to their specialties into corporations or guilds (neither term is very satisfactory; what had begun as mutual assistance associations and funeral colleges were increasingly regulated by the government as the *étatisation* of society deepened).[1] Statius, enthusiastically describing Domitian's new road across the Volturno marshes into Naples, gives a glimpse of Roman divisions of labor and orderly method.

> The first work was to prepare furrows and mark out the borders of the road, and to hollow out the ground with deep excavation; then to fill up the excavated trench with other material, and to make foundations ready for the road's arched bridge, lest the soil give way and a treacherous bed provide an unstable base for the heavily loaded stones; then to bind it with blocks, set close on either side, and with frequent wedges. How many gangs are at work together! Some cut down the forest and strip the mountain sides, some shape beams and boulders with iron tools; others [cement] the stones together . . . others work to dry up the pools and [dig canals] to lead the minor streams far away. These men could cut the Athos peninsula.[2]

. . . There was even a *collegium subrutorum* or guild of demolition experts.[3] During the period under discussion, labor of all kinds seems to have been plentiful in Rome.[4] The proportion of freemen to slaves is not known; we have no document such as the building contract for the north porch of the Erechtheum in Athens, which records that out of a hundred and seven men at work at least forty-two were metics (registered aliens) and twenty were slaves (all of the latter were masons or carpenters).[5] Whatever their status Roman laborers and craftsmen were bonded firmly in groups to which their individualities were largely submerged, just as the small units of materials they put into position were essential but standardized parts of a coherent structural whole. This shaping of manpower and knowledge into a system both orderly and flexible explains certain characteristics of the new architecture. The imperial architect could command a large and well-organized labor force, and with its help he gave monumentality to his ideas and permanence to his buildings.

MATERIALS

In all vaulted buildings of imperial date, with the exception of some provincial work in cut stone, materials were used in a consistent way. Small individual structural elements were combined with mortar to obtain, after the fabric had dried out and cured, structurally continuous and enduring solids. Piers, walls, and vaults were made of concrete, and brick facing was used on piers and non-foundation walls. Wood and stone were as important in erecting buildings as lime, sand, and brick, and a fair amount of metal was used, though not in structural members. These materials will be considered in an approximately ascending order of their significance.

The extensive use of metal in ancient architecture is sometimes overlooked. In addition to decorative elements such as bronze capitals, rosettes, and cornices, metalworkers and foundrymen made doors, conduits, pipes, and a wide variety of fittings and hardware.[6] Metal roof tiles, of the kind used on the Basilica Ulpia and the Pantheon, were not uncommon. Within the structural fabric of ancient stone buildings massive iron clamps, often secured in lead, were frequently used.[7] The timbers of the roof of the Pantheon porch may have been encased in metal, and there were probably

other instances of protecting wooden members with metal sheathing. For hanging ceilings of cement and tile, Vitruvius prescribes the use of large iron bars, hung from iron hooks in the beams above, to carry the suspended weight.[8] In the piers and walls of Roman vaulted buildings a great deal of iron and bronze was used, in the form of cramps and plugs, to insure a permanent bond between marble facing, setting beds of cement, and the brick-faced structure proper. . . .

The various colors of Roman bricks and decorative terra-cottas are important. By using different kinds of clay and by varying the length of firing, colors were deliberately produced for visual purposes. Contrasts of color were common. At Ostia, for example, external pilasters of dark red and capitals and moldings of yellow, all of terra-cotta, appear in Trajanic and Hadrianic tombs and buildings. At Isola Sacra, near Ostia, there are many examples of multicolored decorative terra-cotta inserts in external walls. If these details were meant to be stuccoed over, it is difficult to understand why pieces of various colors were produced and then carefully assembled in architectural and decorative patterns. It is apparent that at least some terra-cotta exterior surfaces were meant to be seen.

In and near Rome, and in those parts of the provinces where suitable materials were available, terra-cotta manufacture became an industry. Huge quantities were made by coordinating the several production processes, a high degree of standardization was achieved, and stocks were laid up in excess and in ignorance of requirements. The standard tile and brick sizes and the fixed shapes and sizes of terra-cotta fittings and parts facilitated planning and helped architects and builders to increase the efficiency of construction. Layout and dimensioning were simplified. The extensive interchangeability of terra-cotta parts, so obvious today, was a radical innovation. They were fully utilized in the economy of building, to the extent that each brick was put to more than one use during construction.

Metal, wood, stone, and terra-cotta were all used, temporarily or permanently, in connection with mortar. The word is used here to indicate all materials of mixed composition that were in a semi-fluid state at the time of actual use in construction: the mortar for brickwork, the mix in which aggregates were placed to make concrete, and the various types of aggregate-free cements such as *opus signinum,* a mortar containing both crushed brick and

pozzolana that was used to line structures carrying or containing water and to protect the exteriors of vaults.[9] Plasters and stuccoes, being non-structural, belong in another category. They were used chiefly for facings, interior moldings, and decorative reliefs.

In Roman times mortar was already of great antiquity. Greek mortars were famous for their strength and quality. Before developing concrete the Romans had used mortars for many purposes, for example to level courses of stones not cut and finished precisely.[10] By the second century B.C. the properties of mortar were quite fully understood and the development of true concrete construction was well underway. When in the next century kiln-fired brick began to replace unfired brick, and pozzolana came into regular use, mortar became an essential material. The lengthy modern discussions of the various types of Roman wall facings are somewhat misleading, for mortar is the most important structural material in Roman non-trabeated architecture. Facings changed, and the changes give some indication of date, but the facings are not the walls themselves.

Vitruvius says that in making mortar, sea sand should be avoided. Good sands, he adds, crackle when rubbed and do not stain white cloth.[11] Lime, after burning, should be set aside to age.[12] By his day the Romans had mastered the use of pozzolana, which they added to the dry mix in lieu of part of the sand. Pozzolana is a friable volcanic material, found in thick beds of chunks and gravel-sized pieces in Latium and Campania and easily reduced to usable form.[13] It often has a distinct reddish or yellowish hue and has the property of forming hydraulic silicates in combination with lime, quartz sand, and water. The importance of pozzolana can be exaggerated, for some large Roman concrete buildings were built without it, but mortar made with it will set readily underwater, an advantage Roman engineers made good use of. The architects and builders of the high empire must have been convinced that pozzolana improved their concrete, for it was used in all the buildings described above and is rarely absent from high imperial construction in Rome and its environs.

Making mortars and using them in the building processes was in effect a process of dehydration—the burning of lime—and subsequent hydration. Because water could be added to the granular substances at the convenience of the builders, the construction of walls and vaults was much facilitated. The amorphous, dry ingredi-

ents could be easily measured and divided into manageable quantities. No highly skilled labor was required. The amounts of mortar needed for use during a given period of time could be readily calculated, and the consecutive steps of preparation and use suited Roman habits of orderly procedure. Mortar gave the architect the basis for structural materials that could be cast in a variety of architectural shapes, and its importance lies in its inherent potential of form. Doubtless there was a long period of trial and experiment. By the early first century the basic problems had been mastered and sound knowledge accumulated empirically. The ruin of part of old Rome in the summer of 64 provided the first city-wide opportunity for the use of mortar, which for nearly three centuries thereafter was the essential substance of vaulted architecture in the capital.

The ultimate synthetic product of Roman experiments with mortars, aggregates, and structural problems was the durable concrete of imperial times. . . . Basically it was a material for casting on a monumental scale. When correctly made and poured it could provide structurally continuous solids from foundations up to the crowns of vaults. The necessity of repeating bearing surfaces was much reduced. Ideally speaking, seamless and jointless structures were made possible. Architects and builders were largely freed from the necessity of thinking and planning in terms of beams and isolated bearing points, and could concentrate upon less fragmented structural and visual forms. Inevitably this led to an architecture more modeled than assembled, and it helps to explain the proliferation of curves in both plans and sections from the middle of the first century onward.

In the economy of vaulted design, shapeless raw materials were transposed into building solids by inverting natural processes.[14] Sand, lime, and pozzolana were made into rock, and clay was baked almost as hard as stone. But the small scale of the individual bricks, and the timing of bringing together the ingredients of mortar, meant that the new materials were pliant and flexible. They were the chief structural resources the great architects of the period had in mind when designing, the equivalent of stone for the Greek masters and steel and reinforced concrete for architects today.

In the use of materials two essential features stand out. One is organization, the result of applying administrative talent to problems of reliable procurement and methodical sequences of construc-

tion. Order and system were brought into complex situations involving the mutual adjustment of many variables and the fairly efficient deployment of thousands of men. The Romans learned much about such things from their predecessors, but the mastery of the economy of vaulted construction was peculiarly their own. From this point of view the method of erecting the Palace of Domitian or the Pantheon was as characteristic of Roman civilization as the law or the army. The second and more significant point concerns the inherent connection between the nature of the materials and the space-geometry of the buildings. Roman builders did not subtract from materials to obtain form, as a stonecutter does when he fashions a squared block or a cornice, but added materials together, binding them freely with mortar and building up steadily around and over a space to give it definition. It was in this sense that bricks and concrete were flexible, occupying and forming with ready adaptability the volumetric boundaries conceived by the architect.

## METHODS

The building process was largely derived from the nature of the materials, which, because the fabric had to dry out and cure, were unfinished at the moment of use. In order to obtain secure and stable buildings, construction had to proceed according to rhythms of work determined by the setting time of the mortar. The speed with which a portion of newly made structure reached sufficient bearing strength was the key factor both in planning construction and in actual building. Brick-faced walls and piers were built, without shuttering, a horizontal layer at a time, and as soon as a layer could bear enough weight the process was repeated and the building rose another few feet. For both stability and efficiency, timing was all.

In order to obtain better siting or footings the Romans were willing to alter natural contours extensively. Valleys were filled and hills were cut back. By Flavian times it was normal practice to place important buildings on level vaulted terraces or deep concrete mats.[15] Long experience with roads, aqueducts, bridges, ports, and other massive utilitarian works provided a sound knowledge of sinking foundations for stable arcuate and vaulted construction. Foundations tended to be deep and extremely substantial. The Esquiline Wing of the Domus Aurea stands upon a vast, thick sheet of concrete, poured in part at least over preexisting houses. This

increased the elevation of the building on the hillside and gave it a substantial base. Rabirius, to obtain his two desired floor levels, filled depressions, cut the Palatine rock back where necessary, and extended his upper platform to the desired limits on lofty vaulted substructures. Again, earlier buildings were filled in or their structure utilized.[16] The vertical staging of Trajan's Markets is composed of vaulted terraces that rise as much as four stories above the slope of the Quirinal. The Pantheon rotunda and drum stand upon a massive ring of concrete. Because of these precautions, evidence of settlement in these buildings is rare. They were quite well prepared to meet the threat of outside forces such as earthquake, subsidence, or extraordinary wind pressure.

The care taken in monumental building to obtain firm footings and to distribute loads fairly evenly is also evident in the supports for bearing walls. The normal practice was to excavate to a depth of two or more meters—foundation walls five and six meters deep are not unknown—and then pour the concrete wall between wooden shutterings. Many of these walls can be examined today. Some have been exposed to the weather for many years, but the negative forms of the shuttering posts (usually placed on the wall side) and of the boards as well are sometimes so clear that the grain of the rough-sawn wood can still be read.

Foundation walls were rarely faced. Once the concrete had cured sufficiently the shuttering was removed and the brick-faced wall was begun above ground level. It is not likely that shuttering, properly shored, was much used to help support faced walls, although a contrary opinion has been held.[17] The use of shuttering against brick-facing would have been difficult. First, the brick wall would have to be built up to a sufficient height to take advantage of vertical timbers long enough to give support to a considerable number of horizontal shutters. Short vertical timbers, supporting only a few boards, would not have kept the wall true. If high shuttering were put up first, the bricks would have had to be laid from the inside, a very unlikely procedure even for thick walls. Since the brick-facing is always very shallow, a mere skin a brick or half-brick deep on the surface of the concrete, it would have become increasingly unstable as it rose without its intended concrete core, and extremely difficult to keep true even if erected from inside up against the shuttering boards. Finally, the risk would be run of having the lower courses of mason's mortar stiffen too much before the concrete was

poured in, preventing the two mortars, which were applied separately, from setting together properly.

The only woodwork that seems to have been required for building brick-faced walls was the scaffolding for the masons and the ladder and ramp systems needed for bringing up bricks, mortar, and aggregate. Since the brick-facings did not function structurally once the mortar had hardened, and since shuttering was impractical, speed of erection and accuracy of construction were functions of the stiffening and drying rate of mortar. The unrestored portions of the walls of such buildings as the Markets and the Pantheon, being absolutely uniform, give no indication of the levels at which construction may have been temporarily halted for drying, for the assembly of new scaffolding, or for the end of the working day. If the mixing of mortar and its delivery to the masons, and to the mouth of the wall, were timed so that it would start to stiffen shortly after it was put in place, then perhaps both of the brick skins and the concrete core could all go up more or less together. The operation could then continue for some distance before it was necessary to halt and allow the wall to gain enough strength to carry an additional load safely and without risking distortion.

The vertical distance between halts that might be accomplished under these circumstances cannot be calculated because the most important variables are unknown. It is likely that the mortars stiffened rapidly. The rows of putlog holes for the horizontal members of the scaffolding indicate that about twenty to twenty-five rows of bricks were laid from a given level. The so-called bonding courses, discussed below, may possibly mark the end of a day's work. What is more important is that true and stable walls and piers could be built accurately by this leap-frog method. Concrete was poured between low, thin retaining walls of brick, and as soon as it set sufficiently to bear the load of the next layer, the process was repeated. Nice adjustments in timing and the supply of materials were required if the labor force was to be used with efficiency. The best masons and practical builders alone could not make the system work, for the details as well as the broad outlines of the planning had to be completed in advance. In practice this probably meant that everyone knew their job from long experience. Even so the Roman genius for order and system lay behind all the day-to-day work.

The facing bricks, from Nero's time onward, were usually sawn or broken into triangles before they were used.[18] Laying and jointing, especially in the principal Trajanic and Hadrianic monuments, can only be characterized as nearly perfect. Yet much of this meticulous work was not intended to be seen. Presumably it cannot have been done to protect the concrete, for foundation walls were usually left unfaced and many of them, little damaged by nature, still support their original loads. Also, inside walls as well as peripheral walls were faced. The facing did not provide a sufficiently rough surface for stucco or cement to adhere to satisfactorily, and the hardness of the bricks and the pozzolana mortar made it difficult to attach anything to the wall at all. Yet the bricks were necessary. They formed temporary, low formwork while the wall was going up in stages. At the lower levels this could have been done more easily and economically with shuttering properly shored. But the higher the wall went the more difficult this would have become and, above a certain height, it would have been all but impossible. Walls fifteen and twenty meters high were built, and for these heights no shoring or other form of counterpressure could have been readily provided. Also, the triangular bricks exposed rough and somewhat porous surfaces for marriage with the mortar of the interior concrete core, for by laying the bricks in simple bond a pocketed interior wall of irregular points was produced. In this sense bricks were used simply as another form of aggregate. Since they were evenly dressed on the outside, the task of keeping the wall in alignment was facilitated.

Early Roman experiments with concrete evolved from the use of relatively uncompacted rubble fills placed between ashlar or other types of stone walls. Facing materials grew thinner and progressively less structural, and cores became increasingly able to bear heavier loads. This evolution intersected the discovery of pozzolana mortars and, later, the quantity production of high-quality kiln-fired brick; the builders of the imperial age made the most out of combining tradition and invention. The multiplicity of functions assigned to brick-facing, which in some cases included a purely aesthetic and visual role, is typical of the economy of vaulted design. The reciprocities established among materials and their functions both during and after actual construction were ingenious. Orderly procedures are necessary to all successful monumental

construction, but the Romans mass-produced building materials and investigated their efficient and appropriate uses to a greater degree than any pre-industrial people. The ancient Latin principle of order, the instinctive habit of trying to put men and things in their proper places of service, lay behind this. . . .

Once the formwork of a vault was in position the actual construction was relatively simple. Mortar and aggregate were raised to the pouring level and put into position.[19] Usually the extrados was given a coat of waterproof pozzolana cement, though terra-cotta tiles were sometimes laid directly upon the concrete, and the huge Pantheon vault was finished with a thin covering of brick. If an oculus was required a stout wheel-form was built. This was positioned horizontally at the open crown of the vault, and rings of bricks, set vertically, were laid around its circumference. The last pours of concrete then brought the fabric of the vault up to this brickwork, and construction was complete. After a period of drying and curing the formwork could be dismantled and the structure given over to the decorators and marbleworkers.

STRUCTURAL FEATURES

Roman engineering was empirical, based upon deductions made from observation and experience. Not all of these deductions can be reached today by studying the buildings, and important data for the analysis of vaulted-style structure and statics are missing. The drying times and curing rates of the mortars, crucial factors in obtaining stability and in the economy of construction as well, are unknown. The true physical composition and precise structural nature of the concrete itself is uncertain.[20] Yet the basic structural principle is clear: stability depended not upon pressure or friction, as in unmortared arches or vaults of cut stone, but upon something very different, the cohesion and homogeneity of the cured concrete mass.[21]

This principle and its application explain many features of vaulted-style construction.[22] The concrete cores, invisible once the buildings were finished, were in theory continuous bearing solids. Vaults were cast by pouring down upon wooden forms in order to fill up the volumes and obtain the surfaces the forms described, and this was done without any thought of voussoirs or other discrete internal divisions of structure. These vaults were physically contin-

uous with their piers and walls, for there were no intervening bearing surfaces. But in practice the problems raised by giving shape and support to the initially formless concrete led to methods of construction that made the finished fabric structurally less simple than theory indicated. In addition, the procedures followed by the builders often caused the ideal continuity of the fabric, inherent in the basic principle, to be interrupted. By using brick to give shape to the concrete walls and piers until they hardened to bearing strength, certain secondary structural problems were introduced. At the beginning these bricks functioned as shuttering, but as the mortar cured they became an inseparable part of the structure, preserving the concrete core within a thin, weatherproof crust to which new outer finishes could be applied when needed. . . .

Although concrete did most of the work, bricks were essential both to construction and structure proper, and in thin walls the facings are probably as important structurally as the concrete. In monumental buildings the facings were falsework, weatherproofing, and structure all in one, and their various infixed devices were developed to solve the problems inherent in constructing permanent formwork, inseparably bonded to the main structure, at great scale. . . .

In a sense a structure grew out of itself because of the relationships among facings, cores, and compression devices (paradoxically, the bulkiness of vaulted designs was the result of a rather clever and economical way of building). The system helped in answering quite readily and efficiently the need for great quantities of construction. The way buildings were put up assisted in making the act of architecture a social one, no inconsiderable achievement and until then unknown in the ancient world. The Romans were able to build functional, permanent structures of many types by means of one architectural technology. Partly because of this, great buildings for public use became commonplace, and architecture of some consequence was brought into daily life and to ordinary towns far more than in the past. In this the economy of construction was an essential force. Its simplicity and method, synchronized to the needs and purposes of an age of cities, facilitated planning and realizing public building programs. Because of these things, and because of what the buildings inspired in later generations, the economy of imperial construction is a significant part of the history of architecture.

137

Behind it lay the attitudes and talents of the new architects. The predetermined order and timing of events meant that they had to direct large groups of men and insure that they did their work without appreciable error. Each of these workmen, like each brick in the walls they made, performed as a soldier under orders. The economy of the new architecture derived maximum efficiency and utility from each element in relation to its neighbors, an expression of an inherent Latin trait. The unknown military tribune, who at the battle of Cynoscephalae in 197 B.C. "judged on the spur of the moment what ought to be done" and detached twenty maniples with which he broke the phalanx of Philip V, expressed the same trait.[23] He had the training to give him judgment, and the materials of his contribution to Flaminius' victory were prepared to respond in an orderly way to his decision. Under difficult conditions he was able to move two thousand infantry quickly, efficiently, and successfully. So it was also with imperial architects, their materials and men.

## THE NEW ARCHITECTURE

What the palaces, the Markets, and the Pantheon show above all else is the maturity of the concept of monumental interior space. The strength and dynamism of imperial civilization were so great that the need for a suitable architecture could not be denied. The Romans, always building, quite naturally sought for forms that would express this ecumenical experience. Vaults were not in any way new when Severus, Rabirius, and their contemporaries gave architecture a fresh beginning with their great buildings. Yet they fashioned the new style with vaulted spaces, and in the last analysis it is the meaning and effects of these spaces that more than anything else give the style its identification and individuality. In Timgad as in Tralles, at Baia as at Bosra, the Roman stewardship of all antiquity and the imperial hope for one inclusive society—coerced or free—were proclaimed by an architecture of splendid interior spaces.

Rome itself was the nexus where many strains of design and technology were gathered together. There, seen in the light of imperial social and political aims, these strains were adapted and reworked as the new style evolved. The forms and effects of this

architecture served the capital and the provinces alike until during the fourth and fifth centuries they were gradually translated into the artistic languages of the early middle ages. In this way Roman concepts of interior space lived on in both East and West. The palaces, Markets, and Pantheon alone cannot carry the whole burden of this complicated story, but they record accurately its first and in many ways most creative chapter and vividly mark the stylistic and emotional distance between the new architecture and that of the past. The inherent value of these buildings as examples is magnified by the long life, after the dissolution of imperial authority in the West, of their architectural principles and the associations evoked by their forms.

CHARACTERISTICS OF DESIGN

The transcendent characteristic of the new architecture was its space-shaping, space-bordering quality (Fig. 23). Whatever the decor, however integrated the trabeation, this quality predominated. Its omnipresent, generative force was the circular curve, occasionally modulated to polygonal shape, upon which progressive architects based their volumetric and spatial creations and with which they resolved and fixed their axes and vistas. The curve gave them the radial focus that more than anything else established the viewer's relationship to their designs. Not only the major vaulted spaces, but their entrances, openings, niches, and decor were evolved from a preoccupation—almost an obsession—with the embracing and focusing qualities of circular lines and surfaces. The indispensable curve gave Roman vaulted architecture its overwhelming sense of place, and its use in three dimensions as the boundary of architectural space is the quintessential feature of the style. Although the formal structure of the style was geometric, a number of shapes were used together in every building. Even the Pantheon, the most unitary of Roman monumental designs, is composed of triangles, a prismatic block, a cylinder, a hemisphere, and apsidal recesses. The imperial architect, unlike a designer such as Ledoux, was not attracted by basic, unadorned geometric shapes standing alone as buildings. Shapes in combination interested him, shapes arranged significantly and harmonically as to scale and meaning, and articulated by an elaborate but consistent system of decoration and well thought-out lighting.

23. Trajan's Forum and Markets, Rome, Early Second Century A.D. (Reprinted from William L. MacDonald, *Architecture of the Roman Empire,* I [1965], Yale University Press, by permission of the author)

Figure A (Eric Spencer after William L. MacDonald
Forum of Trajan and surroundings, plan.
Stone construction throughout Forum, except libraries (E), which were of brick, perhaps for absorption of humidity. Roofs of wood and tiles.

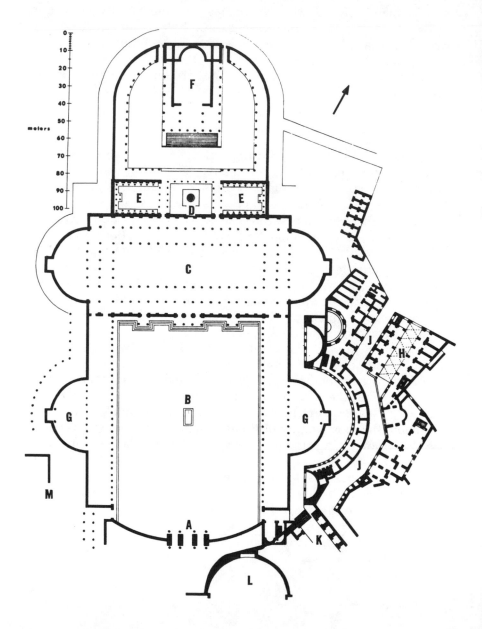

Key:
A. Monumental entrance to Forum of Trajan
B. Equestrian statue of Trajan
C. Basilica Ulpia
D. Column of Trajan
E. Libraries (brick structures)
F. Temple of Trajan
G. Hemicycles, Forum of Trajan
H. Vaulted hall (aula Traiana) in market area
J. Via Biberatica (main street of the markets)
K. Stairs and southeast extension of hemicycle street, originally connecting the
   Forum with the city region to the east
L. Corner of Forum of Augustus
M. Perimeter wall of Caesar's Forum

Figure B (Eric Spencer after B. M. Boyle)
Trajan's Markets. Isometric drawing of remains. Concrete construction
with brick facings.
Key: Same as Figure A

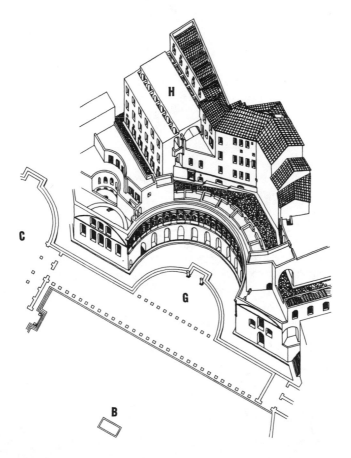

Although in this way Roman design "became absolutely emancipated from precedent, and was pursued as research into the possibilities of form and combination,"[24] the ancient principle of symmetry was not abandoned. Few vaulted-style buildings erected before Hadrian's death in 138 depart to any considerable extent from a basic, underlying frame of mirror or bilateral symmetry. The geometric interior volumes were themselves symmetrical, and were combined symmetrically in plan. Eccentricity of plan and therefore of elevation was extremely rare. Dominant axes and balanced silhouettes, and the almost complete lack of any noncircular curves, explain as much as the solidity of their construction the impression of strength and permanence these buildings give. The stability implied by simple geometric forms was exploited to the full, both through the persistent revelation of their inherent symmetry and by combining them, as for example when a semidomed apse was placed at the end of a barrel-vaulted room. This hyper-symmetry, this unwillingness ever to admit any ambiguity of axis, was so positive a force that even the external axes leading to the entrances of monumental buildings were defined by courtyards or other axially parallel features. By such means even open spaces could be given a certain feeling of interiorness. Unlike the projected axes of Greek monumental architecture, which frequently passed unhindered out across the natural landscape, the center lines of Roman buildings tended to be stopped and fixed by architectural solids nearby—an apse, a nymphaeum, even a gate would do (in a space of centralized plan, another major axis was self-contained within the building itself). Embracing, curved shapes were used to catch and cup the central lines of architectural force as the basin of a fountain catches its jet of water. Against a vertical half-cylinder capped by a shell-form or semidome the movement of an axis was both marked and resolved. The parallel side walls or other bordering features of a central axis, whether of a single space or a large composition of many elements, were almost always exactly alike. As in the atrium house the path along a controlling axis might be interrupted, but this rarely diluted its visual and directive power. The deviations introduced were only temporary, for no real choice of routes was offered and the compelling symmetry of the design was unaffected. . . .

An environment of controlling forms preempted attention and rigorously limited freedom of movement, characteristics inherited

from the past. For centuries the open sacred precinct, with its altar and its looming cult building beyond, had given form and direction to the most fundamental rituals of Roman life. The early imperial fora, with their elevated marble temples dominating elongated enclosures, expressed the same principles in more sophisticated fashion. In the vaulted style the evolution of this traditional directionalism and focus was brought to its logical conclusion. One was now either guided toward a focal concavity or brought into an axially terminal space, a large and well-lighted architectural volume from which the natural world was excluded, where enveloping and radially focused surfaces suggested permanence, stability, and security.

## IMPERIAL CIVILIZATION AND ARCHITECTURE

. . . The vaulted style was infused with the same hortatory quality found in official statuary and reliefs, upon coins, and in the panegyrical literature. This insistent rhetoric of Roman state art reflects the sharp paternalism upon which the coherence and preservation of society was thought to depend. In the buildings this quality is evident in the way the senses were instructed by axis, symmetry, and the properties of concavity. These characteristics of design and sensory instruction also reflected the balance and order, the almost choreographic clarity, of Roman ritual and liturgy. In these ways the vaulted style was a mimesis of the state, a metaphor in tangible form upon its traditions and its claims to all-embracing sovereignty. Naturally it arose in Rome, the center of these traditions and claims, where after Nero's time it was used to create an *urbs pro maiestate imperii ornata.*[25]

All of the great vaulted buildings were charged with the property of expressing unity. Encouragement to individualism was missing because choice was missing. Vaulted architecture was no more permissive than the state itself. Axis, symmetry, and the terminal feature or volume kept everyone *en face* in fact or in mind with the focal, symbolic shape; there were no true alternatives. Roman architecture might be defined as a body of law in masonry, governing human responses by didactic forms whose expressive force was intended to be recognized or apprehended immediately by the sensory faculties. Grace and elegance were sacrificed to this drive to persuade one and all to conform, and this could explain the

preoccupation with the primary geometric shapes so readily yielded by the economy of imperial construction. The age of truly personal expression in architecture lay in the future, for the architecture of Rome, like that of Egypt and Greece, spoke of a particular way of life and the institutions it fostered rather than of the independent opportunity and taste of any single individual.

The nature of imperial society was also expressed in the very orderly way in which diverse human and natural resources were directed toward the end in view. The success of the solution to these essentially logistical problems is evident in the ability of the Romans, during the first and second centuries, to erect large numbers of buildings simultaneously without straining either their knowledge or their economy of construction. Their capacity to move almost as one man toward a desired goal was exploited in an atmosphere of bureaucratic expansion and increasing state regulation, but this made possible that supple manipulation and control of each unit of action and substance that insured the continuity of the necessary rhythms of construction. Bricks and aggregate were deployed through the buildings like maniples and centuries of infantry in the sense that each anonymous unit obeyed the commands of the architect and was dependent upon the proper functioning of exactly similar units assembled in a strictly disciplined order. The hundred foremen, each directing a gang of a hundred men, who are said to have supervised the construction of Hagia Sophia, were the inheritors in Justinian's age of Roman working methods.[26]

The government influenced the new architecture in other practical ways. It largely controlled finances, could focus talent and labor upon architectural objectives if and when it chose, and concerned itself with building codes and schedules of maintenance. Apparently a fair proportion of architects and builders were trained during military service, and many were kept on the government rolls either in the army or in the civil service to be posted to various locations around the Empire as the need arose. The guilds, at first only supervised by the government, were gradually absorbed into its ever expanding, infinitely graded hierarchy. The government was in a position to orchestrate the architectural resources of the whole realm. Sparse as the written evidence is, it suggests that this was done for architecture as for law, the administration, and the army.

That the emperors and their governments used the vaulted style as an instrument of propaganda can hardly be doubted. All official

architecture was used in this way. The proliferation in the provinces of large baths based upon first- and early second-century designs in Rome is the most obvious case, but many other vaulted building types were used in the provinces, such as markets, warehouses, amphitheaters, and municipal nymphaea. Districts and towns in Italy were embellished with an apparent generosity that the emperors surely regarded as a sound investment in the future of the state. Though the financial resources of the Empire were primitively managed there was always money for building after the armies and the supply of Rome had been provided for. The doors of the treasuries were open to provincial governments as well. Astute provincial officials and citizens knew how to take advantage of the government's predisposition to build.[27] The pax romana kept communications open, allowing the style to spread and change as it was conditioned, in both Rome and the provinces, by non-Latin concepts.

What happened in Rome and many imperial cities during the years 54 to 138 is very much like what is happening in industrial countries today. Even making necessary allowances for the profound technological changes of the last two centuries, the Roman experience of architecture and building in the High Empire was more like our own than that of any other age. Both periods are marked by a drive to surpass the old led by men who want the new. Both are concerned with the visual as well as the social condition of the municipality. Today, when imitation Georgian and nondescript buildings are razed by the block and replaced by innumerable variations on the rectilinear silhouette, something of what happened in Rome, Ostia, Leptis Magna, Pergamon, or a hundred other cities of the Empire is taking place. Even the smallest town was given some architectural token to represent the imperial peace. In general the Romans built more slowly and more permanently than we, but they had the same compulsion to make their cities conform, in their public buildings at least, to the modern age. And the modern age was the new imperial order, which uprooted hundreds, sometimes thousands, of families to make way for new housing and municipal buildings.

Unlike the Egyptians and the Greeks, the Romans of the Empire built most of their major buildings for the social commonwealth. The importance of the temple, from the architectural point of view, was challenged by the attention given to secular buildings. Since

imperial society and the state were shaped in the same image, the new vaulted architecture was essentially social in nature. The concept that Roman architecture is basically utilitarian, so popular for so long, is correct with respect to its emphasis upon social utility. What the Romans wanted were places where they might either act upon or debate and consider the very real and never entirely solved problems that arise among men. Roman architecture is the tangible shape of an innermost Roman trait—the desire for the adjustment of one thing with another. For the Romans this adjustment had to take place in a prescribed place ordered in such a way as to facilitate the means adopted. Because the Romans persisted in interpreting this need, the skyline and visual register of central Rome changed ceaselessly for more than two hundred years and the ancient cities of earlier societies, in many cases already extremely rich architecturally, were rebuilt or enlarged with Roman designs. In less ancient lands miniature Romes sprang up. London and Dougga, Ostia and Dura, whatever their rank in the multinational fabric of Roman imperial civilization, all make this clear: neither earlier styles nor traditional forms could alone express and house what Rome hoped to accomplish.

Western Europe and the lands around the Mediterranean still brim with architectural documents of these intentions. The principles of this architecture, for centuries an effective instrument of Roman culture, were not lost when the political framework of ancient society collapsed. They survived the transition to the early middle ages, and together with Roman literature and law have continued ever since to give inspiration and instruction. And Roman architecture has never ceased to be relevant to the study of the nature and meaning of architectural form, for it was an expressive and powerful art, defining a critically important experience of Mediterranean and Western man.

# Roman Architecture

## NOTES

[1] Rostovtzeff, *1*, 379–92, 462; Meiggs, p. 319; cf. *ESAR*, *5*, 246–52. The fundamental work on the guilds is J. P. Waltzing, *Étude historique sur les corporations professionnelles chez les Romains*, 4 Vols. (Louvain, 1895–1900).

[2] *Silvae* 4.3.40–58.

[3] The *collegium subrutorum* appears in *CIL* 6.940. Cf. Meiggs, pp. 311–36, esp. p. 319.

[4] *ESAR*, *5*, 234–36.

[5] R. H. Randall, Jr., "The Erectheum Workmen," *AJA*, *57* (1953), 199–210.

[6] See for example Durm, pp. 344–352; *Oxford History of Technology*, *2* (1956), 236, 419; F. Kretzschmer, *Bilddokumente römischer Technik* (Düsseldorf, 1958), pp. 53–58; R. Calza and E. Nash, *Ostia* (Florence, 1959), Fig. 80.

[7] Vitruvius 2.8.4; cf. 1.5.3. See also Middleton, *1*, 40; W. B. Dinsmoor, *The Architecture of Ancient Greece* (London, 1950), pp. 104–05, 174; Blake, *2*, 90, 92, 93.

[8] 5.10.3; cf. Middleton *2*, 119–20.

[9] Roman mortars are discussed in detail by Blake, *1*, Chap. 9.

[10] Blake, *1*, 145.

[11] 2.4.1. For Roman screening of sand, see N. Davey, *A History of Building Materials* (London, 1961), p. 127.

[12] 7.2.2. The flare kiln used for burning limestone today is almost exactly like the kiln described by Cato, *On Agriculture* 38.

[13] Vitruvius, 2.6; Strabo, 5.4; A. Maffei, *Enclt* s.v. "Pozzolana"; L. Crema, "La volta nell' architettura romana," *L'Ingegnere*, *16* (1942), 941; Blake, *1*, 42–43.

[14] Vitruvius is at some pains to explain the properties of lime and pozzolana in 2.5.2 and 2.6; for the place of such subjects in his scheme of architecture, see F. E. Brown, "Vitruvius and the Liberal Art of Architecture," *Bucknell Review*, 11.4 (1963), 105.

[15] G. Lugli, "Nuove forme dall' architettura romana nell' età dei Flavi," *Atti*, 3, 95–102, discusses this among other innovations of Flavian times.

[16] Lugli, *Roma*, pp. 493–508; A. Bartoli, "Scavi del Palatino (Domus Augustana)," *NS* (1929), 26. Very recently an immense concrete foundation of imperial date, 11 m. high, has been found; it is saw-toothed in plan (cf. Vitruvius, 6.8.7).

[17] Middleton, *1*, 57–58; cf. Blake, *1*, 294.

[18] Blake, *2*, 162–63, gives a good summary of this development; cf. Lugli, *Tecnica*, *1*, 584.

[19] These materials were carried up in baskets. The wheelbarrow, which was in use in China in the third century, did not appear in the West until many centuries later; J. Needham, *Science and Civilization in China* (Cambridge, 1954), *1*, 118; *Oxford History of Technology*, *2* (1956), 642. For cranes, etc., see Vitruvius, 10.2; Kretzschmer (above, n. 6), pp. 23–26; J. Rougé, "Ad ciconias nixas," *Revue des études anciennes*, *59* (1957), 320–328 (a study of *CIL* 6.1785, concluding that the inscription refers to a guild of crane operators; I owe this reference to the courtesy of Professor Lionel Casson); A. G. Drachmann, *The Mechanical Technology of Greek and Roman Antiquity* (Copenhagen, 1963), pp. 142–48, 199. For

the huge construction crane, operated by a treadmill, that appears on a relief from the tomb of the Haterii, see A. F. Burstall, *A History of Mechanical Engineering* (London, 1963), p. 88; cf. F. Castagnoli, "Gli edifici rappresentati in un relievo del sepolcro degli Haterii," *BC*, 69 (1941), 59–69.

[20] For the technical literature, see above, n. 13. On the drying rate of mortars see Vitruvius, 2.4.2; Frontinus, *Aqueducts* 123; Ward Perkins, *The Great Palace of the Byzantine Emperors, Second Report*, ed. D. T. Rice (Edinburgh, 1958), p. 79; cf. *AJA*, 65 (1961), 328; Blake, *1*, 316, 352; Fitchen, *Construction of Gothic Cathedrals* (Oxford, 1961), pp. 262–265. I have never seen anything resembling an expansion joint, even in the largest structures. There is no evidence as to whether the concrete was ever compacted after being tipped into the brick or wood forms, but cf. Vitruvius, 7.1.3. The question of the monolithic character of Roman imperial concrete is much debated. In general it appears that small thick vaults can properly be spoken of as monoliths, but large and relatively thin vaults probably cannot; see Ward Perkins, p. 80; cf. Fitchen, pp. 64–65 and citations.

[21] In the strictest terms these buildings are not entirely in compression, for there is a certain amount of beam and tie action within them.

[22] Among them the "hanging" quality of certain vaults which have partly fallen, for example in the Large Baths of Hadrian's Villa (S. Aurigemma, *Villa Adriana* [Rome, 1961], pp. 90–95), and the large flat slabs of concrete flooring that just may have been used to span small distances but which are more probably the layered pieces of floors of upper stories which have separated from the vault concrete. These slabs can be seen for example at Hadrian's Villa in the three-apsed hall by the Poikele, and in the lower level of the Domus Augustana; cf. Vitruvius, 7.1.3. See also Middleton, *1*, 64, 70–72, *2*, 121, 245.

[23] Polybius, 18.26.1–5.

[24] W. R. Lethaby, *Architecture, an Introduction to the History and Theory of the Art of Building*, 3rd ed. (Oxford, 1955), p. 94, Cf. G. Lugli, "Nuove forme dall' architettura romana nell' età dei Flavi." *Atti*, *3*, 101–02 . . . L. Crema, *Significato della architettura romana* . . . (Rome, 1959; = *BollCentro*, *15*), pp. 14–22.

[25] The phrase is from Suetonius, *Augustus* 28.3.

[26] A. Banduri, *Imperium orientale, sive antiquitates Constantinopolitanae*, in the *Corpus Byzantinae Historiae*, 25.1 (Paris, 1711), 69.

[27] See R. MacMullen, "Roman Imperial Building in the Provinces," *Harvard Studies in Classical Philology*, 54 (1959), 209–210.

# 9. ROMAN WALL PAINTINGS

# FROM BOSCOREALE

## Phyllis Williams Lehmann

### INTRODUCTION

The Roman villa associated with what is apparently the name of one of its
owners, Publius Fannius Synistor, contained some of the finest wall paintings
that have been preserved from antiquity. Excavated in 1900, these paint-
ings, now divided largely between Naples and New York's Metropolitan
Museum of Art, are representative of the finest achievements of Roman
figural and illusionistic art. Furthermore, the possibility that these paintings
have a unifying content (although there is considerable difference of opinion
on its precise nature) is convincingly presented in Phyllis Lehmann's
definitive work on this ensemble, portions of which appear in the following
selection. See cover illustration for figure from the "Cult Room" of the Villa.

Lehmann's work identifies the larger of the two extensively decorated
rooms as a cult-room for the worship of Aphrodite and Adonis. The smaller
of the two rooms, to which the selection in this anthology chiefly refers, also
seems to have had a carefully programmed content, as the reader will
discover. Phyllis Lehmann's study is an exemplar of scholarship, analyzing
the art in the context of the life and thought of the times. A full appreciation
of this aspect of the work can be obtained, of course, only from reading the
entire work.

The initial study of the villa and its paintings was Felice Barnabei's, *La
villa pompeiana di P. Fannio Sinistore scoperta presso Boscoreale*, published
in Rome in 1901. Other studies the reader may wish to consult are the brief
accounts in G. M. A. Richter, "The Boscoreale Frescoes," *Bulletin of the
Metropolitan Museum of Art*, I (1905–6), 95–97, and V (1910), 37–40; by the

same author, "The Boscoreale Frescoes in the Metropolitan Museum of Art," *Art and Archaeology*, VII (1918), 238–246; and Martin Robertson, "The Boscoreale Figure-Paintings," *Journal of Roman Studies*, XLV (1955), 58 ff., which takes issue with Lehmann's interpretation of the theme represented and proposes an alternate one (see also the review of Lehmann's book, pp. 195–196, in the same issue; and the review in *Art Bulletin*, XXXVI [1954], 303–304). The bibliography for the selection by H. A. Groenewegen-Frankfort (pp. 21–22) also contains some titles relevant to Roman painting. Amadeo Maiuri, *Roman Painting* (1953), is a well-illustrated general account of the subject.

> Time will bring into the light whatever is under the earth;
> it will bury deep and hide what now shines bright.
>
> Horace, *Epistles*, I, VI, 24–25.

T wo thousand years ago Italy was dotted with villas in which the weary city dwellers of the day sought peace and refreshment. There the strife of senate and law court, the hustle of the marketplace, the cares of business were laid aside, and one might stroll and meditate in the shade of a portico or cast an appraising glance at the latest crops. For, more often than not, these country houses were combined with farms whose proper management provided a topic of unfailing interest to a society of landowners. Whatever a man's taste, whether he devoted his days in the country to the supervision of his estates, to reading and writing or simply gave himself up to the joys of nature, Varro and Cicero, Horace and Tibullus all testify to the universal passion for country life characteristic of their day. This was the ideal life, the life in which a man might build about him his own perfect world, might live in his own Golden Age.

One of the finest examples of this phase of Roman life brought to light in modern times was the villa found in 1900 on the slopes of Vesuvius near Boscoreale.[1] The better preserved of the paintings that once decorated the walls of this house were cut off and later sold at auction,[2] the largest single group coming to the Metropolitan Museum of Art where, together with the somewhat later paintings from Boscotrecase, they constitute the finest collection of ancient wall painting outside Italy.[3] . . .

Unfortunately, this remarkable villa was both incompletely and unofficially excavated. No scientific records were kept by the excavator, the sole reliable source of information on the original nature of the house being the report on the excavation prepared for the Minister of Public Instruction by Felice Barnabei, in 1901, after the paintings had already been removed from the walls and the excavation concluded.[4] Barnabei's invaluable report suffers from unavoidable omissions and inconsistencies which doom any attempt to give a precise and detailed account of the architectural history of the villa.[5] Nevertheless, sufficient facts are ascertainable to guarantee the essential correctness of the following picture.

The villa must have been built shortly after the middle of the first

century B.C. . . . About a generation later, the columns of the outer courtyard were restored. . . .

No further repairs appear to have been made to the house until after the earthquake of 63 A.D. But the fact that part of the decoration of room H had obviously been destroyed and replastered, and that no mention is made of any decoration whatsoever in the bath of this richly painted villa suggests that like many another house in the region of Pompeii, it had already been damaged in the earlier disaster and not yet completely restored when the final catastrophe came in 79 A.D. In that year, the beautiful villa which had survived more than a century of changing styles in painting and mosaic until it must have been a veritable "antique" among the up-to-date houses of the region disappeared beneath those streams of lava and clouds of ashes which, paradoxically, preserved so much of the ancient life they destroyed by removing it from the irreparable damage of man. . . .

In the last years of the Republic, when the unknown owner whose taste shaped this villa in so personal a fashion had his country house built, the so-called Second Pompeian style was at its height. Illusionism was its keynote. Walls were no longer conceived as structural members whose function of enclosure and support demanded decorative expression. On the contrary, their functional nature was swept aside decoratively and, once they had been equipped with a painted system of architecture, with painted columns and pilasters on whose entablatures the real ceiling seemed to rest, the walls themselves were painted away, were opened up, that the circumscribed space in which one actually lived might merge with the infinite extension of the outer world. Literalness of mind and imagination met in a strange union. For the illusion must be absolutely true to life to be believed. The painted architectural framework of these walls must mirror the actuality of contemporary architecture down to the last detail.[6] Then, and only then, was the mind free to leap beyond the restrictions of reality into the limitless space of imagination and to extend the tangible setting of life into an ideal scene on a painted wall. The longing to transcend the limitations of the individual life and of the physical world that later found expression in the Gothic architect's dissolution of mass in space, in walls that were windows, was reflected in a pictorial style suited to the rational antique mind and susceptible of revival by such a kindred Renaissance spirit as Mantegna.

The villa later owned by Publius Fannius Synistor might serve as a text-book of the earlier phases of the Second Style. It was a *villa rustica*, a countryhouse built on a farm.[7] And although it was not conceived in the luxurious terms of the great estates described by Cicero and Varro, it must provide a comfortable and agreeable residence for the master when he visited his property.[8] It is highly improbable that this house served as the permanent residence of a local farmer, however affluent. The beauty of its wall paintings combined with its modest size suggests that it belonged to that well-known category of Roman property managed by an overseer and visited from time to time by a wealthy owner.[9] Such a man might own several properties of this variety, each equipped for his pleasure and ease when he chose to visit it. Indeed, the quality of the house and the fact that it was built by a slave who, nevertheless, indicated his name, is strikingly reminiscent of the way of life of Cicero whose half-dozen country houses were scattered about Campania and Latium[10] and who maintained his own private architect, Cyrus.[11] . . .

## THE CUBICULUM

Alone among the rooms of this remarkable villa, the cubiculum (Fig. 24) has survived intact and in all its original splendor. The completeness of its preservation and the unique character of its decoration make it a key monument today in the history of ancient painting. . . . Originally, it formed part of a small apartment off the northwest corner of the peristyle where it served as a bedroom or *cubiculum nocturnum* connected with a sitting room or *cubiculum diurnum*.[12] Bedroom and sitting room communicated with each other by means of an antechamber which also gave direct access to the bedroom from the peristyle.

This antechamber or *prokoiton*, a little room 13'4" wide by 5' deep, was paved with a white mosaic floor framed by a black border. The four openings piercing its walls left little space for decoration.[13] Apparently, the central part of each wall was crowned with a painted cornice resting on modillions supported by brackets in the form of serpents growing from calyces and terminating alternately in bearded goats' heads and volutes against a red frieze. A border of tortoise-shell rectangles separated this lower crowning from a higher white cornice seen against the azure background of the sky. Painted

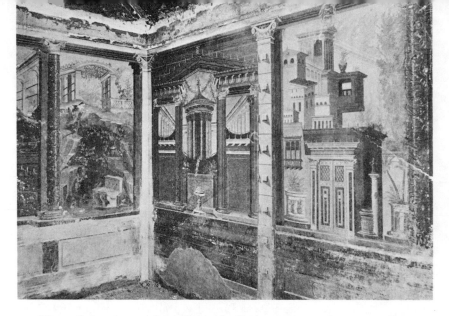

24. View of the alcove of the Cubiculum *in situ* during the excavation. Wall painting from the "Villa of Publius Fannius Synistor" at Boscoreale, Italy, Roman, 1st Century B.C. (The Metropolitan Museum of Art, Rogers Fund, 1903)

pilasters seemed to support the upper cornice and rose in the four corners of the room. Festoons of branches and leaves attached to these pilasters extended into each intercolumniation in the centre of which a pyxis with griffon-headed handles stood on the upper cornice.[14] . . .

Beyond lay the cubiculum or κοιτών proper, a room approximately 13′4″ by 20′, lighted by a single window in the rear wall. It was a typical Second Style bedroom in which the bed stood in an alcove at the back of the room.[15] Unlike earlier alcoves, those of this period were not structurally separate from the forepart of the chamber save for their ceilings, which were vaulted in contrast with the flat ceiling covering the remainder of the room. But decoratively, a clear demarcation reflected the older structural separation of these units. Hence, in the present room, alcove and forepart were divided by a pair of Corinthian pilasters marking the entrance to the alcove and running the full height of the painted walls from cornice to floor.[16] The very form of these pilasters, with their projecting bosses on each drum, differentiated them from the type of pilaster used elsewhere in the room. The theoretical division of alcove from forepart was further emphasized by the mosaic floor. Between the bossed pilasters, a band of colored mosaic marked with five rows of alternatingly red-and-white and black-and-white scales simulated a

154

threshold to the alcove, while its interior was white. Outside, the forepart of the chamber was also paved with white mosaic, here bordered by two bands of black.[17] Finally, the distinction between alcove and forepart found expression in the decoration of the walls, where the three panels occupying each lateral wall of the front part of the chamber were conceived of as independent formal units whose very podia were differentiated from those of the alcove.

Although ceiling and floor no longer exist, the brilliantly-colored walls of the cubiculum may be seen today in their entirety in the Metropolitan Museum.[18] . . .

On either side of the room, the forepart of the chamber was bounded on the north by the bossed pilasters marking the entrance to the alcove, on the south by two panelled white Corinthian pilasters, one placed in each corner. The painted architrave resting on these pilasters is further supported on each side by two Corinthian columns which subdivide each lateral wall of the forepart into three panels and stand on a painted podium deeply indented beneath the central panel to suggest a rectangular niche. The golden cornice of this podium rests on modillions separated from the architrave by a fluted purple frieze and, on either side of the painted niche, it crowns a scarlet dado adorned with a turquoise panel upon which archaistic winged female figures grasping tendrils alternate with anthemia. The rear wall of the niche was apparently light in color and differentiated from its scarlet lateral walls.

The Corinthian columns standing on this podium are the most remarkable of the varied supports painted throughout the villa. Their bright scarlet monolithic shafts rise from a calyx of gilded acanthus leaves springing from a greyish-purple Attic-Ionic base. Spiral golden tendrils climb the scarlet shafts sending out circular whorls and occasional blossoms set with deep purple gems. Gilded Corinthian capitals top the shafts. . . .

Attached to the architrave above the central panel of each lateral wall hangs a gleaming bronze shield while masks mark the centre of the lateral panels. At the left, youthful satyrs open their round eyes and part their lips in amazement and horror; at the right, bearded, white-haired satyrs with brick-red faces cast looks alternately lecherous and aghast at the uneasy spectator.

Turning now, to the left wall (Fig. 25), the visitor finds himself drawn by a variety of visual devices to the central panel of the wall. Rising above the niche cut in the centre of the podium, it faces him

155

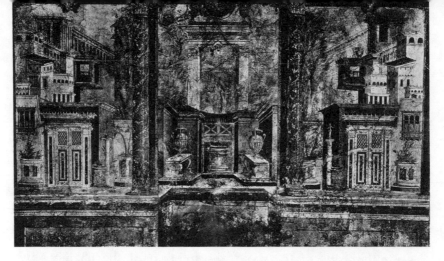

25. Left Triptych of the Cubiculum. Wall Painting from the "Villa of Publius Fannius Synistor" at Boscoreale, Italy (Reprinted from Phyllis Williams Lehmann, *Roman Wall Paintings from Boscoreale in the Metropolitan Museum of Art* [1953], Plate XI, by permission of the author and the publishers, The Archeological Institute of America and The College Art Association of America)

squarely unlike the panels on either side which are seen obliquely from left or right. Here a bronze statue of Diana-Lucina stands beneath a *syzygia* or two-pillar monument within a sacred enclosure. Before the scarlet precinct wall appear various objects used in the cult: golden bronze hydrias on stone benches, a round altar, pomegranates left in offering. The high lavender-pink wall limiting the enclosure at its rear emerges again in the foreground of the lateral panels. There, to left and right, a pile of pastel-colored buildings rises behind this wall which is pierced by a doorway of unimaginable splendor. Ivory leaves inlaid with tortoise-shell and studded with silver close upon these silent buildings. Enigmatic in form and fenestration save for a familiar balcony or colonnade, they tower up against a blue southern sky. What is this brilliant realm of colorful buildings? Town or country, does it reflect any known aspect of the ancient world? Let us glance equally hastily at the remaining walls of this extraordinary room before attempting to answer these questions.

To the right, the forepart of the chamber mirrors the left wall in all essentials. . . . Of the three sides of the alcove, its broad rear wall offers the closest analogy to the lateral walls of the forepart. Like them, it is bounded by white Corinthian pilasters in either corner and subdivided into three panels by two of the same scarlet columns encircled by golden tendrils and, again, dark Corinthian piers appear beyond both columns and pilasters. However, only the

156

scarlet column toward the right of the rear wall is entirely visible. Its companion vanishes beneath the grilled window occupying a large portion of this wall. That this window formed part of the original plan of the room and was not a later addition is proved beyond any doubt by the fact that although a portion of the shaft and all of the base of the column beneath the window were painted, no trace of its capital appears above the opening. Had the entire column been painted on an unbroken wall later pierced by a window,[19] the upper part of its capital would have remained. Furthermore, the lighting of the paintings in this room is consistent. Every single detail of each panel is rendered on the assumption that light enters the room from this window and shadows are cast toward the entrance.[20] The logical expression of illusionism characteristic of the decoration of the entire villa is nowhere more strongly manifest. To have omitted the lower part of the column separating the central from the left panel of the alcove would have marred the structural scheme of the room. To eliminate the portion of capital for which there was space high up on the wall where the flood of light pouring in the window makes it difficult to distinguish any detail was a sensible minor concession. Beneath the buff-colored cornice of the rear podium panelled rectangles of simulated stone run above a low course of greyed-rose, narrow black panels alternating with large mottled green rectangles save for the central stone of rosy-lavender.

Again, the central panel of the wall rises behind a cut-back, here simply of the step upon which the colonnade rests. Within this shallow cut-back intended to emphasize the central position of the panel, a centrality much impaired by the interruption of the window, a dove stands on the podium. In the centre of the panel, a transparent glass bowl heaped with luscious fruits rests on the scarlet coping of a yellow screen wall filling the entire intercolumniation. Above it, a parrot perches on the edge of a black curtain and, in the distance, an arcade of warm pink stone stands against the sky. The symmetrical position of both bowl and parrot within the narrow space at the right of the window constitutes additional proof of the original presence of this window. Without it, there would have been no necessity to squeeze the bowl into a space it barely fits and to place the parrot so that the long feathers of his tail just miss the brown pier.

To the right of this central panel, one looks into the cool darkness of a rocky grotto (see Fig. 24). Streams of water trickling down its

157

ledges are caught in a stone trough at the mouth of the cave which is overgrown with luxuriant sprays of ivy. Here birds warble against the splash of water, filling this solitary retreat with song in marked contrast to the stillness above the grotto where an arched trellis supports clusters of ripe purple grapes. The warm light of this upper region further contrasts with the dim, shaded interior below, heightening the juxtaposition of nature tamed and cultivated and nature wild and untrained. A little, faintly-seen statue of a female divinity in the interior of the cave forms part of the animated world of the birds. Here nature is neither remote nor forbidding but familiar and cherished. As in the forepart of the chamber, the lateral panels of the rear wall are in essence exact counterparts. On this wall, however, the balance of parts is less evident because of the infringement of the window and consequent reduction of space. Yet, so far as space permits, the left side of the rear wall echoes the right. The evident adjustment of the birds to the narrower space available for them at this side constitutes additional proof of the presence of the window in the original design.

The lateral walls of the alcove are likewise counterparts (see Fig. 24). On either side, a round monopteros rises in the centre of a rectangular precinct framed by mauve Tuscan colonnades. Rose-colored Corinthian columns with gilded capitals support its rich entablature and pagoda-like roof. Before this precinct, a golden propylon[21] stands beneath a scarlet wall. Its lateral intercolumniations are barred by scarlet screen walls stretching between the brown piers on the inner side of the propylon. Access to the courtyard through the central opening of the propylon is rendered almost equally difficult by the presence there of a lavender parapet flanked by scarlet altars laden with offerings of fruit. Garlands of leaves or flowers hang over a black curtain visible behind the parapet. Here, as behind the lateral intercolumnia, all sight of the interior of the courtyard could be veiled by raising black curtains. Then only the altars and the gilded silver incense-burner marking the centre of the scene could have suggested what lay behind the propylon. Do they, like the ritual objects preceding the sacred enclosure on the walls of the outer chamber, reflect the presence of a divine sphere beyond? What is the mystery of that silent precinct? Whatever it may be, the lateral walls of the alcove, like each other major unit or subdivision of the cubiculum, are differentiated from the others by an individual podium, in this case, courses of rusticated, burgundy-colored ma-

sonry rising above a narrow sea-green course and topped by a moulded golden cornice.

Finally, the narrow spurs of wall on either side of the entrance to the chamber are decorated with garlands suspended vertically against the scarlet field in the centre of each wall.[22] Above this field, an elegant metal amphora stands on a grey-green cornice against a deep purple rusticated wall,[23] below it, the dado is divided into an upper course of yellow rusticated stone and a deep purple orthostate by the slight projection of another grey-green cornice.

It is a room of contrasts, of pastel-colored buildings set in a framework of brilliant scarlet and gold against an intense blue sky; of man-made objects side by side with the products of nature; of the densely-filled walls of the forepart and the comparative space and quiet of the alcove. Everywhere statues, altars and offerings reveal the penetration of the divine and permanent into the mortal and transitory. Everywhere the individual element takes its place in a clearly defined sphere expressed in the explicit terms of a decorative system. . . .

Not a single element of the lateral panels, height included, but fits the representation of a villa. Towers for grain, for fruit, for pigeons, balconies, porticoes, *diaetæ,* all of them appear individually and collectively in scenes of country life. Each and every one played its logical rôle in the paradoxical life of a great villa where urban tastes were transplanted to a rural setting. It is this very co-existence of strictly rural buildings and buildings of a more elaborate and monumental character in a common setting that constitutes so persuasive a confirmation of the nature of these scenes. Not only may the individual elements of the lateral panels be duplicated in country scenes and villa landscapes but also their juxtaposition within a single framework. The numerous vignettes composed of a temple-like building, a portico, and a cluster of farm buildings set in a landscape animated by figures of men or animals undoubtedly reflect this villa background in simplified form.[24]

And what of the central panels of the lateral walls? How do they fit into this villa sphere, one may ask. The sacred precinct rising on either side of the forepart of the chamber is dominated by a lavender-pink *syzygia* or two-column monument rising above the scarlet outer enclosure wall (see Fig. 25). Festooned with laurel and draped with cloths of yellow or lavender, it frames a bronze statue and supports weathered bronze amphoras on a deep red base. A griffon

and griffoness uphold the cornice upon which winged snakes serve as akroteria.[25] This type of monument is a feature of Pompeian landscapes where its familiar shape indicates a rustic shrine. Generally, it protects a statue; occasionally, simply a gnarled tree and, almost without exception, a pair of vases rests on its entablature. . . . What goddess more suitable to a rustic shrine than she whom Catullus honored as

"child of Latona, great offspring of greatest Jove, whom thy mother bore of the Delian olive-tree, that thou mightest be the lady of mountains and green woods, and sequestered glens and sounding rivers; thou that are called Juno Lucina by mothers in pains of travail, thou art called mighty Trivia and Moon with counterfeit light. Thou, goddess, measurest out by monthly course the circuit of the year, thou fillest full with goodly fruits the rustic home of the husbandman."[26]

Diana-Lucina-Trivia-Luna, she it is whose gleaming image rises before us on the left wall of the cubiculum adorned with her rayed crown, equipped with quiver and baldric, and bearing torches.[27] Goddess of mountains and woods and rivers, helper in childbirth, goddess of the moon and guardian of the farmer's crops, what divinity more appropriate for a villa landscape in a bedroom? Her counterpart on the right wall who wears a crescent in her hair and carries a patera filled with sacrificial objects appears to be a votive statue of her priestess, designated as such by the emblem in her hair and the attribute in her hand.[28] Paler than the shining goddess, she calls to mind Catullus' phrase "paler than a gilded statue."[29]

On either side of the lavender-grey spiked gate leading into the precinct, the scarlet outer enclosure wall forms a shallow recess wide enough to contain a stone bench on which a gilded bronze hydria of elegant shape stands. Together with the burning coals on the sky-blue altar and the ruddy pomegranates in the foreground, these objects reflect the passage of some invisible worshipper. Votive gifts, altar, and vessels, all are familiar elements of countless sanctuaries large or small.[30]. . .

The invariable occurrence of rustic sanctuaries dominated by *syzygiæ* in a country setting where . . . they appear in a milieu further characterized by architectural elements appropriate to villas makes the presence of these rural shrines on the cubiculum walls in no way surprising. . . .

# Roman Wall Paintings from Boscoreale

Strictly or loosely interpreted, the theme of the lateral walls is clear. They represent a single unified villa prospect in which key elements of a great establishment are combined in a suggestive panorama. There the dual nature of villa life, its roots in the productive soil, its flowering in the pleasures of the mind, is crystallized in storage buildings and porticoes, in towers for produce and towers for reflection and urbane living. City and country were fused in this microcosm where the intellectual tastes of the capital might be grafted onto the agricultural realities of suburb and province. The urban aspect of Roman villas is well known alike from monuments and literary sources.[31] It casts the single redeeming light on earlier attempts to understand the lateral panels as city views. Balconies, porticoes, *diaetæ*, they might share with urban scenes. Farm buildings, rustic sanctuaries, all the innumerable details for which parallels have been found only in rural scenes, they do not. . . .

Here in the cubiculum, the unknown owner of the villa from Boscoreale has left a priceless document. Here he might survey the ideal villa of his dreams,[32] a property greater and more luxurious by far than his own *villa rustica*. Reclining in the alcove, he might gaze on the splendor of ivory and tortoise-shell, on statues and vessels of gleaming bronze, on towers and porticoes. He might listen to the warble of birds and the splash of water in the green vistas beyond the window. Where did the outer world begin and its painted image stop? Where was the ideal and where the real? Looking back through the shaded peristyle to the brilliant light of the garden, to the flash of birds and the sparkle of water, it must have been difficult to say. For the ideal was rooted in the real.

Seldom, if ever, has the aspiration of a society been reflected in so polished a mirror. Rarely has the taste of an age left so graphic and indelible an impression. The way of life cherished by generations of Romans and recorded by countless writers appears before us in the brilliant colors of the Second Style. What matter if we look through a painted colonnade to a painted villa when illusion and reality are one?

161

*NOTES*

[Asterisks indicate that a reference is to the book from which this selection is taken.

Additional works cited in the following notes:
Alexander, Christine. "Wall Paintings of the Third Style from Boscotrecase," *Metropolitan Museum Studies,* I, 1928–29.
Beyen, H. G. *Die pompejanische Wanddekoration vom zweiten bis zum vierpen Stil,* The Hague, I, 1938.
Bulle, Heinrich. "Der Leichenwagen Alexanders," *Jahrbuch des kaiserlich deutschen archäologischen Instituts,* XXI, 1906.
Dawson, Christopher. *Romano-Campanian Mythological Landscape Painting,* Yale Classical Studies, IX, New Haven, 1944.
Herrmann, Paul. *Denkmaler der Malerei des Altertums,* Munich, 1904–31.
Rostovtzeff, M. *The Social and Economical History of the Roman Empire,* Oxford, 1926.
Zahn, Wilhelm. *Die schönsten Ornamente und merkwürdigsten Gemälde aus Pompeji, Herculaneum und Stabiae,* Berlin, 1842.]

[1] Excavated by Vincenzo De Prisco on the property of Francesco Vona in Grotta Franchini, slightly more than a mile from Pompeii, and first published by Felice Barnabei, *La villa pompeiana di P. Fannio Sinistore Scoperta presso Boscoreale,* Rome, 1901.

[2] By Durand-Ruel in Paris on June 8, 1903. The catalogue prepared for this auction by A. Sambon, *Les fresques de Boscoreale,* Paris, 1903, contains information not easily available elsewhere and has been extensively quoted. It should be used with great care since it is peppered with inaccurate statements and distortions of fact quite apart from the inaccuracy of its garish color plates.

[3] Brief accounts of the purchase and installation of the paintings were published by Gisela M. A. Richter under the title "The Boscoreale Frescoes," in the *Bulletin of the Metropolitan Museum of Art,* I, 1905–1906, pp. 95–97 and V, 1910, pp. 37–40, as well as a longer discussion, "The Boscoreale Frescoes in the Metropolitan Museum of Art," *Art and Archaeology,* VII, 1918, pp. 238–246. See, too, her *Handbook of the Classical Collection,* New York, 1930, pp. 218–222.

[4] The details recorded by Barnabei, *op. cit.,* pp. 3–6, give a clear picture of the circumstances under which the villa was excavated and its paintings removed. The enthusiasm of Barnabei's descriptions together with the fanciful nature of certain of his interpretations has led at least one prominent writer to complain about his "Rhetorik." Therefore, it may be well to emphasize that his book must remain the fundamental basis of any discussion of the villa. One can only wish that his detailed factual account were still longer, for it is plain that certain parts of the villa were no longer visible when he made his description and that he was forced to rely upon the observations of previous visitors. His Pl. XI indicates the state of the excavation in mid September, 1900, before the committee of investigators began their work.

[5] See, for example, notes 23, 37, 44, 57, Ch. II, notes 3, 16 and the remarks on p. 22.° Thus, the plan published by Barnabei cannot be regarded as more than a generally reliable symbol. Careful observation of the structure of windows, doors, and walls would have clarified a number of issues. The brief discussion of the

building history of the villa by Bice Crova, *Edilizia e tecnica rurale di Roma antica,* Milan, 1942, p. 193, is marred by errors in fact and unfounded suggestions while the plan printed on p. 194, fig. 37, is inaccurate both in drawing and in the identification of individual rooms—Room G, the triclinium is not identified, for example, while Corridor 23 is mistakenly lettered H and indicated as "secondo triclinio con salette"!

[6] The relationship between late Republican architecture and Second Style decoration has been discussed by Richard Delbrück, *Hellenistiche Bauten in Latium,* Strassburg, II, 1912, 169 ff.

[7] Cf. Karl Swoboda, *Römische und romanische Paläste,* Vienna, 1919, p. 20 and fig. 9.

[8] On this subject see, for example, Columella, I, IV, 8.

[9] For a short, clear definition of the chief types of *villæ rusticæ* found in Campania, including a similar characterization of our villa, see Rostovtzeff, *op. cit.,* p. 503, note 21, and the list of *villæ rusticæ* on p. 496, note 26. Note the conclusions drawn by the author in regard to contemporary economic life on the basis of such villas, p. 495.

[10] See O. E. Schmidt, "Ciceros Villen," *Neue Jahrbücher für das klassische Alterthum,* III, 1899, pp. 328 ff., 466 ff.

[11] See the article "Cyrus" by R. Pagenstecher in Thieme-Becker, *Allgemeines Lexikon der bildenden Künstler,* VIII, Leipzig, 1913, p. 235.

[12] Cf. pp. 15 ff.°

[13] Judging by Barnabei's remarks and the plan, the eastern doorway opposite the entrance to room N was simulated in stucco.

[14] The description of the antechamber given above is based on Barnabei's report, *op. cit.,* pp. 71 ff., where it is further indicated that the threshold was of grey breccia and that the entrances from peristyle to antechamber and from antechamber to bedroom were about 3.50 m wide. For analogous pyxides see, for example, the pair in alcove B of cubiculum 16 of the Villa Item (A. Maiuri, *La villa dei misteri,* Rome, 1931, pp. 184 ff.).

[15] This type of cubiculum, including the present example, has been clearly defined and discussed by Olga Elia, "I cubicoli nelle case di Pompei," *Historia,* VI, 1932, pp. 1–28, who uses the term κοιτών for the alcove and προκοιτών for the forepart of such chambers. Given the presence of an actual antechamber before the cubiculum in the villa from Boscoreale, I have preferred to retain the term προκοιτών for the true antechamber as being its nearest equivalent and applied κοιτών to the entire bedroom of which the alcove is a subdivision. Note the cubiculum with *procoeton* in Pliny's Laurentine villa, *Epistulae,* II, XVII, 10. Cf., too, the Tuscan villa, V, VI, 38. The popularity of arched ceilings is reflected in Vitruvius' detailed description of the making of coved ceilings (VII, III, 1 ff.). In the present chamber, the alcove occupied about one-third of the room.

For criticism of the term προκοιτών see the Phrynichus, CCXXVII, p. 321 (*The New Phrynichus,* edited by W. G. Rutherford, London, 1881). I am indebted to Glanville Downey for this reference.

[16] These pilasters are best seen in such an older photograph of the room *in situ* as Barnabei's pl. IX (here Fig. 24), since they were largely destroyed in the removal of the paintings from the original walls. They were apparently chosen as the place for

vertical cuttings in order to avoid splitting the painted prospects.

[17] The virtual disappearance of the bossed pilasters dividing the alcove from the forepart of the chamber, together with the fact that neither the original ceilings nor the several treatments of the mosaic floor were duplicated in the present reconstruction of the cubiculum in the Metropolitan Museum, has resulted in a loss of the original contrast between and differentiation of alcove and forepart. Fortunately, the original appearance of the room was clearly described by Barnabei, *op. cit.*, pp. 72 ff.

[18] Sambon, *op. cit.*, #39–46, pp. 21–25. I am unable to understand Sambon's #43–45, designating the lateral walls of the alcove, since there are two, not three, panels at this point. The cubiculum has been completely reconstructed out of seven sections of wall. Note, too, that Sambon's "right" wall (#41) is actually the left wall as the visitor enters the room, and his "left" wall (#42) the right. For bibliography and a detailed description of the paintings from this room, see the Descriptive Catalogue° (Sambon's #47–48 apparently belonged to another cubiculum—or can they have been additional fragments from the antechamber?).

[19] As Barnabei, *op. cit.*, p. 80, and others have assumed. The grating exhibited in this window is antique, cf. G. M. A. Richter, "The Boscoreale Frescoes," *Bulletin of the Metropolitan Museum of Art*, I, 1905–1906, p. 96.

[20] This fact was observed by Beyen, *op. cit.*, p. 142, note 1, although he looked upon the antechamber door as the true source of light in the cubiculum and was, apparently, troubled by this seeming contradiction. Actually, the primary source of light is the window. Hence illusion and reality are one. (A. Rumpf, "Classical and Post-Classical Greek Painting," *Journal of Hellenic Studies*, LXVII, 1947, p. 19, implies that indication of the direction of light does not occur before the Odyssey landscapes, an evident mistake.)

[21] The composite capitals of this propylon bearing busts on the abacus are, again, not the product of the painter's fancy. For parallels in Italian architecture of the second century B.C. see K. Ronczewski, "Das Kapitell aus der Grotta Campanari in Vulci," *Mitteilungen des deutschen archäologischen Instituts, Römische Abteilung*, XLV, 1930, pp. 59 ff. For the general issue of the reflection of contemporary architecture in Second Style Painting, see the recent discussion of Giuseppe Lugli, *Architettura Italica, Atti della Accademia nazionale dei Lincei, Memorie, Classe di scienze morali, storiche e filologiche*, ser. VIII, vol. II, fasc. IV, 1949, pp. 189–218, and Vallois, *op. cit.*, pp. 281 ff., 364 ff.

[22] The fact that these painted garlands reflect the use of actual garlands in such rooms is suggested by the following passage from Catullus, LXIII, 66–67:

mihi floridis corollis redimita domus erat,
linquendum ubi esset orto mihi sole cubiculum.

[23] The closest analogies to this vessel known to me are a prize amphora on one of the gladiatorial helmets from Pompeii (illustrated by Edward Trollope, *Illustrations of Ancient Art*, London, 1854, Pl. XXXVII, 10), the upper part of a similar vessel on the wall of a house in Delos (Marcel Bulard, *Descriptions des revêtements peints à sujets religieux, Exploration archéologique de Délos*, IX, Paris, 1926, p. 78, Pl. IV, and *idem*, "Peintures murales et mosaiques de Délos," *Fondation Piot, Monuments et Mémoires*, XIV, 1908, Pl. IV), and the two elegant amphoras represented in a mosaic in Naples from the House of The Tragic Poet (for further details and

bibliography see E. Pernice, *Pavimente und figürliche Mosaiken,* pp. 171–172). Although these analogies are not exact—they lack, for example, the calyx from which the bodies of the cubiculum vessels spring—they are very close in general form.

[24] Rostovtzeff, "Die hellenistisch-römische Architekturlandschaft," fig. 49; Herrmann, *op. cit.,* Pl. CCI; Gell-Gandy, *Pompeiana,* London, 1817–1819, Pl. LX; *Le pitture antiche di Ercolano,* III, p. 137 and, to some extent, V, p. 351. Cf. too, the combination of rustic buildings, formal villa buildings, including porticoes, and a round tree container in a Fourth Style painting illustrated by Rizzo, *La pittura ellenistico-romana,* Pl. CLXXV A, and the related setting for a mythological scene in Zahn, *op. cit.,* III, Pl. XLVIII.

It is interesting to note that numerous examples of towers with sloping roofs, slit windows, and bare undecorated walls exactly analogous to those of our panels appear in the park-like villa setting of the beautiful eighth-century mosaics in the Mosque of the Omayyads at Damascus where they are clearly direct lineal descendants or rather survivals of such earlier Roman buildings (see De Lorey, *op. cit.,* pls. II, IV, VII).

In the Third Style paintings of Perseus and Andromeda from the House of Amandus in Pompeii (A. Maiuri, *Le pitture delle case di 'M. Fabius Amandio,' del 'Sacerdos Amandus,' e di 'P. Cornelius Teges'* [*Monumenti della pittura antica scoperti in Italia,* III, *Pompei,* fasc. II], Rome, 1938, p. 8 and pl. B) and from Boscotrecase in the Metropolitan Museum (Alexander, *op. cit.,* figs. 7–8), Perseus meets Cepheus presumably before his palace, the royal household being suggested in abbreviated form by the familiar combination of a temple-like structure and a tower.

[25] These curious akroteria were correctly noted by Beyen, *op. cit.,* p. 155, note 1 (Barnabei, *op. cit.,* p. 74, had defined them as swans). He was mistaken, however, in describing the garlands as suspended from the shield and then branding this as unnatural. Actually, the garlands fall from the red base above the entablature of the monument, are draped around the front faces of the piers and cross behind them. Massimo Pallottino, *op. cit.,* pp. 52 ff., includes this two-pier monument in a discussion of the architectural antecedents of the Arch of the Argentarii in Rome.

[26] XXXIV, 5 ff., quoted above from the translation of F. W. Cornish (*The Loeb Classical Library*), Cambridge, 1939, pp. 39 ff. I am glad to find that Karl Schefold, too, has referred the reader to this poem in discussing this scene, "Der Sinn der römischen Wandmalerei," *Vermächtnis der antiken Kunst,* Heidelberg, 1950, p. 182.

[27] The nature of this divinity has been recognized in one form or another by Barnabei, *op. cit.,* p. 76, who called her Hecate as did Bulle, *loc. cit.,* Beyen, *op. cit.,* p. 154 and Dawson, *op. cit.,* p. 66, note 75, and by Sambon who called her Diana or Hecate Lucifera, *op. cit.,* #41, an identification followed by Rostovtzeff, "Pompeianische Landschaften und römische Villen," p. 108, note 14. E. Petersen, "Antike Architekturmalerei," *Mitteilungen des kaiserlich deutschen archäologischen Instituts, Römische Abteilung,* XVIII, 1903, pp. 127 ff., considered the figure an archaizing Artemis. Less specifically characterized female statues bearing torches in each hand are not uncommon features of rustic sanctuaries. See, for example, Rostovtzeff, "Die hellenistisch-römische Architekturlandschaft," fig. 49.

Note the curious curving shape of the rays of the Boscoreale goddess' crown which appear to be in the form of snakes.

[28] It is difficult to understand this statue other than as a priestess, a type so familiar from Hellenistic sanctuaries. Yet one cannot be absolutely sure of this suggestion. Barnabei, *loc. cit.*, called this figure rather than her counterpart, Diana Lucina; Sambon, *op. cit.*, #42, a "Nymphe champêtre," while Bulle, *loc. cit.*, and Beyen, *op. cit.*, p. 154, thought she might be a Selene. The impossibility of determining what the statue's right arm held or did makes this problem doubly difficult. If, as may well be, this arm is raised in prayer, the statue very likely does represent a priestess. Given the previously mentioned interrelationship between one of the two panel paintings in the alcove of a cubiculum in the House of Obellius Firmus and the Shieldbearer in the Hall of Aphrodite (*supra*, p. 51°), it is particularly interesting to observe the analogy between the second of these panels and the statue under discussion. For the quite similar female figure standing in a sanctuary holding a patera of fruit and a garland in her left hand is most certainly a priestess. For bibliography on the House of Obellius Firmus see above, p. 52, note 97.°

It may be worth noting that Juno Lucina herself is represented holding a patera in one extended hand in a bronze statuette found in Norba and published by L. Savignoni and R. Mengarelli, *Notizie degli scavi*, XXVIII, 1903, pp. 255 ff. and fig. 23 on p. 254. (In any case, note the similar arrangement of the drapery borne over the left arm of a marble statue illustrated by S. Reinach, *Répertoire de la statuaire grecque et romaine*, V, Paris, 1924, p. 384, 8). I am frankly unable to explain why the lower part of both statues is hidden behind the black drapery swathing the base of the *syzygiæ* and barely visible above the scarlet precinct wall.

[29] LXXXI, 4. Barnabei's distinction between a gold statue on the left wall and one of silver on the right (presumably the source of Schefold's remark, "Der Sinn der römischen Wandmalerei," p. 182) is seen in its proper light as a result of this quotation. Probably both statues were of bronze or gilded bronze and varied somewhat in metallic composition, although it is not excluded that a more precious material is implied. In the *Heroides*, XII, 67 ff., Ovid alluded to a golden image of Diana-Lucina in a shrine surrounded by pine trees. The exotic nature of the story, however, and the wealth associated with Medea's family setting may account for this detail.

[30] In this connection, however, and in connection with the altars in the lateral panels, it is interesting to note that E. Pernice, *Hellenistische Tische, Zisternenmündungen, Beckenuntersätze, Altäre und Truhen* (Winter, *Die hellenistische Kunst in Pompeji*, V), Berlin and Leipzig, 1932, p. 70, remarked that in Pompeii, round altars were apparently only used as house altars.

[31] Note, for example, Pliny's comment on his own Laurentine villa, II, 17, 6 ff.

[32] In a totally different sense from Barnabei, *op. cit.*, p. 81, who saw in these walls another "dream" world—Elysium, and the residences of the *dei pii*.

# 10. BYZANTINE MOSAICS

## Otto Demus

INTRODUCTION

When Otto Demus published his *Byzantine Mosaic Decoration: Aspects of Monumental Art in Byzantium* (1948), it was noted that this was the first work to examine Byzantine mosaics in close relationship to their architectural context and to the religious outlook they served. Demus concentrates on the Middle Byzantine system of mosaic decoration (i.e., from the end of the ninth to the end of the eleventh century), for it was then, after the termination of the Iconoclastic Controversy which had begun around the second quarter of the eighth century, that Byzantine art and thought seem to have achieved harmonic balance. However, in a section of the book not drawn upon for the following selection, Demus surveys the sources of the Middle Byzantine system, its historical genesis and aftermath, providing the reader who turns to the entire work a good overview of Byzantine art in broader perspective. Of particular interest to the reader of this selection from Demus's study is the explanation of the nature and significance of the icon, its place in the total decorative scheme of the Byzantine church, and the reciprocal relationship between image and viewer.

For further reading on Byzantine art there are D. V. Ainalov's *The Hellenistic Origins of Byzantine Art* (1961), first published in Russian in 1900; Kurt Weitzmann, *Greek Mythology in Byzantine Art* (1951); Ernst Kitzinger, "The Hellenistic Heritage in Byzantine Art," *Dumbarton Oaks Papers*, XVII (1963), 98–115; two works by John Beckwith, *The Art of Constantinople* (1961) and *Early Christian and Byzantine Art* (1970); two popular, well-illustrated works, André Grabar, *Byzantine Painting* (1953), and David Talbot Rice, *The Art of Byzantium* (1959); Richard Krautheimer, *Early Christian and Byzantine Architecture* (1965); O. M. Dalton, *Byzantine Art and Archaeology* (1965), a reprint of a work published in 1911, but still useful for its survey of a wide range of Byzantine art forms; Otto Demus,

167

*The Mosaics of Norman Sicily* (1950); Kurt Weitzmann, *The Fresco Cycle of S. Maria di Castelseprio* (1951); L. Ouspensky and V. Lossky, *The Meaning of Icons* (1969); and David and Tamara Talbot Rice, *Icons and Their History*. C. R. Morey's *Early Christian Art*, 2nd ed. (1953), has valuable sections on the art of Ravenna; and Cyril Mango's "Materials for the Study of the Mosaics of St. Sophia at Istanbul," *Dumbarton Oaks Studies*, VIII (1962), is useful for its treatment of the existing mosaics and the publication of documents relating to them. S. K. Kostof's *The Orthodox Baptistry of Ravenna*, a fine monograph on an important monument of Ravennate art, stresses the relationship it bears to the art of Byzantium. In *The Dome: A Study in the History of Ideas* (1950), Earl Baldwin Smith traces the origins and meaning of this important feature of both Byzantine and Islamic architecture.

If they are considered as isolated works, Byzantine monumental paintings lose something of their essential value. They were not created as independent pictures. Their relation to each other, to their architectural framework and to the beholder must have been a principal concern of their creators. In the case of church decoration—the field in which Byzantine art rose, perhaps, to its greatest heights—the single works are parts of an organic, hardly divisible whole which is built up according to certain fixed principles. In the classical period of middle Byzantine art—that is, from the end of the ninth to the end of the eleventh century—these principles seem to form a fairly consistent whole, in which certain features are permissible and even necessary, while others, considered out of keeping with them, are avoided. This system was not purely a formalistic one; it was the theologian's concern as much as the artist's. But its iconographical and its formal sides are but different aspects of a single underlying principle which might be defined, crudely perhaps, as the establishment of an intimate relationship between the world of the beholder and the world of the image. This relationship was certainly closer in Byzantine than it was in Western mediaeval art. In Byzantium the beholder was not kept at a distance from the image; he entered within its aura of sanctity, and the image, in turn, partook of the space in which he moved. He was not so much a "beholder" as a "participant". While it does not aim at illusion, Byzantine religious art abolishes all clear distinction between the world of reality and the world of appearance.

The complete realization of the formal and iconographic scheme which grew out of this fundamental principle is, however, an ideal or, at least, an optimal case. The nearest approach to this ideal, the classical solution, is embodied in the mosaic decorations of the great monastic churches of the eleventh century. The principles followed in these monuments of Imperial piety and munificence differ widely from those which underlie early Christian and pre-Iconoclast Byzantine, and still more Western mediæval decorations.

The first thing which strikes the student of middle Byzantine

169

decorative schemes is the comparatively narrow range of their
subject-matter. They show a lack of invention and imagination all
the more remarkable when we realize that there existed at the same
time in Byzantium a powerful current of highly imaginative art
which had its source in the naïve imagery of the people. But this
current seems to have found expression not so much in monumental
painting (save in the provincial hinterland) as in the illustration of
popular religious literature, homiletic or allegorical, even of Scrip-
tural books such as the Psalter or liturgical compositions such as the
*Akathistos*. In illustrating such texts as these the miniaturists could
draw on the store of antique, sub-antique and Oriental imagery
which lent itself to an associative elaboration of the written word.
No such freedom was either claimed by or permitted to the artists
who, as the representatives of official hieratic art, adorned the
mosaic-decorated churches of the Byzantine middle ages. The
moralistic vein which so greatly influenced the decoration of West-
ern cathedrals, with their didactic and ethical cycles, was likewise
entirely outside the Byzantine range. The occupations and labours of
the months, for instance, the personified virtues and vices, the
allegories of the liberal arts, the expression of eschatological fears
and hopes, all that makes up the monumental *speculum universale*
of Western decorations,[1] we shall look for in vain inside the magic
circle of middle Byzantine mosaic compositions. These latter are to
be taken as the Byzantine Church's representation of itself rather
than of Greek or Eastern Christianity; as the product of abstract
theology rather than of popular piety. There is nothing original,
nothing individual, about middle Byzantine decorations if they are
considered from the Western point of view, that is, with regard to
their contents. The individual pictures do not aim at evoking the
emotions of pity, fear or hope; any such appeal would have been felt
as all too human, too theatrical, and out of tune with the tenor of
religious assurance which pervades the ensembles and leaves no
room for spiritual and moral problems. The pictures make their
appeal to the beholder not as an individual human being, a soul to
be saved, as it were, but as a member of the Church, with his own
assigned place in the hierarchical organization. The stress is not laid
on the single picture in isolation: that is "common form" to the
beholder, since it follows a strict iconographic type, like the suras of
the Koran in Islamic decoration, which all the faithful know by
heart. The point of interest is rather the combination of the single

items of the decoration, their relationship to each other and to the whole. It is in this arrangement that we must look for the unique achievement of middle Byzantine decoration. The single pictures were more or less standardized by tradition; the ever-new problem for the theologian and for the artist was the building up of the scheme as a whole. This is true not only of the content of the pictures, but also of their visual qualities. . . . . A majestic singleness of purpose runs right through the Byzantine schemes. Their authors seem to have had as their main aim to represent the central formula of Byzantine theology, the Christological dogma, together with its implications in the organization and the ritual of the Byzantine Church. There are no pictures which have not some relation to this central dogma: representations of Christ in His various aspects, of the Virgin, of Angels, Prophets, Apostles and Saints arranged in a hierarchical order which also includes temporal rulers as Christ's vicegerents on earth. Historical cycles and subjects from the Old and the New Testaments, or from apocryphal and legendary writings, are inserted in this hierarchical system not so much for their independent narrative value as for their importance as testimonies to the truth of the central dogma.

## THE THEORY OF THE ICON

Every single picture, indeed, is conceived in this sense, and middle Byzantine pictorial art as a whole draws its *raison d'être* from a doctrine which developed in connection with Christological dogma. This doctrine was evolved during the Iconoclastic controversy of the eighth and ninth centuries.[2] The relation between the prototype and its image, argued Theodore of Studium and John of Damascus, is analogous to that between God the Father and Christ His Son. The Prototype, in accordance with Neoplatonic ideas, is thought of as producing its image of necessity, as a shadow is cast by a material object, in the same way as the Father produces the Son and the whole hierarchy of the invisible and the visible world. Thus the world itself becomes an uninterrupted series of "images" which includes in descending order from Christ, the image of God, the *Proorismoi* (the Neoplatonic "ideas"), man, symbolic objects and, finally, the images of the painter, all emanating of necessity from their various prototypes and through them from the Archetype, God. This process of emanation imparts to the

image something of the sanctity of the archetype: the image, although differing from its prototype κατ᾽ οὐσίαν (according to its essence), is nevertheless identical with it καθ᾽ ὑπόστασιν (according to its meaning), and the worship accorded to the image (προσκύνησις τιμητική) is passed on through the image to its prototype.

The Christological theme, however, dominated the doctrinal basis of Byzantine theory regarding images not only *per analogiam* but also in a more direct manner. One of the arguments against pictures and statues put forward by the Iconoclasts had been that any representation of Christ was impossible, since every representation (περιγραφή) must either depict Him as a mere Man, thereby denying His Godhead and falling into the anathematized error of Nestorius; or with His two natures, divine and human, intermingled (χύσις), thus following the heresy of Eutyches. The charge of heresy, however, was returned by the Iconodules, who maintained not only that it was possible to represent Christ without falling into heresy, but that denial of this possibility was itself a heresy. Christ would not have manifested Himself in human form if that form were indeed unfit to receive and express the Divine nature. To deny that He could be represented in the form He took in His Incarnation was to doubt the Incarnation itself and with it the redeeming power of the Passion. The Incarnation could not be considered complete, or Christ's human nature genuine, if He were not capable of being depicted in the form of man. The fact that a picture of Christ can be painted furnishes a proof of the reality and completeness of His Incarnation.[3] A painted representation of Christ is as truly a symbolic reproduction of the Incarnation as the Holy Liturgy is a reproduction of the Passion. The latter presupposes the former, and the artist who conceives and creates an image conforming to certain rules is exercising a function similar to that of the priest.

Three main ideas of paramount importance for the whole subsequent history of Byzantine art emerge from this reasoning on the doctrine of images. First, the picture, if created in the "right manner", is a magical counterpart of the prototype, and has a magical identity with it; second, the representation of a holy person is worthy of veneration; thirdly, every image has its place in a continuous hierarchy.

To achieve its magical identity with the prototype, the image must possess "similarity" (ταυτότης τῆς ὁμοιώσεως). It must depict the characteristic features of a holy person or a sacred event in

accordance with authentic sources. The sources were either images of supernatural origin (ἀχειροποίητα), contemporary portraits or descriptions, or, in the case of scenic representations, the Holy Scriptures. The outcome was a kind of abstract verism, governed by a sacred iconography which laid down, enforced and preserved certain rules. In the case of representations of holy persons, this verism made for portraiture in the sense of attaching distinguishing features to a general scheme of the human face and form; in that of scenic representations, for plausibility in the rendering of an action or a situation. If this was done according to the rules the "magical identity" was established, and the beholder found himself face to face with the holy persons or the sacred events themselves through the medium of the image. He was confronted with the prototypes, he conversed with the holy persons, and himself entered the holy places, Bethlehem, Jerusalem or Golgotha.

The second idea, that of the venerability of the icons, follows logically from that of magical identity.[4] The image is not a world by itself; it is related to the beholder, and its magical identity with the prototype exists only for and through him. It is this that distinguishes the icon from the idol. To establish the relation with the beholder, to be fit to receive his veneration, the picture must be visible, comprehensible, easy to recognize and to interpret. Single figures must be identified either by unmistakable attributes or by an inscription. So that they may receive their due veneration from the beholder they must face him, that is, they must be represented in frontal attitude; only so do they converse fully with the beholder (Fig. 26). In a scenic image, which likewise must be characterized by an inscription (to fix its ὑπόστασις or meaning, which in this case is not a person but an event), everything must be clear for the beholder to perceive. Details must not detract from the main theme; the principal figure must occupy the most conspicuous place; meaning, direction and result of the action must be plainly shown; actors and counter-actors must be separated into clear-cut groups. The compositional scheme which best answers these demands is the symmetrical arrangement, which at the same time is in itself the "sacred form" *par excellence*.

Frontality, however, cannot always be achieved in scenic representations: its rigid observance by all the participants in a scene would make the rendering of an event or an action all but impossible. No active relationship between the figures could be established

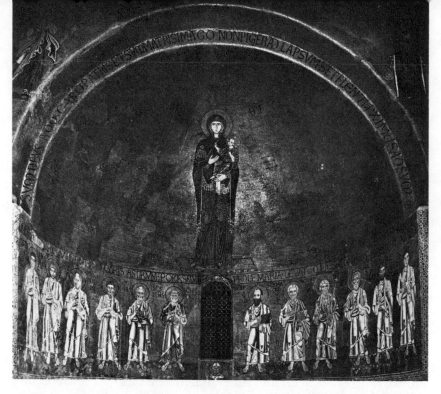

26. Virgin and Child with Saints, main apse, Torcello, Cathedral. Mosaic, Late 12th Century (Alinari-Art Reference Bureau)

under such a limitation, and the law of plausibility, the demand for authenticity, would thus be violated. This was indeed a dilemma for an art which did not know or at any rate recognize pictorial space. Apart from spatial illusionism, the most natural way of rendering an active relation between two or more figures on a flat surface would have been to represent them in strict profile. The figures would then have faced each other, their looks and gestures would have seemed to reach their aims. But this would have severed their relation with the beholder.[5] The attempt was indeed made in such scenes as the Annunciation, the Baptism, the Transfiguration, the Entry into Jerusalem, the Crucifixion, the Doubting of Thomas and the Ascension— scenes in which action counts for less than the representation of glorified existence—to depict at least the main figures in frontal attitudes. But in other scenes, where action is the main theme, this was impossible. For such cases, and for almost all the secondary figures in scenic representations, Byzantine art made use of a compromise between the attitude appropriate to action, the profile, and the attitude appropriate to sacred representation, the full face. The

three-quarter view, combining both attitudes, was introduced; and this even became the dominant mode of projection in Byzantine art. Its ambivalent character allows of either interpretation; within the picture as a profile, in relation to the beholder as a frontal view.

In this system there is hardly any place for the strict profile; a figure so represented has no contact with the beholder. It is regarded as averted, and thus does not share in the veneration accorded to the image. Consequently, in the hierarchical art of icon painting, this aspect is used only for figures which represent evil forces, such as Satan at the Temptation, Judas at the Last Supper and the Betrayal. From the point of view of form, the face drawn in strict profile is for the Byzantine artist only half a face showing, as it does, only a single eye. It is drawn exactly like a face in three-quarter view in which the half-averted side has been suppressed. This method of constructing a profile gives the face a curious quality of incompleteness. Formally, something is missing—just as the otherwise indispensable relation to the beholder is left out as regards the meaning. But the evil figures must not receive the venerating gaze of the beholder, and they themselves must not seem to be looking at him: iconographic theory and popular fear of the "evil eye" go hand in hand. Outside the strictest school of Byzantine iconography the pure profile is also, though seldom, used for secondary figures. Full back views do not occur at all in the classical period of middle Byzantine art; for to the Byzantine beholder such figures would not be "present" at all.

As a result, the whole scale of turning is toned down in classical Byzantine art. It is as if the figures were somehow chained to the beholder; as if they were forced as much as is compatible with their actions into frontal positions. The generally lowered key gives, on the other hand, a heightened importance to the slightest deviations from strict frontality. The eye, expecting frontal attitudes, registers deviations in posture and glance much more strongly than it would if frontality were the exception, as it is in Western art. The projection used in scenic images is, from the formal aspect, a qualified *en face* rather than a real three-quarter view.

But even this three-quarter view, apparently, did not seem to the Byzantine artist an entirely satisfactory solution. The gestures and gaze of the figures still miss their aims: they do not meet within the picture, half-way between figures engaged in intercourse, but in an imaginary point of focus outside, that is, in front of it. There is a

OTTO DEMUS

dead angle between the actors in a scene, an angle which is not quite bridged even by oblique glances. The action takes on a stiff frozen air. To remedy this, to give plausibility and fluency to the representation, two correctives were applied, at first separately, in two different realms of Byzantine art, but from the twelfth century onwards more or less indiscriminately. On flat surfaces, especially in miniatures, ivories, and the like, movements and gestures were intensified in order to bridge the gap between the figures as the actors in the scene. In a field of art which made use of neither pictorial space nor psychological differentiation, gestures and movements could be intensified only, so to speak, from outside, by a heightening of tempo. Intensity of action was preferably conveyed by locomotion. The figures run towards each other with outstretched hands and flying garments. . . . There is a definite tendency in this method of rendering action to point forward in time, to make the result of the action apparent together with the action itself, and so not only to connect the figures of one picture among themselves, but also to establish a relation between the successive pictures of a narrative cycle.

This remedy, however, satisfactory and fertile as it was in illustrative pictures of small size, was hardly applicable to monumental paintings on the grand scale. The violent movements would have seemed too undignified, the whirling forms too contorted and complicated. Another means was therefore needed by the Byzantine decorators to bridge the dead angle and save the threatened coherence. The solution they found was as simple as it was ingenious. They placed their pictures in niches, on curved surfaces. These curved or angular surfaces achieve what an even, flat surface could not: the figures which on a flat ground were only half-turned towards each other could not face each other fully without having to give up their dignified frontality or semi-frontality. Painted on opposite sides of curved or angular niches, they are actually facing each other in real space, and converse with each other across that physical space which is now, as it were, included in the picture. The curvature in the real space supplies what was lacking in the coherence of the image (Fig. 27).

The firm position of the painted figures in physical space makes spatial symbols in the picture itself unnecessary. No illusion is needed in pictures which enclose real space, and no setting is required to clarify the position of the figures. The whole of the

176

27. Annunciation, Church of the Dormition, Daphni Mosaic in squinch, *c.* 1100 (Alinari-Art Reference Bureau)

spatial receptacles (such the pictures really are) can be devoted to the figures themselves and to such motives as are required from the iconographic point of view. Restrained gestures and movements are sufficient to establish the necessary contact. A large part of the golden ground can be left empty, surrounding the figures with an aura of sanctity. This golden ground in middle Byzantine mosaics is not a symbol of unlimited space; it need not be pushed back, as it were, in order to leave sufficient space for the figures to act. They move and gesticulate across the physical space which opens up in front of the golden walls. The shape and the confines of this physical space are not dissolved, but rather stressed and clarified, by the solid coating of gold. The setting of the gold is close and firm, producing a metallic surface whose high lights and shades bring out the plastic shape of the niche.

There is no need, in this formal system, for the figures engaged in intercourse of whatever kind to approach close to each other. On the contrary, they had to be placed at some distance apart in order that they might be brought opposite each other by the curving of the ground. The resulting distances and empty spaces are filled with a tension, an air of expectancy, which makes the event depicted even more dramatic in the classical sense than violent action and gesticulation, or a closely knit grouping, could have made it. The *cæsuræ*

177

contribute also to the legibility, to the plausibility of the image. The main figure is clearly discernible, because comparatively isolated, and presents itself unmistakably as the main object of veneration.

But the venerability of the icon did not affect its composition alone; it also influenced the choice of material. Controversy about the "matter" (ὕλη) of the images played a large part in the Iconoclastic struggle. It was but natural that, to counter the arguments of the Iconoclasts regarding the incongruity of representing the Divine in common and cheap material, the Iconodules should have chosen the most precious material for this purpose. Mosaic, with its gemlike character and its profusion of gold, must have appeared, together with enamel, as the substance most worthy of becoming the vehicle of divine ideas. It is partly for this reason that mosaic played so important a part in the evolution of post-Iconoclastic painting, and indeed actually dominated it. It allowed of pure and radiant colours whose substance had gone through the purifying element of fire and which seemed most apt to represent the unearthly splendour of the divine prototypes.

## ARCHITECTURAL AND TECHNICAL CONDITIONS

These prototypes themselves, to the Byzantine mind, stand to each other in a hierarchic relation, and so their images must express this relationship. They must occupy their due place in a hierarchy of values in which the image of the All-Ruler occupies the central and most elevated position. Clearly, a hierarchical system of images based on the principles which governed the Byzantine Church's own organization could be fully expressed only through an architectural framework that furnished a hierarchy of receptacles within which the pictures could be arranged. A purely narrative sequence of pictures, in the Western sense, or a didactic scheme could be displayed on almost any surface in almost any arrangement. Whether it was used to decorate portals, façades, interior walls or stained-glass windows did not greatly matter. But a Byzantine programme always needed a special framework, namely that in which it had grown up, and which it was developed to suit. This framework was the classical type of middle Byzantine ecclesiastical architecture, the cross-in-square church with a central cupola.[6]

The shaping of this architectural type was a lengthy process, and the final solution was arrived at by several concurring paths. The

essential idea seems to have been conceived as early as the sixth century. Architects with widely different traditional backgrounds approached the problem from different sides. . . . There is evidence of a conscious search for a final solution in accord with the liturgical needs and the æsthetic ideals of the time. Local differentiations gave way before the quest for this ideal type; and, when finally elaborated, it was never abandoned, and remained the basis of the whole of the subsequent development. Even changes of scale did not greatly affect the dominant idea. The final type, fully evolved by the end of the ninth century, was something strangely perfect, something which, from the liturgical and from the formal points of view, could hardly be improved upon.[7] This high perfection might have resulted in sterility, had not the central architectural idea been flexible enough to leave room for variation.

The plan was, in short, that of a cruciform space formed by the vaulted superstructure of transepts arranged crosswise and crowned in the centre by a higher cupola. The angles between the arms of the cross are filled in with lower vaulted units, producing a full square in the ground-plan but preserving the cross-shaped space in the superstructure. Three apses are joined to the square on the east and an entrance hall (sometimes two) stands before it on the west. . . . The cupola always dominates the impression. Even the modern beholder directs to it his first glance. From the cupola his eye gradually descends to the horizontal views.

This process of successive apperception from the cupola downwards is in complete accord with the æsthetic character of Byzantine architecture: a Byzantine building does not embody the structural energies of growth, as Gothic architecture does, or those of massive weight, as so often in Romanesque buildings, or yet the idea of perfect equilibrium of forces, like the Greek temple. Byzantine architecture is essentially a "hanging" architecture; its vaults depend from above without any weight of their own. The columns are conceived æsthetically, not as supporting elements, but as descending tentacles or hanging roots. They lack all that would make them appear to support an appropriate weight: they have no entasis, no crenellations, no fluting, no socles; neither does the shape of the capitals suggest the function of support. This impression is not confined to the modern beholder: it is quite clearly formulated in contemporary Byzantine *ekphraseis*.[8] The architectonic conception of a building developing downwards is in complete accord with the

179

hierarchical way of thought manifested in every sphere of Byzantine life, from the political to the religious, as it is to be met with in the hierarchic conception of the series of images descending from the supreme archetype.

The cross-in-square system of vaults is indeed the ideal receptacle for a hierarchical system of icons. Each single icon receives its fitting place according to its degree of sanctity or importance. . . .

## THE ICON IN SPACE

. . . To describe these mosaics, encased in cupolas, apsides, squinches, pendentives, vaults and niches, as flat, or two-dimensional, would be inappropriate. True, there is no space behind the "picture-plane" of these mosaics. But there is space, the physical space enclosed by the niche, in front; and this space is included in the picture. The image is not separated from the beholder by the "imaginary glass pane" of the picture plane behind which an illusionistic picture begins: it opens into the real space in front, where the beholder lives and moves. His space and the space in which the holy persons exist and act are identical, just as the icon itself is magically identical with the holy person or the sacred event. The Byzantine church itself is the "picture-space" of the icons. It is the ideal iconostasis; it is itself, as a whole, an icon giving reality to the conception of the divine world order. Only in this medium which is common to the holy persons and to the beholder can the latter feel that he is himself witnessing the holy events and conversing with the holy persons. He is not cut off from them; he is bodily enclosed in the grand icon of the church; he is surrounded by the congregation of the saints and takes part in the events he sees. . . .

If, however, the icons were to exist in, and to share, a space which is normally the domain of the beholder, it was more than ever necessary to place them in individual receptacles—in spatial units which are, as it were, excrescences of the general space. Moreover, since the images are not links in a continuous chain of narrative, they must not flow into one another: they must be clearly separated and each must occupy its own place in the same manner as the events and persons they represent occupy distinct places in the hierarchical system. The formal means to this end is the separate framing of each single receptacle. The single units are set off either by their characteristic shapes as spatial units, especially in the upper

parts of the building, or, in the lower parts, by being embedded separately in the quiet colour foil of the marble linings. This marble entablature with its grey, brown, reddish or green hues covers practically all the vertical surfaces of the walls in middle Byzantine mosaic churches, leaving for the mosaics only niches in which they are placed like jewels in a quiet setting. Nothing is more alien to the monumental mosaic decorations of these churches in the central area than the almost indiscriminate covering of the walls with mosaic pictures which is found in the twelfth century in Sicily, Venice and other colonial outposts of Byzantine art. In Byzantium itself the mosaics never lose the quality of precious stones in an ample setting. The icons never cease to be individually framed spatial units; their connection with one another is established not by crowded contiguity on the surface but by an intricate system of relations in space.

## THE IDEAL ICONOGRAPHIC SCHEME OF THE
## CROSS-IN-SQUARE CHURCH

These relations were governed, in the classical period of the tenth and eleventh centuries, by formal and theological principles. . . . We can distinguish three systems of interpretation which are found interlinked in every Byzantine scheme of decoration of the leading, centralized type.

The Byzantine church is, first, an image of the Kosmos, symbolizing heaven, paradise (or the Holy Land) and the terrestrial world in an ordered hierarchy, descending from the sphere of the cupolas, which represent heaven, to the earthly zone of the lower parts. The higher a picture is placed in the architectural framework, the more sacred it is held to be. The second interpretation is more specifically topographical. The building is conceived as the image of (and so as magically identical with) the places sanctified by Christ's earthly life. This affords the possibility of very detailed topographical hermeneutics, by means of which every part of the church is identified with some place in the Holy Land.[9] The faithful who gaze at the cycle of images can make a symbolic pilgrimage to the Holy Land by simply contemplating the images in their local church. This, perhaps, is the reason why actual pilgrimages to Palestine played so unimportant a part in Byzantine religious life, and why there was so little response to the idea of the Crusades anywhere in the Byzantine

empire. It may also account for the fact that we do not find in Byzantium reproductions of individual Palestinian shrines, those reproductions of the Holy Sepulchre, for instance, which played so important a part in Western architecture and devotional life. . . .

The third kind of symbolical interpretation was based on the Calendar of the Christian year.[10] From this point of view, the church is an "image" of the festival cycle as laid down in the liturgy, and the icons are arranged in accordance with the liturgical sequence of the ecclesiastical festivals. Even the portraits of the saints follow to some extent their grouping in the Calendar, and the arrangement of larger narrative cycles is frequently guided by the order of the Pericopes, especially as regards the scenes connected with Easter. Thus the images are arranged in a magic cycle. The relationship between the individual scenes has regard not to the "historical" time of the simple narrative but to the "symbolic" time of the liturgical cycle. This cycle is a closed one, repeating itself every year, during which, at the time of the corresponding festival, each image in turn comes to the front for the purpose of veneration, to step back again into its place for the rest of the year when its magic moment has passed. The profound contrast between this conception of time and that implicit in Western decorative schemes is obvious: in the latter a series of scenes illustrates an historical sequence of events, with its beginning and end clearly marked and with a definite direction parallel with the unrolling of the story. In the strict arrangement of Byzantine decorations the time element is symbolical; it is inter-linked with the topographical symbolism of the building, and therefore closely connected with the spatial element. The flow of time is converted into an ever-recurring circle moving round a static centre. These two conceptions of time correspond to the two dominant architectural types: the Western to the basilican type,[11] with its rhythmic movement from entrance to apse, from beginning to end; the Byzantine to the domed centralized building which has no strongly emphasized direction, and in which the movement has no aim, being simply a circular motion round the centre.

All three Byzantine systems of interpretation, the hierarchical cosmic, the topographical and the liturgico-chronological, are so closely accommodated to the dominant architectural type of the cross-in-square church that they must, in fact, have been elaborated for such a building. Only within this framework could a scheme devised after these principles be satisfactorily placed. Every

attempt, therefore, to adapt such a programme to other types of architecture must have met with great difficulties, and must consequently have resulted in a weakening of the original concepts, as can actually be seen in the provinces.

## THE THREE ZONES

The most obvious articulation to be observed in a middle Byzantine mosaic decoration is that which corresponds to the tripartition into heaven, paradise or Holy Land, and terrestrial world. Three zones[12] can be clearly distinguished: first, the cupolas and high vaults, including the conch of the apse; second, the squinches, pendentives and upper parts of the vaults; and thirdly, the lower or secondary vaults and the lower parts of the walls. These three zones are, in most cases, separated by plastic *cosmetes*—narrow bands of carved stone or stucco which run round the whole edifice.

The uppermost zone, the celestial sphere of the microcosm of the church, contains only representations of the holiest persons (Christ, the Virgin, Angels) and of scenes which are imagined as taking place in heaven or in which heaven is either the source or the aim of the action depicted. Byzantine art from the ninth to the end of the eleventh century made use of only three schemes of cupola decoration: the Ascension, the Descent of the Holy Ghost, and the Glory of the *Pantocrator*, the All-Ruler. This peculiarity distinguishes the strict scheme of the Middle Ages from early Byzantine as well as from Italo-Byzantine decoration. In the five cupolas of the Justinianic church of the Apostles in Constantinople,[13] for instance, there had been five different representations, each forming part of the narrative cycle which filled the whole church. After the Iconoclastic controversy, however, and in connection with the subsequent emergence of the symbolic interpretation of the church building, the cupolas were strictly set apart from the narrative cycle. From the ninth century onwards they contained only representations in which the narrative character had been displaced entirely by the dogmatic content. The three themes above-mentioned dominated Byzantine cupola decorations after the Iconoclastic controversy to such an extent that others were scarcely thinkable; even the small cupolas of entrance halls were decorated with them. . . .

The second of the three zones of the Byzantine church is dedicated to the Life of Christ, to the pictures of the festival cycle. It

harbours the monumental calendar of the Christological festivals and is the magical counterpart of the Holy Land. The cycle of feasts was gradually developed by selection from an ample narrative series of New Testament scenes. It is very probable that the decorations which immediately followed the re-establishment of icon worship did not include any festival icons in the naos. But the austere ideal of the early post-Iconoclastic period was relaxed in the course of the tenth and eleventh centuries. . . . The growth of the festival cycle can also be followed in contemporary ecclesiastical literature: there the number rises from seven to ten, twelve, sixteen and even eighteen pictures, the full development being reached from the twelfth century onwards.[14] The classical cycle of the eleventh century comprised, at least in theory, twelve feasts, the *Dodekaeorta:* Annunciation, Nativity, Presentation in the Temple, Baptism, Transfiguration, Raising of Lazarus, Entry into Jerusalem, Crucifixion, Anastasis (Descent into Hades), Ascension, Pentecost and Koimesis (Death of the Virgin). To this series were frequently added, in pictorial cycles, a few images which elaborated the story of Christ's Passion, namely the Last Supper, the Washing of the Apostles' Feet, the Betrayal of Judas, the Descent from the Cross and the Appearance to Thomas. Other developments were attached to the story of Christ's infancy (the story of His parents, the Adoration of the Magi, the Flight into Egypt, etc.) and to that of His teaching (the cycle of the miracles and parables). . . .

The third and lowest zone of centralized decorations does not contain any scenic images: single figures alone make up the "Choir of Apostles and Martyrs, Prophets and Patriarchs who fill the naos with their holy icons".[15] These figures are distributed in accordance with two iconographical principles which intersect each other: one that of rank and function, the other that of calendrical sequence. It is the former of these which predominates. Sainted priests and patriarchs are placed in or near the main apse, in a hierarchical order which descends from the Patriarchs of the Old Testament, by way of the Prophets and the Doctors of the first centuries of Christianity, down to the humble priests of the Eastern Church. The Martyrs fill the naos, arranged in several groups: the holy Moneyless Healers (the Anargyroi) next to the sanctuaries, the sacred Warriors on the pillars and the arches of the central cupola, and the rest mostly in the transept, distributed in groups according to the dates of their festivals in the liturgical calendar. The third category

comprises the holy Monks, who are placed in the western part of the church, guarding the entrance of the narthex and the naos. Holy women and canonized emperors are depicted in the narthex. But this order is by no means rigid; it allows of variation according to the dedication of the particular church and to its architectonic type. . . . An eternal and holy presence is manifest in the paintings of the highest zone, to the suppression of all narrative and transient elements. There, the timeless dogma is offered to the contemplation of the beholder . . . a sacred world, beyond time and causality, admitting the beholder not only to the vision but to the magical presence of the Holy. In the middle zone the timeless and the historical elements are combined in accordance with the peculiar character of the festival icon, which simultaneously depicts an historical event and marks a station in the ever-revolving cycle of the holy year. . . . Isolated as holy icons and, at the same time, related to their neighbours as parts of the evangelical cycle, the paintings in the second zone are half picture and half spatial reality, half actual scene and half timeless representation. But in the lowest stratum of the church, in the third zone, are found neither narrative scenes nor dogmatic representations. The guiding thought in this part of the decoration—the communion of All Saints in the Church—is realized only in the sum of all the single figures. They are parts of a vast image whose frame is provided by the building of the church as a whole.

*NOTES*

[1] J. Sauer, *Die Symbolik des Kirchengebäudes und seiner Ausstattung in der Auffassung des Mittelalters*, Freiburg i. B., 1902.

[2] For a summary of this doctrinal controversy, see K. Schwarzlose, *Der Bilderstreit, ein Kampf der griechischen Kirche um ihre Eigenart und Freiheit*, Gotha, 1890; L. Bréhier, *La querelle des images*, Paris, 1904; N. Melioransky, "Filosofskaya storona ikonoborchestva", *Voprosy Filosofii*, etc. II, 1907, p. 149 ff; L. Duchesne, "L'iconographie byzantine dans un document grec du IXᵉ s.", *Roma e Oriente*, vol. V, 1912–1913, pp. 222 ff., 273 ff., 349 ff.; A. v. Harnack, *Dogmengeschichte*, Tübingen, 1922, p. 275 ff.; G. A. Ostrogorski, "La doctrine des saintes icones et le dogme christologique" (Russian), *Seminarium Kondakovianum*, I, Prague, 1927, p. 35 ff.; *Idem*, "Die erkenntnistheoretischen Grundlagen des byzantinischen Bilderstreites" (Russian with German résumé), *Ibid.*, II, Prague, 1928, p. 48 ff.; *Idem, Studien zur Geschichte des byzantinischen Bilderstreites*, Breslau, 1929; *Idem*, "Rom und Byzanz in Kampfe um die Bilderverehrung" (Russian with German résumé), *Sem. Kondak.*, VI, Prague, 1933, pp. 73 ff.; E. J. Martin, *History of the*

*Iconoclastic Controversy*, London, 1930; G. Ladner, "Der Bilderstreit und die Kunstlehren der byzantinischen und abendländischen Theologie", *Zeitschrift für Kirchengeschichte*, III, F., I, vol. 50, 1931, p. 1 ff.; V. Grumel, "Récherches récentes sur l'iconoclasme", *Échos d'Orient*, XXIX, 1930, p. 99 ff.—What follows here is a very simplified summary of the main Christological arguments used in the controversy.

[3] This thought can be traced back to the writings of Germanos, at the end of the seventh century. See Ostrogorski, *La doctrine*, etc., *loc. cit.*, p. 36.

[4] Both ideas, that of magical identity and that of venerability, had become firmly established in one branch of popular religious art in the fifth and sixth centuries, long before the beginning of the Iconoclastic controversy. See K. Holl, "Der Anteil der Styliten am Aufkommen der Bilderverehrung", *Philothesia, P. Kleinert zu seinem 70. Geburtstag*, Berlin, 1907, p. 54 ff. The popular belief was that the spiritual force of the venerated Stylites and their power to aid were immanent in their representations. This seems to have been the origin of the belief in the miracle-working power of images.

[5] The problem is similar to that of representing an action on the stage. But there the solution is rendered easier by the fact that the figures are in motion.

[6] The more recent bibliography on this subject will be found in the article "Kreuzkuppelkirche", by W. Zaloziecky, in Wasmuth's *Lexikon der Baukunst*, and in various papers by N. Brunov (*Byz. Zeitschrift*, 27, 1927, p. 63 ff.; 29, 1929–1930, p. 248; 30, 1930, p. 554 ff., etc.).

[7] Few things, indeed, have kept their form so perfectly and unchangingly as the Byzantine cross-in-square church. An analogy from a different field may illustrate this stationary perfection and completion: the violin, whose shape, once perfected, could not be improved upon. Its form is not affected by its scale, whether simple violin or double-bass, just as the form of the Byzantine church remains the same throughout its whole range, from tiny chapel to vast cathedral.

[8] See, for example, the 18th Homily of Gregory of Nazianzus, and Procopius's description of the Haghia Sophia in Constantinople.

[9] See Simeon of Thessalonike, in Migne, *Patrologia Graeca*, tom. 155, col. 338 ff.

[10] The sources of this interpretation are quoted in G. Millet, *Récherches, sur l'iconographie de l'Évangile*, Paris, 1916, p. 25 ff.

[11] For the Western conception, see the writings of A. Schmarsow, especially his "Kompositionsgesetze in den Reichenauer Wandgemälden", *Rep. für Kunstwiss.*, vol. XXXVII, 1904, p. 261 ff., and *Kompositionsgesetze in der Kunst des Mittelalters*, Leipzig, 1915.

[12] This division of the architectural decoration into horizontal zones is in strict accordance with Byzantine and early Christian, as opposed to antique, cosmography. See D. Ainalov, *Ellenisticheskiya osnovy vizantiyskago iskusstva*, St. Petersburg, 1900; and *Rep. für Kunstwiss.*, XXVI, 1903, p. 36.

[13] A. Heisenberg, *Grabeskirche und Apostelkirche*, II, Leipzig, 1908. The Pantocrator programme of the central cupola was the result of later changes. See N. Malicky, "Remarques sur la date des mosaiques de l'église des Stes Apôtres à Constantinople", *Byzantion*, III, 1926, p. 123 ff. with bibliography.

[14] G. Millet, *Récherches, op. cit.*, p. 16 ff., with texts.

[15] After Photius's description of the Nea of Basil I. See O. Wulff, *Altchristliche und byzantinische Kunst*, II, Potsdam, 1924, p. 551.

# 11. THE ORIGINS OF THE BAY SYSTEM

## Walter Horn

### INTRODUCTION

This selection is based on a paper presented by Walter Horn at the 1958 meeting of the Society of Architectural Historians in Washington. Here Professor Horn picks up Strzygowski's intuition that the origins of the bay system in medieval architecture lay in the example of wood construction and supports his thesis with convincing evidence reaching as far back as the Iron Age. This article is a fine example of the disciplined weaving together of documentary and archaeological data in support of a reexamined idea. Yet, as the reader will note in the last two paragraphs, the writer is careful to point out some alternate possibilities, however strongly he may reason against their validity.

For further reading consult Raymond Richards, *Old Cheshire Churches* (1947); Fred H. Crossley, *Timber Building in England* (1953); J. T. Smith, "Medieval Aisled Halls and Their Derivations," *Archaeological Journal,* CXII (1956); Walter Horn, "Two Timbered Mediaeval Churches of Cheshire: St. James and St. Paul at Marton and St. Oswald at Lower Peover," *The Art Bulletin,* XLIV (1962); Walter Horn, "Great Tithe Barn of Chosley, Berkshire," *Journal of the Society of Architectural Historians,* XXII (1963); Walter Horn and F. W. B. Charles, "Cruck-built Barn of Middle Littleton in Worcestershire, England," *Journal of the Society of Architectural Historians,* XXV (1966). For remarks on the significance of this timber "vernacular" architecture, the reader might wish to consult Kenneth J. Conant, *Carolingian and Romanesque Architecture, 800 to 1200,* rev. ed. (1973), 20–42, and footnote 6 for chapter I.

Joseph Strzygowski advanced the theory in 1924 that the medie-
val bay system had its origins in northern wood construction.[1]
This idea was neither accepted nor rejected by architectural
historians; it simply failed to be acknowledged, as were so many
of the ideas promiscuously conceived and propagated by this in-
genious but undisciplined mind. Strzygowski's theory was based
upon the assumption that a tradition of bay-divided wooden houses
existed in the formative phases of the Romanesque, but at that date
he could not point his finger to any bay-divided house that antedated
the emergence of the principle of bay division in monumental
medieval masonry architecture, because the first such house on the
Continent had yet to be excavated. Doubtless there are striking
similarities between the intensely skeletal churches of the Norman
and Frankish Romanesque and certain Scandinavian stave churches,
but none of the churches which Strzygowski cited in support of his
theory were of a date sufficiently early to support the hypothesis
that they might have been a contributing force in the formation
of the Romanesque style, nor could Strzygowski demonstrate that
any such churches existed in the Continental cradle areas of the
Romanesque—not to speak of the fact that the stave churches to
which he referred were centralized structures, and therefore not
truly analogous in type to the basilican bay-divided churches of the
Continent.[2]

There is no doubt, however, that timber churches were a common
phenomenon even on the medieval Continent. Not only is there an
abundance of documentary references to such structures,[3] but an
appreciable number of them survive. Most of these churches have
not been properly recorded, however, as nobody has ever gathered
this material together. Thus, after some hundred years of intensive
architectural research in the course of which we have measured
the dimensions of even the smallest stone incorporated into the
masonry of every fourth-rate medieval country church, the question
of the design and constructional layout of a typical Continental
medieval timber church has been almost entirely neglected.

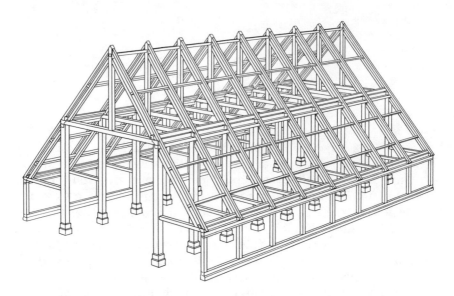

28. Honfleur, Normandy, France. St. Catherine's Original Site, 15th Century (Author's reconstruction based on drawings by M. Jullien)

Of the extant medieval timber churches of Continental Europe, probably the most revealing, historically, is the church of St. Catherine at Honfleur, in Normandy, France.[4] In its present state this church consists of two parallel naves of equal height and two smaller aisles. But in 1946, Monsieur Jullien, an architect of the Monuments Historiques, made the interesting discovery that in its original form the church was a three-aisled structure.[5] M. Jullien observed that the octagonal wooden posts which separate the two naves in the center still today show on their southern faces the complete original set of the mortise holes which formed the springing of the crossbeams and bracing struts of the original aisle. I had occasion in the summer of 1957 to check these observations and found them to be correct in all detail. On the basis of M. Jullien's carefully measured sections and elevations I have prepared the perspective which is shown in Fig. 28. In this, its original form, St. Catherine's stems most likely from the time of the general economic resurgence which followed the eviction of the English from this city in 1450. Some time after completion but still within the course of the fifteenth century, as can be gathered from the profiles of the moldings of the new work (the new work being more complex than the original work but still late Gothic in style), the

southern aisle was taken down and replaced by a second nave, an alteration to which the church owes its present shape.

In France, St. Catherine of Honfleur is the oldest surviving building of its kind, but in England the type can be traced back to the fourteenth century, in Germany and Holland to the ninth, in Belgium to the sixth or fifth.

A late medieval church from the hamlet of Paasloo, Province Overyssel, Holland, was brought to my attention by Messrs. Jan Jans and E. Jans in Almelo.[6] The walls of the church are built in brick and date from the beginning of the sixteenth century. But the roof-supporting inner trusses of timber appear to be of an earlier date. The original timbers survived until 1954, when, suffering from a heavy infestation of death-watch beetles, they were completely replaced by modern timbers. The new work, however, is a true copy of the original work. A fifteenth-century church of practically identical construction, again unpublished, stands in the village of Nyeven, Province Drente, Holland. The record, however, becomes truly rich as we move across the Channel into England. In the county of Cheshire alone there are five aisled and bay-divided timber churches, and two of those reach back to the fourteenth century: the church of St. James and St. Paul in Marton and the church of St. Werburgh at Warburton. Two further churches of the same design, but dating from the fifteenth century, are to be seen in Lower Peover and in Holmes Chapel, Cheshire; to these can be added a fifteenth-century church in Mattingly, Hampshire, and a fifteenth-century church in Ribbesford, Worcestershire. The Cheshire churches are reproduced and discussed in Raymond Richards comprehensive volume on *Old Cheshire Churches*.[7] Numerous other churches of a similar construction type outside of Cheshire may have escaped my attention or may only be brought to light in the future, as the two great archaeological surveys of the *Victoria History of the Counties of England* and the *Royal Commission on Historical Monuments* draw toward their completion.

As in the Continental timber churches previously discussed, so in the above-named English churches the space is subdivided into a nave and two aisles by two rows of free-standing, inner uprights, which are framed together crosswise by means of tie beams and lengthwise by means of plates and purlins.

What vast distribution this construction type must have had in the Middle Ages may be gathered from a medieval timber church

from Stóry-Nupur in Arnessysla, Iceland, torn down in 1875, but accurately recorded in the form of a scale model now on display in the National Museum at Copenhagen.[8] The exact date of this church unfortunately is not known, but a Norwegian Book of Homilies from the beginning of the twelfth century contains a complete description of a church which suggests that the Stóry-Nupur type of church was a common concern in the north Germanic territories of Scandinavia and the Atlantic islands.[9]

Until very recently no evidence existed that bay-divided timber churches of this type existed on the Continent during the formative phases of the Romanesque, but in 1947 P. Glazema unearthed in the villages of Buggenum and Grubbenvorst, Holland,[10] two Carolingian churches of this type. In 1948–50 their number was increased to four when the Landesmuseum in Bonn excavated in the villages of Breberen and Doveren, not far from the Dutch border, two more Carolingian churches of the same construction type on sites which had been bombed in World War II.[11] In Fig. 29 I am reproducing one of these as reconstructed by P. J. Tholen.[12] The discovery of these structures, which could be attributed to the eighth and ninth centuries by pottery shards and other accessories, brought added credence to the results of an excavation which had been made in the 'twenties in connection with the old episcopal church of Maastricht, Belgium (5th–6th centuries). In the interior of this church the excavators had discovered the remains of two ranges of flat stones, which could only have served as base blocks for two rows of wooden uprights, dividing the church lengthwise into three aisles of equal width. Albert Verbeek, who discussed this church at the Sixth Congress of German Art Historians, held at Essen in 1956,[13] pointed at the similarity of the general layout of Maastricht Cathedral to that of the pre-Carolingian churches of Worms and of St. Albans in Mainz, the roofs of which he also presumes to have been supported by two rows of wooden posts.

Taken by themselves these Carolingian and early medieval timber churches are inconsequential. Their significance lies in the fact that they tell us that the constructional layout of a Carolingian timber church was substantially that of the surviving medieval timber churches just discussed, and—if it is the constructional system of a church like St. Catherine's at Honfleur (Fig. 28) or St. James' and St. Paul's in Marton that we have to think of when we read in Thietmar's chronicle (to name just one of countless references to

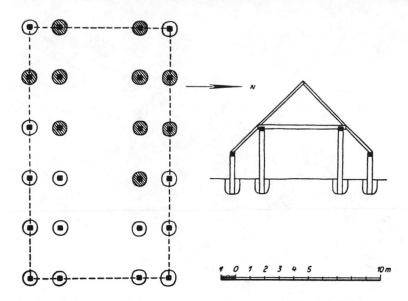

29. Breberen (Near Aachen), Germany; Carolingian Timber Church (Reconstruction P. J. Tholen)

medieval timber churches that could be cited in this connection) that Bishop Unro of Verden erected in the town of Verden toward the middle of the tenth century a church in timber, and made this church "superior in scale and quality to all other churches" (*et magnitudine et qualitate caeteras precellentem*)[14]—then Strzygowski's theory of the origin of the medieval bay system in northern wood construction would indeed require reexamination.

True enough, the evidence so far available is meager, and I would hesitate to base my views about the validity of Strzygowski's theory of the origin of the medieval bay system upon the fragile pedigree of medieval timber churches above discussed. The inquiry, fortunately, is greatly simplified by the fact that the construction type with which we are here concerned—and here Strzygowski's guess, it has to be admitted, turned out to be correct—was by no means confined to the building of churches. Church construction was only one phase, and centuries before anybody had thought of applying these construction principles to churches they had been a standard procedure in house and barn construction. In Fig. 30 I show the plan and reconstruction of a prehistoric cattle barn which the Dutch anthropologist Albert Egges van Giffen excavated in 1934–36 in a hamlet called Ezinge, Province Groningen, Holland.[15] It dates from the third century B.C. The details of the roof are not assured but the roof-supporting posts and the braided wattle walls which en-

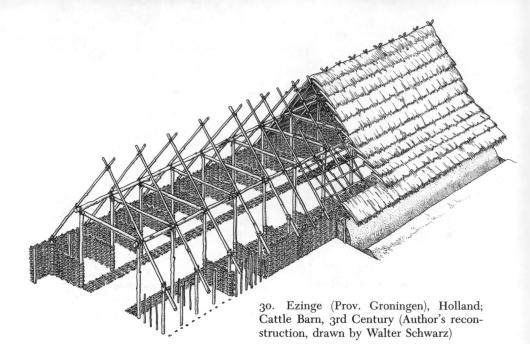

30. Ezinge (Prov. Groningen), Holland; Cattle Barn, 3rd Century (Author's reconstruction, drawn by Walter Schwarz)

closed the house and subdivided the aisles into stalls for cattle were preserved to hip and even to shoulder height, and the braided fodder mats in front of the posts were found in such good condition that they could be stepped upon without sustaining damage. The dampness of the ground in conjunction with the acidity of the wood retained the timbers in an unusually fine state of preservation.

This same site revealed on a lower level an entire settlement of houses of the same design, the varying furnishings of which suggest that we are here confronted with an all-purpose house. Depending on the respective presence or absence of fireplaces or fodder mats, or their combined appearance in one and the same structure, this construction type—without undergoing even the slightest structural alteration—could be used as shelter for humans alone, as shelter for humans and animals combined, as shelter for animals alone, or as shelter for the storage of produce and harvest. The arrangement of the posts leaves no doubt, in my opinion, that these were bay-divided structures, for although none of the actual timbers of the upper parts of these houses are preserved, the posts could not have successfully braced the roof against the lateral thrust of wind and storm had they not been framed together at the top by means of crossbeams and long-beams. Bay division lay in the nature of the materials employed. The reconstruction reproduced in Fig. 30 [is]

194

my own. They do not pretend to be trustworthy in all details and, in fact, having been made some six or seven years ago do not altogether correspond to my present views. Nor do I wish to advance the claim through them that each and every three-aisled Iron Age house that has been excavated so far was bay-divided. But I feel certain that in the Iron Age, bay division was a going concern. In some of the smaller houses, if the uprights were anchored deep enough in the ground the roof might well have been capable of taking the normal thrust of the prevailing winds without having the posts connected crosswise by means of tie beams; but in the larger houses, and especially in such cases where the posts rested on base blocks rather than being sunk into the ground, the uprights must have been connected crosswise as well as lengthwise if the house were to stay up at all.[16]

The Ezinge houses [not reproduced here, but as Figs. 12 and 13 in original article] date from the fourth century B.C. When they were discovered in 1934 they were a relatively rare phenomenon. But between 1934 and 1958 over 200 houses of this construction type have been excavated in Holland, in northern Germany, in Scandinavia, and in England, and today we are able to trace their development, century by century, into the Middle Ages and through the Middle Ages to their modern survival forms.[17] The structural layout of this house-type is well exemplified in a model of a house which Werner Haarnagel excavated in 1949–50 in Wilhelmshaven-Hessens where it could be identified in settlement-horizons of the seventh, eighth, ninth, and tenth centuries;[18] and in excavations conducted in 1951–53 in Emden, the same type was discovered in settlement-horizons of the eleventh, twelfth, and thirteenth centuries.[19] For Holland a closely related house-type had been ascertained as early as 1939 for the period of 700–1000 through an excavation undertaken by van Giffen in the vicinity of the parish of Leens, Province Groningen (Fig. 31).[20]

Medieval architectural history has responded to these discoveries with a peculiar apathy, and our failure to evaluate this material in its proper context has prevented us from tackling one of the major unsolved problems of medieval architectural history—which is, in turn, of greatest importance to the excavators—that of the reconstruction of the guest and service buildings of the Plan of St. Gall.

Apart from the monastic buildings proper, i.e., the church, the claustrum, the noviciate and the infirmary, this plan[21] comprises

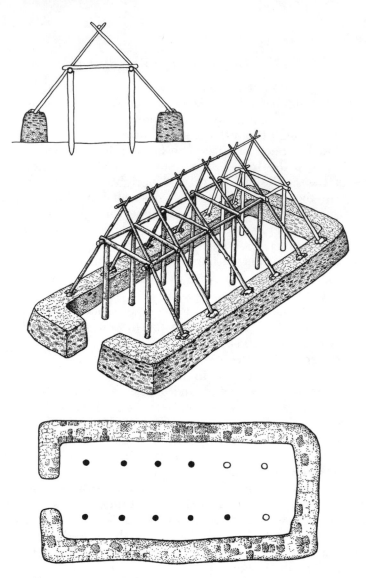

31. Leens (Prov. Groningen), Holland; Medieval Timber House, *c.* 700–1000 (Author's reconstruction, drawn by Walter Schwarz)

a host of subsidiary structures, which are as common to secular life as they are indispensable to the economy of a monastic settlement. Under this category come such installations as the granaries, the house of the gardener and his crew, the house of the duck and fowl keeper, the house of the workmen, some six or seven structures which serve as shelter for the livestock and its keepers, the so-called

"Outer School," and the two monastic guest houses: the House for Visitors of Rank and the Hospice of the Paupers. A typological analysis of the guest and service structures of the Plan of St. Gall shows that they are variants of the house type above discussed. As the Iron Age houses of Ezinge and their early medieval descendants of Wilhelmshaven-Hessens and Leens (Fig. 31), so in the guest and service structures of the Plan of St. Gall the principal portion of the house consists of a large rectangular center room which contains the hearth and serves as common living room, while the more private and more specialized functions, such as sleeping and the stabling for the livestock, are relegated to the peripheral aisles and lean-tos.

Thus in the Guest House for Visitors of Rank the center space is used as the common "dining hall" (*domus ad prandendum*), the chambers under the lean-tos as the "bedrooms for the distinguished guests" (*caminatae cum lectis*), the aisles as "servants' quarters" (*cubilia servitorum*) and as "stables for the horses" (*stabula caballo-rum*). By the same token, in the Hospice of the Paupers the center space serves as "living room for the pilgrims and paupers" (*domus peregrinorum et pauperum*), while the outer rooms are used as dormitories (*dormitorium*), as "quarters for the servants" (*servitorum mansiones*), as "storage room" (*camera*), and as "cellar" (*cellerarium*). Likewise in the House for the Country Servants, as well as in all of the buildings which accommodate the livestock and its keepers, viz., the sheepfold, the goat-shed and the pigsty, the large rectangular center space is designated as the "common living room" (*domus familiae, ipsa domus,* etc.), while the outer rooms serve as "sleeping quarters for the attendant servants" and as "stables" (*cubilia custodientium, cubilia opilionum, cubilia pas-torum* and *cavil* or *stabula*). In order to be taken to their stalls the animals had to be led through the common center room. This held true not only for the structures specifically devised for the purpose of housing livestock, but also for buildings of such a highly resi-dential nature as the Guest House for Visitors of Rank, where the horses, likewise, in order to reach their stables had to be guided through the common living room.

In the majority of the guest and service structures of the Plan of St. Gall the center room is surrounded by wings on all four sides, but on some of the smaller houses the aisles are confined to two or three sides only. Two typical examples of this latter kind are

the House of the Duck and Fowl Keeper and the House of the Physician, while the Guest House for Visitors of Rank is, of course, a typical example of the more common type. Yet in whatever combination this house-type may appear, it is obvious that we are confronted with an all-purpose structure that served a great variety of functions, separate and combined, without entailing even the slightest changes in its basic structural dispositions: it was used in one case as shelter for humans alone, in another as shelter for humans and animals combined, and in still another as storage space for the harvest.

The only medieval house-type known to have comparable versatility of functions (while at the same time retaining unaltered all of its basic structural dispositions) is the house-type of Ezinge, Leens, and Wilhelmshaven-Hessens. The Plan of St. Gall gives us an idea of the immense distribution which this house-type must have had in Carolingian Europe—in fact, it holds the key to the entire unsolved problem of Carolingian residential and rural architecture, for granaries, cow sheds, pigsties, sheepfolds, houses for workmen, guests, and country servants belonged to a category of buildings which in the Middle Ages were even more common to secular life than they were to a monastic settlement.

If we have been negligent in keeping abreast with the discoveries made during the last two decades by our colleagues in the field of prehistory, we have been even more remiss with our own material. France and England are replete with the remains of the most extraordinary aisled and bay-divided medieval timber structures *which we have not even taken the trouble to record properly*. The oldest surviving aisled and bay-divided timber hall of Europe is the castle hall of Leicester. It dates from around 1150. The historical aspects of this structure have been competently dealt with in a study of Levi Fox,[22] but archaeologically this building is as good as uninvestigated. Reliable plans and sections have never been published and are not even locally available. While of the excavated prehistoric and early medieval houses which I discussed above only the ground or bottom timbers survive, in Leicester Castle the situation is exactly reversed. Most of the supporting frame has disappeared, but the roof is preserved. And here we have the earliest residential timber roof of Europe that is still in a perfect state of preservation—a fact which should be of primary concern to the prehistorians who have not had the good fortune as yet of finding

among their excavated house remains sufficient evidence to be certain about the details of reconstruction of the roof system. I am stressing "in a perfect state of preservation" since British archaeologists have recently displayed a tendency to assume that the original twelfth-century roof of the hall of Leicester Castle might have been replaced by a new one sometime in the course of the fourteenth century. This view has been expressed by Mr. C. A. R. Radford,[23] who observed that the tie beam which lies contiguous to the southern gable wall cuts across the cornice of the arches of the Norman windows, and hence could not have been part of the original work. Mr. Radford's observation is correct, but I cannot follow his conclusion. The timber frame of the hall of Leicester Castle, while originally keyed firmly into the gable walls by means of half-beams which rested on masonry brackets, had simply sunk away from its original level early in the nineteenth century, when the wooden Norman pillars were cropped three feet below the meeting point of tie beams and plates, and then shored by modern timbers resting on modern piers of brick. In the summer of 1957 I had an opportunity to study this roof timber by timber. To my own surprise I found it to be original and homogeneous throughout. The frame is out of plumb and has buckled severely, and in places has sunk away from its original position for a distance of almost two feet, but the timbers *are Norman!* And this holds true not only for the tie beams and the rafters and all of their connecting bracing struts, but also for the heavy plates as well as for the headpieces of the supporting piers and their entire complement of bracing struts. The profiles, moldings, and scantling of these timbers are Norman and show none of the refinements and mannerisms of fourteenth-century carpentry work.

On one of the walls of the stairwell which leads to the private court rooms installed on the modern second floor of the hall there is on display a woodcut of a perspective reconstruction of the hall, which was made in 1917 by T. H. Fosbrooke of Leicester (Fig. 32).[24] Save for a few minor details which can be corrected only after the building has been systematically measured (a task which I hope to be able to undertake next summer), this reconstruction is, in my opinion, basically correct. Fosbrooke's woodcut takes us into the interior of a typical medieval castle or manor hall such as must have dotted the European countryside in the twelfth and thirteenth centuries in thousands, if not in hundreds of thousands,

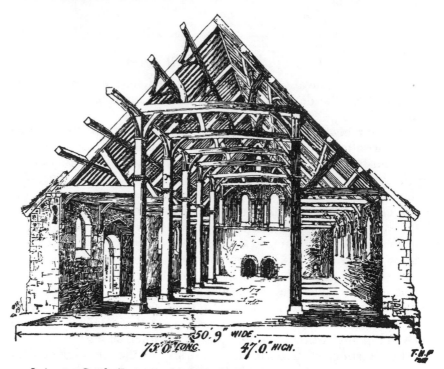

32. Leicester Castle (Leicestershire), England; Interior of Great Hall (Reconstruction by T. H. Fosbrooke)

of specimens. In the homes of those of the highest social and economic level the traditional timber walls were often replaced by masonry, as is the case in Leicester, but in general they were built in timber.[25] As in the guest and service structures of St. Gall and the prehistoric and early medieval houses of Ezinge and Wilhelmshaven-Hessens, so here the hall received its warmth from an open fireplace that burned in the middle of the center aisle. The lord sat at the table on the elevated dais at one of the two narrow ends of the hall, while his retainers took their meals on benches and tables set up along the walls in the aisles of the building. The benches and tables were cleared away after the meal to make room for the bolsters and pillows on which the retainers slept. This is the architectural system of the standard hall not only of the great and powerful lords of the secular order, but also that of the hall of the overlords of the church.

One of the most beautiful feudal halls of England—entirely built in timber—is the palace hall of the Bishop of Hereford. It dates from the same general period as Leicester Hall,[26] is equally well preserved, but has received even less attention from medieval

architectural historians than the hall of Leicester Castle.[27] The hall appears to have survived in its original form up to the time of Bishop Bisse (1713–1721), when it was robbed of its spatial unity by the insertion of a number of inner-wall partitions. It was subjected to further disfiguration under Bishop Atley (1868–1896), who sub-divided what remaining open space there was into a jumble of separate rooms by the insertion of further cross partitions and the construction of a second story. It is in the masonry of these eight-eenth- and nineteenth-century wall partitions and in the space above the plaster ceilings of the rooms installed by Bishops Bisse and Atley that three of the original wooden piers and a substantial portion of the original wooden arcades can still be seen. While only three of the original bays can now be traced, it is possible that the original structure was comprised of five bays. This at least was the view of John Clayton, to whom we owe the first description of the hall.[28]

33. Hereford (Herefordshire), England; Interior of Great Hall (Reconstruction by John Clayton)

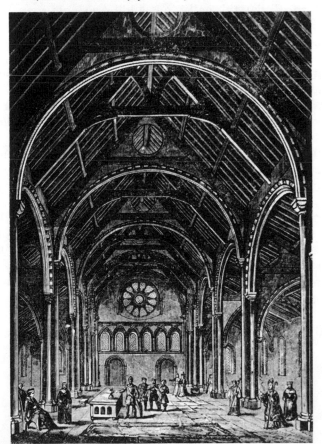

John Clayton is the author also of the superb reconstruction reproduced in Fig. 33, which I am publishing here with the kind permission of the Lord Bishop of Hereford and the City Library and Old House Committee of this city.[29] While unreliable in many of its details—especially in the rendering of the roof and the doubtful large transverse arches—this picture nevertheless recreates in an arresting manner the sweeping spatial grandeur of a typical timbered medieval palace hall. The large and remarkable arcades of this structure, however, though entirely hewn in timber, are a design feature that is not natural to wood and which already comes, of course, under the influence of stone construction. The standard type of feudal English hall had the traditional timber system of straight long- and crossbeams, framed together with the aid of diagonal bracing struts, and in this form the three-aisled timbered hall served in the Middle Ages not only as a domestic feudal residence, but also as a barn, as a hospital, and as a market hall —even as a church.

Westminster Palace, the largest feudal hall in Europe, and the hall of the kings of England, is unfortunately not preserved in its original form. Today this hall is covered by a single span, a masterpiece of hammer beam construction, which King Richard II raised at the end of the fourteenth century.[30] But prior to the invention of the arch-braced hammer beam a hall of this enormous width could not have been spanned in single trusses; for that reason there is general agreement among British archaeologists that when this hall was built by William Rufus between 1097 and 1099 its roof must have been supported, like the roofs of the halls of Leicester and Hereford, by two rows of free-standing inner timbers which divided the structure lengthwise into a nave and aisles and crosswise into a sequence of bays.[31] We can make ourselves a convincing picture of what that system must have looked like in its original form by stepping into one of the monumental tithe barns of the great monastic orders, such as the fourteenth-century tithe barn of Great Coxwell in Berkshire.[32] This is, in its essential lines, what the royal hall in the Palace of Westminster must have looked like from the time of William Rufus to that of Richard II when it was the administrative center at which a major portion of the political history of England was forged.

In medieval England hall and barn were structurally interchangeable, and if there were any difference between the two it consisted

in the fact that the barns, in general, were considerably larger and infinitely more numerous than the halls. No medieval manor was in need of more than one hall, but every medieval manor needed three to five barns. We are in an excellent position to evaluate the density of distribution of medieval barns, not only because of the help provided by the Plan of St. Gall—which gives us the layout of not less than eight such structures—but also because of the survival of a number of written documents of a related nature. One of the most enlightening documents of this type is a dossier of lease agreements of the twelfth century which records the manorial holdings of the dean and chapter of St. Paul's in London.[33] From this inventory we learn that the chapter of St. Paul's derived its sustenance from a total of thirteen manors which were scattered throughout the counties of Hertfordshire, Essex, and Surrey. The number of barns on each of these manors varied from three to five. Thirteen of these barns are so well described that they can be reconstructed on a drawing board. The canon who took the inventory gives us not only the length and width of each barn but, in many cases, even such details as the height and width of the aisles, the height and width of the nave, the depth of the bays and lean-tos, the height from the floor to the crossbeam, and the distance from the crossbeam to the ridge.

In view of the crucial position which this document occupies in the history of the aisled and bay-divided medieval timber barn, I shall translate from the Latin, as a typical example, the description of one of three barns which the chapter of St. Paul's owned on its manor at Wicham, Essex.

> The third barn, which lies further east, is 49½ feet long, not counting its lean-tos, which have a depth of 22 feet. The height of this barn below the tie beam is 15 feet, and above, between the tie beam and the ridge, it is 9½ feet. The nave is 22½ feet wide, and each of its two aisles is 6½ feet wide and 8 feet high. This barn Ailwinus must render full of summer wheat from the entrance toward the east, and from the entrance toward the west it must be full of oats. The center [bay] opposite the entrance must remain empty. It is 11½ feet wide.

The largest of the barns described in the leases of St. Paul's is a barn in a place called Walton on the manor of Adulvesnasa, Essex. It measured 168 feet in length, 53 feet in width, and 33½ feet in

height. Its nave was filled to the ridge with huge stacks of oats and summer wheat, and scattered here and there in the aisles were heaps of barley, the dimensions of which are accurately recorded. This description is a striking tribute to the economic acumen of the landowning corporation which, with these details, made sure that all such goods as a new tenant received on entering the manor were dutifully returned at the termination of the lease.

The lease agreements of St. Paul's range in date from 1114 to 1155.[34] Obviously they establish only a *terminus ante;* they say nothing about the age of the barns. Some of them may have been of relatively recent date. Others may have been centuries old; in fact, may date from any time between the date of inspection and the original land grants in the seventh and eighth centuries.

That barns of this layout and design were as common in the Middle Ages on the Continent as they were in England, we may gather from a glance at Dom Milley's superb engravings of the Abbey of Clairvaux.[35] Published in 1708, these engravings show the settlement substantially in the form it had attained by the close of the twelfth century. In the foreground of the bird's-eye view which shows the monastery from the west, one recognizes two large barns, one lying at right angles, the other parallel to the monastery walls immediately to the right of the entrance. Dom Milley's plan reveals that these were five-and six-aisled structures, and the scale with which the plan is furnished permits us to establish their dimensions as amounting to 90 by 120 feet and to 72 by 168 feet, respectively. Inserted into the edge of Dom Milley's great perspective is a view of one of the outlying granges of Clairvaux, the grange of Ultra Albam. It also contains two barns, one subdivided into five, the other into seven, aisles. The larger of these two barns was 210 feet long and 108 feet wide.

The barns of Clairvaux perished when the monastery was demolished in the wake of the French Revolution. Their loss as historical monuments, however deplorable it may be, is not irreparable, as a considerable number of like-type barns survive, both in France and in England. The earliest of these appears to be the abbey grange of Parçay-Meslay, near Tours in France (Fig. 34), a dependency of the monastery of Marmoutier. Dom Edmond Martène, a learned French Benedictine of the Congregation of St. Maur (1654–1739), who was thoroughly acquainted with the history and the archives of this monastery, lists the abbey grange

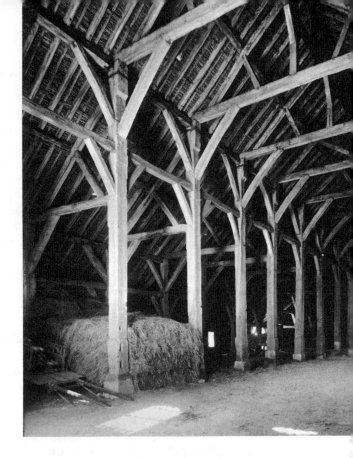

34. Parçay-Meslay (Indre-et-
Loire), France; Abbey Grange,
1211–1227, Interior (Photo:
Philip Spencer)

of Parçay-Meslay as belonging to a group of buildings which were
erected by Abbé Hugue de Rochecorbon (1211–1227).[36] The general
character of the masonry work of the barn, its profiles and its
moldings, is in full accord with this date. This impressive structure
has a clear inner length of 170 feet, 6 inches, a clear width of 80
feet, 2 inches, and a height to the bottom of the ridgepiece of 44
feet, 4 inches. Reliable plans and sections have never been pub-
lished, but are available at the Centre de Recherches of the Monu-
ments Historiques in Paris. Even expert photography does not render
justice to this building; it is only by drawing it up that one can
capture the cathedral-like appearance of this magnificent frame of
timbers which penetrates the space in all directions, dividing it
into parts, and at the same time braiding the parts together into
an all-embracing coherent whole.

There is some question as to whether the present timbers of the
barn of Parçay-Meslay are the original ones. Aymar Verdier, who
discussed this building in his *Architecture Civile et Domestique*,[37]

reports that Mr. Drouet, who acquired the barn after the French Revolution and saved it from demolition, was of the opinion that the original frame of timber had caught fire during the invasion of the Touraine by the English in 1437. I have no means of judging whether this view was based on any valid historical evidence. But even if the present timbers were proved to date from the fifteenth century, this would have little bearing on the basic argument of this study since we are not concerned here with the changing details of carpentry work, but with the constructional system as a whole —and a sufficient number of other thirteenth-century barns survive to indicate that no noteworthy changes took place between the thirteenth and the fifteenth centuries as far as the principle of bay-division is concerned.

A thirteenth-century barn of considerable size and beauty, the property of the Abbey of Longchamp, stood within the very boundaries of the city of Paris until the middle of the nineteenth century, when it was taken down to make room for the fashionable race tracks in the Bois de Boulogne. The timbers of the barn are gone, but they were carefully recorded before being dismantled.[38] And further north, in the abbey grange of Canteloup (Eure), in Normandy,[39] and in the abbey grange of Ter Doest in Belgium[40] there are two thirteenth-century barns of even larger dimensions, the timbers of which are still standing in an excellent state of preservation.

Vast and impressive as they are, there is nothing about these barns that is unique. Good documentary evidence suggests that by the close of the twelfth century the Abbey of Clairvaux alone possessed, on its respective granges, not less than twenty-six such structures, and the Abbey of Foigny probably as many as twenty-eight.[41] If we assume that the agricultural economy of the average Cistercian monastery required in each case a minimum of between ten and twenty barns—and the latter figure may come closer to the truth than the former—we would have to infer that by the end of the twelfth century, when the total of Cistercian foundations had risen to about 500, there were not less than 5,000 to 10,000 Cistercian barns alone.

Of the hundreds of thousands of such barns that once undoubtedly were scattered over the medieval countryside, some thirty or forty survive, and of them the most beautiful, in my opinion, is the great tithe barn of Harmondsworth in Middlesex, whose timbers are still as fresh today as they were in the thirteenth century when they

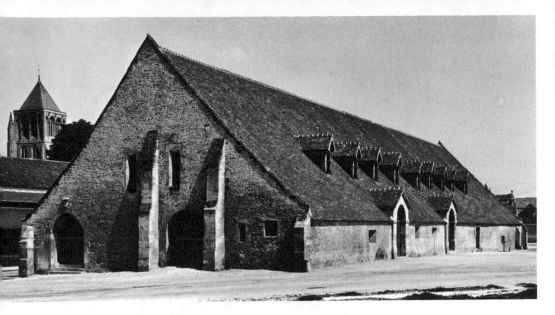

35. St. Pierre-sur-Dives (Calvados), France; Market Hall, 13th(?) Century, Exterior from SW (Photo: Philip Spencer)

were hewn and framed together. Harmondsworth barn is mentioned in a list of alien properties seized by the Crown of England from 1288–1386, in an entry which refers to the year 1293–94 (22 Edward I).[42] This barn has the distinction of having been competently described and recorded as early as 1875 by Albert Hartshorne.[43] It is also succinctly dealt with in the volume on Middlesex of the Royal Commission for Historical Monuments in England,[44] where, however, without any substantiating evidence the barn is ascribed (and wrongly, in my opinion) to the fourteenth century. Harmondsworth barn is 191 feet, 10 inches long, 37 feet, 6 inches wide, and 37 feet, 6 inches high. The feeling of grandeur which this structure evokes as one steps over its threshold into its massive forest of rising timbers, can only be compared to that experienced in entering a medieval cathedral. If I speak of this barn as the finest and most beautiful of all surviving medieval barns of England, I am referring not only to its general proportions—the full nobility of which can only be perceived on the spot—but also to a specific muscular and skeletal type of beauty that occurs only on the highest level of barn construction and finds its expression in an unusually sensitive and convincing down and upward scaling of the timbers, as the eye moves from primary to secondary to tertiary member and back again.

By the time the barns of Parçay-Meslay and of Harmondsworth were built a new variety of the type had sprung into existence, the

207

market hall. The most impressive medieval market hall I know of is the hall of the sleepy little country town of St. Pierre-sur-Dives (Calvados), in Normandy, which is here published for the first time (Fig. 35). It is astonishing that this extraordinary structure should never have found its way into any authoritative treatise on medieval architecture. The hall is 225 feet, 6 inches long, 64 feet, 6 inches wide, and 42 feet, 6 inches high, and may go back to the thirteenth century. Unfortunately the hall was shelled in 1944, and its original frame of timber was at that time almost completely destroyed by fire. Under the competent direction of Mr. Jean Merlet, Architect-in-Chief of the Monuments Historiques, the hall was subsequently restored, and this restoration, carried out by a team of carpenters who reproduced the ancient system to its smallest detail, is one of the masterpieces of French conservationism.

Last summer, Philip Spencer and I studied and photographed altogether seven such halls, all of them unpublished. St. Pierre-sur-Dives was the largest, but its timbers are new, and as far as the scantling, the patina, and the texture of the wood are concerned, it is surpassed by a considerably smaller hall in the city of Arpajon (Seine et Oise), some thirty kilometers south of Paris,[45] which dates from the fifteenth century, and is used—even today—for the same purpose for which it was constructed five centuries ago. A hall of approximately the same dimensions, and so identical in the details of its carpentry work that it must be ascribed to the same master, stands in the nearby city of Milly-la-Forêt. It was erected by Admiral de Graville in 1479, and the patent letter of Louis XI, in which the construction of the hall is authorized, is still preserved in the city archives of Milly.[46] In the same general region of the department of Seine-et-Oise there are three more market halls of similar description—one of outstanding beauty in the city of Méréville. While they too will probably have to be dated into the fifteenth century, we have good reason to assume that the thirteenth-century halls of Paris cannot have looked much different.

I should now like to summarize what I have tried to demonstrate so far in the analytical part of this study before turning to my conclusions.

Discoveries made during the last two decades by German, English, Dutch, and Scandinavian excavators, and a roundup of a pitifully neglected—in parts even uncharted—area of medieval research, suggest that there existed in the Middle Ages an aisled and bay-

Rome: St. Paul's                    Harmondsworth: Tithe Barn

Speyer: Cathedral                    Amiens: Cathedral

36. Space Division in Early Christian and Medieval Architecture (Redrawn by Ernest Born after Construction of William Hill)

divided, all-purpose structure in timber, about the imposing density of distribution of which we have been deplorably misinformed in the past. The existence and general prevalence of this type of structure during the formative phases of Romanesque and Gothic architecture casts new light upon Strzygowski's abortive theory of the origin of the medieval bay-system in wood construction.

The bay system is one of the principal distinguishing features of medieval architecture and is perhaps its most distinguishing single feature. It developed on an architectural organism which by origin was not possessed of this feature, namely, that of the West Roman type of the Early Christian basilica, which, in the wake of a general process of political and cultural Romanization that seized the kingdom of Charlemagne toward the end of the eighth century—as

209

Richard Krautheimer has so convincingly demonstrated[47]—became a leading Frankish building type and the point of departure for the entire development which followed. This West Roman version of the Early Christian basilica was an aggregate of three or more monolithic spaces, internally undivided and of varying dimensions, which shouldered each other axially and transversely, but never intersected one another (cf. Fig. 36, diagram of St. Paul's). The relative measurements of these spaces were not regulated by any set canon of proportions and thus varied greatly. The Romanesque and the Gothic churches, which developed from this prototype form, on the other hand, are bay-divided churches, i.e., churches in which the total space is subdivided into a multitude of equal or homologous parts by means of an all-pervasive skeleton of shafts and arches which act both as divisive and as connective members (cf. Fig. 36, diagrams of Speyer and Amiens Cathedrals).

These concepts are diametrically opposed to one another, and the development which leads from the former to the latter passed through a series of clearly observable steps which have been described frequently and which I shall now recapitulate very briefly.

The first of these consisted of a general rearrangement of the primary geometrical space relationships of the church. The width of the nave and the transept were made equal, their area of intersection, the crossing unit, thus was fixed into a square, and all of the remaining parts of the church were calculated as a multiple of the crossing square. In Carolingian and Ottonian architecture we witness the gradual crystallization of this principle which reaches its apex in the so-called "square schematism" of the Romanesque—but the essential features of this system were already anticipated in the church of the famous Plan of St. Gall of around the year 820. For seven decades the emergence of this peculiar system of unit relationships has been discussed by leading architectural historians, and yet no one has ever been able to explain it. I suggest that the geometricity of the floor plan of Carolingian and Ottonian churches and the modular lay-out of their volume sequence owe their origin to the fact that these churches were constructed by men, to whom—as long as their collective memory could recall—"to build" had been synonymous with building in multiples of a basic spatial unit value.[48] Geometricity and unit sequence had been for them intrinsic elements of timbered frame construction—a feature that becomes strikingly apparent if one glances at the intensely geometrical layout of the

large Iron Age cattle barn of Ezinge, Holland (Fig. 30), or the early medieval houses of the type of Wilhelmshaven-Hessens (Fig. 31).

In Ottonian architecture this steadily increasing trend of calculating the general dimensions of the principal spaces of the church as multiples of a basic unit value gathered added momentum with the introduction of the "alternating support system" which carried into the elevation of the church a rhythm of alternating vertical accents that mirrored in the columnar structure of the wall modular prime relationships which heretofore had been a property of the dimensional organization of the space alone. This was a preliminary to a second decisive step in the development of the medieval bay system which was reached when the geometrical layout of the floor plan found muscular embodiment in a system of rising shafts which were engaged into the masonry walls, and when these shafts were interconnected crosswise and lengthwise by means of arches. As soon as this point was reached the churches could be vaulted, the walls between the rising shafts and arches could be perforated and were progressively transformed into curtain walls—and thus the Early Christian basilica with its aggregate of neighboring monolithic spaces separated by rigid walls had been transformed into that intensely skeletal and bay-divided system of the Romanesque. In church construction as well as in domestic building the totality of the space was now conceived of as a multiple of equal or homologous parts, created by an all-pervasive system of structural members, in function both divisive and connective.

It is very hard for me to believe that the appearance of this concept in stone should not have been connected, developmentally, with the fact that in the territories in which this change took place these principles had been for over a millenium a traditional feature of timbered house construction. In timber this concept is old; in stone it is new. In timber it flows as a logical construction method from the natural properties of the material, and for that reason could be invented on a relatively primitive cultural level. In masonry it ushered in a conflict between style and matter such as could be handled only on a very sophisticated level of civilization, to the extent of leading in its terminal phase—the Gothic—to a complete denial of the natural properties of the stone.

The great architects of the Renaissance, to whom the Gothic was a "monstrous and barbarous" way of building, were fully aware of this dichotomy between material and style in Gothic architecture,

as is expressed in no uncertain terms by Giorgio Vasari, who complained that Gothic buildings "have more the appearance of being made in paper than of stone or marble,"[49] as well as by the author of the famous "Report on the Remains of Ancient Rome" (once believed to be Raphael, but now more commonly ascribed to Bramante or Baldassare Peruzzi), who compared the soaring flight of the Gothic piers and arches with the tensile action of the trunks of living trees, and based upon this simile his puzzling theory of the origins of Gothic architecture in the wooden huts of the primitive forebearers of civilized man.[50] In order to obviate any misconceptions as to my own views in this matter, let me point out that I am not subscribing to Raphael's, Bramante's, or Peruzzi's views. The study with which I am here concerned is devoted to an analysis not of the complex phenomenon of the origins of the Gothic, but to the specific problem of the origins of the medieval bay system, a feature which is an integral part of both the Romanesque and the Gothic, without being identical with either.

If, with these qualifications in mind, then, I readvance Strzygowski's ill-conceived idea of the origins of the medieval bay system in northern wood construction, I wish to make it clear that I do not mean to imply that the architectural system of the Romanesque and Gothic emerged mechanically like a chemical formula from the simple historical superimposition or interpenetration of two formerly separate building traditions: that of the Early Christian stone basilica and that of the medieval timber house. Primarily and above all, of course, the architectural systems of the Romanesque and Gothic are the expression of a spiritual experience, and in the Middle Ages, bay division was as much of a cultural phenomenon as it was a principle of architectural composition.

Sometime between the year 1230 and 1236 a leading French scholastic, William from Auvergne, gave the finishing touches to a book which dealt with the structure of the universe (*Liber de Universo*) and aimed at a total integration of the metaphysical concepts prevailing in his time into a rounded metaphysical vision. The universe here is envisaged as a triad of structurally related hierarchies, each a mirror reflection of the other as well as of the system as a whole with its identical subdivisions into triads of triads of ranks, and in each of these triads each subordinate rank corresponds in substance to its equivalent part in every other triad. The architectural plan that underlies this metaphysical scheme displays the most

# The Origins of the Bay System

astounding analogies with that of the Gothic bay system. As in the latter, so here the whole "is arranged according to a system of homologous parts, and parts of parts"—if I may be permitted to apply to the *substance* of a metaphysical concept a definition which Panofsky in his brilliant essay on Gothic architecture and scholasticism has coined with regard to the *formal layout* of the scholastic treatise.[51]

In its ultimate analysis, then, I would say the problem of the medieval bay system cannot be separated from the rank division of the feudal order, the ecclesiastical order, and the celestial order, and it is in these areas, of course, that we must search for the primary spiritual forces that brought about the transformation of that sluggish organism of the Early Christian basilica into that highly flexible, highly complex, incredibly sophisticated, but equally emotive, organism of the Gothic cathedral. In order to be expressive of the thinking of that period, architecture required a style in which the whole could be conceived as a multiple of homologous parts, and in order to create such a style the rigid Early Christian basilica had to be converted from a monolithic into a cellular and from a crustacian into a skeletal structure. In facing this task, medieval architects had the signal advantage of being able to draw on a tradition in which bay division and skeletal construction had been for over a millenium a guiding principle of construction for the houses in which they dwelled, the halls from which they ruled and governed their land, the barns in which they sheltered their livestock and harvest, the markets in which they traded their produce and even, to some extent, the churches in which they worshiped.

In submitting this theory I should like to end on a precautionary note. I have stressed the native northern aspect of the medieval bay system because this aspect has been generally neglected. But in strongly underscoring what I feel to be in need of primary emphasis I do not mean to diminish the importance of other factors which also may have had a bearing on this matter. While the bay system in the form in which it is here defined is, in my opinion, a typical medieval feature, its primary constituent part—the bay—was known to the Romans, and the morphology of the vaulted canopies of stone which frame the bays of Speyer Cathedral is, of course, a direct derivative of the Roman groin vault, of which the medieval masons had learned to make use, first in the crypts, then in the aisles, and finally in the naves of their churches. It is an incontrovertible

213

historical fact, however, that the vaulted Roman canopy had not found a place of survival in any of the principal spaces of the large Early Christian basilicas of the western type from which the medieval development took its point of departure. Nevertheless there existed, in the sixth century, two churches in northern Syria which had their nave divided into large bays by means of large transverse arches: the basilica of St. Sergios at Rusafa and the Bissos church at Ruweha.[52] I consider it unlikely that either of these two churches exercised appreciable influence upon the development of the medieval bay system. They lie in territory which early in the seventh century had fallen into the hands of the Arabs and which remained outside the sphere of western accessibility even during the time of the Crusades, not to mention the fact that by the time the earliest Crusade took place, in 1096, the medieval bay system had already found its full embodiment in the Cathedral of Speyer.

Yet even if I should be wrong in this assumption—or if it could be demonstrated that similar or related types were known to medieval masons and architects—it must still be pointed out that in Rusafa and in Ruweha bay division remained confined to the nave of the church and was not extended to the church as a whole. The Rusafa-Ruweha bays actually are large compartments rather than bays, and were created by the simple insertion into the nave of the church of two monumental transverse arches carried by elongated piers, but the masonry of the nave walls—diminished as it may be by arcades of extraordinary width—is not reduced to an analogous system of structural members. It is in the full absorption of mass in structure on the one hand, and in the development of an all-pervasive armature of space-dividing and space-connecting shafts and arches on the other hand, that I see the common denominator of the bay division of the Romanesque and Gothic and the bay division of the timbered halls and houses of transalpine Europe.

# The Origins of the Bay System

NOTES

[1] Josef Strzygowski, "Die Europäische Kunst," *Belvedere*, 26 (1924), pp. 35–55; cf. in particular p. 43. The idea is voiced again in Strzygowski's *Nordischer Heilbringer und Bildende Kunst* (Vienna and Leipzig, 1939), p. 233.

[2] On the derivation of the Scandinavian stave churches from central prototypes see Gerda Boëthius, "Stavkyrkans Ursprung och Utveckling," *Festskrift Johnny Roosval* (Stockholm, 1929), pp. 18–33.

[3] For rapid, if only partial, orientation see the references listed under the terms *ligneus* or *bois* in the indices of the following works: Otto Lehmann-Brockhaus, *Schriftquellen zur Kunstgeschichte des 11. und 12. Jahrhunderts für Deutschland, Lothringen und Italien* (Berlin, 1938); Victor Mortet, *Recueil de textes relatifs à l'histoire de l'architecture en France au Moyen Age, XIe-XIIe siècles* (Paris 1911); Victor Mortet and Paul Deschamps, *Recueil de textes relatifs à l'histore de l'architecture en France au Moyen Age, XIIe-XIIIe siècles* (Paris, 1929).

[4] St. Catherine's is briefly dealt with by M. de Caumont in *Statistique Monumentale du Calvados* (Paris-Caen, 1862), IV, pp. 323–338, but has never become the subject of a special monograph, which is badly needed.

[5] Monsieur Jullien's observations have not been published but are incorporated into a set of carefully measured drawings which are on file in the Centre de Recherches of the Monument Historiques in Paris. Prints of these I owe to the kindness of Mlles. Bertholier and Bloch of the Monuments Historiques.

[6] . . . [To] Messrs. Jan and E. Jans of Almelo . . . I am indebted for the following historical information conveyed to me by Pastor H. L. Lieve of Paasloo: Permission to build a church at Paasloo was granted in 1336 by the chapter of St. Clement's in Steenwyk, according to a document in the archives of St. Clement's. Judging from foundations which were discovered some three feet inward of the walls of the present church, this building must have been a little smaller than the present church. Until 1486 the church of Paasloo was the principal church of the district. Thereafter it sank into the status of a chapel, and Oldemarkt became the seat of the principal church.

[7] Raymond Richards, *Old Cheshire Churches* (London, 1947). For Marton, cf. pp. 229–231; for Warburton, pp. 339–341; for Lower Peover, pp. 200–204; for Holmes Chapel, pp. 186–190. Most of the churches listed above are also dealt with in Fred H. Crossley, *Timber Building in England* (London-New York, 1951), pp. 32 ff., where one will also find a reproduction of the handsome late medieval timber church of Coppenhall, Cheshire, which was torn down in 1821. For a description and photographic reproductions of the church of Mattingly, cf. *Victoria History of the Counties of England, Hampshire* (London, 1911), IV, pp. 50 ff.; for Ribbesford, *ibid.*, *Worcestershire*, (London, 1924), IV, pp. 312–314.

[8] The church is mentioned in Daniel Brunn, *Fortidsminder og Nutidshjem paa Island* (Copenhagen, 1898), p. 212.

[9] Gamal Norsk Homiliebok, Cod. AM 619, ed. Gustav Ludvig Indrebø, *Norske historiske kjeldeskriftfond, Skifter*, Vol. 54 (Oslo, 1931).

[10] Dr. P. Glazema, "Outheidkundige opgravingen in door de oorlog verwoeste Limburgse Kerken," *Publications de la Société Historique et Archéologique dans le Limbourg*, 84 (1948), pp. 226–232, 252–258.

[11] Kurt Böhner, Peter Joseph Tholen, and Rafael von Uslar, "Ausgrabungen in den Kirchen von Breberen und Doveren," *Bonner Jahrbücher*, Heft 150 (1950), pp. 192–228.

[12] Reproduced after *Werdendes Abendland an Rhein und Ruhr* (Ausstellung in Villa Hügel, Essen, 18 May–15 September, 1956), p. 95, Fig. 9.

[13] Albert Verbeek, "Eine merovingische Kathedrale?", *Kunstchronik*, 9 (1956), 280–281, with plan on p. 280.

[14] Cf. Otto Lehmann-Brockhaus, *Die Kunst des 10. Jahrhunderts im Lichte der Schriftquellen* (Akademische Abhandlungen zur Kulturgeschichte, 3rd series [Strassburg, 1935]), VI, pp. 13 ff. To the incident mentioned above I add here at random two further typical examples. After the destruction of the Cathedral of Hamburg by the Slavs, Bishop Unwanus (who acceded to the episcopal see in 1013) rebuilt the episcopal "church and all of its appendices in timber" (*ecclesiam et diversoria . . . omnia lignea*). (Cf. Otto Lehmann-Brockhaus, *Schriftquellen zur Kunstgeschichte des 11. und 12. Jahrhunderts für Deutschland, Lothringen und Italien* [Berlin, 1938], pp. 108–109.) Even as late as 1184 the Emperor Frederic Barbarossa erected in the triangular plain formed by the confluence of the rivers Rhine and Main "a church of considerable size and a stately palace in timber" (*ecclesiam maximam et palatium de lignis honestissime fieri iusserat*), "together with numerous other structures of varying description for the purpose of celebrating in the most magnificent manner the great feast of Joy" (i.e., the coronation of his son Henry as King of Germany). And the reason for this was "the narrowness of the streets in the city of Mainz and the bad air prevailing there." Cf. *Arnoldi Chronica Slavorum*, ed. Heinrich Pertz (Hannover, 1868), p. 88.

[15] Albert Egges van Giffen, "Der Warf in Ezinge, Prov. Groningen, Holland und seine Westgermanischen Häuser," *Germania*, 20 (1936), pp. 40–47.

[16] This holds true for a three-aisled Iron Age house which was excavated in 1940 on the Aalburg, near Belfort, Luxembourg, and which even antedates the earliest Ezinge houses (cf. Gustav Riek, "Ein Fletthaus aus der Wende ältere-jüngere Hunsrück-Eiffelkultur bei Belfort, Luxemburg," *Germania*, 26 [1942], pp. 26–34). The reconstruction problems of this, as well as many other Iron Age houses are discussed authoritatively by Adelhart Zippelius, in "Das vormittelalterliche dreischiffige Hallenhaus in Mitteleuropa," *Bonner Jahrbücher*, 153 (1953), pp. 13–45.

[17] I am confining myself here to the most summary bibliography. The material excavated in Holland and in Germany is not summarized at any place, so far as I know, and is scattered through a vast array of prehistoric and regional periodicals, many of which are not easily available in this country. Good surveys of the Swedish material are to be found in such works as: John .Nihlen and Gerda Boëthius, *Gotländska gårder och byar undre äldre järnaldern.* (Stockholm, 1933); Mårten Stenberger, *Öland under aldre järnaldern* (Stockholm, 1933), and Mårten Stenberger, *Vallhagar, A Migration Period Settlement on Gotland, Sweden* (2 vols.; Copenhagen, 1955). The Norwegian material excavated prior to 1942 is summarized in Sigurd Grieg, "The House in Norwegian Archaeology," *Acta Archaeologica*, 13 (1942), pp. 169–178; for the Danish material excavated prior to 1937 see

# The Origins of the Bay System

Gudmund Hatt, "Dwelling Houses in Jutland in the Iron Age," *Antiquity*, 2 (1937), pp. 162–173. For later material cf. Paul Nørlund, *Trelleborg* (Copenhagen, 1948). For Iceland, cf. Mårten Stenberger, *Forntida Gårdar I Island* (Copenhagen, 1943). A royal Anglo-Saxon palace of the seventh century, comprising a total of twenty-five houses, was excavated in the summer of 1956 in Northumbria, England, by Mr. Brian Hope-Taylor. The results of this excavation are in process of being published by the Ministry of Works. The earliest bay-divided timber house known so far was unearthed in the summer of 1954 in a place called Jemgum, near Emden, Germany. It dates from the period of transition from the Bronze Age to the Iron Age (seventh-sixth centuries, B.C.) and is dealt with in Werner Haarnagel, "Die spätbronze-, früheisenzeitliche Gehöftsiedlung Jemgum bei Leer auf dem linken Ufer der Ems," *Die Kunde*, Neue Folge, 8 (1957), pp. 1–43.

[18] Cf. Werner Haarnagel, "Das nordwesteuropäische dreischiffige Hallenhaus und seine Entwicklung im Küstengebiet der Nordsee," *Neues Archiv für Niedersachsen*, 4 (1950), pp. 88–89, and, same author, "Die Flachabdeckung der Wurt Hessens am Jadebusen bei Wilhelmshaven und ihr vorläufiges Ergebnis," *Germania*, 29 (1951), pp. 223–225.

[19] Cf. Werner Haarnagel, "Die frühgeschichtliche Handelssiedlung Emden und ihre Entwicklung bis ins Mittelalter," *Friesisches Jahrbuch* (1955), pp. 9–78.

[20] Albert Egges van Giffen, "Een Systematic Onderzoek In Em Der Tuinster Wierden Te Leens," *Jaarsverslag Van Den Vereeniging Voor Terpenonderzoek*, 20–24 (1935–1940), pp. 26–117.

[21] A full-scale, eight-color, offset facsimile reproduction of the Plan of St. Gall was published in 1952 under the auspices of the Historische Verein des Kantons St. Gallen, and can be obtained through the Fehr'sche Buchhandlung in St. Gall, Switzerland. The facsimile was accompanied by a study of Hans Reinhardt, *Der St. Galler Klosterplan* (92. Neujahrsblatt herausgegeben vom Historischen Verein des Kantons St. Gallen [St. Gall, 1952]).

[22] Levi Fox, "Leicester Castle," *Leicester Archaeological Society Transactions*, 21, part 2 (1942–1943), pp. 127–170.

[23] In a footnote of C. A. R. Radford's report on "Oakham Castle," published in *Archaeological Journal*, 112 (1956), pp. 181–184; cf. note 1, p. 183.

[24] Fosbrooke's reconstruction is mentioned by Margaret Wood, "Norman Domestic Architecture," *Archaeological Journal*, 92 (1935), 191. For a copy of this woodcut, which is here published for the first time as far as I know, I am greatly indebted to Mr. Albert Herbert in Leicester.

[25] New light has recently been thrown upon the problem of the aisled medieval timber hall by J. T. Smith in an article entitled "Medieval Aisled Halls and Their Derivatives," *Archaeological Journal*, 112 (1956), 76–93. Mr. Smith has also recently made the interesting discovery that the hall of Stokesay Castle was in its original form a three-aisled structure (cf. J. T. Smith, "Stokesay Castle," *Archaeological Journal*, 113 [1957], pp. 211–214).

[26] The editors of the Royal Commission on Historical Monuments, *Herefordshire* (London, 1931), Vol. 1, where the hall is dealt with on pp. 116–117, date it into "the late 12th century." Margaret Wood in her "Norman Domestic Architecture," *op. cit.*, p. 188, dates the hall "c. 1160." The Rev. Francis T. Havergal in *Fasti Herefordenses and other Antiquarian Memorials of Hereford* (Edinburgh, 1869),

p. 136, attributes the hall to Bishop William de Vere (between 1174 and 1199). No record as to the name of the builder of the hall or its date of construction exists, but the Norman character of the work is beyond question.

[27] The hall has never been the subject of a special monograph, which is badly needed.

[28] John Clayton discussed the hall in 1847 in a paper read before the Royal Institute of British Architects. Extracts of this discussion are to be found in *Fasti Herefordenses, op. cit.,* pp. 136–138.

[29] Clayton's reconstruction is mentioned in Wood, "Norman Domestic Architecture," *op. cit.,* p. 188. It was not included in John Clayton's work, *Ancient Timber Edifices of England* (London, 1948). A copy of a woodcut fashioned after Clayton's original drawing is in the Refectory Hall of the Bishop's Palace at Hereford, and the City Library of Hereford has a second one. To the Lord Bishop of Hereford as well as to Miss Penelope Morgan and Mr. F. C. Morgan of the Cathedral Library I wish to express my deepest appreciation for their gracious assistance in my studies at Hereford Palace.

[30] Westminster Hall is dealt with in W. R. Lethaby, "The Palace of Westminster in the Eleventh and Twelfth Centuries," *Archaeologia,* 60 (1906), pp. 131–141, and by the Royal Commission on Historical Monuments, *London (West)* (London, 1925), pp. 121–123. For the roof specifically cf. Herbert Cescinski and Ernest R. Gribble, "Westminster Hall and Its Roof," *Burlington Magazine,* 40 (1922), pp. 76–84.

[31] The belief that Westminster Hall in its original state must have been divided into a nave and aisles by two rows of intermediary supports was first expressed by Sidney Smirke in 1836 ("Remarks on the Architectural History of Westminster Hall," *Archaeologia,* 26 [1836], p. 416). Smirke's opinion is shared by every authoritative student of the subject, including the late Director of Works, Sir Frank Baines, Cf. Lethaby, *op. cit.,* p. 136; Cescinski and Gribble, *op. cit.,* p. 76; Royal Commission on Historical Monuments, *op. cit.,* p. 121, and Geoffrey Webb, *Architecture in Britain, The Middle Ages* (Baltimore and Harmondsworth, 1956), pp. 66 and 67, Fig. 38.

[32] Some good photographs and a cross section of this extraordinary structure have been published by Ralph Tubbs, *The Englishman Builds* (Harmondsworth, 1945), pp. 20–21, but otherwise this barn has not been studied.

[33] Published by William Hale, *The Domesday of St. Paul's of the Year MCCXII . . . and other Original Documents Relating to the Manors and Churches Belonging to the Dean and Chapter of St. Paul's in London, in the Twelfth and Thirteenth Centuries,* printed for the Camden Society (London, 1858). The first to draw attention to this precious document was Sidney Oldall Addy, *The Evolution of the English House* (London, 1898), pp. 67, 129 ff.

[34] For the dates see Hale's introductory notes, *op. cit.,* pp. xc-c.

[35] One complete set of these engravings is now in the Cabinet des Estampes of the Bibliothèque Nationale at Paris (Topographie de la France, Aube, Arondissement Bar-sur-Aube, fol. 27, 28, and 29); a second one is available in the Archives de l'Aube at the city of Troyes (Bibliothèque de Troyes, Carteron 1, Planches 2, 3, and 4). The best reproductions are to be found in Alphonse Roserot, *Dictionnaire*

# The Origins of the Bay System

*Historique de la Champagne Méridionale (Aube) des Origines à 1790* (Langres, 1942), I, pp. 392 ff.

[36] Dom Edmond Martène, "Histoire de l'Abbaye de Marmoutier" (publié et annoté par M. l'abbé C. Chevalier), *Mémoires de la Société Archéologique de Touraine*, 25 (1875), p. 200.

[37] Aymar Verdier and F. Cattois, *Architecture Civile et Domestique au Moyen Age et à la Renaissance* (Paris, 1864), pp. 27–35.

[38] Cf. Viollet-le-Duc, *Dictionnaire Raisonné de l'Architecture Française du XIe au XVIe siècle* (Paris, 1863), VI, 43, with plan, section, and elevation.

[39] The barn of the abbey grange of Canteloup is summarily described by Phillippe Lemaitre, "Notes sur Quelques Granges Dimiéres du Departement de L'Eure," *Bulletin Monumental*, 15 (1849), pp. 196–197, but plans and sections are not available.

[40] For plan, section, and elevation of this structure (not altogether reliable, however), see Thomas H. King, *The Study-Book of Mediaeval Architecture and Art* (Edinburgh, 1893), II, Fig. 137; there listed under "Lissewegh."

[41] These figures are based on the rough assumption that every grange dependent on the mother settlement required for its agricultural economy a minimum of two barns, like the abbey grange of Clairvaux, and the outlying grange of Ultra Albam. Clairvaux had a total of 12 granges, and six of those had already been established during the lifetime of St. Bernard (d. 1153); Foigny had a total of 14 (cf. Marcel Aubert, *L'Architecture Cistercienne en France* (Paris, 1947), II, pp. 60–161.

[42] This document is to be found on Exchequer, Queen's Remembrancer, *Extents, etc., of Alien Priories*, Bundle 2, No. 1, mem. 1 (Reference E. 106/2/1: date 22 Edw. I) and was quoted, but not without errors, in Hartshorne's article mentioned in note 43.

[43] Albert Hartshorne, "The Great Barn at Harmondsworth," *London and Middlesex Archaeological Society, Transactions*, 4 (1875), pp. 417 ff.

[44] Royal Commission on Historical Monuments in England, *Middlesex*, (London, 1937), pp. 61–62. To Miss Vera Dallas, Secretary of the Royal Commission on Historical Monuments, I should like to express on this occasion my deepest appreciation for the generous assistance and support which she has extended to me over a period of many years in my research on aisled medieval barns and halls in England.

[45] Photographs, plans, and sections of the market hall of Arpajon have never been published, to my knowledge, but are on file in the Centre de Recherches of the Monuments Historiques in Paris.

[46] The hall of Milly is briefly dealt with in a booklet by Georges Lasserre entitled *Les Rues de Milly* (Etampes, 1925), pp. 6 ff. For access to this booklet, a copy of which I could not otherwise have obtained, I am greatly obliged to the Comte de St. Périer of Morignon. The patent letter of Louis XI which authorizes the establishment of the market and the construction of the hall of Milly has also never been published, but an exact transcript of this important document has been transmitted to me by Mr. Raymond Geber, member of the Commission des Antiquités et des Arts de Seine-et-Oise, to whom I am deeply indebted for his

kindness. I should also like to express my gratitude at this point to my friend Peter Harnden of Orgival, who was the first to draw my attention to this extraordinary group of medieval market halls.

[47] Richard Krautheimer, "The Carolingian Revival of Early Christian Architecture," *Art Bulletin*, 24 (1942), pp. 1–38.

[48] I do not contend that this explains the entire problem of geometricity in medieval architecture, since intensely geometrical concepts appear in many other areas of medieval art, especially in the field of book illumination where they cannot be explained as an offspring of an architectural way of thinking. The problem of medieval geometricity hence has still another dimension and can only be solved in its full complexity when it is possible to define the general mental (or metaphysical?) concepts which underlie these other forms of geometricity. But it cannot be denied that in timbered frame construction geometricity and unit sequence have an immediate constructional rationale which will have to be taken into consideration in any future discussion of this problem.

[49] "Et hanno più il modo da parer fatte di carta che di marmi." See Erwin Panofsky, "Das erste Blatt aus dem 'Libro' Giorgio Vasaris; eine Studie über die Beurteilung der Gotik in der italienischen Renaissance, etc.," *Städel-Jahrbuch*, VI (1930), pp. 25–72 . . . (cf. p. 43), translated into English in Panofsky's *Meaning in the Visual Arts* (New York, 1955), pp. 169–235 (cf. p. 189).

[50] Cf. Panofsky, *op. cit.*, *Städel-Jahrbuch*, pp. 39–40. *Meaning in the Visual Arts*, p. 182.

[51] Erwin Panofsky, *Gothic Architecture and Scholasticism* (Latrobe, 1951), p. 45.

[52] For Rusafa and Ruweha see Howard Crosby Butler, *Early Churches in Syria* (Princeton, 1929), pp. 145 ff., 161 ff. [A] reconstruction of St. Sergios basilica at Rusafa [is] reproduced in Friedrich Sarre and Ernst Herzfeld, *Archäologische Reise im Euphrat—und Tigris—Gebiet* (Berlin, 1920), II, 4, Fig. 133.

# 12. THE ELEVENTH CENTURY AND THE ROMANESQUE CHURCH

*Henri Focillon*

## INTRODUCTION

Henri Focillon's life with art began in childhood: his father, Victor Focillon, was an engraver and a friend of such artists as Monet and Rodin. In the method of Henri Focillon there is always the recurring motif of the relation between style and technique which could find no better evocation than his reference to the tools in his father's studio as being "warm with humanity and bright with use." The best introduction to his method is probably his *Vie des Formes*, published in 1934, and available in English translation as *The Life of Forms in Art*, issued shortly before his death in 1943. In this work he defines his concept of the evolution of styles, expressed in a format analogous to organic growth and implying some reproductive potentiality within the forms themselves. The application of this method—and the realization of its flexibility—is apparent in *The Art of the West in the Middle Ages*, in which the development of the forms of art takes place in a medium compounded of the inheritance of past traditions, the influences of the contemporary moment, and the experimental thrust into the future. For another schema treating the evolution of style, one should read George Kubler, *The Shape of Time* (1962).

Other readings are Arthur Kingsley Porter, *Medieval Architecture*, 2 Vols. (1912), now available in a reprint (1966); by the same author, *Romanesque Sculpture of the Pilgrimage Roads*, 10 Vols. (1923), also available in a 1966

reprint; K. J. Conant, *Carolingian and Romanesque Architecture 800–1200*, 3rd rev. ed. (1973); George H. Crichton, *Romanesque Sculpture in Italy* (1954); Corrado Ricci, *Romanesque Architecture in Italy* (1925); E. W. Anthony; *Romanesque Frescoes* (1951); A. Grabar and Carl Nordenfalk, *Romanesque Painting* (1958), with numerous colorplates; and Denis Grivot and George Zarnecki, *Gislebertus, Sculptor of Autun* (1961).

Additional works are Joan Evans, *Cluniac Art of the Romanesque Period* (1950); Whitney Stoddard, *Monastery and Cathedral in France* (1966); Peter Lasko, *Ars Sacra, 800–1200* (1972). Howard Saalman, *Medieval Architecture* (1962), is a brief survey, and George Zarnecki, *Romanesque Art* (1971), is a handy, well-illustrated picture book with short text. Otto Demus and Max Hirmer, *Romanesque Mural Painting* (1970), is a beautifully illustrated volume.

THE GREAT EXPERIMENTS: THE ELEVENTH CENTURY

The Middle Ages were from the first involved in a clash of traditions. In one aspect, the history of the period may be envisaged as a long-drawn effort by the West to resolve the conflict of forces resulting from the barbarian invasions. Two kinds of humanity were at grips, of which one had advanced through a long and glorious era of civilization, while the other had remained attached to the most primitive systems of social and cultural life. One built cities of stone, the other temporary shelters. One regarded architecture as an element of prime importance in man's activity, and, in artistic representation, respected the appearances of life, while for the other art was ornament and consisted in abstract composition. Nor was this the only conflict. The axis of the Mediterranean world had long been shifting, and this movement was now accelerated and stabilized by a combination of new factors—the peace of the Church (the official recognition of an Oriental religion), the importance of Constantinian Jerusalem, the foundation of the Eastern Empire, the decline of Rome as against metropolitan Byzantium and the still prosperous Hellenistic cities, the prestige of the great Sassanian empire, and the submergence of the West beneath the barbarian hordes. Asiatics were the missionaries of Christianity, especially to the Gauls. Egypt gave birth to monasticism, which built its first monasteries and churches there and was then diffused abroad. In Syria, Anatolia and Transcaucasia, where Christianity was recognized from the third century, an intense religious life, strongly colored by local genius, led to the erection of great numbers of buildings, very various in plan and structure, in which the ancient forms of Mesopotamia and Iran were adapted to Hellenistic techniques. The barbarians, too, played their part in the Orientalization of Europe, for their art was not only a repository of those less evolved Oriental motifs such as had long been incorporated in the La Tène style, but it was also in contact with, and transmitted,

223

elements of remoter origin, from beyond the steppes. The advance of Islam to the Pyrenees, the exodus of Syrian monks during the iconoclastic disputes, the travels of merchants and pilgrims, introduced a succession of new factors. Thus the Middle Ages were from the first confronted with the problem, Orient or Rome?—and with this was indissolubly linked the further problem, Mediterranean or barbarian culture? The history of medieval art recounts the manner in which the West, after a period of dependence on Mediterranean, Oriental and barbarian forms, established a judicious equilibrium, created its own forms, its architecture, its humanism, and defined its own specific culture.

The period following the invasions, during which the new political groupings were consolidated, shows not so much a sudden radical breach with the antique tradition, as a kind of shifting of values.[1] The towns continued to shelter within their walls, under the tutelage of the Bishops, institutions inherited from the Empire, and in some districts these survived for long periods. But the tone of civilization ceased to be urban; it absorbed rustic habits and primitive social formulae. Henceforward objects meant more than buildings, and symbols were more interesting than human figures. The newcomers, even those who had been clients of Rome and associates of her fortunes, retained their seminomadic ways, their mistrust of towns, and their taste for ornament and luxuriant, symmetrical, linear composition. On the rural estates, their life differed little from that of their forebears; they imposed new laws of property, a novel juridical system, and their own conception of the relationship of man with man. In the towns themselves, the decay of the crafts, and the shrinking of wealth and of trade, all contributed to a kind of narrowing of the patterns of life and of the scope of mental activity. By the time a conditional security had been restored, the tone of historical life was changed for centuries to come. The Roman buildings still stood; but often they had served as quarries when stone was needed for the ramparts, and it was long before they ceased to be despoiled for their columns for the adornment of Christian basilicas.[2] A few workshops of funerary sculptors remained faithful to the traditions of the Italian marble-workers, for all the arts this is the slowest to renew itself and lives longest on its conventions and formulae. Princes were not antagonistic to the conservation of antique culture, some indeed prided themselves upon it, but they were concerned only with its external trappings, and their

best-meant efforts to direct the life of the spirit remained unfruitful, the caprices of amateurs.

It is by no means certain that the invasions merely accelerated an already inevitable decline. It is true that antique art, in most of its official manifestations under the late empire, seems watered-down by the academism of copyists, but it still retained its capacity for self-renewal under the influence of regional traditions. This is apparent in Gaul, in the vitality of the popular genius as shown in the best of the small-scale sculpture—rightly considered to be a contributory factor in the genesis of medieval art.[3] Moreover, the architecture, sculpture and metalwork of imperial times was not unsympathetic to those influences, which, from the sixth century, came to dominate the West; indeed Rome had had a taste for them, and ever since the time of her first expansion into the Hellenistic cultural area had remained in close touch with the Orient; perhaps, even before she went to school with Greece, some older, remoter impressions had come to her by way of Etruria. In later times Asiatic traders had brought to her coasts and provinces a special kind of Christianity, a mixed bag of merchandise, masterpieces of cunning metalwork, and a number of decorative motifs which are found alike on the lintels of Syrian basilicas and the tombs of Merovingian hypogea. But Roman art powerfully consolidated all these exotic contributions into its own substance, its own development, even as it were into the very mortar of its masonry, and from these disparate factors constituted the luxuriant and massive unity of its mighty buildings.

When one considers the art of the Goths in Italy, that of the Visigoths in Spain, or that of the Franks in Gaul, they seem all to be put together from the same elements and display more or less identical characteristics. Fragmentary survivals or hard desiccated copies of antique art rub shoulders with Eastern motifs and with the ornamental vocabulary of the nomads, which was now some-times transcribed into stone for purposes of monumental decoration. Upon these uneasy juxtapositions, a mosaic rather than a style, Byzantine stereotypes became encrusted. Architecture, known to us largely from texts, is hard to visualize. If the chroniclers may be believed, it was audacious and brilliant; but the crypts of Jouarre and Grenoble display mean technique and an unambitious program. Clearly the keynote of the period is not to be found here. The decadence of the arts of stone is however counterbalanced by a

wonderful development of the arts of ornament. The abolition or schematic reduction of the human figure coincides with a new skill and fertility in abstract design. This is the vital factor. It is this which characterizes the true interregnum between the two kinds of humanism. An encyphered conception of the universe, rejecting the human figure as inessential or even repugnant, replaces a plastic vision which had been entirely dominated by man and which had based itself on the realism and actuality of its images. When we come to examine the origins of Romanesque sculpture, we shall see the parts played by the East, by the North, and by prehistoric cultures in the creation of this geometrical absolutism, its significance for Islam, and the manner in which the West reintegrated it into the monumental scheme by allying it with living forms. It must be realized that it was from the first an essentially innovating element.

Carolingian art was less concerned to change the elements of this complex than to modify their proportions. The restoration of the Western Empire, the work of learned clerks, who, to recompense the signal services rendered to Christianity by a great family, seized the opportunity of reviving a title and a formula associated in their minds with so much recollected splendor, naturally inclined the minds of men to consult the examples of ancient Rome and to emulate Byzantium. On the basis of traditions already several centuries old and within the framework of a composite Oriental-barbarous style, the art of the period is characterized by two dominant factors—a return to monumentality and a renaissance of the human figure. The former affected not only architecture, but also the development of the great cycles of history-painting in the palaces of the Rhine and the Moselle, and even, as was demonstrated recently, the mode of setting cabochon gemstones, which in other respects departed little from the traditional system.[4] As for the human figure, it did not—for reasons which will appear—assert itself in stone-sculpture. We have only insecure evidence of the way it was handled by the bronze-founders of the Aix workshops, but it abounds in the manuscripts, where, in certain presentation-miniatures, it is treated with the amplitude of monumental painting. Meantime, an ancient Celtic culture was maintaining and developing figure-art in quite another direction. From the seventh to the tenth century, the Irish manuscripts bring before us in their strange cypher a mysterious dream and a disconcerting logic which envelop

man, beast and plant in the convolutions of their interlace—a kind of chaos preceding genesis.[5] Palmette-man, interlace-man and spiral-man confront the togaed evangelist and the count in ceremonial chlamys. They are opposing worlds, but they tend to interpenetrate. For a time Carolingian art resuscitated humanistic programs, setting the human figure once again in the field of the painted page, and transporting an equestrian emperor from the Eternal City to stand before the palatine chapel. But it did not prepare or secure the future of medieval art by such means; rather would it have condemned it to the monotonous repetition of exhausted themes. A greater promise lay in contact with that spirit of ornamental fantasy wherein the human figure seems bound and paralyzed but where in fact it is extending the range of its experiences and, as it were, testing its capacity for the astonishing diversity of life.

. . . Carolingian architecture can show us buildings which are vaulted throughout—Aix and Germigny—as well as the vaulted ground storeys of the monumental porches. These latter are massive blocks, their upper storeys often of complex elevation, which comprise both western entrance and a chapel dedicated to the cult of the Savior or some saint. Highly individual creations, they foreshadow the vast Romanesque porches and, in their tower development, the future of the harmonic façade.

It might appear that the components of Romanesque art were already present in this period, and that the beginnings of that art must therefore be put back beyond the eleventh century to the advent of the Carolingian architects. Yet, however important the groundwork which they laid, however interesting their experiments and however promising their results, they left untouched the problem of vaulting in stone the great basilican naves, together with the associated problems of abutment and direct lighting. These questions, on the other hand, were the major preoccupation of Romanesque research from the eleventh century onwards. There is moreover a fundamental distinction to be made between Romanesque and Carolingian art, for the latter did not incorporate its monumental decoration in the substance of the stone, but continued to apply a veneer of ornament—mosaic or painting—or employed substitute materials, especially plaster. The various techniques still led separate existences and were not yet dominated and molded by a unified architectural thought. It cannot be said that the sculptors of the period lacked the capacity for figure work—the skill

displayed in great numbers of lovely ivories proves the contrary—but the taste for monumental stone sculpture was still dormant in the West, though certain Asiatic Christian communities were already creating, especially in the Transcaucasian churches, important figures and grand compositions.[6] A pictorially biassed Middle Age, which hid the stone beneath a glittering surface decoration, hung plaster reliefs like precious ex-votos on the line of the imposts, or ran their soft and delicate lacework along the string-courses and into the window-embrasures, was the immediate predecessor of a Middle Age which expressed itself completely in stone, and whose sculpture and painting also were architecturally conceived.

It must, however, be acknowledged that the Carolingian ivory carvers, whose works are so various in composition, sentiment and handling, occasionally foreshadowed and perhaps pointed the way to certain decisive experiences of Romanesque monumental sculpture. They do at any rate display two principles which, when applied to monumental sculpture, endowed it with precision and originality—the principle of close adaptation of the design to its frame, and that of ornamental figure composition. On a comb from Cologne, pierced with rosettes and decorated on the reverse with foliage scrolls, figures are arranged and twisted so as to respect and even emphasize the very irregular outline and peculiar form of the field in which they are inscribed. Again, the ivory at St. Gall attributed to the famous artist-monk Tuotilo[7] has, in the upper part of a Crucifixion composition, figures of angels arranged precisely in the manner of ornamental foliage stems, a decorative conformation which recurs in its original guise in the band of foliage which runs along the top edge of the plaque. What we see here is no coincidence, but a conscious stylistic procedure. . . .

## THE ROMANESQUE CHURCH

### I

Even the most homogeneous style is defined only by the sequence of its development. As early as the eleventh century, Romanesque architecture had taken on a characteristic form marked by the systematic use of wall-arcades and flat pilasters, but it was simultaneously elaborating, in the course of a long series of experiments, the classic Romanesque forms whose apogee fell in the first third of the twelfth century. Historically significant monuments, ambitious programs, a single conception individually expressed by various regional groups and a beautiful and abundant sculpture dominated by the laws of the architecture—these were the main features of this superb moment of equilibrium, when images of God and of man, wrought from the building stone of the churches, mingled with the strangest fantasies of the human mind. The dreams of the most ancient East were reanimated, and embodied once more in figure-compositions; but the primacy of architecture imposed on them a logic, a profound harmony, which were the authentic expression of the West. This equilibrium, once achieved, was not overthrown by a sudden onset or insidious infiltration of new forms. Its stable principles and balanced clarity had emerged out of the flexible and many-sided researches of the experimental period, and they eventually lapsed again into a period of decline, marked by disorganization, ossification, and forgetfulness of the inherent laws of the style. We shall see that Romanesque art had its Baroque phase—using the word not in the limited sense of the historical period which followed the Renaissance, but as a designation for a state of mind whose recurrent manifestations appear in the lifetime of every style. It may be characterized on the one hand by academic dryness and the mechanical repetition of prototypes or, on the other, by forgetfulness of proper functions, profusion of ornament, and extravagant experiments, which call in question the value of acquired experience and the authority of the fundamental stylistic laws. But these destructive variations, these signs of weariness, incomprehension and forgetfulness, are in some sense a confirmation *a posteriori* (one might say, by *reductio ad absurdum*) of the value of the principles which they distort and deny. They are part of and they demonstrate the vitality of

a style. If we were to content ourselves with a mere enumeration of the characteristics of Romanesque architecture and sculpture as if they were invariable data, neglecting the fact that they were in constant development from the late tenth to the early thirteenth century and beyond, we should be unable to appreciate all their aspects, which would often seem contradictory, and we should fail to perceive how those contradictions were harmonized by the hidden links which were forged between them by the evolution of the thought and life of the time.

In the monuments of the last third of the eleventh century and the first third of the twelfth, the Romanesque style is seen at the height of its powers. It was no mere passive expression of its place and time. Romanesque man comprehended himself through Romanesque art. The spirit of a great system of architectural thought was the keynote to which poetry, science, philosophy and language were attuned. Then, as never before, the spirit of form determined the form of the spirit. This stylistic maturity coincided with a historical maturity, which furthered it by the consistency of its aims, the boldness of its policies, the abundance of its resources and the moral force of its institutions, particularly those of urbanism and monasticism. Both the latter are forceful illustrations of the twofold character of the Middle Ages, at once sedentary and nomadic, local and European. Each town acted as a focus and magnet of its surrounding countryside, distilled its qualities, and concentrated in itself the peculiar local traditions and experiences. But at the same time the towns were all linked together by trade, and by the identity of their statutes, brought about by copying each other's charters—a fact of which we shall find remarkable confirmation in the Gothic period and which was not without influence, for example, on Burgundian art. Monasticism favored the interpenetration of localities to an even greater extent. By filiation, it propagated itself over enormous distances, and the monasteries were not only the refuge of exemplary Christians, detached from the life of their time, nor mere centers of meditation and culture, nor yet—in accordance with the spirit of their first foundation, renewed by the Cistercians—agricultural stations set up near a source of water for the purpose of tilling the virgin soil of desert places. For besides being planned, as they had already been in the Carolingian era, on the scale of towns, complete with schools, industrial and artistic workshops, scribes, blacksmiths and masons, they also intervened powerfully in the

temporal destinies of the world, they cast a fine-meshed net over all Christendom, they were an organizing force and a focus of action. We should have a very inadequate understanding of the history of the early Middle Ages if we failed to take account of the expansion of Irish monachism. Similarly, in the Romanesque period, the political and moral stature of Cluny was outstanding.[8] It was a monarchy of monks, a monarchy of the spirit, ruled over by the abbot of Cluny, the abbot of abbots, whose moral authority was effective even beyond the organization of which he was head. The greatest of these abbots were both saints and leaders of men. Their community gave the Church several popes, numerous theologians, and a number of those great figures who, like St. Odo and St. Hugh, epitomize, and at the same time transfigure by their virtues, the age in which they live. Cluny, said Émile Mâle, was the greatest phenomenon of the Middle Ages. The modern development of orders vowed to contemplation or charity, and lying rather aside from the main currents of spiritual action (even when one takes into account the revival of institutions more exacting in their demands on the life of the spirit), provide no basis for our understanding of this immense priestly organization and its relations with the kings, emperors and popes, whom it often welcomed and entertained within the walls of its principal house. These great abbots were artists, not after the manner of princes enamored of pomp and architectural splendor, but in a more profound and fundamental way. They loved music so greatly that when they came to decorate their church they caused the capitals of the sanctuary to be carved with figures symbolizing the various modes of plainsong. They loved nobility and dignity of form even as embodied in corruptible flesh, and one of them extolled a predecessor for the perfection of his beauty. These men stand in the foreground of the history of Romanesque art, not indeed as initiators of its morphology and style, for the roots of those lay deeper, but in the capacity of organizers. They it was who chose the sites of its activity, or at least it was they who animated the roads along which stand its most important monuments.

Cluny organized the pilgrimages, and thereby became the moving spirit of that nomadic middle age which rolled in wave after unceasing wave down the roads which led towards Santiago de Compostela and the oratory of San Michele on Monte Gargano.[9] This does not mean—far from it—that Romanesque art is exclusively Cluniac and that its leading features are to be traced back to Cluny itself, nor

even that it was strictly dependent on the geography of these far-flung routes. The significance of the pilgrimage roads lay in the fact that they traversed various regions, beckoning always towards foreign horizons and intermingling the sedentary and the travelling populace; while acting as channels for the propagation of artistic types, they also attracted to themselves the forces and traditions of the localities through which they passed and these tended both to swell and to modify the character of the waves of influence. At the stages of the journey they fostered the dissemination of the *chansons de geste*,[10] and in doing so they mingled one aspect of the Middle Ages with another. They magnified local saints into saints venerated throughout the Western world, and by permitting the transmission of images over great distances, they enriched the universal language of iconography. The old Roman roads had been instruments of Roman penetration. The pilgrimage roads had a twofold action. They may have contributed to the unity of Romanesque art, but they also ensured its variety.

II

In embarking on the study of the architecture which took its place in this system it is more than ever necessary that we should bear in mind the basic factors of the art of building.[11] A building is composed of plan, structure, composition of masses, and distribution of effects. The architect is simultaneously and to a greater or less degree geometer, engineer, sculptor and painter—geometer in the interpretation of spatial area through the plan, engineer in the solution of the problem of stability, sculptor in the treatment of volumes, and painter in the handling of materials and light. Each type of talent and each phase of a style lays stress on one particular aspect of the art; the perfect harmony is attained only in the great periods. The importance of the plan is primarily sociological, for it is the diagram, the graphic representation, of the program. The proportional relationships are indicative not only of the spirit of the style but also of the practical needs which the building is called upon to serve; the circlet of chapels radiating from the apse is not simply harmonious form but is necessitated by religious practice, while the curving ambulatory is designed to ensure a free flow of movement. For an eye accustomed to the study of architecture and the realization of the plan in space, the plan will suggest much more, and will even indicate the structural solutions. But one must

remember that a building is not simply a matter of fitting a suitable elevation on to a pre-arranged plan, and the similarity of two plans does not necessarily and in every case entail the similarity of the composition of masses. Even though the plan is in some sense the abstract basis of these latter, yet they possess their own essential values, especially in a style which lays stress on the beauty of the masses, as does the Romanesque architecture of the twelfth century. They contribute to the stability of the building (here we are considering not a visual harmony, but actual resistance to thrust) and, arranged in order of size and of greater or less projection, they superimpose on the relationships of plane geometry a system of monumental relationships without which there would be no architecture, but only a diagram drawn out, like a flower-bed, on the ground. It is essential, particularly in Romanesque studies, to make the effort of considering a building as a collection of solids and of gauging the relationships between them. This manner of approach is doubly sound, since in Western architecture, at least in the period under discussion, the exterior masses invariably correspond with the internal distribution of parts and their three-dimensional relationships, so that the plan may be deduced from them, though the converse is not true. The truth of this observation may be demonstrated by a single example: a transept which does not project beyond the aisle-walls is hardly apparent on the plan. Finally the silhouette of a building, that most significant of values, results from the composition of masses.

The problems of structure and equilibrium, which are so important in large, complex, lofty, vaulted buildings such as those of the Romanesque period, arise mainly from the use of a stone covering, but this is not necessarily true in every case, since lofty walls surmounted by a wooden roof also require buttressing, though to a lesser extent, and northern and northeastern France, not to mention other areas, can show examples of this type of structure which are completely faithful to the spirit and style of their time in plan, mass and effects. A building is not carved or hollowed out of a monolith, but *constructed*, that is, composed of separate elements, assembled according to rules in which the architect figures as an interpreter of the force of gravity. The Greeks opposed the action of gravity in the vertical direction only. The medieval masters in most cases had to solve a problem involving oblique components and the counteraction of thrust, and, by an admirable process of

reasoning, they progressively specialized each member of the structure according to its function, and devised for it a form which was at once the most suitable and the most expressive of its purpose. It is in this respect that their architecture is most truly an art of logical thought, whereas the Greeks, having adopted once for all the straightforward solution of verticals and horizontals, were thereafter interested only in melodic variations of the proportions.

Besides being an interpreter of gravity the architect is also an interpreter of light, by virtue of the calculation and composition of his effects. This question must not be limited to the problems of lighting, though they in themselves are of capital importance, and we shall see how intimately they were linked with the problems of structure and equilibrium, and how their solutions evolved throughout the Middle Ages in step with the structural solutions. But the study of effects is of wider scope. It concerns the relationships of void and solid, of light and dark, and—perhaps most important—of plain and decorated. Again, a building is not an architect's drawing or a photographic print, it is composed of solid matter. It is obvious that this fact has specific and far-reaching effects on every detail of the treatment. It is of fundamental importance for the structure, since the various kinds of material have their own peculiar qualities and requirements, and these determine the functions which they can perform, the types of masonry for which they can be used, and the extent of the program to which they can be applied. Materials, moreover, have texture and color, and with these they make a pleasing and powerful contribution to the life of architecture, which is not intended merely for technical analysis and dissection but for the delight of the eye. They play their part within the system of relationships which we have just outlined, here stressing the solid, the broad luminous surface, the monumental economy of ornament, and there emphasizing the void, the equivocal effect of light and shade, and the profusion of carving; thus, though the vocabulary of forms may be constant, syntax, language and poetry are constantly recreated.

The elements can be isolated intellectually, but it must not be forgotten that they exist together, and that it is their organic interconnection, not their juxtaposition, which makes the building. We already have some idea of the interdependence of plan and structure, plan and masses, masses and equilibrium, and masses and effects. The architect conceives his building synthetically. Even in

the first flash of an idea, his thought includes the diversity of the parts. Admittedly, of course, the genius of a school, a locality or a master may concentrate on one particular aspect. There are builders and there are decorators. But a medieval building is a harmony of living forces which mutually penetrate, amplify, restrain, modify and define each other. The interrelationship of the masses, and the various relationships by which the effects are qualified, are transformed from top to bottom, from pavement to rooftree, and in every dimension of the architecture. Each individual member shares in the life of the organism as a whole. And what is true of the Gothic skeleton of arches and ribs is no less so for the massive Romanesque structure of compact vaults and thick walls, as a more detailed examination will show. We are compelled to deal with the elements one by one, but we must never lose sight of the fact that these elements are all functions of each other. And when we analyze the regional varieties of Romanesque architecture, which testify so strikingly to its historical vigor, we shall find that they owe their individuality not so much to what may perhaps be called their superficial features, or to the treatment of details, as to modifications of the interrelationship of parts. In this respect they constitute dialectal varieties comparable with the various romance idioms.

The program of the Romanesque basilicas was that of an enormous reliquary open to all comers. The monastic church of the time served both monks and pilgrims. It sheltered the bodies of the saints and attracted the devotion of the faithful. Renowned relics, the miracles wrought by them, the pious legends which surrounded them, the cult which exalted their virtues, the enhanced value of prayer uttered beside them—all this intense spiritual fervor created the prosperity of the great abbeys, and at once necessitated and made possible the grandeur of their scale. As in the progress of cities, demand created supply. The plan of the pilgrimage churches is as if drawn by the immense throngs which passed through them, by the order of their going and of their standing still, the places where they stopped and the places where they moved onward. Sometimes a great narthex, a survival of the old church of the catechumens, precedes the church, and serves as its vestibule, though large enough, with its central nave, aisles and upper storey, to form a separate church. The church proper has three, and sometimes five, naves. It was thus enabled to impose order on the multitudes within, by cutting parallel furrows in the moving mass. One or two tran-

septs, with oriented chapels opening off them, form two or four projections on the plan, each one so large that it seems an additional church set at right angles to the first. But they did not interrupt the progress of the pilgrim. They provided the throng with auxiliary entrances and exits, and they formed part of that architectural topography of pilgrimage which permitted of uninterrupted circulation within the building, from the west front to the chapels of the apse and from the chapels of the apse back to the west front. Sometimes, as in Saint-Sernin at Toulouse (Fig. 37), a continuous aisle surrounds the transept arm, extends along the choir, makes the circuit of the apse, and so returns. The long choir favored the development of ceremony. But it was the east end which, in both plan and elevation, in both the establishment of the program and the treatment of the masses, was the vital part of the church. Here are disposed the chapels which sheltered the relics of the saints, in addition to those which in some cases were preserved in the crypt, as in the martyrium of the primitive basilica. The most frequent arrangement is that in which small apses radiate from the ambulatory, a scheme whose earliest examples we have already noted in the second half of the tenth century; this was the best arrangement from the point of view of circulation. But a whole family of churches preserved the orientation of the apses by disposing chapels of diminishing scale in echelon; and this plan was best from the point of view of presentation, the chapels being parallel to one another and opening directly on to choir and transepts. This scheme is known as the Benedictine or Berry plan, though it is not confined to that province. The finest and most characteristic example is perhaps that of Châteaumeillant. But it was the radiating plan which prevailed, and Romanesque art, which had received it from the Carolingian tradition, bequeathed it in due time to its Gothic successor. . . .

37. St. Sernin, Toulouse. Romanesque, *c.* 1080–1120 (Reprinted by permission of Penguin Books Ltd. from Kenneth John Conant, *Carolingian and Romanesque Architecture 800–1200* [1974 paperback edition], p. 159, Fig. 113 [4], Architectural plan for St. Sernin, Toulouse. © Kenneth John Conant, 1959, 1966, 1974)

a. Aerial view, St. Sernin, Toulouse (Reportage Photographique Yan)

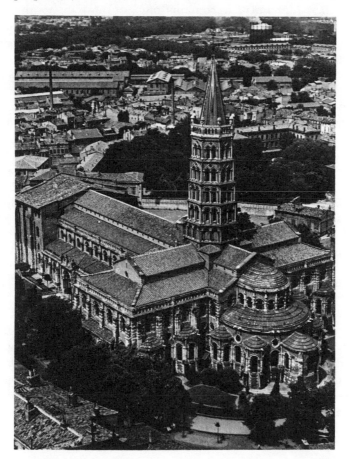

ROMANESQUE DECORATION

I

. . . At first sight how remote from us [Romanesque sculpture] seems! Is it possible that this is ours—this strange vision, entwined so mysteriously with the stone and inscribing the walls of the buildings with fancies which are often indecipherable, like the characters of a lost language? Can it be that our conception of man, life and the world is divided by such an abyss from that of our forebears? In Gothic sculpture we recognize ourselves, we find our own kind of humanity; it remains our contemporary, almost our neighbor—much more so than Renaissance sculpture, which was based upon the resuscitation of an earlier age for which we can no longer feel more than an intellectual sympathy and admiration. The endless ranks of images which fill the Gothic cathedrals evoke in us a kind of spiritual kinship, which we freely acknowledge; in many ways even, they are like a vivid recollection of our past life, our own past, and that of our towns, our suburbs and our country-side. We can name the animals and the plants, and the saints with their workingmen's faces who stand in the doorways are of the same race as our own fathers. But wherever we turn, the images of Romanesque art disconcert us by their composition and their senti-ment. It is an art abundant in monsters, visions, and enigmatic symbols. It seems at first sight much older than the age which it so faithfully expresses and the architecture to which it so exactly conforms.

Let us study it first as a system of signs before we attempt to interpret it as a system of forms. Every art is language, in two ways—once by its choice of subjects, once by its treatment of them. Iconography floodlights the life of the spirit. It is not a collection of symbols, a vocabulary, or a key; the novelty of M. Mâle's studies[12] consists in the widening of its horizons and the deepening of its perspectives, both historical and moral, to form a broad and detailed panorama of the spiritual life of the past. Romanesque iconography was epic. It bestowed super-human proportions on God-made-man and man-in-the-image-of-God; sometimes even it gave them an appearance divorced from humanity. It surrounded them with a cortège of monsters which entwine them in their coils. To expound

and present them to the people it chose, as a terrible warning, the most extraordinary page of the whole Bible. The story of the Last Days, foretold in words of fire by an enthusiast filled with the afflatus of the Jewish Bible, inspired it with majestic terror. The seer roused the visionaries. The faithful entering the church were not welcomed by the evangelic Christ of the thirteenth-century *trumeau*, but compelled to file beneath the tympanum of the Last Judgment as if they themselves were about to hear their sentence from the mouth of the inflexible Judge. At La Lande de Cubzac, the sword of the Word flashes from the lips of the Apocalyptic Christ, who stands beside the symbolic candelabrum, holding in his hand the book sealed with seven seals. In a less strange guise, alone or flanked by two angels who seem to fan the flames of the glory which surrounds Him, it is this same God of the Apocalypse who figures on the old Aragonese tympana, at Perrecy-les-Forges in Burgundy and Mauriac in Auvergne, and who finally, in the second half of the twelfth century, appears again and again in monotonous profusion, accompanied by the tetramorph of Evangelists, above the portals of northern France. But it was particularly in the tympana of Languedoc, in the first half of the century, that the theme was developed with the full amplitude of the epic. Christ the Judge, whose kingdom is founded on the destruction of the universe and the punishment of sinners, emerges from the mystery of the end of time like an apparition suddenly risen before the eyes of His terror-stricken followers. Surrounded by convulsive shapes, He is accompanied by the twenty-four Elders carrying lamps and viols. At Beaulieu there appears behind Him the cross of His sacrifice, and of the redemption of mankind. Even when, as at Vézelay, He is the Christ of Pentecost, charging the Apostles with their mission,[13] He is still a terrible God. The Oriental Potentate of Moissac is Lord of a world from which the Good Shepherd of the catacombs, the Christ of Psamathia, and all those figures of Hellenistic Christianity who still combined divinity with youth and harmonious beauty have passed away. One might believe that the Romanesque Apocalypse trembled still with millenarian terrors, passed on by Beatus' illustrated commentary, which served as its guide through this Divine Comedy in stone. There is a breath of the East in these strange figures, this fearful conception of the Master of Days. Yet the same epic spirit, the same legendary disproportions, the same superhuman quality, are characteristic of the tales of knightly prowess created,

at the same time and often at the same places, out of the recollection and imagination of the peoples of the West. The God of the sculptors and the heroes of the poets are ornaments of the same horizon of thought: the visionary theology of Scotus Eriugena, if it did not directly inspire the iconography, helps us at least to understand its intellectual climate. The unity of the period is not founded on a congeries of completely heterogeneous borrowings; unfamiliar elements were welcomed because they responded to a need, and we shall see how they were subsequently elaborated.

The stories of the Gospels and the lives of the saints, and still more the representation of the world, are touched with the same strangeness, and many details betray the remoteness of their origin. Sir Arthur Evans has recently shown that the theme of the Adoration of the Kings goes back to the remotest antiquity,[14] and it should be observed that already on Sumerian monuments it is accompanied by the motif of the guiding star. In Syria, Mesopotamia, Transcaucasia and Egypt the East Christian communities were the heirs of an iconographical tradition built up over thousands of years; they in turn devised new elements and established stereotypes which fixed the images for the future. The three cycles of Nativity, Passion, and Parables, the essential chapters of the iconography of the Gospels, are full of Oriental features, whose history and diffusion can be followed from the throne of Maximian and the ampullae of Monza down to Romanesque times. The Byzantine drama *Christos Paskon*,[15] whose influence is vouched for by numerous manuscripts, spread the knowledge of the *mise en scène* of the Resurrection and the other episodes centered on the Tomb. The prophets of the Coming of Christ were born of the Biblical East and insinuated themselves into still older Oriental forms. Daniel standing between the lions who lick his feet is Gilgamesh, the master of animals in Assyrian art. An Oriental silk at Saint-Maurice d'Agaune in Valais, the national sanctuary of the Burgundians, shows the manner in which these themes were able in the early Middle Ages to penetrate the West and to become invested with a Christian significance, before they made their appearance on Romanesque capitals. Thus we find the Biblical and Gospel figures intimately linked with the oldest images of Asia,[16] and even when they are of more recent origin, they have very often been composed and fixed in the East. Hence the indisputably exotic tonality in the choice and treatment of subjects.

This quality of Romanesque iconography strikes us still more forcibly when we consider the number and the strangeness of the monsters which inhabit it. Man himself loses his identity and, obedient to the law of metamorphosis by which this universe is constantly created, broken down and recomposed, he also assumes a monstrous guise. Even when probability is respected, the animal life is of bewildering variety. The bestiary of the steppes, which had been diffused by the invasions, and the Asiatic fauna which had filled Visigothic manuscripts such as the Sacramentary of Gellone and now reappeared, often in copies after Arabic ivories, introduced into the churches the menagerie, the "paradise" of the Oriental monarch. But, seized by that hidden power which remolded living creatures to its own needs, and conferred on them a multiple existence more mobile and passionate than life itself, the animals are subdivided, reunited, acquire two heads on one body or two bodies for one head, gripe one another, devour one another, and are again reborn, all in an indecipherable tumultuous *mêlée*. What name can we give, what meaning assign to these fancies, which seem to emanate from the caprice or delirium of a solitary visionary and which yet recur throughout Romanesque art, like the images of some vast collective nightmare? Of what virtues, what sins are they the incarnation? At times we seem on the point of penetrating these symbols, but immediately they flicker away into the monstrous inanity of the compositions.

Such are the general characteristics of this iconography. It is rich in Oriental elements. It is epical and teratological. It gives us the epic of God, the epic of the end of the world, and the epic of chaos. Is there not a singular contradiction between the order of the churches and the tumult of these images, between the rules of an architecture whose strength, stability and logic we have been at pains to demonstrate, and the rules of an iconography between whose transfiguration of God and deformation of His creatures one may scarcely find a middle term, between structures dominated by a conception of plan and masses which is purely Western, and an iconography which derives most of its resources from the East? Only the study of the forms permits us to resolve this apparent contradiction; it will likewise assist us to make a true assessment of influences, and it will also demonstrate the profound harmony of thought between the technique of the Romanesque decorative artist and the intellectual technique of his period.

241

## II

This technique had a twofold character: it was architectural, in that the figures were made to conform to their architectural setting and it was ornamental, in that the figures were drawn and composed in accordance with ornamental schemes. In our brief study of the experiments carried out in the course of the eleventh century we have already caught a glimpse of some of the earliest applications of these principles and of the manner in which they tended—in opposition to the academic forms of antique art and in alliance with the abstract repertory which had become diffused through Europe—to substitute for the verisimilitude of the images their just adaptation to a surrounding frame, and to replace the harmony and proportions of life by the harmony and proportions of an abstract system. The forms of architecture and the forms of life being fixed, what compromise could be established between them? Romanesque architecture did not offer indifferent fields to the decorator, but fields whose shape and function were clearly defined. The genius of the style lay in its association of sculpture with these functions. By adopting once for all the frieze-system, which had flourished in the eleventh century alongside more adventurous lines of research, it would have renounced its fundamental originality. It might also have allowed sculpture to flow indifferently over the wall-surfaces, and assimilated it to those severe and powerful masses in truly monumental beauty: but sculpture in architecture and for architecture demanded a much stricter economy. Where is it found, in a twelfth-century church? On capitals, tympana and archivolts. True, it did not altogether abandon the friezes and the arcades, but its development depended on the more tyrannical constraint exercised by frames which were ill-adapted to receive the image of life. Yet these frames seized upon sculpture, bestowed on it a new passion, imposed on it movement, mimicry and drama. To enter the system of the stone, man was forced to bend forward or lean backward, to stretch or contract his limbs, to become a giant or a dwarf. He preserved his identity at the cost of unbalance and deformation; he remained man, but a man of plastic material, obedient—not to the caprice of an ironical idea—but to the exigencies of a system which comprehended the entire structure.

Romanesque art was to make the church "speak"; space had to be found for an abundant iconography, without disturbing the

architectural masses and their functions. It was necessary to set on top of the columns, at the same time avoiding the appearance of meagerness and insignificance, not one or two figures—Christ in Majesty, St. Anne and St. Elizabeth, Adam and Eve—which could easily be disposed axially or confronted, but the more numerous actors of the Nativity, the Flight into Egypt or the Last Supper. We must remember that it was in the Corinthian capital that human figures first began to be inserted; they were abducted from the charms of continuous narrative, the storyteller's dispersal of effects, and wedded to architecture, grouped in a colleret of figures or assigned the role of atlantes. In the course of this treatment the living organism was twisted out of shape and out of proportion, but it gained thereby an unexpected eloquence. Bound by every limb to the block of stone, and bound by the continuity of the movement to its companions, which are a prolongation and multiplication of itself, it gave rise to compact systems from which the removal of a single element would entail the ruin of the massive unity of the whole. The loose narrative of the frieze-style was succeeded by the complex strength of drama, with its concentrated impact, and its mimicry accentuated by the deformation of the actors. This architectural conformity did not operate only within the framework of the Corinthian capital. The cushion capital also, when it accepted figure decoration, submitted it to the same discipline. So too, did the capital formed like a truncated and inverted pyramid; and when the capitals of conjoined or adjacent columns were adorned with a single composition, the bridging of the gap between the two masses produced some unexpected but logical applications of the same principle.

A similar problem, but with rather different data, was set by the decorations of the archivolts. How could the image of man, and, in a more general sense, the image of life, be accommodated within the arch-moldings which curve around the semi-circular tympanum? . . . The decoration of the moldings is sometimes disposed radially, while at other times it follows the curve of the arch. In the former case, each voussoir is treated as a unit and closely contains the figure or ornament which it receives—bearers of offerings following one another in procession up to the keystone and down again on the other side, horses' heads, and ornamental frets worked in the stone as in ivory or ironwork. In the latter case, the figure occupies several voussoirs, bending with the arch; a body may cross the keystone,

or the heads of two symmetrical bodies may be confronted there; the living creature becomes an architectural curve and is identified with the molding itself. The whole of southwestern France is rich in these surprising configurations. . . . Human figures sometimes try to escape to some extent from this narrow bondage. Instead of the radial or circumferential position, they take up a tangential one, forming with the curve of the arch an angle which hardly ever varies. The elongated bodies stand erect or bend over within the arch, their bellies slightly prominent, and punctuated by a spot of shadow between the thighs. . . .

The composition of a tympanum is not determined by a vague symmetry. Its elements must be both deployed and concentrated. Its lower and wider part extends to very nearly the same length as the lintel on which its rests. The upper segment narrows rapidly. The two parts are held together by the radii of the arch. A fan-shaped composition would seem to be the most favorable and harmonious solution, but the Romanesque sculptors by no means restricted themselves to that alone. Sometimes they made it more complex by the insertion of a triangular pediment, which is not outlined by projecting moldings, but is visible in the lines of heads which rise toward the central axis (and emphasized, as at Vézelay, by the fiery rays emanating from the hands of Christ), or may be suggested, in less elaborate compositions, by the movement of the mandorla-carrying angels as they bow down before the glory of God. Sometimes they subdivided it so as to obtain, with the help of some curvilinear triangles, a collection of rectangular frames, as at Cahors, and Carennac. Sometimes the composition blossoms like a flower or a palmette, with living figures forming the lobes. It was the special function of the monsters to contort themselves to suit these various schemes, but man also conformed. In accordance with a kind of morphological perspective, which, though equivalent with hierarchic perspective, yet precedes it in the structural and logical order, and is more insistent in its demands, the witnesses and actors of these impressive scenes, the attendants of the throne of heaven, increase in scale in proportion to their nearness to the Deity, who alone occupies the center and towers up to the full height of the tympanum.

. . . Finally, we may mention a class of rectangular panels, decorating *trumeaux* and doorjambs, which reveal to us one of the most curious aspects of this technique. The principle of exact

conformity to the frame, strictly applied, results (there are many examples) in creatures of absolutely geometrical shape—the circle-men, like the delightful acrobat on the keystone of the archivolt at Vézelay, above the Zodiac, the lozenge-men, and the rectangle-men. But this last shape, once defined, could never satisfy the manifold demands of the iconography, which required other heroes than these massive witnesses, and especially they were unfitted to share in that restless movement with which Romanesque art is filled. Hence the figure conterminous with its frame was displaced by the figure which touched its frame at the greatest possible number of points. With elbow, shoulder, knee, and heel the body, whose parts are disposed on multiple axes, makes contact with the limits of the enclosing field, and thus describes a whole series of triangles. In this way there was produced a family of figures which, even in their immobility, enliven the firm and ponderous masses of Romanesque architecture with ceaseless movement; this sculpture, though dominated by the laws of a massive equilibrium, presents itself in the guise of a series of experimental studies in motion (Fig. 38). . . . To a superficial observer this interpretation might seem a product of vain ingenuity, and this geometric grid a device to support a preconceived system. But the album of Villard de Honnecourt[17] provides, *a posteriori*, a brilliant confirmation. This Picard master-mason, whose notebook testifies to an insatiable curiosity, fed by wide experience, and foreign travel, resurrected some aspects of the "lost art," whose rules had been forgotten by his contemporaries and of which, after him, there seems to be no trace. By insisting on the interest of what he calls the "art de jométrie" and by divulging the secret of the triangulation of figures, he confirms the historical importance, the authenticity, and the systematic character of the processes which we have analyzed.

Architectural conformity and the use of geometric schemes, even if they are the fundamental characteristics of Romanesque technique, do not in themselves account for all its aspects. This essentially architectural sculpture was devised for particular positions and for frames which determined its arrangement and movement; but it is also ornamental—it established or rather modeled its image of life in accordance with the forms of ornament. The man, the beast and the monster are not only volute, medallion, molding, wall-mass, or function, they are not assembled only in accordance with the broad lines of a geometric scheme; they are also palmette

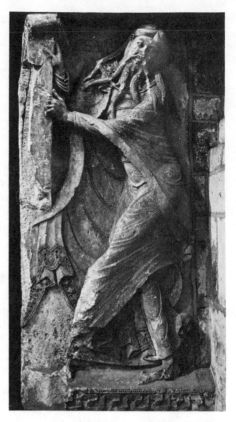

38. Prophet Isaiah, from abutment of doorway, monastery church of Notre Dame, Souillac. Romanesque, Early 12th Century (Marburg-Art Reference Bureau)

and foliage-scroll. Recent research,[18] the point of departure for which was provided by the juxtaposition of a design composed of ornament in the pure state, and a figure composition in which its main lines are exactly reproduced, as if the sculptor wished to leave beside his work the key to its understanding, has brought to light the prodigious decorative "underpainting" of Romanesque sculpture. Moreover, if we envisage the ornament not as a static vocabulary or a collection of invariable formulae but as a dialectic or multiple development in which each term may be deduced from its predecessor, we find that the dialectic of the figure sculpture reproduces, in its movement and variety, that of the ornament. Three primary motifs—the foliage-scroll, the heart (with or without a palmette), and the motif formed by setting two foliage-scrolls back to back about a central axis—give rise to a large number of ornamental variations whose forms and interrelationships reappear in many of the figure compositions of Romanesque sculpture. If it were

merely a question of explaining in this way the symmetries of confronted and addorsed objects, or the genesis of the monsters with two heads or two bodies, this fact would amount to no more than evidence of a very common and widespread habit, though it would still be noteworthy, since it was abandoned by European art after the twelfth century. But in fact there is a complete system, an immense variety of forms which can only be explained by the dialectic of ornament. An inexhaustible vitality, differing from organic life, and of even greater richness and multiplicity, but as highly organized, arises out of, and owes its diversity to, these abstract devices, and modulates its variations according to their variations. Very ancient motifs, such as the sea-siren with the double tail, were also admitted to this realm of forms, not as alien elements arbitrarily inserted or passive recipients of influence, but because they, too, had originated in an ornamental idea, whose shape and aptitude for life they still preserved, and were ready participants in the play of metamorphoses. In the setting within which this process of transformation operates, it links together all the movements, leaving no single gesture unconnected, and ensures that all the parts interlock and interpenetrate, so that each block of ornament in pictorial guise is like a small separate world, close-knit and compact, a law unto itself. The great complex compositions of the tympana are very often the expanded and diversified, yet quite regular, version of an ornamental motif which runs through the whole, controlling and influencing every detail. The epic of the Last Day, the Adoration of the Kings, and all the other stories and visions, adorned the stones of the churches with a mysterious flora, with the characters of a hidden language, by which their own poetic content was enhanced. Thus the study of the technique of Romanesque sculpture has revealed to us a poetry and a psychology. The feeling and subtlety of the dialectical process as applied to these forms runs parallel with the dialectic of pure thought. It is not without significance that both church-decoration and the scholasticism of the period were equally dominated by the philosophy of abstraction, and that both groups of purist logicians were given to the spinning of elegant formal patterns. But whereas the dialectician lost himself in a labyrinth of unprofitable composition, the sculptor, in conjunction with the architect, was creating a new world, extending the limits of man's experience, and giving shape and form to his wildest fantasies.

247

*NOTES*

°1 These ideas have been expanded by H. Focillon, *Du moyen-âge germanique au moyen-âge occidental, in Moyen-Age. Survivances et réveils* (Montreal, 1945), pp. 31–53.

2 At Lyon, for instance, the columns of the Temple of Augustus were utilized for Saint-Martin d'Ainay. Similarly in the crypts (Jouarre, Grenoble) and baptisteries (Poitiers, Riez, Le Puy, etc.). See C. Enlart, *Manuel*, 2nd edition, I, p. 414, note 1, and p. 145.

3 L. Bréhier, *L'art en France, des invasions barbares à l'époque romane*, p. 9. Examples of indigenous survivals are the pediment-shaped lintels which are common in Auvergnat and Belgian Romanesque, the geometrical motifs of Gallo-Roman mosaics, and, in figure-sculpture, the god with the purse from Lezoux (Musée de Saint-Germain), the mother-goddesses, the god with the hammer, etc.

4 J. Seligmann, *L'orfèvrerie carolingienne, son évolution*, Institut d'art et d'archéologie de l'Université de Paris, Travaux du groupe d'histoire de l'art, 1928, p. 137.

5 See L. Westwood, *Miniatures and Ornaments of Anglo-Saxon and Irish Manuscripts* (London, 1868); P. Gilbert, *Facsimiles of the National Manuscripts of Ireland*, 5 vols. (London, 1874–84); H. Focillon, *L'art des sculpteurs romans*, p. 97, 102, 103. °See also G. L. Micheli, *L'enluminure du haut Moyen-âge et les influences irlandaises* (Brussels, 1939); F. Henry, *Irish Art in the Early Christian Period* (London, 1940); F. Masai, *Essai sur les origines de la miniature dite irlandaise* (Brussels, 1947), (whose conclusions have not been universally accepted).

6 See J. Baltrusaitis, *Études sur l'art médiéval en Géorgie et en Arménie* (Paris, 1929). In Georgia, the tympana of Djvari and of Ateni (seventh century), of Ochque (ninth century), and of Koumourdo (946); in Armenia, the stelae of Haritch (fifth to sixth century), the reliefs of Zwarthnotz (seventh century), etc.

7 A. Goldschmidt, *Die Elfenbeinskulpturen aus der Zeit der karolingischen und sächsischen Kaiser* (Berlin, 1914 etc.), 1, 163. °See E. de Wald, *Notes on the Tuotilo Ivories in Saint-Gall*, Art Bulletin, 1933, pp. 202 ff.

8 E. Mâle, *L'art français et l'art allemand du moyen âge*, pp. 93–4. Gregory VII, Urban II and Paschal II had been Cluniac monks. On the constitution of Cluny see V. Mortet, *Note sur la date de rédaction des Coutumes de Farfa* (Mâcon, 1911). °More recently: G. de Valous, *Le monachisme clunisien des origines au XVe siècle* (Ligugé and Paris, 1936); J. Evans, *The Romanesque Architecture of the Order of Cluny* (Cambridge, 1938), and *Cluniac Art of the Romanesque Period* (Cambridge, 1950); to which must be added: Société des amis de Cluny, C. Oursel, ed., *A Cluny, Congrès scientifique . . .* , 9–11 *juillet* 1949 (Dijon, 1950).

9 The *Book of St. James*, a fine copy of which is preserved in the chapter-library at Compostela, was written to assist pilgrims, probably by the monks of Cluny, at some date after 1139. See J. Bédier, *Légendes épiques*, III, p. 75; E. Mâle, *L'art religieux du XIIe siècle en France*, p. 291 and notes 3 and 4. The fourth book of the Compostela Codex was published by Père Fita, Paris, 1882. In addition, see Lavergne, *Les chemins de Saint-Jacques en Gascogne* (Bordeaux 1887) Dufourcet, *Les voies romaines et les chemins de Saint-Jacques*, Congrès archéologique de Dax et Bayonne, 1888; Abbé Daux, *Le pèlerinage de Saint-Jacques de Compostelle*

(*Paris* 1898), cited by Mâle, *op. cit.*, p. 289, note, and Ginot, *Les chemins de Saint-Jacques en Poitou* (Poitiers, 1912). The part played by the pilgrimage roads in the history of architecture was first studied by the Abbé Bouillet, the historian of Conques and Sainte-Foy, in Mémoires de la Société des Antiquaires de France, 1892, p. 117. The Via Tolosana linked Provence with Languedoc, and leaving Arles, continued by way of Saint-Gilles du Gard, Toulouse, and the Somport pass. The stages of the Auvergne route were Le Puy, Congues, Moissac. A third route connected Burgundy and Aquitaine, from Vézelay to Saint-Léonard and Perigueux. The fourth and last, leaving Tours, traversed Poitou and Saintonge, and passed by way of Bordeaux to join the two preceding routes at Roncevaux, where they crossed the Pyrenees. Each route was an unbroken chain of sanctuaries. The pilgrimage road from France into Italy, crossing the alps by the Great St. Bernard or Mont Cenis passes, joined the Emilian Way via Modena, then the Cassian Way at Arezzo, reaching Rome by way of Viterbo. Influences travelled back and forth along the roads of St. Michael just as they did along those of St. James. On the relationship between Sant' Antimo in Tuscany and Conques, see J. Vallery-Radot. *Églises romanes*, p. 178, and on that between San Michele of Clusa and Le Puy, id., *ibid.*, pp. 176, 177, and the study by E. de Dienne, Congrès archéologique de Puy, 1904. °The most recent editions of the Guide for the Pilgrims of St. James are by J. Vieillard (Mâcon, 1938), and by W. M. White-hill (Santiago, 1944). See also P. David, *Études sur le livre de Saint-Jacques*, Bulletin des Études Portugaises, Vols. 10–12, 1946–1948.

[10] It is well known that the *chansons de geste*, according to Gaston Paris, are the ultimate fruit of centuries of composition whereas for J. Bédier, *Les légendes épiques*, 2nd ed. (Paris, 1914–21), they arose from the pilgrimages themselves. Note also the observations of G. Cohen, *La civilisation occidentale au moyen âge*, p. 211, where he indicates on the one hand the part played in the poems by geography and the northern abbeys, and on the other the continuity of poetic tradition attested by a ninth-century text such as the *Chanson de Saint-Faron de Meaux*.

°[11] H. Focillon has expressed the same views in *Vie des formes* (Paris, 1934), translated as *The Life of Forms in Art* (New Haven, 1942, and New York, 1948).

[12] *L'art religieux du XIIe siècle en France* (Paris, 1924), chaps. I, IV.

°[13] On the iconographic meaning of the Vézelay tympanum, see A. Katzenellenbogen, *The Central Tympanum at Vézelay*, Art Bulletin, 1944, pp. 141–151.

°[14] A. J. Evans, *The Earlier Religion of Greece in the Light of Cretan Discoveries* (London, 1931).

[15] See V. Cottas, *Le théâtre à Byzance* (Paris, 1931), and *Le drame Christos Paskon* (Paris, 1931).

°[16] See J. Baltrusaitis, *Art sumérien, art roman* (Paris, 1934).

[17] Bibliothèque Nationale, ms. fr. 19, 093. First published by Lassus and Darcel (1858), then by H. Omont in the series of phototype albums issued by the department of manuscripts, and most recently by Hans R. Hahnloser (Vienna, 1935).

[18] J. Baltrusaitis, *La stylistique ornementale dans la sculpture romane* (Paris, 1931), chap. 5, VII, p. 273, L'animal (genèse des monstres); VIII, p. 301, Le personnage. The method followed in this remarkable book has revolutionized the subject.

# *13.* THE ICONOGRAPHY OF A ROMANESQUE TYMPANUM AT VÉZELAY

## *Adolf Katzenellenbogen*

### INTRODUCTION

This selection examines the arrangement and subject matter of the central tympanum in the narthex of Sainte-Madeleine at Vézelay, and proposes a web of meanings in which the prophecies of Isaiah, the old mission of the Apostles, and the new mission of the crusaders have been harmonically interwoven. A fine example of iconographical analysis, this selection has the added interest of linking the complex program of this tympanum to the historical events of the era and to the guiding genius of the theologian, Peter the Venerable.

With respect to the fantastic creatures who appear on this relief, the reader may wish to consult such works as T. H. White (ed. and trans.), *The Book of Beasts, Being a Translation from a Latin Bestiary of the Twelfth Century* (1954), or Ernst and Johanna Lehner, *A Fantastic Bestiary: Beasts and Monsters in Myth and Folklore* (1969).

Among other works by the late Adolf Katzenellenbogen are *Allegories of the Virtues and Vices in Mediaeval Art* (1939); "The Prophets on the West Facade of the Cathedral of Amiens," *Gazette des Beaux-Arts*, S.6, XL (1952); and *The Sculptural Programs of Chartres Cathedral* (1959), which was awarded the Charles Rufus Morey Prize by the College Art Association as the best book in the history of art to be published in 1959.

The central tympanum in the narthex of the Abbey Church of Sainte-Madeleine at Vézelay, which was created between about 1120 and 1132, has proved to be one of the most tempting and brittle iconographical enigmas of medieval art (Fig. 39). Its explanation has been attempted time and again with a wide variety of results.[1] In more recent years the conflicting opinions have been narrowed down to two different interpretations, established by Émile Mâle and Abel Fabre.[2]

Émile Mâle has related the program of the tympanum to the events on the day of Pentecost. He has explained the central scene as the *Descent of the Holy Spirit* with Christ Himself bestowing the rays of heavenly grace on His apostles. The numerous groups of figures surrounding the central scene in the eight compartments of the archivolt and on the lintel represent those nations to whom the apostles will preach the gospel, now that they are endowed with the power to speak in all languages. Monstrous races are among these nations. According to medieval belief, they live at the ends of the earth. In the archivolt some people are characterized as being sick. They are already experiencing the miracle-working of the apostles. On the left side of the lintel, however, the groups who offer their gifts and bring a sacrificial bull still remain faithful to their old erroneous belief, but the word of the Lord will reach them too.

According to Abel Fabre the central scene represents the Mission which Christ gave to His apostles immediately before His Ascension.

The apparent discrepancy between the two interpretations which relate the central scene either to the Pentecost or to the day of Ascension may find a solution if one considers briefly the meaning of the tympanum decorating the western portal of the church at Anzy-le-Duc (c. 1125).[3] Here the problem is similar, although less complex. The tympanum represents the *Ascension of Christ,* a favorite theme of Burgundian Romanesque sculpture. The enthroned Christ, whose mandorla is held by two angels, occupies the center of the tympanum, while Mary and the twelve apostles, who are

253

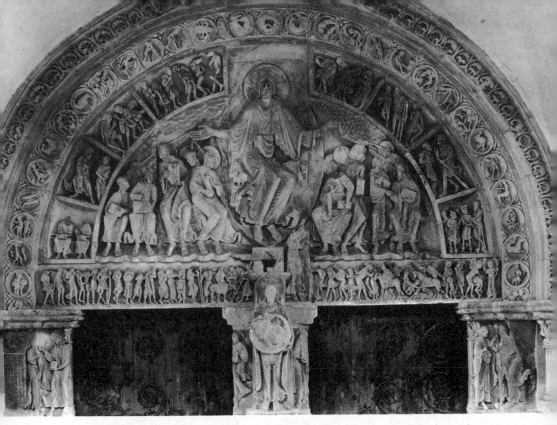

39. Tympanum: The Mission of the Apostles, Center Portal of Narthex, Ste-Madeleine, Vézelay, 1120–1132 (Marburg-Art Reference Bureau)

the witnesses of the Ascension, are rendered on the lintel. Yet the program of the tympanum is not restricted to this event. It also gives visible form to the prediction of the second coming of Christ which the two Men in White made to the apostles: "This same Jesus, which is taken up from you into heaven, shall so come in like manner as ye have seen Him go into heaven."[4] The second coming of Christ, an event still remote at the time of His Ascension, does not remain just a prediction, but is actually represented. In the archivolt the twenty-four Elders are shown as the witnesses of His coming at the end of time. Thus the tympanum gains a twofold meaning. If Christ is considered in context with the figures on the lintel, He is the Christ of the Ascension, if in context with the Elders of the archivolt, the apocalyptic Christ. Two events are clearly telescoped to make the meaning of the tympanum more comprehensive. The triumphant return of Christ to heaven is merged with His triumphant reappearance to judge mankind.

254

The fact that different events are telescoped here may justify an analogous interpretation of the more complicated aspects of the Vézelay tympanum. Its main literary source may be found in Acts 1 : 4–9. Just before He was taken up and received by a cloud, Christ prophesied to His apostles that they would receive the power of the Holy Spirit and be His witnesses unto the uttermost part of the earth. In my opinion, just as at Anzy-le-Duc the theme of the *Ascension of Christ* is expanded by giving visible form to the prediction of His second coming, so at Vézelay the *Ascension of Christ* is supplemented by the sculptural rendering of His predictions. The promise of the giving of the Holy Spirit is represented by the rays emanating from His hands. The reference to the future missionary work of the apostles is illustrated on lintel and archivolt by the representatives of the various nations, some of whom were supposed to live at the edge of the world. Thus the representation of the ascending Christ who leaves His apostles and is received into a cloud is merged with the *Mission of the Apostles* and with the giving of complete and final power through the Holy Spirit in what may be called an encyclopedic representation of the Mission. Such a telescoping might have been suggested by the summarizing sentence (Acts 1:2): "Until the day in which He was taken up, after that He through the Holy Ghost had given commandments unto the apostles whom He had chosen."

This interpretation may also be corroborated by the fact that until the fourth century A.D. the Ascension of Christ was celebrated on the afternoon of the day of Pentecost and that a continuous pictorial tradition represents the two events on the same page of manuscripts or even fuses them in a compositional unity.[5]

It seems to me that a more precise analysis, which is based not only on the text of the New Testament, but considers also certain passages of the Old Testament and the historical situation in the epoch of the crusades, can further clarify the meaning of the tympanum. Not merely a general idea is represented here; a program of an astonishing preciseness, of an encyclopedic complexity and of a crystalline clarity seems to have been translated into visible terms. It must have been conceived by an outstanding theologian.

I shall first try to analyze this program, then to relate it to the historical events at the time of its creation. Finally I shall venture to identify the author of the program.

I

The encyclopedic *Mission* on the Vézelay tympanum seems to be strongly influenced by Old Testament prophecies referring to the coming salvation of mankind. It also indicates in a definite manner three specific tasks and the power to perform them, which Christ had given to His apostles:

He had given them the power to save or to condemn (Matt. 18:18; Mark 16:16; John 20:23).

He had sent them out into the world to preach the gospel to all the nations (Matt. 28:19), or, as St. Mark says, to every creature (16:15), so that they would be His witnesses unto the uttermost part of the earth (Acts 1:8).

He had given them the command and the power to heal the sick and to drive out devils (Matt. 10:1, 8; Mark 16:17, 18; Luke 9:1).

The task of saving or condemning is indicated in the central scene and in the four lower compartments of the archivolt. The task of preaching the gospel to all the nations is represented on the lintel. The task of healing the sick and of driving out devils is indicated in the four upper compartments of the archivolt. First I shall analyze the central scene, then the lintel and the archivolt.

In the central scene the apostles at Christ's right, the side where, in the Last Judgment, the blessed appear, are shown in the process of saving mankind. The apostle at the extreme left takes the lock away from his book. The next one holds his open book on his lap. His neighbor, probably St. John, shows the open book even more emphatically before his chest, before his heart. St. Peter, next to Christ, holds the key which will open paradise to the blessed. There is an increase in the size of the apostles toward the mighty, towering central figure of Christ. And to this increase in size corresponds a gradual increase in the intensity of the gestures and attributes of salvation. On the left side of Christ, however, the apostles have their books closed, thus indicating that they can condemn. St. Jerome expressed the same idea when he wrote that the apostles reveal the Savior to those who believe, but hide Him from those who do not believe.[6] This conception is also reflected in the clouds which flank the upper side of Christ's mandorla. On His right they are calm. On His left they look like thunderclouds.

The central scene, the final empowering of the apostles by Christ Himself, radiates into the subordinated scenes of the lintel and archivolt, where many of the small figures point with ecstatic gestures toward the center.

The apostles must preach the gospel to every creature. They must convert mankind. This task is represented on the lintel. From both sides approach groups of people engaged in vehement discussions. The procession coming from the right is received by St. Peter, the dispensator, with the keys of the heavenly kingdom, and St. Paul, the teacher of the gentiles. They are the princes of the apostles, also the traditional patrons of the abbey.[7]

At the extreme left the procession begins with a group of barefoot men mostly clad in short tunics and armed with bows and arrows. The next group brings offerings, a bowl full of fruit, a special cake, a fish, an object which is now partially destroyed, probably a box with incense, and a pail with wine or milk in it. Near the center of sacrificial scene is represented, obviously influenced by some classical prototype.[8] A sacrificial bull stands there among priests and helpers of the sacrifice.

At the right side, a soldier clad in mail and armed with a shield hands his sword with its point down to the apostles. He leads a group of other soldiers and men, who have not taken sufficient time to arm themselves, so eager are they to rush toward salvation. There is a pygmy, an inhabitant of Africa, who mounts a horse from a ladder.[9] Close to him at the left stands another pygmy, now partly destroyed, to whom a man of normal size talks in an emphatic manner. The procession is still extremely dramatic at the end, where two family groups gesticulate violently. The group at the very right has a monstrous appearance. It belongs to the fabulous race of the Panotii, the people with large ears. Classical and medieval writers report that they live in India or on some island far in the north.[10]

How are we to explain these two processions? Immediately before His Ascension Christ tells His apostles that they shall be His witnesses unto the uttermost part of the earth (Acts 1:8). The gospel according to St. Mark (16:15) relates that Christ gives His apostles the command to preach the gospel to every creature. These passages suggest in a general manner the idea of representing various and even monstrous peoples as the object of the missionary work of the apostles. Yet they say nothing about a frantic procession, where people admonish and push each other. It is rather the prophecies

257

of the Old Testament which foretell, and in an emphatic manner, the effect of the coming salvation on mankind. Isaiah has described this in great detail. We know that these prophecies were quoted again and again early in the twelfth century.

Isaiah predicts that nations from afar will come that they may be saved: "Behold, these shall come from far, and, lo, these from the north and from the sea, and these from the land in the east" (49:12).[11] He speaks not only of the known peoples, but of the unknown peoples, too: "Behold, thou shalt call a nation that thou knowest not, and nations that knew not thee shall run unto thee" (55:5). Among these unknown peoples the Middle Ages include the pygmies and the Panotii. Even those of unusual appearance, like the man, the woman, and the child with large ears, would be saved. . . .

On the right side of the lintel the people are clearly more bewildered than on the left. Some, as we have seen, are talking vehemently. No better description of their attitudes and gestures could be given than that one provided by another prophecy of Isaiah: "The ends of the earth were afraid, drew near and came. They will help everyone his neighbor, and everyone will say to his brother: 'Be of good courage'" (41:5, 6).

Thus Isaiah's prophecies seem to be translated on the lintel out of dramatic pictorial language into dramatic relief sculpture. And another passage seems to have exerted an even more direct influence. This is the famous crowning prophecy in the last chapter, where the Lord says: "And I will set a sign among them, and I will send those of them that are saved to the nations in the sea, to Africa and Lydia that draw the bow, to Italy and Greece, to the isles afar off, to those that have not heard of me, neither have seen my glory; and they shall declare my glory among the gentiles" (66:19). This passage was interpreted by medieval theologians as the sending out of the apostles to all these nations[12] which, it seems, are represented on the lintel. . . .

The meaning of the lintel is even more complex. Not only do the peoples mentioned by Isaiah seem to be represented here, but they stand at the same time for different classes of humanity. We see the hunters with bow and arrow, the peasants and the fishermen, who bring the fruits of the soil, of the trees, and of the water. We see the priests, the soldiers, and the savage races. These different classes of humanity are arranged in a hierarchical order. The lowest

classes form the ends of the two processions, at the extreme left
the hunters, at the extreme right the savages. The highest classes,
the priests and the soldiers, are accorded the favored places at the
heads of the processions.

The other tasks of the apostles are represented in the eight
compartments of the archivolt. Here groups of people, who by their
appearance and costumes represent different races, discuss in a
passionate manner the mission of the apostles and the power which
Christ bestowed upon them. Some of them have again a monstrous
appearance. There are the sick who will be healed by the apostles,
and those whose souls will be saved by them. Specific examples
illustrate the tasks of the apostles. The four upper compartments,
which show different examples of physically and mentally defective
people, are a kind of an encyclopedia of these defects which the
sculptor renders in extremely dramatic terms. With feverish gestures
some of these sick people express their hopes of being healed. They
point toward the central scene, as if the realization of these hopes
were now at hand. . . .

The program of the archivolt stresses the idea that the grace about
to be accorded to the gentiles descends upon them by degrees. The
two compartments at the top show people laboring under the
severest permanent physical defects. In the next two transient or
minor ailments are shown. These defects and ailments can only be
cured by the working of miracles. The following pair of compart-
ments refers to those who can be saved by conversion, while in the
lowest pair the effects of grace are already apparent. In a similar
manner the groups on the lintel are arranged in graduated symmetry
from the ends toward the center. What is true of iconography also
applies to form: the idea of gradation is expressed in the very scale
of all the sculptured figures. Largest of all is Christ in the center.
His size stresses His all-pervading power. By their smaller size the
apostles are characterized as His helpers. Still smaller, and therefore
least important, are the peoples at the periphery. They are only
the objects of the work of salvation which Christ performs through
His apostles.

The violent gestures of the little figures show how the grace of
the Holy Spirit radiates immediately throughout the world. The
*Mission of the Apostles* has a world shaking, cosmic aspect. This
cosmic aspect is further enlarged by the outer archivolt, which
comprises the twelve signs of the zodiac and little scenes portraying

the occupations of the twelve months.[13] Christ is not only the ruler over space, over all the races of the world, but also over time, over the cycle of the year and its activities. . . .

<div align="center">II</div>

The central tympanum at Vézelay was created between the first and the second crusades, in an epoch which gave a new impulse to religious feeling and broadened the outlook of medieval thinkers. It was created in Burgundy, in the center of France, at a place which played a prominent role in the history of the crusades.

In 1095, on the eve of the first crusade, Urban II, the Cluniac Pope of French descent, had planned, according to William of Tyre,[14] to hold a council either in Vézelay or in Le Puy, but decided in favor of Clermont. There he called upon clerics and laymen to rescue the Christians of the East, to liberate by a pilgrimage in arms Jerusalem and the Oriental churches which had been overrun by the Moslems and were suffering so miserably. That was about thirty years before the tympanum was created. About fifteen years after its completion it was in Vézelay that St. Bernard preached the second crusade in 1146 and Louis VII, the king of France, took up the cross. Again it was from Vézelay that, in 1190, Richard Coeur de Lion and Philip Augustus, the French king, started for the third crusade. . . .

The canonical Acts of the Apostles and apocryphal acts report how the twelve apostles had, each in his allotted region, conquered the world for the Christian faith. They had established the Church unto the ends of the world. But later, with the coming of the Arabs, infidels had gradually overrun many parts of the world: all of Asia and Africa, and even parts of Europe.

In 1095, at the end of the Council of Clermont, Pope Urban II addressed the assembly. His speech, as different writers relate it in different versions, sounds like the proclaiming of a new mission which set a twofold task to the clerics and one to the laymen. The clerics alone were urged to persuade men of all ranks to take up the fight against the Moslems. According to Fulcher of Chartres, the Pope said: "Qua de re supplici prece hortor, non ego, sed Dominus, ut cunctis cuiuslibet ordinis tam equitibus quam peditibus, tam divitibus quam pauperibus, edicto frequenti vos, Christi

praecones, suadeatis, ut ad id genus nequam de regionibus nos-
trorum exterminandum tempestive Christicolis opitulari sa-
tagant."[15] But both clerics and laymen were called upon to re-
conquer the lost parts of the world for the Christian faith and
to liberate Jerusalem, the navel of the earth, and the Lord's
Sepulcher. . . . What had been achieved by the apostles had to be
achieved again, at the end of the eleventh century. The clerics were
urged to preach the crusade in their districts, and they were sent
out, together with the laymen, to reconquer the lost parts of the
world which once had been conquered by the apostles. Thus the
choice of the subject to be represented in the tympanum just at
this time seems to bear a deeper meaning. The encyclopedic *Mission
of the Apostles* prefigures the new mission of the crusaders. . . .

We have seen that the prophecy in the last chapter of Isaiah was
very likely the main literary source of the lintel. Medieval writers
believed that it had been fulfilled by the apostles, but it seemed
to be fulfilled again in the first crusade. This is the opinion of Peter
the Venerable. Once the prior of Vézelay, he had become abbot
of Cluny in 1122. In his sermon *In laudem sepulcri Domini* he quotes
this very prophecy which, he believes, came true again, when the
crusaders liberated the Holy Sepulcher from the rule of the infidels
and "purified with their holy swords the place and habitation of
heavenly purity."[16] This idea has its counterpart on the lintel where
the foremost soldier on the right, who may be considered as a
prototype of the crusading knights, presents his sword to the apostles
that it may be made holy.

Some other very characteristic elements in the program of the
tympanum seem to reflect quite closely ideas which the abbot of
Cluny has expressed in his writings. We have seen that the proph-
ecies of Isaiah may have played a paramount part in the conception
of the program. It is this same prophet whom Peter the Venerable
likes to quote as his primary witness. He invokes him as "eximie
prophetarum" or "maxime prophetarum."[17] "Audite divinum pro-
phetam," he says in his sermon on the Holy Sepulcher, "immo
praecipuum in prophetis ad vos ante multa saecula propheticum
oculum convertentem."[18]

Shortly after quoting the prophecy of the last chapter of Isaiah,
Peter the Venerable gives a list of miracles. He mentions first the
giving of sight to the blind, then the restoring of hearing to the
deaf and of speech to the dumb.[19] These are the three organic

defects, which are represented in the same sequence in the topmost compartment at the left. . . .

Since so many ideas which are expressed in the tympanum can be found in the writings of Peter the Venerable, may we not draw the conclusion that he may have worked out the program to be sculptured in the narthex at Vézelay? Peter the Venerable was a great theologian who took a keen interest in the liberation of the Holy Land. The Abbey of Vézelay was closely affiliated with Cluny and Peter had once been its prior. All this may speak in favor of his authorship. He might even have conceived the program while he was still there, although the actual sculpturing of the tympana was done during his abbotship at Cluny. In any case, the deep and complex meaning of the central tympanum betrays ideas of a great theologian. According to his program, prophecies of the Old Testament, their fulfillment by the *Mission of the Apostles* and their refulfillment by the new mission of the crusaders are interwoven here into a grandiose, cosmic, encyclopedic and at the same time beautifully dramatic unity.

## NOTES

NOTE: This article grew out of a lecture given in April, 1943, at The Pierpont Morgan Library, New York.

[1] See, for instance, G. Sanoner, "Portail de l'abbaye de Vézelay," *Revue de l'art chrétien*, LIV (1904), pp. 448 ff.; L. Eugene Lefevre, "Le symbolisme du tympan de Vézelay," *ibid.*, LVI (1906), pp. 253 ff.; Paul Mayeur, "Le tympan de l'église abbatiale de Vézelay," *ibid.*, LVIII (1908), pp. 103 ff.; Paul Mayeur, "Les scènes secondaires du tympan de Vézelay," *ibid.*, LIX (1909), pp. 326 ff.

[2] Émile Mâle, *L'art religieux du XII siècle en France* (Paris, 1922), pp. 326 ff.; Abel Fabre, "L'iconographie de la Pentecôte," *Gazette des Beaux-Arts*, 65° année (1923), II, pp. 33 ff. See also A. Kingsley Porter, "Spain or Toulouse? and Other Questions," ART BULLETIN, VII (1924–25), p. 20.

[3] A. Kingsley Porter, *Romanesque Sculpture of the Pilgrimage Roads* (Boston, 1923), Figs. 96, 97. Conant has recently reinterpreted in a similar manner the tympanum which once decorated the great portal at Cluny. See Kenneth John Conant, "The Third Church at Cluny," *Medieval Studies in Memory of A. Kingsley Porter*, II (Cambridge, 1939), pp. 335, 336.

[4] Acts I:II.

[5] The two events are represented on the same page, for instance, in the Carolingian Bible of S. Paolo fuori le mura, fol. 292v (Amédée Boinet, *La miniature carolingienne* [Paris, 1913], pl. CXXVIII). See also the Golden Gospel Book from

# The Iconography of a Romanesque Tympanum at Vézelay

Echternach, late tenth century (Gotha, Landesbibliothek, Ms. 1.19, fol. 112v; Albert Boeckler, *Das goldene Evangelienbuch Heinrichs III* [Berlin, 1933], Fig. 173). Both events are merged in a miniature of a Gospel Book from Seitenstetten of the early thirteenth century (Pierpont Morgan Library, Ms. 808, fol. 24; *Catalogue of the Renowned Collection of Western Manuscripts the Property of A. Chester Beatty*, ii [London, 1933], pl. 18). In some eleventh-century illustrations of the *Ascension of Christ* rays emanate from the clouds on which Christ stands. See Ernest T. Dewald, "The Iconography of the Ascension," *American Journal of Archaeology*, xix (1915), pp. 277 ff.; Figs. 19, 20.

[6] *Commentaria in Isaiam*, lib. iii, cap. 6 (*Patrologia Latina*, 24, col. 96).

[7] See Hugo of Poitiers, *Historia Vizeliacensis Monasterii*, lib. iii (*Patrologia Latina*, 194, col. 1605): "Ecclesia Vizeliacensis ab inclito Gerardo comite nobiliter fundata, nobilius ab eodem attitulata beatorum Petri et Pauli apostolorum nomini ascripta, juri assignata, regimini credita, protectioni commissa." Cf. also the beginning of a privilege granted by Pope Leo IX in 1050: "Leo episcopus, servus servorum Dei, Gaufrido abbati Vizeliacensis coenobii, quod est in honore Domini nostri Jesu Christi et veneratione ejusdem genitricis et beatorum apostolorum Petri et Pauli et beatae Mariae Magdalenae, ejusque successoribus in perpetuum" (*Patrologia Latina*, 143, col. 642).

[8] See Jean Adhémar, *Influences antiques dans l'art du moyen âge français, Studies of the Warburg Institute*, no. 7 (London, 1939), pp. 177 ff.

[9] Pliny, *Natural History*, vi. 35. 188, ed. H. Rackham, ii (London and Cambridge, 1942), p. 478. They are also mentioned as inhabitants of India.

[10] Pliny, *op. cit.*, iv. 13, 95; vii. 2. 30, ed. Rackham, ii, pp. 192, 526; C. Julius Solinus, *Collectanea Rerum Memorabilium*, xix. 8, ed. Th. Mommsen (Berlin, 1895), pp. 93, 94; Isidore of Seville, *Etymologiae*, xi. 3. 19, ed. W. M. Lindsay, Oxford.

[11] Cf. also Isaiah 2:2–4; Jeremiah 16:19; Zechariah 8:20–23.

[12] St. Jerome, *Commentaria in Isaiam*, lib. xviii, cap. 66 (*Patrologia Latina*, 24, cols. 692 ff.); Isidore of Seville, *De Fide Catholica*, lib. i, cap. 55 (*ibid.*, 83, cols. 493, 494); Haymo of Halberstadt, *Commentaria in Isaiam*, lib. iii, cap. 66 (*ibid.*, 116, col. 1082); Hugo of St. Victor, *Sermo de quibuslibet Apostolis* (*ibid.*, 177, cols. 1039 ff.).

[13] The chronological cycle consists of twenty-six medallions, comprising the twelve signs of the zodiac, the twelve labors of the months, and two extra medallions, i.e., the third from below on either side. Four additional medallions, which do not refer to the cycle of the year, form the topmost arc of the semicircle.

The two extra medallions which are inserted in the cycle of the year represent at the left, a man warming himself at a fire and another taking off his garment, at the right, a bearded man carrying a wrapped woman on his shoulders. These four figures may personify the four seasons. The four medallions at the top show an eagle, a dog (?), a man and a siren. One might think that three elements are symbolized by them, air by the eagle, earth by dog and man, and water by the siren. May one even go a step farther and see fire symbolized by the adjoining sign of the lion? Such groups of cosmological significance already frame late antique Mithraic reliefs, thereby stressing the power of the pagan god. On the relief of the *Birth of Mithras* from Trier, for instance, the zodiac and the four winds are grouped around the new-born god, while symbols of the four elements are repre-

263

sented in the crowning gable. See Fritz Saxl, *Mithras* (Berlin, 1931), Fig. 199.

[14] *Historia Rerum in Partibus Transmarinis Gestarum,* lib. I, cap. 14 (*Patrologia Latina,* 201, col. 231).

[15] "Wherefore, I exhort with earnest prayer—not I, but God—that, as heralds of Christ, you urge men by frequent exhortation, men of all ranks, knights as well as foot-soldiers, rich as well as poor, to hasten to exterminate this vile race from the lands of your brethren, and to aid the Christians in time" (August C. Krey, *The First Crusade* [Princeton and London, 1921], p. 29). I am greatly indebted to the Princeton University Press for the kind permission to quote this and other translations from Krey's book. For the original text, see *Fulcheri Carnotensis Historia Hierosolymitana,* lib. I, cap. 3, ed. Heinrich Hagenmeyer (Heidelberg, 1913), pp. 134, 135.

Cf. also the command, as reported by Balderic, Archbishop of Dol, in his *Historia Hierosolymitana,* lib. I, cap. 4: "Et conversus ad episcopos: 'Vos,' inquit, 'fratres et coepiscopi, vos consacerdotes et cohaeredes Christi, per ecclesias vobis commissas id ipsum annuntiate, et viam in Jerusalem toto ore viriliter praedicate. Confessis peccatorum suorum ignominiam, securi de Christo celerem paciscimini veniam'" (*Recueil des historiens des croisades, Historiens occidentaux,* IV, [Paris, 1879], p. 15).

[16] *Patrologia Latina,* 189, col. 985.

[17] *Tractatus adversus Judaeorum inveteratam duritiem,* cap. 1 (*ibid.,* col. 509); cap. 5 (*ibid.,* col. 608).

[18] "Listen to the divine prophet, yes indeed to the foremost among the prophets, who has turned his prophetical eye towards you many ages ago." For the original text, *see ibid.,* col. 982.

[19] *Ibid.,* col. 986.

# 14. MEDIEVAL ICONOGRAPHY

## Emile Mâle

## INTRODUCTION

Since its publication in 1898, Emile Mâle's *L'Art Religieux du XIIIe Siècle en France* has enjoyed an important place in the literature dealing with the iconography of medieval art. The English translation of 1913 (available in paperback as *The Gothic Image*) is the source for the selection in this anthology. In this work the imagery of Gothic cathedral decoration is related to the theological literature of the Middle Ages, particularly to the *Speculum* of Vincent of Beauvais, which supplies the framework for Mâle's study. Since Mâle is primarily concerned with the meaning of the images in Gothic decoration, one should read in conjunction with it Erwin Panofsky's *Gothic Architecture and Scholasticism* (1951), which emphasizes the role played by the diffusion of a scholastic "mental habit" in establishing relationships between scholastic thought and Gothic architecture.

For the iconography of Christian art there are a number of works in English. The numerous volumes by Anna B. Jameson are still valuable references: *The History of Our Lord*, 4th ed., 2 Vols. (1881); *Sacred and Legendary Art*, 2 Vols. (1911); *Legends of the Monastic Orders* (1911); *Legends of the Madonna* (1911). Other studies are Adolphe Didron, *Christian Iconography*, trans. by E. G. Millington, 2 Vols. (1896), and Maurice Drake, *Saints and Their Emblems* (1916). For the iconography of the Renaissance there is Erwin Panofsky's brilliant *Studies in Iconology* (1939), of which the introductory chapter is an excellent orientation to the whole subject of meaning in a work of art. It is also available in a paperbound edition. For mythological themes in art, there are such works as E. Panofsky

and F. Saxl, "Classical Mythology in Medieval Art," *Metropolitan Muséum Studies,* IV, 2 (1933); Kurt Weitzmann, *Greek Mythology in Byzantine Art* (1951); and Jean Seznec, *The Survival of the Pagan Gods* (1953). André Grabar, *Christian Iconography: A Study of Its Origins* (1968), deals with Christian images of late antiquity and their origins in the visual arts, especially useful for the metamorphosis from pagan to Christian content. Joan Evans, *Monastic Iconography in France from the Renaissance to the Revolution* (1970), examines the later history of this area of iconography, and Gertrud Schiller, *Iconography of Christian Art,* I (1971), deals with the iconography relating to Christ. While not, strictly speaking, an iconographical study—for its range is much broader than that—G. B. Ladner's *Ad Imaginem Dei: The Image of Man in Medieval Art* (1965) is a stimulating study of developments.

## GENERAL CHARACTERISTICS OF
## MEDIEVAL ICONOGRAPHY

The Middle Ages had a passion for order. They organized art as they had organized dogma, secular learning and society. The artistic representation of sacred subjects was a science governed by fixed laws which could not be broken at the dictates of individual imagination. It cannot be questioned that this theology of art, if one may so put it, was soon reduced to a body of doctrine, for from very early times the craftsmen are seen submitting to it from one end of Europe to the other. This science was transmitted by the Church to the lay sculptors and painters of the thirteenth century who religiously guarded the sacred traditions, so that, even in the centuries in which it was most vigorous, medieval art retained the hieratic grandeur of primitive art.

These are the general principles which it concerns us to state at the outset as briefly as possible.

### I

The art of the Middle Ages is first and foremost a sacred writing of which every artist must learn the characters. He must know that the circular nimbus placed vertically behind the head serves to express sanctity, while the nimbus impressed with a cross is the sign of divinity which he will always use in portraying any of the three Persons of the Trinity.[1] He will learn that the aureole (i.e. light which emanates from the whole figure and surrounds the body as a nimbus) expresses eternal bliss, and belongs to the three Persons of the Trinity, to the Virgin, and to the souls of the Blessed. He must know that representations of God the Father, God the Son, the angels and the apostles should have the feet bare, while there would be real impropriety in representing the Virgin and the saints with bare feet. In such matters a mistake would have ranked almost as heresy. Other accepted symbols enabled the medieval artist to

# EMILE MÂLE

express the invisible, to represent that which would otherwise be beyond the domain of art. A hand emerging from the clouds, making the gesture of benediction with thumb and two fingers raised, and surrounded by a cruciform nimbus, was recognized as the sign of divine intervention, the emblem of providence. Little figures of nude and sexless children, ranged side by side in the folds of Abraham's mantle, signified the eternal rest of the life to come.

There are also accepted signs for objects of the visible world which the artist must learn. Lines which are concentric and sinuous represent the sky, those which are horizontal and undulating represent water. A tree, that is to say a stalk surmounted with two or three leaves, indicates that the scene takes place on the earth; a tower pierced by a doorway is a town, while if an angel watch on the battlements it is the heavenly Jerusalem.[2] Thus we have a veritable hieroglyphic[3] in which art and writing blend, showing the same spirit of order and abstraction that there is in heraldic art with its alphabet, rules and symbolism. . . .

## II

The second characteristic of medieval iconography is obedience to the rules of a kind of sacred mathematics. Position, grouping, symmetry and number are of extraordinary importance.

To begin with, the whole church is oriented from the rising to the setting sun, a custom dating back to primitive Christian days for it is found even in the *Apostolical Constitutions*. In the thirteenth century Gulielmus Durandus cites this as a rule without exception:—"The foundations must be disposed in such a manner that the head of the church lies exactly to the east, that is to the part of the sky in which the sun rises at the equinox." And, as a matter of fact, from the eleventh to the sixteenth century it is difficult to find a badly oriented church. Like other traditions of medieval art the rule fell into neglect toward the time of the Council of Trent, the Jesuits being the first to violate it.

Each cardinal point has its significance in churches oriented in this way. The north, region of cold and darkness, is usually consecrated to the Old Testament, and the south, bathed in warm sunlight is devoted to the New, though there are many exceptions to the rule.[4] The western façade—where the setting sun lights up the great scene of the evening of the world's history—is almost

268

invariably reserved for a representation of the Last Judgment. The medieval doctors, with their curiously bad etymology, connected *occidens* with the verb *occidere,* and the west became for them the region of death.

After orientation it was relative position which most engrossed the artist, here again at one with the theologian. In early times certain passages in the Bible led to the belief that the right hand was the place of honor. Is it not written, for example, in the Psalms: "Adstitit regina a dextris tuis in vestitu deaurato?" In the *Shepherd* of Hermas which belongs to primitive Christian literature, the right is the place given to those who are marked out for honor. In the account of the third vision it is said that the Church caused Hermas to be seated on a bench at her side. When he would have seated himself to her right she signed to him to pass to the left, because the right is reserved for those who have suffered in the name of God. The medieval theologians in their turn laid great stress on the dignity of the right hand place, and the artists did not fail to conform to so well-established a doctrine. When, for example, the Savior is represented in the midst of His apostles, St. Peter—first in dignity—occupies a place to the right of the Master.[5] In the same way in the scene of the Crucifixion or in that of the Last Judgment, the Virgin is to the right, St. John to the left.

Again, the higher place was considered more honorable than the lower, and from this some curious compositions resulted. Of these the most striking is that of the figure of Christ in Majesty supported by the four beasts of the Apocalypse. The four beasts, symbols of the evangelists as we shall show later, were placed according to the excellence of their natures—man, eagle, lion and ox. When it was a question of disposing them in a tympanum, the dignity conferred by the higher and that conferred by the right hand place had to be taken into consideration. The following arrangement was the one generally adopted. The winged man was placed at the top of the composition and to the right of Christ, the eagle at the top to the left, the lion at the bottom to the right, the ox at the bottom to the left[6] (Fig. 40). . . .

But no disposition met with more favor than that controlled by symmetry. Symmetry was regarded as the expression of a mysterious inner harmony. Craftsmen opposed the twelve patriarchs and twelve prophets of the Ancient Law to the twelve apostles of the New,

269

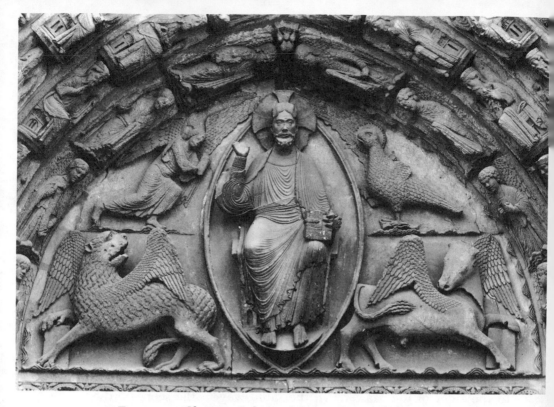

40. Tympanum: Christ as Judge and Ruler of the Universe with Symbols of Evangelists, Central Portal, West Façade, Chartres Cathedral, *c.* 1150 (Marburg-Art Reference Bureau)

and the four major prophets to the four evangelists. A window in the south transept at Chartres shows—with audacious symbolism—the four prophets Isaiah, Ezekiel, Daniel and Jeremiah bearing on their shoulders the four evangelists, St. Matthew, St. John, St. Mark, St. Luke. In this way the artists would tell us that although the evangelists rest upon the prophets, yet from their spiritual vantage-ground they have a wider outlook. The four and twenty elders of the Apocalypse frequently correspond to the twelve prophets and the twelve apostles. . . .

Schemes of this kind presuppose a reasoned belief in the virtue of numbers, and in fact the Middle Ages never doubted that numbers were endowed with some occult power. This doctrine came from the Fathers of the Church, who inherited it from those Neoplatonic schools in which the genius of Pythagoras had lived again. It is evident that St. Augustine considered numbers as thoughts of God. In many passages he lays it down that each number has its divine significance. "The Divine Wisdom is reflected in the numbers

impressed on all things."[7] The construction of the physical and moral worlds alike is based on eternal numbers. We feel that the charm of the dance lies in rhythm, that is in number; but we must go further, beauty is itself a cadence, harmonious number.[8] The science of numbers, then, is the science of the universe, and from numbers we learn its secret. Therefore the numbers met with in the Bible should be considered with reverent attention, for they are sacred and full of mystery.[9] He who can read them enters into the divine plan. . . .

A few examples will give some idea of the method. From St. Augustine onward all theologians interpreted the meaning of the number twelve after the same fashion. Twelve is the number of the universal Church, and it was for profound reasons that Jesus willed the number of His apostles should be twelve. Now twelve is the product of three by four. Three, which is the number of the Trinity and by consequence of the soul made in the image of the Trinity, connotes all spiritual things. Four, the number of the elements, is the symbol of material things—the body and the world—which result from combinations of the four elements.[10] To multiply three by four is in the mystic sense to infuse matter with spirit, to proclaim the truths of the faith to the world, to establish the universal Church of which the apostles are the symbol.[11]

Computations of this kind were often more than ingenious, and at times reached real grandeur. The number seven, regarded by the Fathers as mysterious above all others, intoxicated the medieval mystic. It was observed first of all that seven—composed of four, the number of the body, and of three, the number of the soul—is preeminently the number of humanity, and expresses the union of man's double nature. All that relates to him is ordered in series of sevens. Human life is divided into seven ages with each of which is associated the practice of one of the seven virtues. The grace necessary for the practice of these seven virtues is gained by addressing to God the seven petitions of the Paternoster. The seven sacraments sustain man in the exercise of the seven virtues, and guard him from falling into the seven deadly sins.[12] The number seven thus expresses the harmony of man's nature, but it also expresses the harmonious relation of man to the universe. The seven planets govern human destiny, for each of the seven ages is under the influence of one of them. Thus seven invisible threads connect man with the scheme of the universe.[13] . . .

## III

The third characteristic of medieval art lies in this, that it is a symbolic code. From the days of the catacombs Christian art has spoken in figures, showing men one thing and inviting them to see in it the figure of another. The artist, as the doctors might have put it, must imitate God who under the letter of Scripture hid profound meaning, and who willed that nature too should hold lessons for man.

In medieval art there are then intentions a knowledge of which is necessary to any real understanding of the subject. When for example in scenes of the Last Judgment we see the Wise and Foolish Virgins to the right and left hand of Christ, we should thereby understand that they symbolize the elect and the lost. Upon this all the commentators on the New Testament are agreed, and they explain it by stating that the five Foolish Virgins typify the desires of the five senses, and the five Wise Virgins the five forms of the contemplative life. To take another example, it is not as rivers that the four rivers of Paradise—the Gihon, Phison, Tigris, and Euphrates—are represented pouring water from their urns towards the four points of the compass, but as symbols of the evangelists who flooded the world with their teaching like four beneficent streams.

An Old Testament personage in the porch of a cathedral is but a type, an adumbration of Christ, the Virgin, or the future Church. At Chartres the form of Melchizedek, priest and king, bearing the bread and wine to Abraham, should remind men of another priest and king who offered bread and wine to His disciples. At Laon Gideon calling down rain from heaven on to the fleece he had laid on the earth, reminds men that the Virgin Mother was this symbolic fleece on whom fell the dew from on high.

A detail of apparent insignificance may hide symbolic meaning. In a window at Bourges the lion near to the tomb from which the risen Christ comes forth is a type of the Resurrection. It was generally believed in the Middle Ages that for three days after birth the cubs of the lioness gave no sign of life, but that on the third day the lion came and with his breath restored them to life. And so the apparent death of the lion represents the sojourn of Jesus in the tomb, and its birth was an image of the Resurrection.

In the art of the Middle Ages, as we see, everything depicted is informed by a quickening spirit.

Such a conception of art implies a profoundly idealistic view of the scheme of the universe, and the conviction that both history and nature must be regarded as vast symbols. We shall see later that this undoubtedly was the view of the medieval mind. Further, it should be remembered that such ideas were not the property of the great thirteenth century doctors alone, but were shared by the mass of the people to whom they had permeated through the teaching of the Church. The symbolism of the church services familiarized the faithful with the symbolism of art. Christian liturgy like Christian art is endless symbolism, both are manifestations of the same genius. . . .

From what has been said it is evident that medieval art was before all things a symbolic art, in which form is used merely as the vehicle of spiritual meaning.[14]

Such are the general characteristics of the iconography of the Middle Ages. Art was at once a script, a calculus and a symbolic code. The result was a deep and perfect harmony. There is something musical in the grouping of the statues in the cathedral porches, and in truth all the elements of music are present. Are there not here conventional signs grouped according to the law of numbers, and is there not something of the indefinite quality of music in the infinite symbolism dimly discerned behind the outward forms? The genius of the Middle Ages, so long misunderstood, was a harmonious genius. Dante's Paradiso and the porches at Chartres are symphonies. To thirteenth century art more truly perhaps than to any other might be given the title of "frozen music."

## METHOD USED IN THE STUDY OF
## MEDIEVAL ICONOGRAPHY

### THE MIRRORS OF VINCENT OF BEAUVAIS

The thirteenth century was the century of encyclopedias. At no other period have so many works appeared bearing the titles of *Summa, Speculum* or *Imago Mundi*. It was in this century that Thomas Aquinas coordinated the whole body of Christian doctrine, Jacobus de Voragine collected the most famous legends of the saints,

Gulielmus Durandus epitomized all previous writers on the liturgy, and Vincent of Beauvais attempted to embrace universal knowledge. Christianity came to full consciousness of its own genius, and the conception of the universe which had been elaborated by previous centuries received complete expression. It was believed to be possible to raise the final edifice of human knowledge, and in the universities which had recently been founded throughout Europe—above all the young university of Paris—the work was carried on with enthusiasm.

While the doctors were constructing the intellectual edifice which was to shelter the whole of Christendom, the cathedral of stone was rising as its visible counterpart. It too in its fashion was a *Speculum*, a *Summa*, an *Imago Mundi* into which the Middle Age put all its most cherished convictions. These great churches are the most perfect known expression in art of the mind of an epoch. We shall attempt to show that in them a whole dogmatic scheme found expression in concrete form.

The difficulty lies in grouping in logical sequence the innumerable works of art which the churches offer for our study. Surely we have hardly the right to dispose of the matter according to some arbitrary scheme which appears to us harmonious. It is necessary to discard modern habits of mind. If we impose our categories on medieval thought we run every risk of error, and for that reason we borrow our method of exposition from the Middle Age itself. The four books of Vincent of Beauvais's *Mirror* furnish us with the framework for the four divisions of our study of thirteenth century art.

If Aquinas was the most powerful thinker of the Middle Ages, Vincent of Beauvais was certainly the most comprehensive. He might well be called an epitome of the knowledge of his day. A prodigious worker, he passed his life like the elder Pliny in reading and making extracts. He was called "librorum helluo," the devourer of books. St. Louis threw open to him the fine library containing virtually all the books procurable in the thirteenth century, and at times came to visit him at the abbey of Royaumont, where he loved to hear him talk of the wonders of the universe.

It was probably toward the middle of the century that Vincent of Beauvais published the great *Mirror*, the *Speculum majus*, which to his contemporaries seemed the supreme effort of human learning. Even today one cannot but admire so stupendous a work.[15]

His learning was immense, yet it did not overwhelm him. The order which he adopted was the most imposing which the Middle Age could conceive—the very plan of God as it appears in the Scriptures. Vincent of Beauvais's work is divided into four parts—the Mirror of Nature, the Mirror of Instruction, the Mirror of Morals[16] and the Mirror of History.

In the Mirror of Nature are reflected all natural phenomena in the order in which they were created by God. The Days of Creation mark the different chapters of this great encyclopedia of nature. The four elements, the minerals, vegetables and animals are successively enumerated and described. All the truth and the error which had been transmitted by antiquity to the Middle Ages are found there. But it is naturally on the work of the sixth day—the creation of man—that Vincent of Beauvais dwells at greatest length, for man is the center of the universe and for him all things were made.

The Mirror of Instruction opens with the story of the Fall, the recital of the drama which explains the riddle of the universe. Man has fallen, and only through a Redeemer can he hope for salvation. Yet in his own strength he can begin to raise himself, and through knowledge to prepare for grace. There is in knowledge a quickening power, and to each of the seven Arts corresponds one of the seven Gifts of the Spirit. After expounding this large and humane doctrine Vincent of Beauvais passes in review all the different branches of knowledge; even the mechanical arts are included, for by the labor of his hands man begins the work of his redemption.

The Mirror of Morals is closely connected with the Mirror of Instruction, for the end of life is not to know but to act, and knowledge is but a means to virtue. Out of this springs a learned classification of the virtues and vices, in which the method, divisions and often the very expressions of Aquinas are found—for the *Speculum morale* is the *Summa* in abridged form.

The last division is the Mirror of History. We have studied human nature in the abstract, and we now turn to man himself, watching his progress under the eye of God. He invents arts and sciences, he struggles and suffers, choosing sometimes vice, sometimes virtue in the great battle of the soul which is the sum of the world's history. It is hardly necessary to observe that for Vincent of Beauvais, as for Augustine, Orosius, Gregory of Tours and all the historians of the Middle Ages, true history is the history of the Church, the City

of God, which begins with Abel the first just man. There is a chosen people and their history is the pillar of fire which lightens the darkness. The history of the pagan world is deserving of study only with reference to the other; it has merely value as a synchronism. It is true that Vincent of Beauvais did not scorn to tell of the revolution of empires, and even delighted in speaking of pagan philosophers, scholars and poets, but such subjects are really incidental. The dominant thought of his book—the idea which gives it unity—is the unbroken line of saints of the Old and New Testaments. Through them and them alone the history of the world becomes coherent.

Thus was conceived this Encyclopedia of the thirteenth century. In it the riddle of the universe finds solution. The plan is so comprehensive that the Middle Ages could conceive of nothing which it did not include, and until the Renaissance the following centuries found nothing to add to it.

Such a book is the surest guide that we can choose for our study of the great leading ideas which lay behind the art of the thirteenth century. Striking analogies are noticeable, for example, between the general economy of the *Speculum Majus* and the plan followed in the porches of the cathedral of Chartres. As was first pointed out by Didron in the authoritative introduction to his *Histoire de Dieu*, the innumerable figures which decorate the porches may well be grouped under the four heads of nature, instruction, morals, and history. We do not know whether that great decorative scheme was directly inspired by Vincent of Beauvais's book with which it was almost contemporaneous, but it is obvious that the arrangement of the *Speculum Majus* belonged not to him but to the Middle Ages as a whole. It was the form which the thirteenth century imposed on all ordered thought. The same genius disposed the chapters of the *Mirror* and the sculpture of the cathedral. It is then legitimate to seek in the one the meaning of the other.

We shall therefore adopt the four great divisions of Vincent of Beauvais's work, and shall try to read the four books of the *Mirror* in the façades of the cathedrals. We shall find them all four represented, and shall decipher them in the order in which the encyclopedist presents them. Each detail will in this way find its place, and the harmony of the whole will appear.

# Medieval Iconography

. . . The Mirror of Nature is carved in brief on the façades of most of the French cathedrals. We find it at Chartres, at Laon, at Auxerre, Bourges and Lyons, treated in a restrained and conventional way. At Chartres a lion, a sheep, a goat and a heifer stand for the animal world, a fig tree and three plants of indeterminate character represent the vegetable kingdom; there is an element of greatness in this summing up of the universe in some five or six bas-reliefs. Some naïve details are full of charm. In the representation at Laon the Creator sits in deep reflection before dividing the darkness from the light, and counts on His fingers the number of days needed to finish His work. Later in the series, when His task is accomplished, He sits down to rest like a good workman at the end of a well-spent day, and leaning on His staff He falls asleep.

One might well feel that these few typical forms were inadequate representations of the wealth of the universe, and might accuse the thirteenth-century craftsmen of timidity and want of power, did the animal and vegetable worlds really occupy no further place in the cathedral scheme. But a glance upward shows us vines, raspberries heavy with fruit and long trails of the wild rose clinging to the archivolts, birds singing among the oak leaves or perching on the pillars. Beasts from far-off lands side by side with homely creatures of the countryside—lions, elephants and camels, squirrels, hens and rabbits—enliven the basement of the porch, while monsters securely fastened by their heavy stone wings bark fiercely at us from above. How little do these old masters with their unequalled, if naïve love of nature deserve the reproach of lack of power or invention. Their cathedrals are all life and movement. The Church to them was the ark to which every creature was made welcome, and then—as if the works of God were not sufficient for them—they invented a whole world more of terrible beings, creatures so real that they surely must have lived in the childhood of the world. . . .

There are few cases in which it is permissible to assign symbolic meaning to animal forms, but they are of such a kind that through literary references one may reach sure conclusions.

The four beasts surrounding the figure of Christ in Glory, found in the porch of so many churches, form the first class of representa-

tions in which the symbolic meaning cannot be mistaken. The motif of the four creatures—the man,[17] the eagle, the lion and the ox—so frequent in the Romanesque period, became more rare in the thirteenth century though not entirely discarded. The four creatures are seen, for example, on the Porte du Jugement of Notre Dame at Paris. It is true they no longer have the breadth, the heraldic boldness which is so striking at Moissac, and they no longer fill the tympanum but hide humbly in the lower portion of the doorway.

From earliest Christian times the man, the eagle, the lion and the ox, first seen in Ezekiel's vision by the river Chebar and later by St. John round the throne of God, were accepted symbols of the four evangelists.

. . . The emblem of St. Matthew is the man, because his gospel begins with the genealogical table of the ancestors of Jesus according to the flesh. The lion designates St. Mark, for in the opening verses of his gospel he speaks of the voice crying in the wilderness. The ox—the sacrificial animal—symbolizes St. Luke, whose gospel opens with the sacrifice offered by Zacharias. The eagle—an echo of the natural history of the Bestiaries—who alone of created things was reputed to gaze straight into the light of the sun, is the emblem of St. John, who from the first transports men to the very heart of divinity. Again, these same creatures are symbols of Christ, for in them may be seen four great mysteries in the life of the Savior. The man recalls the Incarnation, and reminds men that the Son of God became man. The ox, victim of the Old Law, calls to remembrance the Passion—the Redeemer's sacrifice of His life for mankind. The lion, which in the fabled science of the Bestiaries sleeps with open eyes, is the symbol of the Resurrection, for therein, says the lectionary, is a figure of Jesus in the tomb. "For the Redeemer in virtue of His humanity appeared to sink into the sleep of death, but in virtue of His divinity He was living and watching." Lastly, the eagle is a figure of the Ascension. Christ rose to Heaven as the eagle rises to the clouds. Summing up its teaching in a precise formula, the lectionary lays it down that Christ was man in His birth, ox in His death, lion in His Resurrection, eagle in His Ascension.[18]

But the four creatures have yet a third meaning, and express the virtues necessary for salvation. Each Christian on his way to divine perfection must be at once man, ox, lion and eagle. He must be man because man is a reasonable animal, and he who treads the

path of reason alone deserves that name. He must be ox because the ox is the sacrificial victim, and the true Christian by renouncing worldly pleasures sacrifices himself. He must be lion because the lion is the most courageous of beasts, and the good man having renounced all worldly things fears nothing, for of him it is written, "The righteous are bold as a lion." And he must be eagle because the eagle flies in the heights looking straight into the sun, type of the Christian who with direct gaze contemplates the things of eternity.

This is the Church's teaching on the four creatures, but only one of these interpretations, that likening the apocalyptic beasts to the evangelists, survived medieval times. The others shared the fate of all the old mystical theology, and at the Reformation fell into oblivion. But Protestants themselves remained faithful to tradition on the first point, and in the seventeenth century Rembrandt painted his sublime St. Matthew of the Louvre listening with all his soul to the words of an angel who, deep in shadow, whispers to him of eternal things. . . .

### THE MIRROR OF INSTRUCTION

The world has come into being. The work of God is finished and perfect, but the harmony is destroyed for man has misused his liberty. Sin has brought misery into the world, and henceforth mankind is like the wretched Adam and Eve who at the top of Notre Dame at Paris seem to shiver in the mist and the rain.[19]

The Church proclaims through her art that fallen humanity can only be restored through the grace of God and the sacrifice of Christ, but that man must merit grace and must take his part in the work of redemption. In the preface to his *Speculum doctrinale* Vincent of Beauvais expresses the conviction—"Ipsa restitutio sive restauratio per doctrinam efficitur" and, as the sequel shows, by "doctrina," he understands work of every kind, even the humblest. The Middle Age was not only the age of contemplation, it was also the age of work accepted and conceived not as servitude but as enfranchisement. Manual labor—in substance we quote Vincent of Beauvais—delivers man from the necessities to which since the Fall his body is subject, while instruction delivers him from the ignorance which has weighed down his soul.[20] And so in the cathedrals, where all medieval thought took visible shape, knowledge and manual

labor are given a place of equal honor. In the church where kings, barons and bishops fill so modest a place we find representations of almost every craft. At Chartres and Bourges, for example, in the windows given by the guilds, the lower part shows the donors with the badges of their trade—trowel, hammer, wool-carding comb, baker's shovel and butcher's knife.[21] In those days no incongruity was felt in placing these pictures of daily life side by side with scenes from the legends of the saints. The dignity and sanctity of labor were expressed in this way. . . .

But it was to the primeval work of tilling the soil, the task which God Himself imposed on Adam, that the Church seems to have given the foremost place. In several French cathedrals the cycle of the year's work is carved round the orders of the arch or on the basement of the porch.[22] A sign of the zodiac accompanies each scene of harvest, tillage or vintage. Here are really "The Works and Days."

The custom of decorating the churches with calendars in stone was well-established in primitive Christian times, for we know that the pavements of early basilicas were sometimes engraved with symbolic figures of the seasons. The mosaic from a church at Tyre given to the Louvre by the Renan mission represents scenes of the hunt and vintage accompanied by figures of the months.[23] This work is classical in character, and probably came from some thermæ or villa. The Church did not scruple to borrow pagan forms, and to hallow them by reading into them a Christian meaning. The sequence of the months became a reminder not only of the cycle of labor, but also of the cycle of the Christian year—the round of prayers and festivals.

The Romanesque churches, whose pavements were so often decorated with the signs of the zodiac, show how faithfully the traditions of earlier centuries were preserved. . . .

At Chartres[25] and Paris[26] the signs of the zodiac and the rural scenes which accompany them were disposed so as to follow the course of the sun. The signs of the months mount like the sun from January to June and descend from June to December. . . .

From manual labor man rises to instruction which by dissipating error enables him in some measure to raise himself after the Fall. The Seven Arts (the Trivium and the Quadrivium) open out seven paths of human activity. On the one side are grammar, rhetoric, dialectic, on the other arithmetic, geometry, astronomy and music.

Above the Liberal Arts stands Philosophy, the mother of them all. Philosophy and the Arts contain all the knowledge possible for man to acquire apart from revelation.[27]

The artists of the thirteenth century, intent upon embracing the whole domain of human activity, did not fail to include on the façades of their cathedrals the eight Muses of the Middle Ages. These queenly figures—youthful and serious—were never denizens of this world; they live enthroned above it like the Ideas of which Goethe speaks. . . .

The cathedral teaches that work of any kind demands respect. Another lesson she would teach men is to expect neither riches from manual labor nor fame from learning. Work and knowledge are the instruments of man's inner perfection, and the things which his activities gain for him are of a material and fleeting nature.

In the cathedral at Amiens a curious figure embodies this moral truth. There is in the upper part of the south porch a kind of half-wheel round which seventeen small figures are arranged. Eight of them seem to be carried up with the wheel, and eight others descend with it. At the top a man is seated, his head crowned and a scepter in his hand, motionless while all around him moves. Is this, as Didron tried to prove, an allegory of the different ages of man?[28] We do not think so. The figures descending so abruptly with the wheel are dressed in rags, and have bare feet or shoes through which their toes appear. This surely must convince one with Jourdain and Duval that this symbolic half-circle is not the wheel of Life, but the wheel of Fortune.[29] A miniature in an Italian manuscript of the fourteenth century supports this interpretation.[30] Near to the figure which seems to mount the wheel is written "regnabo," near to that enthroned at the summit "regno," near to those descending on the other side "regnavi" and "sum sine regno." The subject is certainly power, riches, glory, pomps and vanities of the world, and the wheel expresses the instability of these things. . . .

THE MIRROR OF MORALS

Nature, knowledge, virtue—that is the order in the *Speculum majus*. It will be remembered that these are the three worlds of Pascal, the world of material things, the world of mind and the world of love. The unity of Christian thought is so marked that one finds it unchanged through the centuries. Virtue is higher than

knowledge or art, said the Middle Ages, it is man's goal. But curiously enough the artists have sometimes placed the highest in the lowliest position. At Paris and Amiens the twelve pensive maidens who symbolize the virtues are not enthroned above the doorway with the angels and the blessed, but are placed at the level of men's eyes so that in passing to and fro they may learn to know them well. Age after age, worn by the rubbing of countless hands, covered with the dust from countless feet, they stand indeed one with the life around them. . . .

Apparently it was Tertullian who first represented the Virtues as warrior-maidens struggling with the Vices in the arena. "See," says he, "wantonness overthrown by chastity, perfidy killed by honesty, cruelty thrown down by pity, pride conquered by humility; these are the games in which we Christians receive our crowns."[31] . . . He was the first to give naïve expression to the profound teaching that Christianity had not brought peace to the world but a sword, and that the soul had become a battlefield. In its ignorance of the true nature of man the ancient world tried to establish a harmony which is not of this world, for so long as man lives will the conflict between his two natures exist. The drama which to the ancients was the struggle of man with Fate is in reality a conflict raging within the soul.

The idea of an inner battle, or Psychomachia, does not indeed belong to Tertullian since it is one of the fundamental ideas of Christianity, but to his imagination is due its concrete embodiment. . . .

From the twelfth century onward the theologians, and after them the artists, began to see the opposition of the virtues and the vices under new aspects. Honorius of Autun, one of the perennial sources of inspiration for medieval art, conceives virtue as a ladder which links earth to heaven.[32] He interprets the vision of Jacob in a moral sense. Each of the fifteen rungs of the ladder is a virtue, and he gives their names—patientia, benignitas, pietas, simplicitas, humilitas, contemptus mundi, paupertas voluntaria, pax, bonitas, spirituale gaudium, sufferentia, fides, spes, longanimitas and perseverantia. . . .

About the same time another metaphor appeared. The theologians of the twelfth and thirteenth centuries who studied the connection between virtues and vices with such diligence, frequently compared them to two vigorous trees. Hugh of St. Victor,

one of the first to present this new idea in fully developed form, gives a name to each branch of the two trees.[33] One is the tree of the old Adam and has pride as its root and main stem. From the trunk spring seven great boughs, envy, vainglory, anger, sadness, avarice, intemperance, luxury. In its turn each bough divides into secondary branches. For example, from sadness grow fear and despair. The second tree is the tree of the new Adam with humility for its trunk, and the three theological and the four cardinal virtues as its seven main branches. Each virtue is subdivided in its turn. From faith grow the shoots of chastity and obedience, from hope come patience and joy, from charity concord, liberality, peace and mercy. The first of these trees was planted by Adam and the second by Christ, it is for man to choose between them. One of the most famous of thirteenth-century books, the *Somme le Roi* written in French for Philip the Bold by Brother Laurent, his Dominican confessor, presents Hugh of St. Victor's idea under new forms. The author begins by showing the two trees of good and of evil, but with a deeper knowledge of human nature he gives love, that is charity, as the root of the first tree, and desire, that is egoism, as the root of the second. Thus all the vices spring from love of self, as all the virtues from forgetfulness of self.

### THE MIRROR OF HISTORY

So far the subject of our study has been man in the abstract—man with his virtues and his vices, with the arts and sciences invented by his genius. We now turn to the study of humanity living and acting. We have reached history.

The cathedral recounts the history of the world after a plan which is in entire agreement with the scheme developed by Vincent of Beauvais. At Chartres, as in the *Speculum historiale,* the story of humanity is virtually reduced to the history of the elect people of God. The Old and the New Testament and the Acts of the Saints furnish the subject matter, for they contain all that it is necessary for man to know of those who lived before him. They are the three acts in the story of the world, and there can be but three. The course of the drama was ordained by God Himself. The Old Testament shows humanity awaiting the Law, the New Testament shows the Law incarnate, and the Acts of the Saints shows man's endeavor to conform to the Law. . . .

But since the Council of Trent the Church has chosen to attach herself to the literal meaning of the Old Testament, leaving the symbolic method in the background. And so it has come about that the exegesis based on symbolism of which the Fathers made constant if not exclusive use, is today generally ignored. For this reason it seems useful briefly to set forth a body of doctrine which so often found expression in art.

God who sees all things under the aspect of eternity willed that the Old and New Testaments should form a complete and harmonious whole; the Old is but an adumbration of the New. To use medieval language, that which the Gospel shows men in the light of the sun, the Old Testament showed them in the uncertain light of the moon and stars. In the Old Testament truth is veiled, but the death of Christ rent that mystic veil and that is why we are told in the Gospel that the veil of the Temple was rent in twain at the time of the Crucifixion. Thus it is only in relation to the New Testament that the Old Testament has significance, and the Synagogue who persists in expounding it for its own merits is blindfold.

This doctrine, always held by the Church, is taught in the Gospels by the Savior Himself, "As Moses lifted up the serpent in the wilderness, even so must the son of man be lifted up,"[34] and again, "Even as Jonah was three days and three nights in the belly of the whale, so shall the Son of man be three days and three nights in the depths of the earth."[35] . . .

An immense popular literature relating to the Bible arose in the East. These legends have a very different character according as they refer to the Old or the New Testament. The traditions relating to the Old Testament, which first claim our attention, are full of marvels, and introduce us to a fairy world as strange as that of the *Thousand and one Nights*. The rabbis with their commentaries and the Arabs with their stories created a new Bible, all dream and phantasy;[36] amendment and expansion of the sacred text occur in every line. . . .

Such stories bear the mark of their origin. In the burning deserts of the East the imagination seems to have something of the nature of that light which creates the unreal world of mirage.

All of these marvellous stories were not known to the Middle Ages, though some travelled as far as the West and were accepted by the commentators. Some of them were inserted by Peter

Comestor in the *Historia Scolastica* and by Vincent of Beauvais in the *Speculum historiale.*

At times the artists drew inspiration from them. . . .

No figure in the New Testament owes more to legend than that of the Virgin. The Gospel account in which she rarely appears, and still more rarely speaks, soon seemed inadequate to men who would know of her family, her childhood, the circumstances of her marriage, her latter years and her death. And so there arose in primitive times the apocryphal stories which charmed the Middle Ages. The figure of the Virgin is seen against a background of legend, as in the pictures of the old German masters she is seen against a hedge of roses. . . .

The cult of the Virgin which grew up in the twelfth century developed in the thirteenth. The bells of Christendom began to ring the Angelus, the Office of the Virgin was recited daily, and the finest cathedrals arose under her patronage. Christian thought, meditating through the centuries on the mystery of a virgin chosen of God, anticipated the dogma of the Immaculate Conception, and as early as the twelfth century the mystical church of Lyons celebrated that festival. The monks ever thinking of the Virgin in their solitude extolled her perfections, and more than one of them deserved the title of Doctor Marianus, which was given to Duns Scotus. The new orders, Franciscans and Dominicans, true knights of the Virgin, spread her cult among the people. . . .

The history of the Christian world is presented in the cathedrals as it is in Vincent of Beauvais's *Speculum historiale,* where periods are reckoned not by the deeds of emperors and kings but by the lives of saints. The windows and statuary of the churches proclaim that since the coming of Christ the really great men are the doctors, confessors and martyrs. Conquerors who filled the world with their fame appear in the humblest of attitudes; tiny figures smaller than children, they kneel at the feet of the saints.

We know from the *Speculum historiale* that such was the medieval conception of history. Nothing could be more surprising than the scheme of the great work from which so many generations of men—and the kings themselves—learned history. At the beginning of each chapter Vincent of Beauvais mentions the emperors of the East and of Germany and the kings of France, and devotes a few lines to their battles and their treaties. He then reaches his subject, the story of the saints who were contemporaries of these kings and

emperors. His heroes are abbots, anchorites, young shepherdesses, beggars. The translation of relics, the founding of some monastery, the healing of a demoniac, the retreat of a hermit to the desert, are to him the most important facts in the history of the world. . . .

In the eyes of the thirteenth century the real history of the world was the story of the city of God. It is necessary to bear in mind such a conception of history in order to understand the innumerable legends of saints which are painted or carved in the cathedral of Chartres, where each window or bas-relief is like a chapter from the *Speculum majus.* In this reading of history the enormous number of images of saints which decorate the churches find at least partial explanation. . . .

The cathedral is as we have seen the city of God. In it the righteous, and all who from the beginning of the world have worked at the building of the holy city have their place. But those who are descended, as St. Augustine has it, not from Abel but from Cain, are not found there whatever the part they may have played in life. There is no place for Alexander or for Caesar.

The Christian kings themselves are rarely seen there. The honor was not given to all, but was reserved for those who were preeminent as workers for the kingdom of God—for Clovis, Charlemagne and St. Louis. And so profane history when it does appear in thirteenth-century glass may in a sense also bear the name of sacred history. . . .

## CONCLUSION

In one of the chapters of *Notre Dame de Paris,* that book in which rare rays of light break through the darkness, Victor Hugo says: "In the Middle Ages men had no great thought that they did not write down in stone." What the poet grasped with the intuition of genius we have labored to demonstrate.

Victor Hugo was right. The cathedral is a book. It is at Chartres, where each Mirror finds its place, that this encyclopedic character of medieval art is most evident. The cathedral of Chartres is medieval thought in visible form, with no essential element lacking. Its ten thousand figures in glass or in stonework form a whole unequalled in Europe.

It may be that other great French cathedrals were originally as complete as Chartres still is, but time has dealt more harshly with them. Yet nowhere else appears so coherent an effort to embrace the whole of the universe. Either intentionally or because the loss of neighboring work has destroyed the balance, each of the other great cathedrals seems designed to place in relief some one truth or doctrine; a diversity which is not without its charm. One chapter for instance is developed at Amiens, another at Bourges.

Amiens is the messianic, prophetic cathedral. The prophets of the façade stand like sentinels before the buttresses and brood over the future. All in this solemn work speaks of the near advent of a savior.

Notre Dame at Paris is the church of the Virgin, and four out of six portals are dedicated to her. She occupies the center of two of the great rose-windows, and round her are grouped the saints of the Old Testament or the rhythmical sequence of the works of the months and the figures of the virtues. She is the center of all things. Never weary, the centuries sang her praises turn by turn, the twelfth century in the Porte Sainte-Anne, the thirteenth in the Porte de la Vierge, and the fourteenth in the bas-reliefs on the north side. Nowhere was she more beloved.

Laon is the cathedral of learning. Knowledge is there placed in the forefront, and the Liberal Arts accompanied by Philosophy are sculptured on the façade and painted in one of the rose-windows. The Scriptures are presented in their most mystical form, and the truths of the New Testament are veiled under the symbolism of the Old. Famous doctors, one feels, must have lived beneath her shadow. She has indeed something of their austerity of aspect.

Reims is the national cathedral. Others are catholic, she alone is French. The baptism of Clovis fills the angle of the gable, and the kings of France occupy the windows of the nave. The façade is so rich that on a coronation day it needs no further decoration, for tapestries of stone hang in the porches. She is ever ready to receive kings.

Bourges celebrates the virtues of the saints. The windows illustrate the *Golden Legend*. Round the altar the life and death of apostles, confessors and martyrs form a radiant crown.

The doorway at Lyons recounts the wonders of creation. Sens unfolds the immensity of the world and the diversity of the works of God. Rouen is like a rich book of Hours in which the center

of the page is filled with figures of God, the Virgin and the saints, while fancy runs riot in the margin.

Though in each cathedral one chapter of the Mirror is, as we see, developed by preference, it is seldom that the others are not at least indicated, thus suggesting the desire to give encyclopedic teaching. Aware of the power of art over childlike and humble souls, the medieval Church tried through sculpture and stained glass to instill into the faithful the full range of her teaching. For the immense crowd of the unlettered, the multitude which had neither psalter nor missal and whose only book was the church, it was necessary to give concrete form to abstract thought. In the twelfth and thirteenth centuries, doctrine was embodied both in the drama of the liturgy and in the statues in the porch. By its marvelous inner force Christian thought created its own medium. Here again Victor Hugo saw clearly. The cathedral was the people's book of stone rendered gradually valueless by the coming of the printed book. "The Gothic sun," he says, "set behind the colossal press at Maintz."

At the end of the sixteenth century Christianity had lost its plastic power, and had become solely an inward force.

*NOTES*

[1] It is not our object, as we have said, to write the history of the nimbus nor of the other attributes passed in review in this chapter. The greater number date back to remote antiquity, and some (like the nimbus) to pagan times. The question has been fully treated by Didron, *Hist. de Dieu*, pp. 25–170.

[2] All these symbols are constantly used in glasspainting.

[3] The word hieroglyphic does not seem too strong if one remembers that the evangelists were sometimes represented in the form of men with the head of the ox, the eagle and the lion (see capital in the cloister at Moissac). Here medieval art joins that of ancient Egypt, and is perhaps even derived from it through the Christian art of Alexandria.

[4] It was scrupulously observed at Chartres. The heroes of the Old Covenant are sculptured in the north porch, those of the New in the south porch. In Notre Dame at Paris the great rose-window to the north is devoted to the Old Testament, that to the south to the New. At Reims the rose-window to the north (mutilated) again shows scenes from the Old Testament (the Creation, Adam, Cain, Abel, &c.), that to the south (restored in the sixteenth century, but doubtless on the old model) is filled with figures of Christ and the apostles. It is curious that the rule is still observed in the fifteenth century. At St. Ouen at Rouen and at St. Serge at Angers

the windows to the north portray the prophets, those to the south the apostles. The practice was also known to the East. In the monastery of Salamis the Old Testament is to the left, that is to the north, and the New to the right, the south. See Didron and Durand, *Iconographie chrétienne. Traduction du manuscrit byzantin du Mont Athos* (Paris, 1845), 8vo, p. xi. On the symbolism of the north and south see especially G. Durand, *Ration.*, lib. IV., cap. xxiii., xxiv.; and Rabanus Maurus, *De Universo*, ix., *Prol.* "auster sancta Ecclesia est fidei calore accensa."

[5] There are a few exceptions to prove the rule. In the great porch at Amiens, for example, St. Paul is to the right of Christ and St. Peter to the left. This arrangement takes us back to primitive Christian art. In early times St. Paul was placed to the right and St. Peter to the left of Christ to mark the substitution of the Gentile for the Jew. This is the reason given even in the twelfth century by Peter Damian in a treatise he wrote on representations of the two chief apostles (*Patrol.*, cxlv.). St. Paul, he said, placed the hosts of the Gentiles on the right hand of God. And he adds, St. Paul was of the tribe of Benjamin, and Benjamin means "son of the right hand." The old doctrine is perpetuated in the papal bull, where St. Paul is seen to the right and St. Peter to the left of the Cross.

[6] Old porch at Chartres.

[7] St. Augustine, *De libero arbitrio*, lib. II., cap. xvi. *Patrol.*, Vol. xxxii, col. 1263.

[8] *Id., ibid.*

[9] St. Augustine, *Quaest. in Heptateuch.; Patrol.*, Vol. xxxvi.–xxxvii., col. 589; see also St. Augustine's treatise *De Musica*, chapter "De numeris spiritualibus et æternis," vi. xii., *Patrol.*, Vol. xxxii., col. 1181.

[10] St. Augustine, *In Psalm.*, vi.; *Patrol.*, Vol. xxxvi.–xxxvii., col. 91. "Numerus ternarius ad animum pertinent, quaternarius ad corpus," and Hugh of St. Victor, *Patrol.*, Vol. clxxv., col. 22.

[11] On the number twelve see Rabanus Maurus, *De Universo*, xviii. 3; *Patrol.*, Vol. cxi., "Item duodecim ad omnium sanctorum pertinent sacramentum, qui, ex quatuor mundi partibus per fidem Trinitatis electi, unam ex se faciunt ecclesiam"; and Hugh of St. Victor, *De scripturis et script. sacris, Patrol.*, Vol. clxxv., col. 22.

[12] On the number seven see Hugh of St. Victor, *Exposit. in Abdiam, Patrol.*, Vol. clxxv., col. 400 *sq.*

[13] Subtle and learned Italy connected the planets with the seven ages of man on the capitals of the Ducal Palace at Venice, and in the frescoes in the Eremitani at Padua. *Annales archéol.*, t. xvi. pp. 66, 197, 297.

[14] A question which has given rise to lengthy controversy in medieval archaeology is that of the deviation of the axis of churches, so frequently noticed in the choir. Is such an irregularity due to chance, to necessities of a material order, or has it a symbolic intention? Was it not done in remembrance that Christ, of whom the church is an image, inclined His head when He died on the Cross? Viollet-le-Duc does not commit himself, though recognizing that such an idea would be in harmony with all that we know of the genius of the Middle Ages (*Dictionn. raisonné de l'architect.*, article *Axe*). For my part I was long disposed to interpret the deviation of the axis in a mystical sense. The notable memoir that M. de Lasteyrie devoted to this question, (*Mém. de l'Acad. des Inscript. et Belles-Lettres*, Vol. xxxvii. (1905), has convinced me that this deviation could have no symbolic meaning. When not due to the necessities of the site, it resulted from

an error in measurement, and always corresponds to a break in the work of building. The precise examples given by M. de Lasteyrie must surely remove all doubt. M. Anthyme Saint-Paul, so long one of the champions of symbolic interpretation, almost immediately on the publication of the *Mémoire* signified his adhesion to M. Lasteyrie's theory *Bullet. monum.* (1906). This symbolism discarded, what remains of the ingenious deductions of Mme. Félicie d'Ayzac who had tried to show that the small door in the side of Notre Dame at Paris, the *porte rouge*, was the figure of the wound made by the lance in the right side of Jesus, *Revue de l'art chrétien* (1860 and 1861)? Symbolism has too large a place in medieval art to leave room for the fancies of modern interpreters.

[15] *Speculum majus,* Douai (1624), 4 Vols., folio. This is the reprint made by the Jesuits. We shall constantly refer to this edition.

[16] Vincent of Beauvais had not time to write the *Mirror of Morals,* and the work that bears that title dates from the beginning of the fourteenth century. (See *Histoire littér. de la France,* Vol. xviii. p. 449.) But it is evident that the *Speculum morale* was part of his original plan, and that is all that concerns us here.

[17] The first is not an angel, as is often stated, but a man. It will be seen that he expressly symbolizes human nature.

[18] The miniaturists gave artistic form to this symbolism. Near to the man (St. Matthew) they sometimes represented the Nativity, near to the ox the Crucifixion, near to the lion the Resurrection, and near to the eagle the Ascension. Examples of this practice are known from the tenth century (*Evangeliarium* of the Emperor Otto *Bull. Monum.* [1877], p. 220), down to the fourteenth (Bibl. Mazarine, MSS. 167, f. 1, *Postilla* of Nicolas de Lyra).

[19] The statues of Adam and Eve are modern, but are reproductions of the originals.

[20] *Speculum doctrinale,* I. ix. The same idea is developed by Honorius of Autun in his *De animae exsilio et patria, Patrol.,* clxxii., col. 1241. The idea is this: the soul's exile is ignorance, the native land is wisdom, the Liberal Arts are so many cities on the road which leads there.

[21] At Chartres there are as many as nineteen craft guilds. See Bulteau, *Monogr. de la cath. de Chartres,* i. p. 127.

[22] E.g. Senlis (west porch); Semur (north porch); Chartres (old porch, north porch, window in choir); Reims (west porch, mutilated series); Amiens (west porch); Notre Dame at Paris (west porch and rose-window to the west); Rampillon (Seine-et-Marne) (west porch). The rose-window in Notre Dame at Paris as reproduced in Lenoir's *Statistique monumentale de Paris,* Vol. ii., Pl. XIX., is the outcome of several restorations, but the original state is given by Lasteyrie, *Hist. de la peint. sur verre,* p. 141. Didron thought to recognize a third Zodiac at Notre Dame at Paris—west façade, left doorway, trumeau. I do not share his view. The artist did not set out to represent the labors of the months, but to make a sort of thermometer. At the bottom there is a man warming himself before a good fire, higher up a man looking for wood, then a man taking a walk but still wearing a cloak, then a curious figure with two heads and two bodies, one body clothed, the other nude, evidently an expression of the sudden variations of temperature in spring. Then one sees a figure clothed only in breeches, and lastly an entirely nude figure. On the other side of the trumeau there is a ladder of the ages of man.

[23] Reproduced in the *Ann. arch.*, Vol. xxiv.

[24] See the pavements in the church at Tournus, in Saint Rémi at Reims (now removed), in Saint-Bertin at Saint-Omer, and in the church at Aosta. Suger, faithful to tradition, had the works of the twelve months executed in mosaic on the façade of St. Denis (see fragment in the Musée de Cluny).

[25] The archivolts of the north porch.

[26] West façade, Portail de la Vierge; pillars.

[27] Augustine, treatise, *De ordine*, ii. 12. *Patrol.*, xxxii., col. 1011.

[28] Didron, *Iconographie chrétienne. Guide de la peinture du Mont-Athos*, p. 408, note. This theme of the ages of man is not unknown in French medieval iconography. I believe they are to be seen at Notre Dame at Paris (west front, left porch, to the right on the trumeau). There are six ages beginning with adolescence ("infantia" is missing).

[29] Jourdain and Duval, *Le Portail Saint-Honoré ou de la Vierge dorée à la cathédrale d'Amiens* (Amiens, 1844), 8vo.

[30] The miniature was published by G. de Saint-Laurent, *Guide de l'art chrétien*, iii. p. 346.

[31] Tertullian, *De Spectaculis*, xxix. On this subject see Puech, *Prudence* (Paris, 1888), 8 vo, p. 246.

[32] Honorius of Autun, *Scala coeli minor*, col. 869; *Spec. Eccles.*, col. 869; *Patrol.*, clxxii. He did not invent the metaphor, but took it from St. Joannes Climacus.

[33] Hugh of St. Victor, *De fructibus carnis et spiritus. Patrol.*, clxxvi., col. 997.

[34] St. John 3:14.

[35] St. Matthew 12:40.

[36] The Jewish and Arabic traditions relating to the chief persons of the Old Testament are collected in Migne's *Dictionnaire des apocryphes*, 2 Vols., 4to (1858).

# 15. THE BYZANTINE CONTRIBUTION TO WESTERN ART OF THE TWELFTH AND THIRTEENTH CENTURIES

*Ernst Kitzinger*

## INTRODUCTION

The old stereotype of a static—even stagnant—Byzantine tradition has been effectively overturned by the scholarship in this area over the past thirty-five years. Not only was Byzantine art a continually developing tradition, it was not insulated from the West and, indeed, time and again made significant contributions to the art of western Europe. The major breakthrough in this view of Byzantine art occurred at the inauguration of the Dumbarton Oaks Center for Byzantine Studies, in Wilhelm Koehler's paper "Byzantine Art in the West," published in *Dumbarton Oaks Papers*, I (1941), 61 ff. (*Dumbarton Oaks Papers* are essential to the study of Byzantine art, and the student should consult this series for other titles relevant to this aspect of Byzantine art and to the general field of Byzantine studies.) The line of investigation inaugurated by Koehler's pioneer paper has been carried on by other scholars like Ernst Kitzinger, one of whose articles is reprinted here, and by Otto Demus, whose *Byzantine Art and the West* (1970) is one of the most recent contributions. For further reading on this subject, there are

Ernst Kitzinger, "Byzantium and the West in the Second Half of the Twelfth Century: Problems of Stylistic Relationship," *Gesta,* IX, 2 (1970), 49–56; by the same author, "Norman Sicily as a Source of Byzantine Influence on Western Art in the Twelfth Century," in *Byzantine Art—An European Art: Lectures,* Athens (1966). In the same volume are contributions by D. Talbot Rice ("Britain and the Byzantine World in the Middle Ages"), W. F. Volbach ("Byzanz und sein Einfluss auf Deutschland und Italien"), and S. Runciman ("Byzantine Art and Western Mediaeval Taste"), among others. There are also Kurt Weitzmann, "Various Aspects of Byzantine Influence on the Latin Countries from the Sixth to the Twelfth Century," *Dumbarton Oaks Papers,* XX (1966), 3 ff.; and by the same author, his important study of a North Italian ensemble of around 700 A.D., *The Fresco Cycle of S. Maria di Castelseprio* (1951).

The two centuries from A.D. 1100 to 1300 witnessed the greatest achievements in the history of Western mediaeval art, namely, the creation of Gothic cathedral art in the North and a new birth of painting in Italy. During this same two hundred years' span Western Europe was brought into the closest contact it ever had with the art of the Greek East, the art of Byzantium. The question is whether there is any causal connection between these two sets of facts, and, if so, what that connection is.[1]

The question was answered in essentially negative terms by the originators of modern art historical inquiry, Lorenzo Ghiberti in the fifteenth century and Giorgio Vasari in the sixteenth. Solely concerned, of course, with Italy, they blamed the *maniera greca* for everything that was wrong with painting in that country before the genius of Giotto ushered in a new era.[2] . . .

Since the days of Ghiberti and Vasari, and more particularly during the last hundred years, a good deal of study has been devoted to Byzantine art. Along with this exploratory work has come a thorough-going reappraisal of the role of Byzantium vis-à-vis the art of the West. To stay within the Italian domain for the moment, a school of thought has developed which credits Byzantium with a constructive and positive contribution to the dramatic evolution of painting in that country, particularly in the thirteenth century.[3] Yet, the assessment of Byzantium's role remains ambiguous. As recently as 1948 Roberto Longhi, one of Italy's most brilliant art historians, published a now famous article in which—so far as the value of the Byzantine contribution is concerned—Vasari's case is in effect restated.[4] The *maniera greca* was a blight, the Greeks were the "sterilizers" of Dugento painting, the triumphs of Giotto and Duccio were achieved in the teeth of, rather than with the help of, this alien intrusion. While Longhi's article displays a startling lack of comprehension of Byzantine art and its history, Victor Lazareff, one of the foremost living authorities in that field, with excellent credentials also as a student of Italian art, likewise takes a rather negative

view of Byzantium's over-all role in relation to the latter.[5] Thus the issue remains very much alive in our own day; indeed, so far as Italy is concerned, the negative appraisals of the Byzantine contribution have, on balance, won out over the positive.

Study of mediaeval art in the transalpine countries is, of course, of much more recent origin. Born of the historical and aesthetic concepts of Romanticism, it tended from the outset to put a positive evaluation on whatever Byzantine influences and affinities were observed, and this positive attitude has remained characteristic of much of the research in that field. But even in the North examples of the "Vasarian" approach are not lacking. . . .

The point at issue, then, is not whether Byzantine influences are present in Western art of the twelfth and thirteenth centuries—on this the proponents of Byzantium and its detractors are on the whole agreed—but the evaluation of its role. Was Byzantium essentially a retarding, chilling, and obstructing element in Western art or was it a positive, life-giving, and constructive one?

Before going further, I should make it clear that my observations will be confined to the pictorial arts on which the whole debate has been traditionally focussed. Architecture, which of course constitutes an essential part of the total Western achievement during the period in question, had its own distinct development, to which the Byzantine contribution is at best elusive and indirect.[6] Our topic is the role of Byzantium vis-à-vis the emergent Gothic in Northern sculpture and painting, on the one hand, and vis-à-vis the new birth of painting in Italy, on the other.

The conflicting assessments of this role are due in large part to uncertainties about Byzantine art itself. Here again it is useful to go back to Vasari whose concept of that art was of extreme simplicity. To him the *maniera greca* meant monotonous and repetitious representations of saints, tinted rather than painted (i.e., drawn with lines and primary colors rather than modeled in the round), standing on the tips of their toes, with eyes staring and hands open. Moreover, it meant a totally static art, entirely determined by usages and traditions handed on from one painter to another, generation after generation, without any attempt at change or improvement, and thus wholly lacking in development.[7] This is Vasari's "image" of Byzantine art, and in spite of all the attention—and in great part sympathetic attention—given to this art in more recent times, this image (like the image which, two centuries after Vasari, Edward

296

Gibbon drew of the Byzantine state and Byzantine civilization as a whole) is still very much with us, witness the modern art historians whom I quoted. Vasari's concept refused to die for the same reason, no doubt, that Gibbon's will not die, namely, that it is partly true. Monotonous rows of saints with staring eyes and open hands are not hard to find in Byzantine art. It is also true that such representations recur without essential change through many hundreds of years, so that one may well speak of virtual stagnation, especially if one uses as a yardstick the pace of development, say, in the Italian Renaissance, or in our own time. But, of course, there is another side to Byzantine art, a side perpetually nourished and reinvigorated by Byzantium's Greco-Roman heritage, thanks to which figures may appear in lively action, in three-dimensional corporeality, and in spatial settings. Frescoes such as those of Castelseprio and Sopoćani, and miniatures such as those of the Joshua Roll or the Paris Nicander Manuscript (B.N., suppl. gr. 247) are just as "Byzantine" as Vasari's rows of saints, and it is on works displaying to a greater or lesser degree this antique heritage that the proponents of a positive role of Byzantine art vis-à-vis the West have most often drawn. In one sense, however, the proponents have tended to agree with Vasari. They, too, have often treated Byzantine art as essentially static, witness the fact that the examples with which they have illustrated Byzantine influences have at times been chosen rather indiscriminately from different centuries. Yet, one of the achievements of modern scholarship has been an increasingly clear understanding of the development that took place within Byzantine art through the long centuries of its existence. While this development has not as wide a range as that of Western art, while the swings of the pendulum are, as it were, less great, the evolutionary pattern is nevertheless real and organic. To be aware of this, to take the measure of where Byzantine art itself stood at the time the intensive contacts with the West began and how it progressed from this point on is a first prerequisite for a proper appraisal of the East-West relationship.

The mosaics of Daphni (see Fig. 27), the most representative monument of Byzantine pictorial art remaining to us of the period about A.D. 1100, provide a logical starting point for such a survey, which in the circumstances must necessarily be brief and somewhat oversimplified. The Daphni style embodies a rare synthesis, a moment of extraordinary equilibrium between the two antithetic

elements always present in Byzantine art, the "classical" and the "abstract." Figures stand out clearly, almost starkly, against large areas of empty ground and are structured firmly by means of a rather simple and schematic system of lines, which also stands out very clearly, particularly in the draperies, and recurs time and again in more or less identical and stereotyped patterns. But, in spite of these abstract settings and linear "armatures," figures are organic and three-dimensional. This is due partly to subtle and skillful modeling within the linear framework, but chiefly to a bold use of contrasts of light and dark, whereby the figures acquire a great deal of relief and a solid bodily presence.

Of the two elements so nicely balanced here—the organic and the linear—it is the latter which wins out more and more in Byzantine art in the course of the twelfth century. In the votive panel of the Emperor John II Comnenus in the south gallery of St. Sophia, a mosaic of about 1120, the "painterly" elements of the Daphni style have already been largely eliminated (Fig. 41). Every feature—eyes, nose, mouth, hands—is so fully and clearly defined by neat and emphatic lines and all shading is so smooth and regular that, instead of solid flesh, we seem to behold a brittle, sharp-edged mask of fine porcelain. This calligraphic, linear quality remains dominant in Byzantine painting throughout the twelfth century. The head of St. Panteleimon from the frescoes at Nerezi in Macedonia, dated 1164, is indeed a direct descendent of the heads of the mosaic panel of John II, with the pattern of lines refined almost to the point of preciousness. But Nerezi, in its famous cycle of Gospel scenes, also illustrates a further step, namely, an increasing complexity of these linear patterns (Fig. 42). In the draperies these begin to form all manner of zigzags, curls, and eddies, which, though not really motivated by the action of the body underneath, do impart to the figures a new liveliness, a nervous intensity. And this agitation is not confined to draperies; it seizes the entire figure, as well as the scenic setting, so that the whole composition begins to heave and swirl. What we see here is, in fact, the beginning of that "dynamic" phase which was to dominate Byzantine art in the last decades of the twelfth century. It is only rather recently that this phase has come to be recognized as a major and distinctive phenomenon in the main stream of the Byzantine stylistic evolution.[8] As we shall see, to be aware of this phase is of considerable importance for a correct understanding of what happens in the West during the same period.

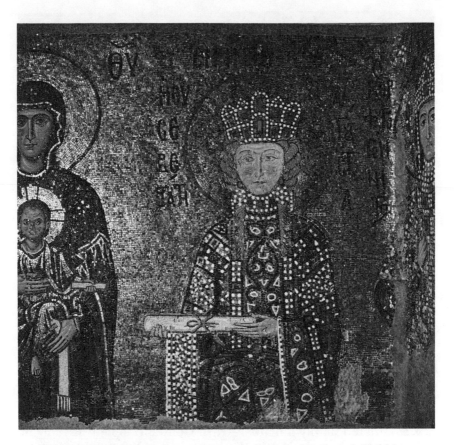

41. Empress Irene (detail), from mosaic panel of the Virgin and Child between Emperor John II Comnenus and Empress Irene, South Gallery, Hagia Sophia, Istanbul, Byzantine, *c.* 1118 (The Byzantine Institute, Dumbarton Oaks)

When paintings such as those of Nerezi first became known they were called "neo-hellenistic," because of the evident fact that there is in them a new intensity of gesture and facial expression, a new emotional power and human empathy.[9] But in the purely formal sense the term is misleading because these paintings remain essentially within the linear tradition of the first half of the century. There is no return here either to the "painterly" devices or to the solidity and monumentality (or, for that matter, to the classic nobility and poise) of the human form which we found at Daphni. Certainly the highly sophisticated interplay of agitated linear patterns adds to the emotional power of these figures, and to do so may well have been the original purpose of the new dynamism. But it soon becomes an

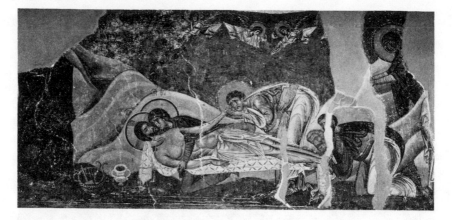

42. Lamentation of Christ, Wall Painting, Naos, Church of St. Panteleimon, Nerezi, *c.* 1164 (Josephine Powell)

end in itself, divorced from all inner motivation, and what may at first have seemed to have the makings of a powerful Byzantine baroque ends up, in the 1190's, in a strange sort of mannerism (Fig. 43). Looking back from this point to the mosaics of Daphni, one must certainly grant that there was in Byzantine art of the twelfth century a stylistic development of considerable magnitude.

What is true of the twelfth century applies even more to the thirteenth. In the whole history of Byzantine art this is one of the most crucial centuries and one of the most obscure. At one time it was considered simply a hiatus. Art in Constantinople was thought to have gone into a decline in the latter half of the twelfth century and to have come to a virtual standstill during the period of the occupation of the city by the Crusaders (1204–1261).[10] The new flowering under the Palaeologan dynasty in the early fourteenth century was thought to have been due to new impulses from Italy.[11] Today this view is no longer tenable. We still lack, and probably always shall, a coherent series of monumental mosaics and paintings from the capital itself with which to bridge the gap between the late twelfth and the early fourteenth century. But in miniature painting a continuity of production has been conclusively demonstrated.[12] And the more we have learned of mural paintings in some of the Byzantine "successor states," notably Serbia, Bulgaria, and Trebizond, the more we have come to realize that the monuments in these areas reflect a common tradition, a single, organic development. It may well be that Constantinople was the main generative center of this development throughout.

43. Angel of the Annunciation, Wall Painting from bema arch, Church of St. George, Kurbinovo, *c.* 1191 (Josephine Powell)

Having already made use of mural paintings in the Balkans as representatives of some stylistic phases in the twelfth century, I shall draw on the great Serbian fresco decorations of the thirteenth century to illustrate the major evolutionary trends in Byzantine art of that period. Except in certain provincial backwaters[13] the phase of excessive, mannerist agitation was at an end by A.D. 1200. In its place (and, one is tempted to assume, by way of a reaction) there now appear a new simplicity and calm monumentality both of form and expression.[14] The change is strikingly apparent in wall paintings of the Church of the Virgin at Studenica, dated A.D. 1208–1209. This new concentration on the essential structure and integrity of the human form and on the power of its simple presence is the basis of the entire subsequent development. At first the monumental effects are still achieved with the linear means inherited from the twelfth century. But—and this is the essence of the stylistic evolution in the thirteenth century—increasingly this linear frame is filled with volume and weight. Monumentality, at first achieved mainly through great, sweeping lines, becomes more and more a matter of solid modeling and heavy mass and is vastly enhanced in the process. The

301

frescoes of Mileševo show how far this evolution had progressed by about 1235; those of Sopoćani, another thirty years later represent its peak (Fig. 44). It is still possible here to detect in many figures the old linear framework underlying the design, particularly of the draperies. But certain passages—thighs, elbows, heads above all— are modelled so conspicuously as to appear to be thrust forward from the picture plane. What is more important, these thrusts are not isolated; they are centrally motivated and controlled by a powerful body which thus appears endowed with an autonomous inner force, rhythm, and weight, such as it had not possessed at any time since classical antiquity. It is by their own power that these figures seem to bulge out from the wall. It is their own volume also which appears to create space around and depth behind them, so that the traditional and conventional "stage props," the mountains, buildings, and pieces of furniture likewise curve and bulge—but inward *into* the picture, thus creating a "cave space" for the figures to breathe and act in. This "volume style" has long been known from the mosaics of the Kariye Djami, its outstanding representative in Constantinople itself. Actually, in this great and miraculously well-preserved ensemble dating from the first decades of the fourteenth century the style already appears slightly prettified, mannered, and overcharged with conscious classical reminiscences. The heroic age of the "volume style" was the 1260's and 1270's, the period immediately following the Greek reconquest of Constantinople under the Palaeologan dynasty.[15] It hardly needs emphasizing that the remarkable—and still imperfectly understood—stylistic evolution leading up to this climax is one to which Vasari's description of the *maniera greca* is almost entirely irrelevant.

Before trying to determine what bearing all this has on the art of the West we must consider two preliminary questions. The first is whether, in focussing on the stylistic aspects of Byzantine art, we have not from the start narrowed down the issue too much. Are there not other aspects—Byzantium's preeminence in certain crafts and techniques, for instance, or its highly developed religious and imperial iconography—which loom just as large, or larger, in the total picture? Our other preliminary question—and a very basic one—is what actual knowledge of Byzantine art the West can be shown or presumed to have had in the period which concerns us.

As to the first of these two questions, the artistic relationship

44. Patriarch, Wall Painting, Naos, Church of the Holy Trinity, Sopoćani, *c*. 1258–1264 (The Byzantine Institute, Dumbarton Oaks)

between East and West does, of course, have other aspects aside from the stylistic one. There are, for one thing, certain *media* which became prominent in Western art during the twelfth and thirteenth centuries and which were wholly or largely imported from Byzantium. One such medium is wall mosaic, a forgotten art in the West until it was revived in the latter half of the eleventh century under Byzantine tutelage;[16] another is panel painting, which we are apt to think of as a typically Western art form until we pause to consider how much its central role in the history of Western art owes to the impact of the Byzantine icon on Italian Dugento painting;[17] a third medium which should be mentioned here is stained glass, an art form which until recently was considered quite exclusively Western, but which in the light of some new finds in Istanbul may turn out also to have received an initial stimulus from Byzantium, though the Greeks never developed the aesthetic potential of this medium as it was developed in the Gothic cathedral.[18]

Then there is the Byzantine canon of *iconographic themes and types*, which all along had exerted great and authoritative influence

303

in the West; this, too, was heavily drawn upon in certain contexts, in the "imperially" oriented art of Sicily and Venice, for instance;[19] in the illumination of luxury manuscripts in England and France about and after 1200,[20] and in thirteenth-century panel painting in Tuscany.[21]

Finally, mention must be made of the West's perennial fascination with the splendor and luxuriousness of the Byzantine *sumptuary arts,* a fascination powerfully stimulated during this period through reliquaries and other precious objects brought back by the Crusaders, and particularly through the mass of Byzantine objects d'art which came to the West after the sack of Constantinople in 1204. In certain types, especially of devotional and liturgical objects and utensils, this influence is clearly discernible.[22]

Yet, for our purposes, I feel justified in concentrating on the strictly stylistic aspect. In an over-all assessment of the role and meaning of Byzantine influences in Western art in the twelfth and thirteenth centuries style undoubtedly is the crucial issue.[23]

Turning now to the question of the actual means of transmission whereby Byzantine art became known in the West, the first point to be made is that opportunities for contact were, of course, plentiful in the age of the Crusades. I have just now referred to the objects d'art brought back in large quantities by the Crusaders themselves. Merchants and diplomats also added to this traffic. The two Byzantine reliquaries enshrined in the Morgan Library Triptych, for instance, probably were brought to the Monastery of Stavelot by its great Abbot Wibald, who travelled to Constantinople twice on diplomatic missions.[24] Other contacts were established not through travellers but through commissions placed in Constantinopolitan workshops by wealthy Western patrons, and it is noteworthy that this practice is well attested as early as the second half of the eleventh century.[25]

Still, when one tries to put together all the solid evidence, the picture remains spotty. What important and representative examples of Byzantine art would a twelfth-century artist, say in France or England, actually have had occasion to see? How many Western artists ever did set eyes on the mosaics of Daphni or of St. Sophia? Even in the case of so massive an exposure to Byzantine art as is generally agreed to underlie the *maniera greca* in thirteenth-century Italy, how much do we know of actual, concrete links?

In trying to give an answer, however summary, to these questions it is necessary to distinguish between the travel of *objects* and the

travel of *artists*. So far as the former is concerned, the richest and most consecutive evidence is indeed in the area of the sumptuary arts, especially metalwork. Beginning with the series of bronze doors commissioned in Constantinople by the Pantaleoni and other South Italian magnates since the 1060's,[26] and the great gold and enamel pala ordered in the Byzantine capital soon thereafter by the Venetians for the high altar of San Marco,[27] there was a steady flow of such objects, a flow powerfully reinforced by the Crusaders' quest for relics which also involved the relics' precious containers.[28] But for portable objects in the pictorial media—especially illuminated manuscripts and icons—which are of particular interest in relation to our central problem of stylistic influences, the evidence is far less ample. Thus, it must be borne in mind that few, if any, of the great examples of Byzantine miniature painting preserved in Western libraries today were in the West during the Middle Ages. Most of these manuscripts came to the West during the age of Humanism. Undoubtedly, Byzantine illuminated manuscripts had travelled earlier. One manuscript, now in Vienna, was commissioned in Constantinople for the Church of St. Gereon in Cologne about A.D. 1077.[29] Another, in Paris, apparently came to France with a Constantinopolitan delegation in 1269.[30] There is also the remarkable group of manuscripts with miniatures in a near-Byzantine style, recently identified by Professor Buchthal as products of ateliers in the Crusader States.[31] All these manuscripts are in Western European Libraries, and in the great majority of cases this presumably means that they were brought to the West before the final collapse of Latin rule in 1291. In a few instances there are specific indications to that effect.[32] This, however, is the only major group of manuscripts which one can point to as a possible conveyor of a fairly continuous, if not altogether pure, sampling of Byzantine artistic developments. In the matter of icons the evidence is more meager still. Important as this medium came to be for the West, I know of only one authentically Byzantine icon of the Crusader period which is definitely known to have reached the West within that period, namely, the icon of the Virgin which Frederick Barbarossa gave to the Cathedral of Spoleto in 1185.[33] A number of twelfth- and thirteenth-century mosaic icons—outstanding among works of Byzantine art of those centuries—may have reached Italy (and particularly Sicily) at an early date,[34] but we do not know how early and the same is true of the one and only icon from the Crusaders' ateliers in the Holy Land so far located on Western soil.[35]

One may well wonder whether in the over-all picture the traffic in objects was as important as it is sometimes thought to be. It is true that this traffic, aside from exposing Western artists to samples of more or less contemporary Byzantine art, may also have brought to their attention works of earlier and in some cases perhaps *much* earlier periods; we shall have occasion to refer to the role which Byzantine "antiques" may have played in the Western stylistic development.[36] I strongly suspect, however, that in the final reckoning the migration of artists was of greater moment than the mute challenge of objects.[37] Here mention must be made first of all of the Byzantine mosaicists working in Italy. The first such workshop was established in Montecassino about the year 1070 at the bidding of Abbot Desiderius,[38] and this is, in fact, the only quite reliably documented case of Byzantine artists executing wall mosaics on Western soil during the entire period which we are considering. There is no doubt, however, that further teams of Byzantine mosaicists were imported by Italian patrons (notably the kings of Sicily and the doges of Venice) throughout the twelfth century, and the influx continued, if on a reduced scale, in the thirteenth. Thanks to the activities of these workshops, a major and highly representative branch of Byzantine pictorial art was continuously and through successive phases of its development kept before the eyes of Westerners, and while the influence of the mosaics, particularly in the countries north of the Alps, has sometimes been overrated, it was certainly real and important. What counts here is not only the example of the finished product, but also the opportunity of personal contacts with Greek masters which the mosaic workshops afforded.[39] Occasionally a Greek icon painter also may have found his way to the West.[40] As for Western artists travelling East, we now know, thanks to the recent explorations by Professors Buchthal and Weitzmann, that there were illuminators and panel painters from Italy, France, and other Western countries in the Crusader states.[41] It is possible, or even probable, that some of these artists eventually returned to their homelands.[42] Much scantier, but in many ways more important, evidence is provided by certain fragments of sketchbooks, especially those of Freiburg and Wolfenbuettel. Here we see Western artists in the actual process of noting down motifs from Byzantine models—and very up-to-date models—for subsequent use in their own or their colleagues' work. It is most unlikely that these studies and exercises were done at home solely with the

help of some stray objects from the East that happened to have come to hand. In all probability these are travel notes—comparable in this sense to many of the drawings in Villard de Honnecourt's famous and nearly contemporary sketchbook—but travel notes made in a Byzantine, or, at any rate, semi-Byzantine milieu.[43]

So much for the actual contacts, the channels of communication, between Byzantine art and the West. The fact that there is a strong "live" element in this relationship is important, especially when considered in conjunction with our earlier observations concerning the internal development in Byzantine art during the period under discussion. The existence of these live contacts further adds to the image of Byzantine art as a living entity. This is indeed a basic point, essential to a true understanding of our entire problem. The greatest obstacle to a correct assessment of Byzantium's contribution to the art of the West is what may be called the "ice box" concept, the idea that the art of Byzantium was merely a sort of storehouse, an inert receptacle in which a repertory of traditional forms was conveniently and immutably preserved for the West to draw on. In actual fact it was an art still in the process of evolution and still capable of sending forth live impulses and live emissaries. How crucial a point this is will soon become apparent as we turn to the art of the West and consider its relationship to Byzantium in its successive phases.

A major breakthrough in the study of this relationship was accomplished exactly twenty-five years ago by Wilhelm Koehler. In a lecture given at the inauguration of Dumbarton Oaks,[44] Koehler introduced the concept of a great wave of Byzantine stylistic influence which powerfully affected the pictorial arts of Western Europe in the first half of the twelfth century. All of Koehler's specific observations were not new. But there was a three-fold significance to this truly seminal study: it pointed up the essential unity of what had until then been treated as more or less disparate phenomena in various branches of the pictorial arts in Italy, in France, in England, and in Germany; it focussed on style as the crucial area of contact between East and West during this period; and it penetrated beyond the mere definition of stylistic features to an understanding of what motivated Western artists in adopting these features.

The epitome of this international style of the first half of the twelfth century is what Koehler called the "damp fold," the soft,

clinging drapery which so often is seen enveloping the limbs of painted or carved figures of this period in characteristic curvilinear patterns. When one compares earlier (or contemporary, but conservative) work from the same regions in which this feature does not appear, it becomes apparent that behind this purely formal device lies a new interest in the human form and its organic structure and movement; it signifies, to use Koehler's own words, "a new type of human being." The "damp fold" implies a fully rounded, actively and autonomously functioning body such as the flat, wraith-like creatures of the preceding era—creatures that were, so to speak, bent, twisted, and patterned by an outside force—do not possess. And it is quite evident that the source of the "damp fold"—and of the underlying concept of the human form—was Byzantium.

Koehler was aware that this massive Byzantine influence had its origin in the greatly intensified artistic contacts with the Greek East which were established in the second half of the eleventh century, particularly in Italy.[45] I have referred to some of these contacts, which, be it noted, belong to what would seem to be from a purely historical point of view an unpropitious era, the era just after the great Schism of 1054 and before the First Crusade. The arrival of Byzantine artists and objects in Montecassino, Venice, and elsewhere during this period can be shown to have had stylistic repercussions in the West even before the "damp fold" became the hallmark of an international Western European style.[46] Indeed, that style already embodies a mature and sophisticated stage in the process of Western apprenticeship. The emergence of the "damp fold" and all that it implies may have been, however, not only a matter of the West gradually penetrating closer to the essential formal qualities of Byzantine art. It may have been aided by recent stylistic trends in Byzantium itself; specifically, by the increased linearism which we have found to be characteristic of Byzantine art after 1100, and by the clearer exposure of the body's organic structure inherent in that development. . . . Byzantium may indeed have set, early in the twelfth century, new patterns and new challenges to which the West responded.

This was most certainly true in the second half of the twelfth century. I referred earlier to the "dynamic" style which emerged in Byzantine pictorial art during that period, and I said that this stylistic phase has been recognized only rather recently as a distinct and important one within the Byzantine development itself. The

realization of what this phase meant for the West is more recent still. Indeed, its importance is only just beginning to be understood. . . .

On Italian soil the Byzantine dynamic style is represented in pure, or almost pure, form by a number of mosaic and fresco decorations. Foremost among these are the mosaics of Monreale, executed by a team of Greek artists largely, or even entirely, within the decade from 1180 to 1190 (Fig. 45).[47] Reflections of the style can be seen in many places in Austria,[48] in Saxony,[49] in the Rhineland,[50] in France,[51] and in England.[52] English art was particularly deeply touched by this wave and, more than any other, derived from it ways of expressing extremes of emotional agitation.

Yet we must beware lest we go too far. A spirit of more or less intense agitation is an almost universal phenomenon in the pictorial art of Western Europe in the final decades of the twelfth century, and all of this agitation cannot be ascribed to the influence, or, at any rate, the *direct* influence of Byzantium. Byzantium is not a universal key. To illustrate the limits of what it can account for let me refer to one of the great masterpieces produced in the West during this period, the Klosterneuburg Altar of 1181.[53] Its superb series of enamel plaques illustrating events from the Old and New Testaments in typological confrontation is the work of Nicholas of Verdun, the enigmatic genius whose oeuvre is the culminating glory of the great twelfth-century flowering of the goldsmith's art in the Meuse valley and the Rhineland. That there is a good deal of Byzantium in Nicholas' stylistic background there can be no doubt.[54] This Byzantine ingredient, however, is not really the dynamic style, but rather the art of the 1150's and 1160's when that style had not yet come into being. Where Nicholas' basic Byzantine affinities lie can be shown best, not through the finished enamels, but through an unfinished engraving which came to light on the back of one of the plaques in a recent restoration: this plaque, which depicts the Holy Women's visit to the Sepulchre, shows, so to speak, the skeleton of Nicholas' style, and the relationship to Byzantine work of about 1160–1170 is evident.[55] On the basis of such antecedents Nicholas develops his own version of the dynamic style, and while it is impossible to ignore the fact that the date of the Klosterneuburg Altar coincides roughly with the beginning of the work at Monreale the relationship here is not specific. Time and again in studying and analyzing Nicholas' enamels, one is reminded of Byzantine work of

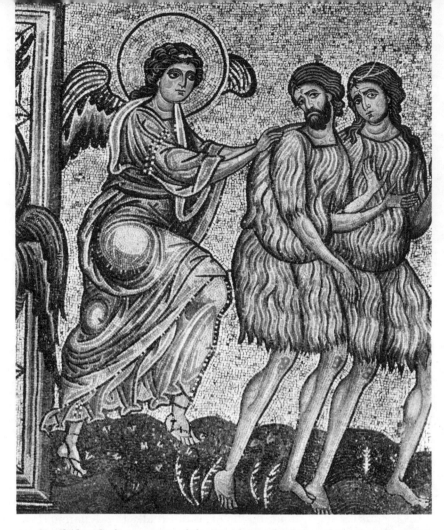

45. Angel (detail), from mosaic of the Expulsion of Adam and Eve from Paradise, Nave, Cathedral, Monreale, before 1183 (Alinari-Art Reference Bureau)

the "dynamic" phase.[56] Yet it is difficult to point to any concrete connections.

Thus, there arises here the problem of *parallelisms* between East and West as distinct from that of direct influences. Of course, the problem can arise only because Byzantine art was a moving stream, not a stagnant pool. It now appears that not only was there a succession of currents branching off from this stream and flowing into the stream of Western art, but, in addition, the two streams shared a common general direction. As a matter of fact, this was true not only in the late twelfth century, but in other periods also.

Parallelism, as distinct from, and in addition to, direct influences, may have been a factor of some importance as early as the year one thousand when the Ottonian style was reaching maturity in the West, and Constantinople was distilling from the classical revivals of the "Macedonian renaissance" a mature mediaeval style of its own. Indeed, from that time on, and until about A.D. 1300, one can speak in a very broad sense of a common artistic evolution embracing both East and West and betokening a common cultural framework for all of European Christendom.[57] But in the late twelfth century this phenomenon becomes particularly evident and it will remain so for the ensuing one hundred years. Perhaps one should avoid the slightly mystical concept of a "Zeitstil" and think rather in terms of loose and broad connections, of general impulses which may have gone in either direction. In the particular case of Klosterneuburg there may have been a vague and perhaps indirect stimulus from Byzantium's "dynamic" phase, a stimulus which in the mind of a great artist like Nicholas of Verdun merged and coalesced with others from quite different sources to produce a broadly comparable result.

I have purposely singled out Nicholas of Verdun. He was a dominant figure in a region which played a leading role in Western Europe at the time when the Gothic pictorial style took shape. By focussing a little longer on his oeuvre and sphere of influence I can best illustrate Byzantium's role in that process, a role which after the 1180's and the 1190's becomes more and more elusive. Nicholas' own style undergoes a striking development.[58] Agitation and dynamic power reach a climax in the latter stages of the Klosterneuburg series and in some of the majestic figures of prophets from the Cologne Shrine of the Three Kings which are generally agreed to be his work. But the storm abates in his late work, the Shrine of the Virgin at Tournai dated 1205, and gives way to a calm, quiet serenity. It is a remarkable change, perhaps the most remarkable that can be observed in any one personality in the generally anonymous world of mediaeval art. Nicholas, in his later years, became an exponent of a style which about the year 1200 began to dominate the pictorial arts, not only in his own region of the Meuse, but in northern France and in England as well. Towering figure that he was, he himself undoubtedly had helped to pioneer the new style. The classic calm and lucid serenity which characterizes his work at Tournai had appeared a few years earlier in English and northern French art: in the last of the miniatures of the great Winchester

Bible, for instance; in the Westminster Psalter; and in the Psalter of Queen Ingeborg. It was a broad and broadly-based movement to which terms such as "neo-classicism" and "classical revival" have been aptly applied. It was a prelude to true Gothic rather than Gothic itself.[59]

Now there was, as we have seen, at precisely the same time a return to calm and monumental serenity also in Byzantine art, where this phase played much the same role in relation to subsequent developments that the Meusan, French, and English "neo-classicism" was to play in the evolution of Gothic. But this surely is *only* a case of parallelism, and parallelism of the most general kind. There is no question, no evidence here of a broad and massive wave of influence comparable to the great Byzantine waves that swept the West in the twelfth century.

The sources of this Western "neo-classicism" are varied and complex. The heritage of the West's earlier classical revivals—the Carolingian and Ottonian particularly—undoubtedly played an important part. Indeed, in the Meuse region, which was Nicholas' true home ground, a taste for classical forms was almost endemic. But there is in his style, and in his late work particularly, a closeness to the real antique, an almost Phidian quality which time and again has defied explanation. An acquaintance with such remains of Roman provincial art as may have been visible in northwestern Europe could not by itself account for this quality. On the other hand, I also find it hard to believe that Nicholas travelled to Greece and studied the sculptures of the Parthenon. I would suggest that an important part was played in his development by an encounter, not so much with true antiques, as with works of what has come to be known as the "Byzantinische Antike" of the sixth and seventh centuries, works of the minor arts of the period of Justinian and Heraclius in which there is a very strong classical element. When one places side by side with figures from the Tournai Shrine reliefs from Maximians' Chair, one finds specific similarities in facial types, in stances, in the strange apron-like garments, and in details of drapery design which it would be difficult to match elsewhere. The heads of certain of the prophets of the Cologne Shrine also invite such comparisons. . . .[60]

Thus, there *is* a Byzantine element here, but it is an element stemming from a Byzantine past so remote that in the perspective of the year 1200 it must have seemed like antiquity itself. I have

previously suggested that during the Crusades such ancient works may have reached the West in increased numbers, and although examples of Justinianic ivory carving and metalwork had been available all along, interest in this art may have been stimulated by new imports. In this sense the Western "neo-classicism" of A.D. 1200 may owe something to the East-West traffic of the time. . . . But the point is that [it] was an essentially autonomous achievement inspired primarily by works of the distant past and not dependent on, though vaguely parallel to, the exactly contemporary phase in Byzantine art.

This "neo-classicism," however, was the seed bed in which the classical phase of French thirteenth-century cathedral art grew. There are paths leading from Nicholas of Verdun and the Ingeborg Psalter to the sculptures of Laon, Chartres, and Rheims.[61] I cannot follow these steps in any detail. Many scholars believe that the great classical statuary of Rheims could not have come into being had not their creators seen true and large-scale Greek or Roman sculptures.[62] But, if so, they merely broadened and deepened the approach to the antique which Nicholas and his contemporaries had made a generation earlier.

Thus, we can now see what the over-all contribution of Byzantium to the nascent Gothic was. We have moved, step by step, from waves of massive influence to parallelism, and finally to a classical revival which draws on sources altogether independent, at any rate, from contemporary Byzantium. The waves of influence were absorbed only to be transcended, and, in the end, the West achieved its own sovereign approach to classical antiquity.[63] There had been moves in this direction before. The importance of the various "proto-Renaissances" of the twelfth century, especially in Italy and France, should not be minimized.[64] But it was Byzantine art with its continuous and living challenge which had provided the principal schooling for the great and decisive breakthrough in the early thirteenth century. In successive stages it had held before Western eyes an ideal of the human form, first as a coherent and autonomous organism, then as an instrument of intense action and emotion. This was what enabled the West finally to make its own terms with the classical past, and to create its own version of a humanistic art. Ultimately Byzantium's role was that of a midwife, a pace-maker. Though, in this sense, the part it played was crucial, it had little direct influence on mature Gothic art. Once the great independent breakthrough toward the classical had been accomplished in the early thirteenth century, the

countries that had been responsible for it—northern France, Flanders, and England primarily—were no longer susceptible to massive stylistic influences from the Greek East. Of the transalpine countries, only Germany experienced a further strong wave of Byzantine stylistic influence in the first half of the thirteenth century, a wave which produced the so-called "Zackenstil"; but this, in European terms, was a cul-de-sac.[65] Otherwise, from here on, so far as northern Europe is concerned, the relationship to Byzantium is mainly a matter of that broad and elusive parallelism of which I spoke earlier. This parallelism, however, continues throughout the great period of "high" Gothic. When one stands in the church at Sopoćani and beholds its fresco decoration with those great statuesque figures seemingly bulging forward from the walls (Fig. 44), and, at the same time, soaring upward with a powerful thrust, one cannot help thinking of the sculptured statues of French and German cathedrals.[66] But what, if any, concrete links this may involve is still a mystery.[67]

I shall be brief on the subject of the new birth of painting in Italy at the end of the thirteenth century. Obviously I could not do justice here to this vast and complex story. I only want to make one point which I consider essential, namely, that in its broad outlines, in its over-all pattern, the evolution in the Italian Dugento repeats that which we have just followed in the north: waves of Byzantine influence lead to an intensive and independent encounter with the antique which, in turn, is the prelude to complete emancipation.[68]

The further waves of Byzantine influence which reach Italy in the thirteenth century are what is commonly known as the *maniera greca*, that controversial phenomenon of which I spoke at the outset. In claiming it as analogous in character and effect to the Byzantine waves of the twelfth century that led to the emergence of Gothic, I have, by implication, declared my view of the matter. The *maniera greca* was not the dead hand of tradition. It reflects a series of live impulses from a living art. These impulses entered the main stream of the Italian development, and far from retarding or interrupting that development played an important, if indirect, part in bringing about its final climax.

This can be shown most readily by focussing on the second half of the Dugento and, more particularly, on the impact made on Italian painting of that period by what was then the latest Byzantine development, namely, the "volume style" of the early Palaeologan

period. The influence of this style was immediate and obvious in the Venetian mosaic workshops,[69] but it also made itself felt as early as the 1270's in central Italy,[70] and, above all, in what was to become the heartland of the Italian Renaissance, Tuscany. Some details from the mosaics in the dome of the Florence Baptistery which have sometimes been attributed to the young Cimabue invite direct comparison with Palaeologan work.[71] So do the frescoed Evangelists in the Upper Church at Assisi, which are generally agreed to be a work of Cimabue of the 1280's or early 1290's. If these figures are heavy and corporeal, if, with their obliquely placed furniture, they seem to come forward from the picture plane, if the accompanying architecture appears staged in depth, it is obvious where the principal source for all this lies.[72] In the young Duccio's Ruccellai Madonna, also a work of the 1280's, the same influence may be less immediately identifiable because it has been sublimated, as it were, and tempered with other elements, most obviously in the throne.[73] Shown in the same oblique and depth-creating view as that of the Assisi Evangelists, it has become a fanciful and elegant piece of miniature Gothic architecture. But Duccio's strong and direct indebtedness to contemporary Byzantium becomes evident in comparing the busts on the frame of the Madonna with Byzantine miniatures of the same period,[74] or the head of one of the angels[75] with an angel from Sopoćani.[76] What is even more important here than the purely formal similarities is an ethos of serene, aristocratic humaneness which these figures share. And whatever the complexities of Duccio's development, whatever other ingredients contributed to the further evolution of his style, there is still a strong Palaeologan flavor in his Maestà of 1308, witness a comparison with the almost contemporary work in the Kariye Djami (Figs. 46 and 47).

Clearly, then, the Greek influence involved something more than an endless repetition by unimaginative Italian craftsmen of stale and outworn Byzantine formulae. It was a living challenge emanating from the most recent developments in Constantinople and taken up by leading artists.[77]

Meanwhile, however, there had been another movement of great importance, namely, a return to Italy's own antique heritage. A number of Italian thirteenth-century artists borrowed consciously and systematically from Roman and early Christian art, thus continuing the chain of "proto-renaissances" of the twelfth century. Niccolo Pisano is a famous example. But the most systematic and

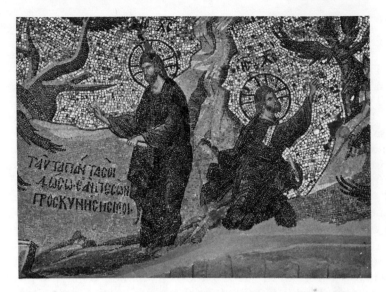

46. The Temptations of Christ (detail), from mosaic in outer narthex, Kariye Djami, Istanbul, second decade of the 14th Century (The Byzantine Institute, Dumbarton Oaks)

47. Christ in Gethsemane (detail), from Duccio's *Maestà*, Opera del Duomo, Siena, 1308–1311 (Anderson-Art Reference Bureau)

deliberate effort to revive the ancient native heritage took place in Rome in the last decades of the century, when Cavallini restored the fifth-century wall paintings of San Paolo f.l.m. and Torriti "recreated" in the apse of S. Maria Maggiore an early Christian type of mosaic complete with rich, fleshy acanthus rinceaux and a Nilotic landscape with sporting cupids.[78] What is important here—and to realize it one need only look at the figures of saints in Torriti's mosaic—is that the early Christian element merges and coalesces with a strong influence from the Byzantine "volume style" (Fig. 44).[79] What might otherwise have been a fussy accumulation of antiquarian detail becomes part of a monumental vision in which the grandeur and majesty of the human figure are powerfully proclaimed. And it was from this fusion of Eastern Hellenism and native late antique art, accomplished in Rome in the closing decades of the thirteenth century, that Giotto received decisive impulses. Giotto's new image of man—dignified, autonomous, creating, and completely dominating his spatial environment—owes much to Cavallini and his Roman circle, though it was nurtured also by further borrowings from the antique.[80] Thus, there is indeed a repetition of the chain of evolution that a century before had led from direct Byzantine influence to the "neo-classicism" of Nicholas of Verdun, and, finally, to the classic art of Chartres and Rheims.

Both in Italy and in the Gothic North, the Byzantine contribution was essentially a midwife service. It is not true to say that the Byzantine currents were without a future, let alone that they were merely obstructions. It *is* true to say that in the end the West found salvation elsewhere. Both of the decisive breakthroughs in the history of Western mediaeval art involved intensive and independent study of, and borrowing from, classical and early Christian antiquity. In this sense they were reactions against Byzantium. But they were preceded and, indeed, triggered by intensive waves of Byzantine influence.

It is clear also what accounts for this influence. The spell which Byzantine art held for so long—and in Italy so much longer than in the North—was due to its sustained quest for humane values. The Greek artists who in the twelfth and thirteenth centuries pursued their age-old interest in the human form and proclaimed successively its organic cohesion, its capability of conveying emotions and moods, and, finally, its power to create and dominate space, held out challenges and provided lessons such as the West's own mute relics

317

of antiquity could never have provided by themselves. Italy, for profound historical reasons, was captivated by these values far more strongly than were the transalpine countries. Hence the long duration of her state of apprenticeship—but hence also the thoroughness of the humanistic revolution which followed. Italy after 1300 was far less prone to "mediaeval reactions" than was the Gothic North; she was, in fact, firmly launched on the road to the Renaissance.

My subject was the Byzantine contribution to Western art, not the artistic relationship between East and West in its entirety. Had the latter been my theme more would have had to be said about the limitations to which Byzantine influence always was subject in the West. Whenever one puts side by side with a Byzantine work of art a Western mediaeval one—even, and, indeed, especially, a Western work that cleaves very closely to a Byzantine model—one cannot help being forcibly struck by what are, from the Byzantine point of view, misunderstandings, misreadings, or, at any rate, reinterpretations. The manner and direction of the departure from the Byzantine norm differ depending on the period and on the national background of the Western artists involved. But there are definite trends. There are strictly morphological changes, such as the tendency to replace Byzantium's soft, painterly lines by sharper and more calligraphic ones,[81] or its rather loose and vague correlation of figures and objects in space by some form of constructivism whereby the single elements of a picture become, so to speak, building blocks neatly and often tightly stacked in zones and staged in receding planes.[82] And there are the more subtle psychological changes, the casting-off of emotional restraints, the attempts at increased empathy, the unwonted touches of drastic realism, and the expressionist excesses which in some instances lead to distortion and caricature.[83] All these are Western attitudes of long standing; most of them can be discerned in the Western approach to the art of the Greek East even in the Carolingian period, and some earlier still. They bespeak deep and fundamental differences, differences that reach far beyond the realm of form and have to do with wholly divergent attitudes toward the role and function of religious art, and ultimately toward the entire world of the senses.

Here lies a vast field of further enquiry. It is a fascinating field encompassing as it does the whole problem of the Greek and the Western world in their estrangement as well as in their kinship. But my purpose was a more limited one. It will have been accomplished

318

# The Byzantine Contribution to Western Art
## of the Twelfth and Thirteenth Centuries

if I have been able to show that during a crucial period of its artistic development the West received from Byzantium vital help in finding itself.

*NOTES*

[Asterisks indicate references to Vol. XX of *Dumbarton Oaks Papers* (1966)]

[1] The problem is part, or rather the core, of the Byzantine Question, which has occupied historians of mediaeval art for more than one hundred years. See Ch. Diehl, *Manuel d'art byzantin*, 2nd ed., II (Paris, 1926), p. 712 ff.

[2] On *maniera greca*, see, in general, E. Panofsky, *Renaissance and Renascences in Western Art* (Stockholm, 1960), pp. 24 f., 34.

[3] See especially P. Toesca, *Storia dell'arte italiana*, I (Turin, 1927), p. 918 ff.; P. Muratoff, *La peinture byzantine* (Paris, 1928), p. 132 ff.; R. Oertel, *Die Frühzeit der italienischen Malerei* (Stuttgart, 1953), pp. 38, 57, and *passim;* also G. Millet, "L'art des Balkans et l'Italie au XIIIᵉ siècle," *Atti del V congresso internazionale di studi bizantini*, II (= *Studi bizantini e neoellenici*, VI [Rome, 1940]), p. 272 ff., where, however, a rather sharp distinction is drawn between the art of the Balkans and the art of Byzantium proper. Millet's ideas are developed further in a recent book by R. Valland, eloquently entitled *Aquilée et les origines byzantines de la Renaissance* (Paris, 1963).

[4] R. Longhi, "Giudizio sul Duecento," *Proporzioni*, 2 (1948), p. 5 ff., especially pp. 9 f., 21 f., 24 ff. See also F. Bologna, *La pittura italiana delle origini* (Rome, 1962), a book based on Longhi's premises.

[5] V. N. Lazareff, "An Unknown Monument of Florentine Dugento Painting and some General Problems Concerning the History of Italian Art in the Thirteenth Century" (in Russian), *Ezhegodnik Instituta Istorii Iskussto* (1956; published in 1957), p. 383 ff., especially p. 427 ff. While Lazareff explicitly rejects Longhi's extreme position (p. 437), essentially he considers the *maniera greca* of the thirteenth century as a foreign interlude antithetic to what he regards as the main line of development of a national Italian art.

[6] H. Sedlmayr, *Die Entstehung der Kathedrale* (Zurich, 1950), pp. 198 ff., 346 f.

[7] G. Vasari, *Le vite de' più eccellenti pittori scultori ed architettori*, ed. by G. Milanesi, I (Florence, 1878), pp. 242 f., 250 f.

[8] O. Demus, *The Mosaics of Norman Sicily* (London, 1949), p. 417 ff.; E. Kitzinger, *The Mosaics of Monreale* (Palermo, 1960), p. 75 ff.; K. Weitzmann, "Eine spätkomnenische Verkündigungsikone des Sinai und die zweite byzantinische Welle des 12. Jahrhunderts," *Festschrift für Herbert von Einem* (Berlin, 1965), p. 299 ff.

[9] Muratoff, *op. cit.*, p. 127.

[10] N. Kondakoff, *Histoire de l'art byzantin considéré principalement dans les miniatures*, II (Paris, 1891), p. 166 ff.

[11] The principal proponent of this thesis was D. V. Ainalov; for references, see O. Demus, "Die Entstehung des Paläologenstils in der Malerei," *Berichte zum XI. Internationalen Byzantinisten-Kongress München 1958*, IV, 2 (Munich, 1958), p. 33 f., note 141; p. 36, note 158.

[12] K. Weitzmann, "Constantinopolitan Book Illumination in the Period of the Latin Conquest," *Gazette des Beaux-Arts,* 6th ser., 25 (1944), p. 193 ff.

[13] O. Demus, "Studien zur byzantinischen Buchmalerei des 13. Jahrhunderts," *Jahrbuch der österreichischen byzantinischen Gesellschaft,* 9 (1960), p. 77 ff., especially p. 86 ff.

[14] Demus, *op. cit. (supra,* note 11), p. 25 ff.

[15] *Ibid.,* p. 29 f.

[16] See *infra,* p. 36.°

[17] Lazareff, *op. cit. (supra,* note 5), p. 428 ff., especially p. 436; H. Hager, *Die Anfänge des italienischen Altarbildes* (Munich, 1962), *passim.*

[18] A. H. S. Megaw, "Notes on Recent Work of the Byzantine Institute in Istanbul," *Dumbarton Oaks Papers,* 17 (1963), p. 333 ff., esp. p. 349 ff.

[19] The most obvious examples in these two centers are provided by mosaic decorations; see, in general, O. Demus, *Byzantine Mosaic Decoration* (London, 1947), p. 63 ff.

[20] H. Buchthal, *Miniature Painting in the Latin Kingdom of Jerusalem* (Oxford, 1957), p. 56.

[21] Cf. note 17, *supra.*

[22] A. Grabar, "Orfèvrerie mosane—orfèvrerie byzantine," in: *L'art mosan,* ed. by P. Francastel (Paris, 1953), p. 119 ff.; *idem,* "Le reliquaire byzantin de la cathédrale d'Aix-la-Chapelle," *Forschungen zur Kunstgeschichte und christlichen Archäologie,* III: *Karolingische und Ottonische Kunst* (Wiesbaden, 1957), p. 282 ff. (Grabar, however, fails to mention the key witness for the adoption in the West of the Byzantine type of utensil symbolizing the Heavenly Jerusalem, namely, Theophilus' chapters on censers: *Theophilus De Diversis Artibus,* ed. by C. R. Dodwell [London-Edinburgh-Paris-Melbourne-Toronto-New York, 1961], p. 111 ff.). R. Rückert, "Zur Form der byzantinischen Reliquiare," *Münchner Jahrbuch der Bildenden Kunst,* 3rd ser., 8 (1957), p. 7 ff. A. Frolow, *Les reliquaires de la vraie croix* (Paris, 1965), pp. 105 ff., 126 ff. and *passim.*

[23] For evidence that during the period here under consideration the stylistic aspect of Byzantine works of art became for Western artists an object of study and imitation in its own right, quite often dissociated from iconographic meaning, see the two papers by K. Weitzmann in the present volume (especially pp. 20, 76)°; also my remarks on "motif books" on p. 139 ff. of a paper published in Athens (cf. *infra,* note 39).

[24] A. Frolow, *La relique de la vraie croix* (Paris, 1961), p. 335 f.

[25] H. R. Hahnloser, "Magistra latinitas und peritia greca," *Festschrift für Herbert von Einem* (Berlin, 1965), p. 77 ff., esp. p. 79 ff.

[26] *Ibid.,* p. 81.

[27] *Ibid.,* p. 80 ff. Hahnloser questions the traditional date of 1105 for this commission and suggests that work on it may have begun soon after the accession of Alexius I in A.D. 1081 (p. 93). He also suggests that in commissioning works of art in Constantinople the Venetians may have been influenced by South Italian precedents (p. 80).

[28] (Comte Riant), *Exuviae sacrae Constantinopolitanae* (Geneva, 1877–1878). Frolow, *op. cit. (supra,* note 24), p. 144 ff. (on relics and reliquaries of the True Cross; see also the interesting graph on p. 111).

# The Byzantine Contribution to Western Art
## of the Twelfth and Thirteenth Centuries

[29] Vienna, Nationalbibliothek, MS Theol. gr. 336. See P. Buberl and H. Gerstinger, *Die byzantinischen Handschriften*, 2 = *Beschreibendes Verzeichnis der illuminierten Handschriften in Oesterreich*, N. S. IV, 2 (Leipzig, 1938), p. 35 ff. I am grateful to Prof. H. Buchthal for drawing my attention to this manuscript.

[30] Paris, Bibliothèque Nationale, MS Coislin gr. 200. See *Byzance et la France médiévale* (exhibition catalog, Paris, Bibl. Nat., 1958), p. 30 f.

[31] Buchthal, *op. cit.* (*supra*, note 20).

[32] *Ibid.*, pp. 41, 66 f., 92 note 2.

[33] S. G. Mercati, "Sulla Santissima Icone nel duomo di Spoleto," *Spoletium*, 3 (1956), p. 3 ff.

[34] V. Lazareff, "Early Italo-Byzantine Painting in Sicily," *The Burlington Magazine*, 63 (1933), p. 279 (icons in Palermo and Berlin). There is reason to believe that the mosaic icon of the Transfiguration in the Louvre (E. Coche de la Ferté, *L'antiquité chrétienne au Musée du Louvre* [Paris, 1958], p. 71) also was in Sicily before it came to Paris; the evidence for this is in the papers of the architect L. Dufourny (Paris, Bibl. Nat., Cabinet des Estampes, Ub 236, vol. VII).

[35] See K. Weitzmann's paper on Crusader icons in the present volume (p. 75 and fig. 52).°

[36] *Infra*, p. 41 f.°

[37] As long ago as 1893, E. Muentz wrote: ". . . l'influence byzantine . . . s'exerça pour le moins autant par l'action personnelle des artistes fixés en Italie principalement, que par l'importation des oeuvres d'art." ("Les artistes byzantins dans l'Europe latine," *Revue de l'art chrétien*, 36 [1893], p. 182 ff.). Muentz' study, supplemented for Italy by A. L. Frothingham (in *American Journal of Archaeology*, 9 [1894], p. 32 ff.), was based on literary and epigraphic evidence. I do not know of any systematic modern re-examination of that evidence.

[38] Leo of Ostia, *Chronicon Casinense*, III, 27 (Migne, PL, 173, col. 748).

[39] I have discussed the background and the impact of the Byzantine mosaicists working in Italy in the twelfth and thirteenth centuries in another paper read at the Dumbarton Oaks symposium of 1965; also, with special reference to the Sicilian workshops, in a lecture given in Athens in 1964 ("Norman Sicily as a Source of Byzantine Influence on Western Art in the Twelfth Century," *Byzantine Art—An European Art:* Lectures Given on the Occasion of the Ninth Exhibition of the Council of Europe [Athens, 1966], p. 121 ff.).

[40] The icons discussed by Lazareff in his paper "Duccio and Thirteenth-Century Greek Ikons" (*Burlington Magazine*, 59 [1931], p. 154 ff.) are probably too late in date to prove this point for the period before A.D. 1300. See the paper by J. Stubblebine in the present volume (p. 101). On the other hand, Professor Stubblebine has suggested that the two icons from Calahorra in the National Gallery in Washington may have been painted by Greek artists on Italian soil (*ibid.*, note 38).

[41] Buchthal, *op. cit.*, p. xxxiii and *passim;* K. Weitzmann, "Icon Painting in the Crusader Kingdom" (in the present volume, p. 49 ff.).°

[42] Weitzmann, *ibid.*, p. 75.°

[43] *Ibid.*, pp. 76, 79 ff.° See also my paper published in Athens (*supra*, note 39), especially, p. 139 ff.

[44] "Byzantine Art in the West," *Dumbarton Oaks Papers*, 1 (1941), p. 61 ff.

[45] *Ibid.*, p. 79.

[46] Cf., e.g., the wall paintings of the baptistery of Concordia Sagittaria, which reflect the style of the mosaics of the main portal of San Marco in Venice, mosaics which in turn are closely dependent on those of Hosios Lukas (see the exhibition catalog *Pitture murali nel Veneto e tecnica dell'affresco* [Venice, 1960], p. 36 f. and pl. 3. I owe this reference to Professor O. Demus.).

[47] For references, see *supra*, note 8.

[48] The pen drawing of the seated Christ in Vienna MS 953 (from Salzburg), which generally has been attributed to the period about or soon after 1150 (see H. J. Hermann, *Die deutschen romanischen Handschriften = Beschreibendes Verzeichnis der illuminierten Handschriften in Oesterreich*, N. S., II [Leipzig, 1926], p. 138 ff. and fig. 84), in my opinion cannot be earlier than the mosaics of Monreale.

[49] Weitzmann, *op. cit.* (*supra*, note 8), p. 309 ff.

[50] Demus, *op. cit.* (*supra*, note 8), p. 445 ff.; also my paper published in Athens (*supra*, note 39), especially, pp. 131 f., 135 f.; and K. Weitzmann's paper quoted *supra*, note 41, p. 23 f.

[51] J. Porcher, *L'enluminure française* (Paris, 1959), pl. 36 and p. 38.

[52] Demus, *op. cit.* (*supra*, note 8), p. 450 f.; also my paper published in Athens (*supra*, note 39), especially, p. 136 ff.

[53] Fl. Röhrig, *Der Verduner Altar*, 2nd ed. (Vienna, 1955).

[54] For general discussions of Nicholas' background, in which many influences converge, see H. Swarzenski, *Monuments of Romanesque Art* (Chicago, 1954), p. 29 ff.; Röhrig, *op. cit.*, p. 30 ff.; H. Schnitzler in *Der Meister des Dreikönigenschreins* (exhibition catalog, Cologne, 1964), p. 7 ff.

[55] O. Demus, "Neue Funde an den Emails des Nikolaus von Verdun in Klosterneuburg," *Oesterreichische Zeitschrift für Denkmalpflege*, 5 (1951), p. 13 ff., esp. p. 16 ff. and fig. 26. Röhrig, *op. cit.*, fig. 53.

[56] H. Schnitzler, *Rheinische Schatzkammer: Die Romanik* (Düsseldorf, 1959), p. 9. What H. Swarzenski once called "the enigmatically early date" of the Klosterneuburg Altar ("Zwei Zeichnungen der Martinslegende aus Tournai," *Adolph Goldschmidt zu seinem siebenzigsten Geburtstag* [Berlin, 1935], p. 40) certainly appears less puzzling when seen in this light.

[57] See in general M. Gigante, "Antico, bizantino e medioevo," *La Parola del Passato*, 96 (May-June 1964), p. 194 ff., esp. p. 212.

[58] Schnitzler, *op. cit.* (*supra*, note 54), p. 9 ff.

[59] O. Homburger, "Zur Stilbestimmung der figürlichen Kunst Deutschlands und des westlichen Europas im Zeitraum zwischen 1190 und 1250," *Formositas Romanica: Beiträge zur Erforschung der romanischen Kunst Joseph Gantner zugeeignet* (Frauenfeld, 1958), p. 29 ff. O. Pächt, "A Cycle of English Frescoes in Spain," *Burlington Magazine*, 103 (1961), p. 166 ff., esp. p. 171. L. Grodecki, "Problèmes de la peinture en Champagne pendant la seconde moitié du douzième siècle," *Romanesque and Gothic Art = Studies in Western Art: Acts of the Twentieth International Congress of the History of Art*, I (Princeton, 1963), p. 129 ff., esp. p. 140 f.

[60] These stylistic connections seem to me more specific than those with more recent products of Byzantine metalwork, such as the silver reliefs from Tekali and Bochorma (H. Schnitzler, *op. cit.* [*supra*, note 54], p. 10 and figs. on pp. 7, 57).

## The Byzantine Contribution to Western Art
## of the Twelfth and Thirteenth Centuries

Works of the minor arts of the *early* Byzantine period were cited long ago by Wilhelm Vöge to account for the classicizing strain in early Gothic art ("Ueber die Bamberger Domsculpturen," *Repertorium für Kunstwissenschaft,* 22 (1899), p. 94 ff., esp. p. 97 ff.; *ibid.,* 24 (1901), p. 195 ff., esp. p. 196 f.). Influences from works of Byzantine art of the tenth and subsequent centuries should not, however, be ruled out altogether (see *infra*).

[61] W. Sauerländer, "Beiträge zue Geschichte der 'frühgotischen' Skulptur," *Zeitschrift für Kunstgeschichte,* 19 (1956), p. 1 ff., esp. p. 2 (importance of Meusan metalwork; for earlier literature on this subject, see the references in note 5), p. 15 with note 56 (relationship of Laon to Nicholas of Verdun), p. 21 ff. (relationship of Chartres to Laon); see also *idem,* "Die Marienkrönungsportale von Senlis und Mantes," *Wallraf-Richartz-Jahrbuch,* 20 (1958), p. 115 ff., especially p. 135 (importance of English illuminated manuscripts). H. Reinhardt, *La cathédrale de Reims* (Paris, 1963), p. 145 ff.

[62] Reinhardt, *ibid.,* p. 148 f.

[63] See the excellent formulation by O. Demus apropos of Nicholas of Verdun: "Er dürfte der erste nordische Meister gewesen sein, der durch die Oberflächenschicht des italobyzantinischen Stilhabitus zu den antiken Grundlagen der Form durchsteiß und damit der langdauernden Lehrzeit der nordischen Kunst bei der byzantinischen ein Ende machte" (*op. cit.* [*supra,* note 55], p. 18).

[64] Panofsky, *op. cit.* (*supra,* note 2), p. 55 ff.

[65] H. Swarzenski, *Die lateinischen illuminierten Handschriften des XIII. Jahrhunderts in den Ländern an Rhein, Main und Donau* (Berlin, 1936), p. 8; O. Demus, *op. cit.* (*supra,* note 13), p. 88. The "Zackenstil" is not simply a lingering reflection of the Byzantine "dynamic" wave of the late twelfth century, but was formed on the basis of quite up-to-date Byzantine models; see Weitzmann, *op. cit.* (*supra,* note 12).

[66] This was my experience when visiting Sopoćani in 1953. I was happy to find during the preparations for the 1965 symposium at Dumbarton Oaks that my friend Professor Otto Demus had independently come to the same conclusion. In the lecture on wall paintings which he gave at the Symposium, Professor Demus made striking comparisons between figures from Sopoćani and statues from Naumburg Cathedral which are of virtually the same date.

[67] A. Frolow has recently suggested a direct influence of Byzantine paintings and mosaics to account, or to help account, for the characteristic sweeping curve of Gothic statues ("L'origine des personnages hanchés dans l'art gothique," *Revue archéologique* [1965], I, p. 65 ff.). But, if there was such an influence in the thirteenth century—as distinct from, and in addition to, a development growing from seeds sown during the period of the West's own "neoclassicism" about A.D. 1200—that influence was absorbed and transposed in the freest and most sovereign manner. The gradual and essentially autonomous emergence of the motif in French early thirteenth-century sculpture has been beautifully described by W. Vöge ("Vom gotischen Schwung und den plastischen Schulen des 13. Jahrhunderts," *Repertorium für Kunstwissenschaft,* 27 [1904], p. 1 ff., esp. p. 5).

[68] This parallelism between the Northern and the Italian development was noted by Koehler, *op. cit.* (*supra,* note 44), p. 86 f., and Panofsky, *op. cit.* (*supra,* note 2), p. 137.

[69] O. Demus, "The Ciborium Mosaics of Parenzo," *Burlington Magazine*, 87 (1945), p. 238 ff., esp. pl. 1 A and p. 242; *idem, op. cit. (supra,* note 11), p. 39.

[70] Toesca, *op. cit. (supra,* note 3), p. 970 f. (Grottaferrata).

[71] *Ibid.,* p. 1003 and fig. 705. The figures of prophets in the central disk of the vault of the Scarsella, which also derive very obviously from Palaeologan art, have been attributed by O. Demus to Venetian mosaicists who came to Florence after 1301 ("The Tribuna Mosaics of the Florence Baptistery," *Actes du VIe congrès international d'études byzantines,* II [Paris, 1951], p. 101 ff., esp. p. 106 ff.; for illustrations, see *I mosaici del Battistero di Firenze* [a cura della Cassa di Risparmio di Firenze], V [Florence, 1959], pl. 15 ff.

[72] Demus, *op. cit. (supra,* note 11), p. 40 and figs. 18, 32. For Cimabue's work at Assisi and its Byzantine affinities, see also the paper by J. Stubblebine in the present volume (p. 96 f. and figs. 14–17).°

[73] Stubblebine, *ibid.,* p. 99 f. and fig. 22.°

[74] *Ibid.,* p. 99 and figs. 16, 21, 23.° See also V. N. Lazareff, in *Vizantiiskii Vremennik,* 5 (1952), p. 178 ff., esp. fig. 8.

[75] Stubblebine, *op. cit.,* fig. 26.°

[76] V. J. Durié, *Sopoćani* (Belgrade, 1963), pl. 32. For comparisons with Byzantine icons, see Stubblebine, *op. cit.,* figs. 28, 29 and p. 99 f.°

[77] Stubblebine, *ibid.,* p. 100.° For Palaeologan influences on miniature painting in Sicily in the early fourteenth century, see the paper by H. Buchthal in the present volume (p. 103 ff.).°

[78] W. Päseler, "Der Rückgriff der römischen Spätdugentomalerei auf die christ- liche Spätantike," *Beiträge zur Kunst des Mittelalters* (Berlin, 1950), p. 157 ff. Panofsky, *op. cit. (supra,* note 2), p. 137. For Cavallini's work in S. Paolo see J. White, "Cavallini and the Lost Frescoes in S. Paolo," *Journal of the Warburg and Courtauld Institutes,* 19 (1956), p. 84 ff.

[79] P. Toesca, *Pietro Cavallini* (Milan, 1959), p. 6.

[80] Oertel, *op. cit. (supra,* note 3), p. 68. Panofsky, *op. cit. (supra,* note 2), pp. 119, 137, 148, 151 ff. (with further references).

[81] See, e.g., figs. 34, 35; also K. Weitzmann's two papers in the present volume, *passim* (e.g., p. 7 f. and figs. 8–11; p. 66 and fig. 32; p. 69 and fig. 33 f.; p. 81 f. and fig. 66 ff.).°

[82] See, e.g., Stubblebine, *op. cit.,* p. 87 f. and fig. 1 f; p. 92 f. and fig. 11 f; p. 97 and fig. 18.°

[83] See, e.g., fig. 13; also K. Weitzmann's two papers, p. 16 f. and fig. 27; p. 60 and fig. 19; p. 63 f. and fig. 23; p. 64 and fig. 26.°

# 16. THE GENERAL PROBLEMS

# OF THE GOTHIC STYLE

## Paul Frankl

### INTRODUCTION

This selection from Frankl's posthumously published *Gothic Architecture* (1962) is from the second part of that volume, and it is considered by some to be the most stimulating section. Following a broad survey of the genesis and changing fortunes of the idea of "Gothic," this selection treats the development of a Gothic Style as an "immanent" or internal process within the constructional problems confronting the Gothic builders. In it Frankl stresses the interrelationship of building practices, patronage, function, and symbolism as determinants.

Frankl's earlier work *The Gothic: Literary Sources and Interpretations Through Eight Centuries* is not only a thorough review of the literature on the Gothic, but it examines as well a number of special problems. Erwin Panofsky's *Gothic Architecture and Scholasticism* (1951) is especially valuable in drawing attention to correspondences between the form of medieval scholastic writings and the form of Gothic architecture presuming a pattern of thought common to both. Clarence Ward's *Medieval Church Vaulting* (1915) is still useful and Joan Evans's *Art in Medieval France* (1948) is a fine survey. The second volume of Henri Focillon, *The Art of the West in the Middle Ages* (1963; first published in French, in 1938) treats Gothic art in general. Works dealing with more specific aspects of Gothic art are: Otto von Simson, *The Cathedral of Chartres* (1956), and, by the same author, *The Gothic Cathedral: Origins of Gothic Architecture and the Medieval Concept of Order* (1964); H. Jantzen, *The High Gothic: The Classic Cathedrals of Chartres, Reims, and Amiens* (1962); A. Katzenellenbogen, *The Sculptural*

*Programs of Chartres Cathedral* (1959, 1964); J. Pope-Hennessy, *Italian Gothic Sculpture* (1955); J. Dupont and C. Gnudi, *Gothic Painting* (1954); Whitney Stoddard, *The West Portals of Saint-Denis and Chartres* (1952); L. Grodecki, "The Transept Portals of Chartres Cathedral," *Art Bulletin*, XXXIII (1951), 156–164; James R. Johnson, *The Radiance of Chartres* (1965); *Abbot Suger on the Abbey Church of St. Denis and Its Art Treasures*, translated by Erwin Panofsky (1946); James Ackerman, "'Ars sine scientia nihil est.' Gothic Theory of Architecture at the Cathedral of Milan," *Art Bulletin*, XXXI (1949), 84–111; George Kubler, "A Late Gothic Computation of Rib-vault Thrusts," *Gazette des Beaux-Arts*, series 6, XXVI (July-December 1944), and other articles on Gothic vaulting in this same issue; and Alan Borg and Robert Mark, "Chartres Cathedral: A Reinterpretation of Its Structure," *Art Bulletin*, LV, 3 (1973), 367–372. *Chartres Cathedral*, edited by Robert Branner (1969), is a handy, well-illustrated paperback anthology of documents and writings on that monument of the Gothic style.

Finally, there is one literary work—Henry Adams's *Mont-Saint-Michel and Chartres* (1904, reprinted many times)—that remains an enduring delight.

# 1. THE TERM "GOTHIC" AND THE CONCEPT OF THE GOTHIC STYLE

THE architect who built the choir of St Denis must have spoken to Suger about the *arcus* in the vaults; William of Sens in speaking to the Abbot of Canterbury no doubt used the term *fornices arcuatae*, and Villard de Honnecourt probably spoke to his apprentices of *ogives*. However, no name for the style itself is known to have existed at this time; indeed, it is unlikely that any name did exist, for, in the regions where the Gothic style was born and developed, "building in the Gothic style" was simply called building. In Germany, the chronicler Burckhard von Hall wrote, about 1280, that the church at Wimpfen im Tal, which was begun in 1269, was built *more francigeno*. This name does not describe the style, but simply indicates its origin, which confirms the view that no special name yet existed for the style as a whole.

Petrarch (1304–1374) was in Cologne in 1333 and wrote that he had seen an uncommonly beautiful *templum* there which was unfinished, but which was rightly called the most magnificent in the world (*summum*). In spite of that Petrarch was among the first men, if not the first, to value the age of classical antiquity higher than his own on every count. He did not base this conclusion only on the poor quality of the Latin of his time, compared with that of Cicero and Vergil, and on the low standard of scholarship, compared with that of Plato (of whom he knew little); he also compared the poor quality of the painting and sculpture of this age with the perfect reproductions of natural forms achieved by the Greeks and Romans. Since he regarded himself as a descendant of the Romans, it is in his works that the theory that everything bad came from the "barbarians" was born.

This "Barbarian theory" was adopted by humanistic circles.[1] In his biography of Brunelleschi, Manetti wrote that architecture fell into decadence after the end of the Roman Empire, that the Vandals,

the Goths, the Lombards, and the Huns brought their own, un-talented architects with them, that architecture improved slightly for a few years under Charlemagne, and that it then fell into decadence once more until the appearance of Brunelleschi in 1419.

Filarete, who lived from about 1400 to about 1469, had similar ideas on the history of architecture. He wrote, "cursed be the man who introduced 'modern' architecture." By "modern" he meant Gothic, which still appears to have had no name. He continued, "I believe that it can only have been the barbarians who brought it to Italy."

Alberti said that it would be absurd to paint Helen or Iphigenia with Gothic hands—with the hands of old women. In the Italian text, the phrase is *mani vecchizze e gotiche,* but, in the Latin edition, Alberti translated this with the words *seniles et rusticanae.* The word Gothic does not therefore seem, as yet, to have acquired its modern sense. Gothic meant rustic or coarse, like the Goths.

Gradually the word Gothic came to be applied not to barbarians in general, but only to certain specific barbarians. Filarete puts the blame on the *transmontani,* expressly adding, "the Germans and the French." In 1510, in the report of the so-called Pseudo-Raphael, the idea was further narrowed down: he spoke only of the *maniera tedescha.* In this report, too, the theory is first advanced that the Gothic style had its origins in the forests, because the Germans could not cut down trees, but bound together the branches of living trees, thus creating the pointed arch. This theory that the Gothic style was born in the forests of Germany lived on in various forms with unbelievable tenacity, sometimes in a literal form, and sometimes in the form of metaphors.

In 1520, page xv of Cesariano's work is headed, "secundum Germanicam symmetriam."

Vasari contrasted this bad architecture with the classical orders, and wrote: "There is also another manner of architecture which is called the German manner." He completely forgot the real culprits, the French, and went on to say: "This manner was invented by the Goths." In writing of the Palazzo dei Signori at Arezzo, he used the term *maniera de' Goti,* while Palladio reverted to the phrase, *maniera tedesca*—not *gotica.*

In France, however, it was never forgotten that the Gothic style was not born in Germany. Philibert de l'Orme, who lived from 1512 to 1570, called it *la mode Françoise.*

## The General Problems of the Gothic Style

In Germany, Sandrart, in his *Teutsche Akademie,* which was published in 1675, revived the Italian theories. He seems to have been familiar with Filarete's manuscript, or at least to have had indirect knowledge of it, for he wrote that, by inventing bad architecture, the Goths "had called down more than a thousand million curses on their heads." Filarete had modestly contented himself with a single curse.[2]

From the history of the name of the Gothic style, it can be seen how muddled the concept was. The Goths, who in 410, under the leadership of Alaric, destroyed Rome, or rather parts of it, were made responsible for all the architecture that was created between 410 and 1419, and, in countries other than Italy, even for works executed up to the time of Vasari—that is, about 1550.

During the eighteenth century, in the course of a slow process of development, a more positive view of the Gothic style was reached, and, with it, the concept of what was Gothic changed. Historians began to distinguish two periods; they gave separate names to different parts of the earlier periods and reserved the term Gothic for the last period alone. The evil reputation of the men who destroyed the good architecture of Rome, however, stuck until the connexion was either forgotten, or was no longer felt. As early as 1840, Kugler said that we no longer think of the Goths when we say "Gothic." Nevertheless, those men who were beginning to feel enthusiasm for the Gothic style tried to find a better name for it, but none of these names, neither *style ogival,* nor Kugler's Germanic style, nor any of the others, found support.

When in the course of the nineteenth century historical knowledge of the birth of the Gothic style, its development, and its spread increased, the Late Gothic style was still regarded as part of the Gothic style. Moreover, the growing study of the essential Gothic elements, beginning with Wetter's book, and the attempts to interpret the essence of the Gothic, which began with the work of Viollet-le-Duc, and have continued to our own day, have neutralized the effects of personal taste and have led to a more intensive analysis of the concept of Gothic style.

The scholarly consideration of the Gothic style began with descriptions of individual buildings and so came to the study of individual members, such as pointed arches, piers, rib-vaults, windows, doorways, roofs, and towers. At the same time a desire grew to understand the essence of the Gothic style which could permeate

such divergent features as piers and windows. The Gothic style was said to possess a picturesque quality, a quality of infinity, a vegetal quality, a romantic quality. All these different concepts were first formulated in the eighteenth century and were then considered more closely in the nineteenth and systematically bound into one unified concept.

Some of these concepts were also applicable to sculpture and painting, and the concept of what was Gothic was widened to include, not only architecture, but also the fine arts. After this, the term became more and more extensible, until critics began to speak of Gothic literature and poetry, of Gothic music, of Gothic philosophy and metaphysics, of Gothic civilization, and, finally, of the Gothic man. This process was begun by de Laborde in 1816, when he wrote an introduction on political history to his work on French architecture. In 1843, Schnaase went further; he presented his public with a panorama of medieval civilization. At about the same time, Vitet proposed the theory that the Romanesque style was created by the clergy, whereas the Gothic style was the creation of the laity. Viollet-le-Duc tacitly accepted this theory, but broadened it with a combination of *l'esprit gaulois* and his own theory of functionalism. Succeeding generations accepted this legacy, and *l'esprit gaulois* developed further under the influence of the fantastic racial theories of Gobineau, whose forerunners had appeared as early as the eighteenth century. The study of medieval symbolism can also be traced back to the Romantic period (e.g. to works of Boisserée and later of Ramée), and the background to the history of Gothic civilization grew more and more rich and colourful.

The sceptics, who appeared about 1900, did not perceive the metaphorical driving belt which must be assumed to run between Gothic civilization and Gothic architecture, if one is to accept an explanation of stylistic developments in terms of the many factors which go to make a civilization. It was, of course, obvious that certain architectural traits must be a reflection of the civilization of their time, but it was not known whether these traits should be interpreted as reflections either of social factors or of national ones, or whether perhaps they sprang from a change in the nature of piety. Perhaps it was these factors, and many others besides, which were the roots from which history grew, and which provided the branch of architecture with its sap. Historians spoke of many different roots, but, basically, their search was for the primary root

of all these roots, and they gave this title sometimes to one root and sometimes to another.

Nobody can doubt the legitimacy of these studies, but, if one stands in front of an actual building and asks oneself what a certain base of a certain pier, or a certain triforium, or a certain rose-window has to do with scholasticism, chivalry, courtly love, or even the liturgy, not to mention politics and economics, one realizes that all these many theories do not give a sufficient answer: and yet the problem is one which must be faced.

. . . The development of the Gothic style [can be viewed] as an immanent process which took place within building lodges. To clarify the problem, one can call those other factors which penetrated the lodges from outside external factors, and one can exclude them from architectural discussion, in which they would only cause confusion. As soon as one starts to look for the influence of these external factors, however, one realizes that every other branch of human activity followed its own immanent development, just as did the field of architecture. The problem that was so disturbing to nineteenth-century historians can be expressed in a single question. Did all these immanent lines of development run parallel to one another, and, if so, what was the force which produced this parallel course?

## 2. THE DEVELOPMENT OF THE GOTHIC STYLE
### SEEN AS AN IMMANENT PROCESS

The improvement of Romanesque groin-vaults came about as a result of a rational consideration of the geometric construction of the arches and the surfaces of the cells; the building technique employed, that is, the centering; their statics, both during and after construction; and also the economic problems which they presented. But all these considerations always went hand in hand with the aim of producing an aesthetically satisfying result. The changes had nothing to do with the Crusades, which began only later, or with the liturgy, or with philosophy. The architects were intent simply upon making necessary improvements. As far as can be reconstructed, this was a process of trial and error which led to the replacement of diagonal, wooden centering arches by the stone *cintre permanent,* that is the rib.

Here, the question must indeed have arisen as to whether the

architectural patrons of this time, the clergy, were in agreement
with the introduction of this innovation; but this question can be
ignored for the moment. The development . . . shows that the
rib-vault, in its turn, was further improved by a combination of
rational considerations and aesthetic criticism, which resulted in the
introduction of pointed arches, first over the four sides of each bay,
and finally in the diagonals also. This process, too, was an immanent,
or an internal one. Just as master-masons did not determine the form
of the liturgy or indulge in metaphysics, so the clergy did not build
scaffolding, or draw designs for arches or for the profiles of ribs.
These are different spheres, different jobs, requiring special skills,
and it need hardly be said that no amount of knowledge of meta-
physics can help one to build a rib-vault, and that on the other hand
the ability of an architect to build a vault cannot help him to decide
whether general concepts are realities or mere names.

However, rib-vaults presented only part of the problem. The real
problem was how to achieve conformity throughout a whole church.
History shows that the transformation of Romanesque architectural
members to conform with the ribs was not achieved overnight. Ribs,
being members crossing each other diagonally, demanded that shafts
also be turned diagonally. Therefore, the form of bases and capitals
had also to be altered. In the case of sexpartite vaults, this meant
that the number of shafts had to be increased. The question as to
what form piers should take became an urgent one. The steps taken
to solve this problem led ultimately to the dissolution of the wall
into a grille and the introduction of the new Gothic kind of relief. In
this kind of relief, one layer is conceived as projecting in front of
another, not as lying behind it, just as ribs are seen to project in front
of the cells of a vault rather than cells to lie behind the ribs. The
slenderness of the rib set the proportions for slenderer supports, and
its structural character seemed to demand the change from Ro-
manesque structure to specifically Gothic structure. The new sys-
tem allowed an increased emphasis on verticals (Fig. 48), yet left the
architect of Sens the possibility of choosing the golden mean, and the
architect of the Sainte-Chapelle that of using the fairly moderate
proportional ratio of 1 : 2. The tendency to emphasize verticals only
governed the work of certain schools and generations. . . .

The real propelling force of the rib lay both in its diagonality, and
in its property of dividing each spatial compartment of the church
into interdependent, fragmentary spatial units. The tendency to-

48. Amiens Cathedral, interior of nave, view toward apse, French Gothic, begun 1220 (Marburg-Art Reference Bureau)

wards a more and more resolute reshaping of spatial parts and architectural members to conform to the principle of partiality, and the resulting change in the forces of the members . . . must also be considered in discussing the immanence of the development of Gothic architecture. . . .

It must not be supposed that all architectural members became Gothic to the same degree at the same time. Vaults had achieved their classic Gothic form long before bases had undergone the same degree of change. But, in every case, it was the criticism of architects and their imaginative energy which demanded these changes, devised them, and finally realized them. The philosophers, the clergy, the knights, and the kings played no part in the solution of the problems; they were internal problems of the lodges.

Although every good monograph deals with the forms of bases, and distinguishes between the work of architects by the profiles they

used, a detailed examination of the history of this one member would not be sufficient to explain the immanent development of the Gothic style.

The changes in the forms of the great circular windows show this development much more clearly. . . . It is easy to recognize the variations and combinations in the forms of circular windows as the result of consistent steps. . . .

. . . Every step which marked some degree of progress in the solving of the problem of filling oculi was conditioned by the demands of the whole church, and was therefore part of the greater progress of the continual increase in the emphasis on partiality: and yet every such step also set its own special problems within the greater overall problem. Every architect was involved in the common task as a follower of his predecessors and, more particularly, of his own teacher, and found in this general task his own personal task, which he fulfilled with his own imaginative powers and his own spiritual energy, according to the nature and the degree of his personal talents.

Within this process, there are those who vary, those who combine, and those who correct, some tending towards increased clarity, others towards increased splendour, yet others to both. There are steps which created something entirely new, like the system of Noyon (or perhaps earlier of the choir at St Denis), the consequences that were drawn from the form of the buttresses and flying buttresses at Chartres, and the form of the tracery at Reims. In our historical consideration we follow the works of all these architects, both the modest ones, like the architect of Senlis, and the men of genius, like the designer of Lincoln, the architects of the English chapter houses and their successors at Ely and Gloucester, Peter Parler, and many others. It is their spiritual achievements which have given us such rich gifts. However, even these men of genius were firmly bound by the whole process of development; for even the great intuitions come only out of hard work. No man who was not a member of one of the lodges could take part in the creative development of the Gothic style, not even Albert the Great, although, according to legend, he is supposed to have done so. To participate, one had to belong to the profession.

The continuity of the development was the product of instruction, and on this subject we are fairly well informed. The more the Gothic style developed, and the more complicated it became, the more

impossible it was for a self-educated man to enter the field. From the ranks of the trained masons the most gifted were picked out, after they had completed their compulsory period of journeying, and were made the foremen who constituted the link between the creative architect and his executive craftsmen. Where foremen not only seemed capable of forming this link and controlling the actual labour, but also showed some aptitude for creative design, they were put to work as draughtsmen under the supervision of the architect, until they were finally equipped to carry out their own designs. The reason we have better knowledge of the organization of Late Gothic lodges is that the architects of the earlier period had easier problems to solve and could therefore treat legal and instructional problems more lightly. In the Late Gothic period, proper examinations were held, at which the apprentices had to produce a master-piece.[3] But by whatever process architects were selected from the twelfth century onwards, it is clear that an apprentice was subject to the judgement of the older generation and that he had to be familiar with the ideas of the masters before he could reach the stage at which he himself, when faced with a new problem, could make his own constructive criticism of their work.

This explains the small extent of the steps taken within the lodges, and the interplay of influences, which was the result of the travel of apprentices and of the calling of architects from one place to another. Even in the spread of the style over regions far distant from one another, which was the result of journeys of whole bands of masons, or of educational journeys like that of the German architect who began the church at Wimpfen in 1269 and "had just returned from Paris," continuity was always conditioned by the personal ties which kept architects to lodges. Every architect was, according to his talent and imagination, free to make a leap if he dared, but his spring-board was provided for him, and his work became, in turn, a spring-board for his pupils.

The picture drawn here explains the connexion between the factors of tradition and originality: what we call immanence is founded on both. Younger architects followed existing tracks and continued them, and they were bound to understand the sense of direction set by a strong tradition, because they had to append their innovations organically to what already existed. Only rarely, as in the case of Brunelleschi, did an architect make a radical break with this sense of direction, and even he stood in a current and was the

exponent of the ideas of his own social class of humanists. The lodge of S. Maria del Fiore at Florence did not consist so exclusively of masons as did those in other towns. Here there are also laymen, and it was their presence which produced the spiritual atmosphere that enabled Brunelleschi to break with all the traditions of the Gothic style. . . .

The immanence of the development of the Gothic style is no mystery. It would be one if one were to believe that the last Gothic works, such as King Henry VII's Chapel, Annaberg, and the network of flying ribs at Frankfurt, had been in existence in some other sphere outside our world since 1093, waiting for their own realization and, like a magnet, directing the countless little steps in the development towards their own creation. Immanence, on the contrary, operates the other way round. The introduction of the rib-vault proposed a general sense of direction, leading to a goal which could not be foretold, but could only be realized through a strict adherence to this direction. This is not like a search for the North Pole, which already exists, but is a chain of creations, providing a chain of surprises, which culminates in the final surprises of the ultimate Late Gothic style.

This aspect of the immanence of the development is the product of the inner, spiritual labours of the professional workers engaged in the field of architecture. *Immanere* means to stay within. By immanence, we mean that tendency in a course of development which is determined from within the subject of the development. However, as has already been explained, the different immanent processes in different spheres of activity existing within the same cultural environment seem to be subject to another, higher, and all-embracing immanence. It is to these other spheres that we shall turn next.

### 3. THE MEANING AND THE PURPOSE
### OF CHURCH ARCHITECTURE

An architect builds a pulpit as well suited as possible to its purpose; he seeks the most suitable position in the church, raises the level of its floor, and builds steps, a rail, and a sounding-board. The purpose of the pulpit is that sermons shall be preached from it. The sermon, too, has a purpose; it is intended to instruct, to edify, and to confirm belief, but its meaning lies in what is preached. To understand the meaning of a pulpit, it is sufficient to recognize its purpose,

but to understand the meaning of a sermon, it is not enough to understand that its purpose is to edify: one must actually understand what is said by the preacher. Purpose is a limited case within the wider concept of meaning.

The same thing is true of an altar. The architect must arrange it to fulfil its purpose, so that Mass can be read and a congregation attend, but the meaning of this arrangement lies within the Mass itself.

Church architecture embraces a number of purposes, which are the products of the various actions of the Christian cult. The overall purpose of a church is to serve the whole cult, but its meaning lies in religious devotion. The meaning embraces the whole gamut of religious ideas and feelings—contemplation, repentance, and the resolution not to sin any more, consolation and hope. The meaning of a church lies in belief, and only the differentiation between all the activities of the cult splits this meaning into a variety of individual functions. To understand the meaning of a Gothic church, one must understand both the meaning of religion and, more especially, the meaning of the Christian religion during the age of Gothic architecture, and the special purposes underlying the church, according to whether one is entering either a cathedral, a monastic church, a parish church, or a chapel of a castle.

Dehio has discussed very fully the changes within the architectural programme of the church while the Gothic style reigned.[4] Some of the innovations which were introduced had their roots in the period of the Romanesque, for instance the building of longer choirs to allow for the larger number of clergy. The lengthening of an existing choir at *Laon* is a specially clear expression of the demands of the clergy about 1205.

A second innovation which influenced architecture was the exhibition of newly acquired relics on altars, and the translation of older relics from crypts to the churches above. Even within the Romanesque style, the Cluniacs of Hirsau and the Cistercians had decided against crypts. At *St Denis* Suger preserved the old crypts because, as consecrated ground, they seemed sacrosanct to him. From the time of the building of *Noyon*, however, crypts were only built where the site demanded it, for instance at *Bourges*, *Siena*, and *Erfurt*. The building of crypts resulted in choirs lying several steps higher than the naves: with their disappearance, choirs and naves came to lie at the same, or almost the same, level.

337

The clergy needed some kind of barrier to separate them from the laity, in order not to be disturbed at their prayers, which took place seven times a day, and it was from this need that rood-screens and screens dividing choirs from choir aisles developed. In Spain and in England, this tendency was taken a stage further, and the east end of the nave was also reserved for the clergy. These high screens, which sometimes take the form of walls, . . . destroy the open view that was originally intended, and, because of this, many rood-screens in France and Germany were later removed. The exclusion of the congregation was felt to be too aristocratic, and even the clergy probably found this attitude of separation presumptuous. . . . There were Gothic rood-screens in *Notre-Dame* in *Paris*, in the cathedrals at *Reims*, *Naumburg*, and *Strassburg*, and in many other churches. Moreover, in Paris, the screens between the choir and the choir aisles have been preserved, and one can experience for oneself how exclusive the effect of these insertions is in every sense. Judged stylistically, they are extreme cases of the insertion of one spatial unity into another, and certainly nobody would wish that the one at *Albi* did not exist. However, it can be seen in all these parts of churches whose access was more or less forbidden to the laity, that their purpose, stated barely and soberly, was to express a system of social strata.

The increase in the number of the clergy was one of the reasons for the increase in the number of altars and therefore also of chapels. The rows of chapels round choirs were continued along choir aisles. Dehio noted that the cathedral in *Barcelona* has thirty-one chapels and that the church of S. *Petronio* at *Bologna* was intended to have fifty-eight; and, in an imaginary description of the church of the *Holy Grail*, there are seventy-two. Although this was a church on a central plan and the number is probably connected with some symbolism of numbers (3 times 24), the need for so many chapels must, nevertheless, be understood to be the result of the number of the Knights of the Holy Grail, who must also be regarded as clergy.

The significance of purpose can be seen equally clearly where its action is negative. In parish churches, where there were few priests, and sometimes only one, there was no increase in the number of chapels, and in the churches of the mendicant orders the position of the chapels and the significance of sermons influenced the designs to which they were built.

To these factors must be added the fact that allowances had to be

made for processions. We know that the ante-rooms or porches at *Cluny* and *Vézelay* served the purpose of protecting participants in processions from the weather while they were lining up for their entrance into the church. Both these ante-rooms date from the Transitional period, and they had only a few impressive Gothic successors; their function appears to have been transferred to porches and the lower storeys of towers.[5] The arrangement of processions may have been variable, but it is nevertheless legitimate to say that Gothic cathedrals are processional spaces. . . .

However, the form of a building is not determined by purposes only. This is true even if one does not confine oneself to the consideration of subsidiary functions, such as those of altars and pulpits. Even the reciprocal interplay of all the ritual functions embraced within a whole church does not give a clear, unequivocal solution, although the architect must try to achieve the best possible interplay. It is not in this respect that sacred functions can be differentiated from secular ones. The fabrication of tools, weapons, clothes, bridges, means of transport, or signs proceeds, in every case, from a general conception of what is required, and continues with a search for the most suitable materials and forms. The fabrication of a hammer proceeds from a general conception of its purpose and its mechanical principles; this conception is then narrowed by a consideration of the special function which it is to serve—whether it is to be used by a mason or a precision engineer. Finally, however, it must be decided what materials are to be used for the handle and the head and what form they shall take. In other words, function always leaves a "margin of freedom" which cannot be resolved by utilitarian considerations and which is not objectively pre-determined.

So far we have only considered purposes which spring from human activity, but one can also speak of the functions of structural members. It is just as much a matter of course to demand that they should function in a church building as in a secular building. The forms of piers, arches, walls, and vaults are dictated by their own special functions, but even these functions never entirely determine their forms: there always remains a "margin of freedom." A purely utilitarian building is determined by its own special purpose in just the same way as a church, but even here, purpose can never determine form completely. Gothic vaults must be examined in the light of their function; it is important to understand their static

principles and the functions of diagonal ribs, ridge-ribs, and tiercerons, but, even when these functions have been understood, the question as to why these members have so many different profiles in different churches still remains unanswered, since each profile fulfils the necessary static function, in so far as it exists, equally well.

Although much could be said about the functions of the spatial parts of a church, and about the functions of its architectural members, it need not be said here. It will also be sufficient to say that lighting and the arrangement of windows and lamps primarily serve a practical purpose, but that there is, once again, a "margin of freedom" in the siting of windows and lamps, and in the choice of the dimensions and the shape of windows.

This consideration leads to the question as to what are the tendencies by which the "margin of freedom" is eradicated and a final form reached. In reaching it, the architect appears to be absolutely free; but he is not, for the question of cost always plays a part, either by inhibiting his imaginative powers, or by influencing him to build something of great splendour. The designs for most of the buildings of rich monasteries and dioceses were made with confidence in the charity of future generations, and economic factors, combined with the course of wars, often determined the fate of Gothic buildings. Some, like the cathedrals of Beauvais and Narbonne, have remained unfinished to our day; some, like the cathedrals of Cologne and Prague, were not finished during the Middle Ages; and others, like the façade at Strassburg, were completed in the Middle Ages, but to a changed plan. In every case, the financial administrator had a say in the discussions. However, the economic position only laid down the general framework of how much splendour the architect could allow himself. The actual form to be taken within the "margin of freedom" was not determined by the treasurer, but by the architect. Within the bounds of the conditions laid down, he seems, then, to have been perfectly free—but even this is not quite true.

## 4. SYMBOLS OF MEANING

In addition to the actual programme of building, there were sometimes also special wishes and demands of a patron to be taken into consideration. Suger wrote that the choir of St Denis was built with twelve supports, to signify the twelve apostles: *duodecim apostolorum exponentes numerum*. He went on to say that the

twelve supports in the ambulatory signify the twelve minor prophets. He gave the *tertium comparationis* by quoting St Paul's epistle to the Ephesians 2:19: both believers and churches are built upon the foundations of the apostles and the prophets; both are *habitaculum Dei in Spiritu,* and both therefore signify the same thing. Our text does not say that these piers portray the apostles and the prophets, but that those in the choir indicate (*exponentes*) the number of the apostles, and that those in the ambulatory signify (*significantes*) the number of the prophets. Portrayal would require caryatids. There may be other documentary evidence of cases in which it would be justifiable to say that an architectural member portrays something, but . . . in the case of St Denis, it would be senseless to say that the figure twelve was portrayed, and inexact to say that the apostles and the prophets were portrayed in the figure twelve. The number of the piers indicates the number of the apostles which, in turn, directs the attention of the visitor to the text from St Paul. In this way, it can be understood that the meaning of church architecture as a *habitaculum Dei in Spiritu* came to life in Suger's mind—as it can in anybody's mind who counts the supports and knows the relevant text.

This kind of "representation" is called symbolic. The piers and columns at St Denis are only piers and columns to a visitor—and were even to Suger and his architect. The connexion between the number and its significance was made in Suger's mind; we can understand this process only if we are told of it; and this is true also of many other cases. Often, of course, patrons and architects did not think of any symbolism. At St Denis, Pierre de Montereau added a pair of piers to the end of Suger's series of twelve. The older piers, of course, preserve their symbolism, but there are now fourteen, and the two new ones either represent nothing, or something other than apostles. In countless cases, symbols were fitted to architectural members afterwards, and, since the time of the Romantics, much research has been done into this symbolism. Nowadays, people often find it difficult to understand. For example, Durandus says that the tiles on the roof of a church are the warriors and princes who defend it against the heathens.[6] Of course, one can easily answer that a heathen is unlikely to climb on the roof, and that the tiles protect the church against rain and snow; or one can answer that mosques also have tiles, but that these are not designed as a protection against Christians. What is meant, however, is that, just as the princes

protect the Church as an institution, so the tiles protect the church as a building. To examine every one of these countless abstruse likenesses and comparisons from a rational point of view would be to miss the point. None of the men who created these symbols intended his likenesses to be taken literally. To those who claim that any simile limps, one can reply that they should trust to the leg that does not limp. It must be realized, however, that these symbols vary in value, and that some of them are immediately convincing, while others are far-fetched.

Suger was not an architect: he was a theologian and had been educated according to the precepts of his age. From the time that Christian churches were first built, it was the theologians who ordered their construction, even if princes and emperors sometimes decided the programme and gave money for the project. Theologians were thoroughly familiar with the New Testament, which is full of comparisons and symbols. . . . Jesus's metaphors and symbols refer to purely spiritual things which are illuminated by the metaphor, and can often not be expressed better, if at all, in any other terms.

Medieval theologians altered the direction of these comparisons. Jesus had said, "I am the door" (that is, to the Father): they inverted this and said that the door was Jesus. This difference may seem small, but the idea of Jesus remained a spiritual one, and, in this connexion, even the door became an intellectual and spiritual passageway, for the symbolists mentally changed the real doorway into a spiritual one. Whether one takes this difference seriously or not, one must understand the inversion involved if one is to understand the way in which the Gothic clergy regarded churches, and the way in which they educated the laity to grasp this kind of symbolism.

Where symbolism made use of sculpture or painting, the underlying idea was more easily comprehensible. Where a statue of Christ was placed in front of the central pier of a main doorway, and one therefore walked past him into the interior, anyone could understand that here Christ was supposed to be understood as a spiritual door.

. . . Just as every architectural member represents something, so does every spatial part, and so, above all, does the church as a whole. Recent research has been very productive in giving interpretations of Romanesque architecture. Thus, the building of a west as well as

342

an east choir in the same church, as it was done in the Romanesque period, has been shown to derive from the opposition between *sacerdotium* and *imperium*. The emperor, when he personally attended state services, sat in the western choir, and the purpose of building a fixed architectural section of a church to correspond to the choir which was the ceremonial territory of the bishop can be traced to the rivalry between popes and emperors, which dates back to the time of Constantine.[7] However, functions do not always produce symbols: thus, while naves were built for the laity, they do not represent the laity. In the case of a reserved space, the idea may arise that this space represents the person for whom it is reserved. A choir does not necessarily represent God, or the bishop as the representative of God, but this meaning could be introduced, and probably was, where a western choir, as the space reserved for the emperor, was set opposite an eastern choir. There are also other interpretations of spatial parts as symbols representing something, and they can be very fruitful, but they do not yet seem to have been studied with reference to the Gothic style. In the Gothic churches, double choirs disappeared, and this may lead one to conclude that the French kings did not feel the same opposition to the papacy, nor the same rivalry over certain questions of their rights and powers, as the German emperors. However, it is doubtful whether the significance of this disappearance contributes much to the understanding of the Gothic style. . . .

The interpretation of double choirs as representing the split between the Church and the Empire leads to the idea of the indivisible unity of the *Civitas Dei,* and thus to the real meaning of the architecture of a church as a whole—the Christian idea of the kingdom of God. This idea embraces both the eternal, that is the timeless and placeless, existence and omnipotence of God, and his temporary and earthly existence in Man and the works of Man. The building of churches on earth as the seat for religious services is, at the same time, always a symbol of the transcendent kingdom of God. Church architecture may mark the contrast between pope and emperor or between monks and laymen; it may set nuns' galleries in isolation, and so on; but these functional divisions always reflect the differences between certain social strata, or at least strata of responsibilities within the *Civitas Dei,* which remains an immutable idea to which any division is subordinate. The building of churches as houses of God can therefore always be interpreted as a symbol of

343

the *Civitas Dei*, of the *regnum Dei*, both here and in eternity—and this is the sense in which it was interpreted.

A Christian church has this idea in common with every holy place of every other religion. Greek and Roman temples, too, were intended to be places that were not of this world—to be "numinous." Even the flat ceilings and vaults of classical antiquity were characterized, by their decoration with sculpture and painting, to represent the sky.[8] According to ancient beliefs, the sky was a spherical bowl in which, or beyond which, lay a world to come; it was the boundary between the visible and the invisible, though, of course, there is also much on earth that is invisible, especially the ideas of men and their intellectual processes. Man embraces within himself the world to come. "The kingdom of God is within you."[9] Man is the *habitaculum Dei*, but with the essential addition, *in Spiritu*. God dwells in the mind and in the heart: this is his kingdom. If one says that the kingdom of Heaven lies in the heart of Man, then Heaven becomes a symbol; it ceases to be the astronomical sky of classical antiquity or of Copernicus and Kepler, and becomes a symbol of the life to come, which is within Man, who lives continuously in this world and the next at one and the same time.

Symbols are a special kind of concept. The material parts of a church are drawn from nature; they consist of minerals, metals, and woods, and even if, like glass, they are artificially made, their raw material still comes from natural sources. In the building of a church, this aspect is always the main consideration, and Suger showed great concern for the finding of a suitable quarry and of trees of the right length for roof-beams. Even in the preservation of buildings, one is bound to return to this first degree of concepts, for it is physical and chemical aspects which come to the fore when downpours, or a change in the level of the water-table, or lightning, or fire produce material changes.

In a finished church, the materials from which it is built become part of the concept of the church as a whole. The spiritual meaning of the activities which take place in the church, in so far as they have a function, is not a natural product, but a human conception or a combination of human conceptions. All that is material remains as an integrating factor, but the fact that this visible, tangible, and spatial distribution of materials has been created for the purpose of Divine Service means that there is a second degree of concepts. In this second concept of church architecture, which exists within the

concept of function, a church is regarded as "suitable" for the sacred activities of religious men. In the formulation of the programme for the building of a church, and in its design, this concept is perpetually alive and active. If the building is suitable for religious services, then the material structure of the church is embraced in the conception of the *habitaculum Dei*—but *in Spiritu*. A "suitable" building thus becomes a "suitable" sacred building; it offers all that the spiritual man demands. . . .

This second degree of concepts is contained within a third degree. . . . God dwells in a church in the same way as he does in the hearts of men. A material structure which is regarded as a building suitable for the holding of religious services becomes an element in the concept of a house of God. The first degree of this concept comprises natural objects; the second comprises the works of Man; but the third embraces the field of symbols. . . .[10]

A church as a whole is a symbol of God—or rather, one symbol of God, for there are many others. Kingship is another symbol: a king possesses the kingdom over which he reigns. The Church is the kingdom of God. The Christian religion is eschatological. The world is temporary; it was created, and, on the Day of Judgement, it will cease to exist. Then the everlasting kingdom of God will come into being, in the form of an eternal heaven and an eternal hell. It is of this kingdom that St John speaks in the book of the Revelation. . . .

One would like to quote the whole book, for it is a continuous chain of symbols; every conception in it contains more than is inherent in the words in which it is expressed. The city, its dimensions, its geometrical form, precious stones, pearls, gold, and glass: all these are symbols, and, in combination, they symbolize the kingdom of heaven after the end of the world. If one sees them as symbols, one can similarly regard any church as a representation of the kingdom of heaven—here and now, or after the end of the world. . . .

With their material substance (this is the first degree, that of natural materials), painting and sculpture can reproduce a natural model, or an inner conception (the second degree, that of representation); but they can also be symbols (and this is the third degree). It increases our understanding when iconography reconstructs the literary or poetic source on which the painter or the sculptor has drawn. . . . Our differentiation between the three degrees of meaning makes it possible to recognize that iconography deals with the

345

mere portrayal of a person, a landscape, an action, etc., that is, with the second degree, and at the same time to investigate whether this meaning itself is a symbol—that is, a symbol of a meaning. Iconography as such remains within the literary, or, in some cases, the poetic sphere of painting or sculpture, that is, it remains within the intellectual content of the fine arts.[11] However, studies of iconography usually move beyond the consideration of symbols of meaning to that of symbols of form.

The difference between these two fields of symbolism is an important one, and leads to the real root of the problem. It has been shown that a Gothic church, like every other church, is a symbol of the kingdom of God; and this symbol remains a literary one. How, then, can a Gothic church be a means to opening the mind to the idea of this kingdom, or of the New Jerusalem, even if the visitor does not know the Apocalypse and has never heard of the idea of the kingdom of God?

## 5. FORM SYMBOLS

. . . Form itself can become a symbol, co-ordinated with the realm of the symbolism of meaning and expressing the same things by the use of its own means. If we can understand the symbolism of the form of a church, it will tell us more than can a comprehension of the symbolism of its meaning.

Every church is different in form; the form of its space, of its members, and of its light are all different from those in any other church. It consists of different-coloured materials, of light limestone, dark granite, red brick, etc., or it may have had colour added in the form of paint or plaster. Every individual building is a unification of these factors, tending towards a particular style. It is always true to say that a church represents *the* New Jerusalem, but, according to its form or, more especially, to its style, the New Jerusalem may be Byzantine, Carolingian, Romanesque, or Gothic. Within each style, one can further differentiate between its phases and between its local schools. Hagia Sophia and St Mark in Venice represent a different New Jerusalem; so do the church of St Mary-in-Capitol at Cologne and the cathedral at Speyer, Notre-Dame in Paris and the cathedral at Reims, Annaberg and King's College Chapel, Cambridge.

We have . . . taken it for granted that everyone knows not only

that every church is a house of God or the new paradise, but also that the form of the house or the garden changed from Romanesque to Early Gothic, High Gothic, and finally Late Gothic. . . .

. . . A man who feels in a Gothic way, and who stylizes himself accordingly, requires, for divine services, not only a building which fulfils its utilitarian purposes and furthermore the function of symbolizing the concept of the house of God, but also a building which, through its Gothic form, symbolizes what that particular man feels.[12]

The question as to how a form devoid of meaning can become a symbol, and thus take on a meaning, can easily be answered: it assumes meaning through our own aesthetic attitude.

Man is born into this world and, from the cradle to the grave, stands in a perpetually changing relationship to it; he is determined by it, and, with tools and other means, works to create his own world out of it. This is a practical attitude towards the world. Only in the course of the development of mankind and of the individual does a second attitude appear, by which the world is seen independently of its usefulness. In the pursuit of scientific knowledge, man does not ask himself whether a circular form can be used to create a wheel, but what a circle is, what it was before the world was created, and what it will be after the end of the world. When man assumes an objective attitude he strives to see beyond himself and to consider the world separately from himself. The aesthetic attitude is the exact opposite of this: here man seeks to draw the world *into himself.* The fact that subjectivity takes a different form in the case of every individual is immaterial, for subjectivity draws on the views of man, in contrast to the scientific exclusion of the human being. This change does not take place in the realm of reason, but in the realm of feeling.

When a Gothic architect built a circular window, his work was bound up with a practical and theoretical attitude: for he had to know how to construct a circle geometrically and how, in practice, to set about building it in stone on a big scale, on a façade, and at a considerable height; but his decision to make the window circular was based on aesthetic grounds. There were many possibilities open to him, and this multiplicity corresponds to the "margin of freedom" mentioned earlier. Economic and practical questions may also have played a part in determining, for instance, whether or not it would have been cheaper to build a rectangular window. Questions of

347

symbolism may have arisen too, for instance as to whether the window was intended to represent a wheel of fortune, or the sun; but the final decision regarding the position of the centre, the length of the radius, and the interior form could only spring from the aesthetic attitude of the architect.

Historians of mechanics say that, originally, fallen trees were used for the transportation of loads; later, circular discs were made by sawing or, more probably, chopping logs, and finally the wheel, with a hub and spokes, was invented. It is impossible to say whether this is what did in fact happen; the wheel, however, was presumably not the product of an aesthetic attitude. A mechanic considers a circular form valuable because it can be rolled; a theorist, as such, assigns no value to anything, but merely defines concepts; but the man who considers a circular form aesthetically, feels the connexion between any point on the circumference and the centre as an inter-relation-ship, as a contrast between radial movement and concentration, and as a form representing repose. The symbolist moves past objective existence, and can choose a circle as a symbol for the *orbis*, for fortune, for the sun, or for Christ. If he remains within the realm of meaning he creates a symbol of meaning, but even this is based on the aesthetic factor of comparison. Science seeks identities and equations; poetry seeks likenesses and metaphors; but the symbolist of form regards a circle aesthetically, and he chooses a circular form as a symbol of perfection and eternal tranquillity and peace. His symbol is not conventional: it is immediate and compelling.

Science seeks to recognize what things are in terms of themselves: an aesthetic attitude feels what they are in relation to us. A blue ceiling can be cold or warm, according to the temperature, but, to our feeling, it is always cool. It stands at a measurable distance from us, but, for us, it is always far away, even if we climb on to a scaffolding. We thus change the temperature and the distance of an objectively existent colour. Every aesthetic reaction produces an interchange within various fields of the senses—in visibility, warmth, taste, statics, dynamics, and so on. For instance, blue is restful, yellow is pungent; everyone is familiar with these frequently quoted phenomena. The architect lives perpetually in this realm of em-pathy in which forms are felt. Some decisions can be made without any hesitation, but others can only be made through a careful weighing of whether one form matches others which have already been chosen—whether it creates harmony or disturbs it.

## The General Problems of the Gothic Style

A visitor who is susceptible to aesthetic effects can understand the forms chosen by the architect. He may be delighted by them, or he may be passionately opposed to them, but before he feels one or other of these emotions, he must thrust his practical and theoretical ideas to the back of his mind for the moment and consider the work aesthetically. If he cannot do that, he is like a blind man trying to see light. There are people who are unmusical; others have no feeling for architecture and cannot understand the language of stone. Some people understand the language of poetry better than that of architecture. Anyone who has feeling for architecture also possesses a certain degree of understanding of it, and the creative master must possess this understanding in its highest degree. . . .

. . . Every form of vault and pier, of spatial subdivision, of window and doorway, and of tower and roof was directed at the aesthetic understanding of the visitor; every one was a formal symbol, as were density, laxity, movement, rotation, colour, sparkle, roughness, shadow, etc. They say an infinite quantity of things, and one need only be able to see in order to hear what is said tacitly. Beside this symbolism of form, the symbols of meaning pale.

In the symbolism of form, we can see splendour or asceticism, oppression or verve, sterility or elastic vitality, a cheerful enjoyment of life or sombre depression. One says of space that it spreads, it rises, that it is quick or slow in tempo, that it circles, it spirals, or it concentrates. Some historians of art positively luxuriate in the application of their own feelings to architectural interiors, and it is equally possible to project one's feelings into architectural members. Figures cannot do justice to the wealth of the proportions and rhythms at St Germer, although everything there still breathes simplicity, nor to the infinitely more complicated proportions and rhythms of Pirna or Tomar, and even the best description of an aesthetic impression is far surpassed by the original impression. . . . Admittedly, well-chosen words can open the eyes of an unpractised visitor, but perfectly to understand the symbolism of form is like understanding the mime of a great actor.

Besides the three attitudes that we have discussed, which Man can adopt towards the world, there is a fourth. We can regard, recognize, and feel ourselves and the world as standing on a common, metaphysical foundation; and this is the religious attitude, in which the common background is God. During his devotions, a religious man performs a certain mime; he kneels, lowers his head, and folds

his hands. This is the visible expression of the fact that he submits, that his hands are inactive, and that his spirit is seeking contemplation. He can pray anywhere, in his own room, even in the open air, but a prayer chamber for the multitude, a church, must aim, through its symbolism of form, to provide a suitable aesthetic framework for the prayers of the many.

One should be wary of anthropomorphic discussions of works of art, but they can sometimes be of more help than a host of words. We can say, for instance, that a church should be practical for the holding of services, and that its meaning can be left to the realm of the imagination. We can simply say, "This must be the house of God," but, in fact, we demand more than this. We want to be able to *see* that it is the house of God. Metaphorically, we demand that a church should itself be devout, that it should praise the Lord day and night, and at all times. This is what church architecture is.

*NOTES*

[1] On this, and on what follows, see Frankl, *The Gothic,* 299 ff.

[2] For Christopher Wren's theory of the Saracen origin of Gothic, see Frankl, *The Gothic,* 360 ff.

[3] Frankl, *The Gothic,* 110 ff.

[4] Dehio, *K. B.,* II, 24.

[5] Examples are Noyon, Dijon (Notre-Dame), Troyes (St Urbain), and Casamari.

[6] The best and most comprehensive introduction is given in Joseph Sauer, *Symbolik des Kirchengebäudes* (Freiburg i. Br., 1902). On the subject of the figure twelve, see p. 66. There are also much older treatises on numerical symbolism; see Frankl, *The Gothic,* 211 ff.

[7] Günter Bandmann, *Mittelalterliche Architektur als Bedeutungsträger* (Berlin, 1951), 229. His interpretation seems doubtful when applied to places where the emperor could hardly have been expected to worship—for instance, at Maria Laach.

[8] Karl Lehmann, "The Dome of Heaven," *The Art Bulletin,* XXVII (1945), 1–27.

[9] Luke 17: 21: regnum Dei intra vos est.

[10] Unfortunately, mathematicians also call their signs symbols, although they are really only signs. In the terminology of my *System etc.* (Note 181 to Chapter 4), signs like signposts, numbers, and letters have a meaning in the second degree of concepts; signposts or the marks on a scale are cognate with their meaning (direction, distance, etc.), and letters and musical notation are conventions. Signs become symbols when they take on a higher meaning—for instance, a cross is a sign for a meaning of the second degree in mathematics, but if it signifies the Cross of Christ, or Christ himself, it becomes a symbol of the third degree, as do the attributes for the saints.

[11] It should be stressed once more that representational art embraces sculpture and painting, but not architecture. The Italians classified all three arts under the heading *arti del disegno,* but one could also put the art of writing (signum), that is calligraphy, under this heading.

[12] Fundamental for the definition of the concept Art is Willi Drost, "Form als Symbol," *Zeitschrift für Ästhetik und allgemeine Kunstwissenschaft,* XXI (1927), 358.

# 17. PAINTING IN FLORENCE AND SIENA AFTER THE BLACK DEATH

*Millard Meiss*

### INTRODUCTION

*Painting in Florence and Siena After the Black Death* examines the emphatic shift of style and mood in Tuscan painting around the middle of the fourteenth century in the context of a series of social and economic setbacks climaxed by the dreadful circumstances of the Black Death. Meiss contends that these disastrous events influenced the character of the art, turning it away from the gentle Franciscan-inspired painting of the earlier decades of the century, exemplified by Giotto and his followers. The new art, pessimistic and guilt-ridden, became more Dominican in tone and appealed to the conservative taste of a new population drawn largely from provincial backgrounds. In linking together the experiences of a society and the temper of its art, Meiss has developed a fascinating—and penetrating—study of some of the determinants involved in changes of style. The range of this work is such that it must be considered essential not only to students of the history of art, but to students of cultural history generally.

Other works that examine art in its social context—from a Marxist point of view—are George Plekhanov, *Art and Society* (1937) and Frederick Antal, *Florentine Painting and Its Social Background* (1948). Francis Klingender, *Art and the Industrial Revolution* (1947) deals with questions regarding the relationship between developments in British art and the impact of industrialization. A general history of this type is Arnold Hauser's

353

*Social History of Art* (1951). In conjunction with the selection that follows, one might read the reviews in *The Journal of Aesthetics and Art Criticism,* XI, 4 (1953), and *The Art Bulletin,* XXXIV, 4 (1952). A good, well-illustrated survey of the painting of this era is Robert Oertel, *Early Italian Painting to 1400* (1968).

# INTRODUCTION

In one of his *Trecento novelle,* written around 1390 toward the end of his life, Franco Sacchetti relates the following incident: "In the city of Florence, which has always been rich in talented men, there were once certain painters and other masters who were at a place outside the city called San Miniato al Monte for some painting and other work that had to be done in the church; after they had had a meal with the abbot and were well wined and dined, they began to converse; and among other questions, this was posed by one of them called Orcagna, who was head master of the noble oratory of Our Lady of Orto San Michele: 'Who was the greatest master of painting that we have had, who other than Giotto?' Some replied Cimabue, some Stefano, some Bernardo [Daddi], others Buffalmacco, and some named one master, and others another. Taddeo Gaddi, who was one of the company, said: 'Certainly there have been plenty of skillful painters, and they have painted in a manner that is impossible for human hand to equal; but this art has grown and continues to grow worse day by day.'"[1]

The story, which has come down to us incomplete, then takes a jocular turn in the remarks of the sculptor Alberto di Arnaldo. He belittles the opinions of the others, saying that excellent painters, the equals of Giotto, were working at that very moment—the Florentine women, whose skill in cosmetics corrects the defects of the greatest painter of them all, God.

The proposals for Giotto's nearest rival have an authentic ring, and it is generally agreed, though we cannot be certain, that the story reflects a conversation at a gathering at S. Miniato in the late 'fifties.[2] We know all the artists present and those mentioned in the discussion—one group, Taddeo Gaddi, Orcagna, Bernardo Daddi, Cimabue, Alberto di Arnaldo by their works, another, Stefano and Buffalmacco (the St. Cecilia Master?), by reputation. We should expect the assembled masters to accept the preeminence of Giotto

355

without question. And as for the choices expressed by the group, they are remarkable, so far as we can judge, only for the omission of Maso, surely Giotto's greatest follower, and perhaps Nardo. Taddeo Gaddi himself was not proposed, possibly because he was present; nor Orcagna, who was both present and the proponent of the question. Quite surprising, however, at least on first consideration, is the statement of Taddeo Gaddi. For it goes beyond an acceptance of the superiority of Giotto, already dead some twenty-three years, to assert a continuous decline of the art into the present moment.[3]

Though laments about the state of contemporary art are common enough in history, precisely in the fourteenth and fifteenth centuries they were exceedingly rare. Taddeo's pessimistic opinion is thus exceptional in its time, and it is all the more remarkable because of the occasion on which it was expressed. For it was spoken in the very presence of Orcagna, certainly the greatest Florentine Trecento painter after Giotto, excepting only Maso di Banco. And it ignores the stature not only of Orcagna but of his brother Nardo and of Andrea Bonaiuti, who were inferior to Maso but no less gifted than any of the other masters of the earlier part of the century, Bernardo Daddi and Taddeo Gaddi himself included.

The significance of this extraordinary judgment may be grasped, I believe, if we consider the historical position and the taste of its author. Taddeo Gaddi was the most devoted pupil of Giotto. He had worked with him, according to Cennino Cennini, for twenty-four years, and in the later 'fifties he was the only veteran of Giotto's circle still alive. His insights and his taste were those of an earlier time, and the utter failure to recognize the greatness of Orcagna, if we may trust Sacchetti, suggests an important truth—the profound difference of the art of this painter and his contemporaries from that of Giotto and his successors in the earlier part of the century.

This difference implies not only that people with a taste formed in the earlier Trecento might fail to understand Orcagna, but also that some members of Orcagna's generation might feel less enthusiastic than their elders about Giotto. Possibly we may find an intimation of this in a rather cryptic comment of a writer of the time. In the great chorus of approval of the painting of Giotto that begins with Dante and Riccobaldo and extends into the fifteenth century there was only one discordant note. It was introduced by a writer just a few years younger than Orcagna, Benvenuto da Imola. Though

Benvenuto was not Florentine, he lived for a time in Florence[4] and he was quite familiar with Florentine critical and historical thought. In his commentary on the *Divine Comedy,* which he wrote *c.* 1376, he upheld the reputation and the superiority of Giotto, but qualified it with what, in the light of earlier and later opinion, amounts to heresy. "Giotto," he said, "still holds the field because no one subtler than he has yet appeared, even though at times he made great errors in his paintings, as I have heard from men of outstanding talent in such matters."[5]

These are serious charges against the man who had been widely hailed as the founder of modern painting and the greatest master since the Greeks. They have been ignored by almost all later historians, and recently one scholar has attempted to dispel them by attributing their meaning exclusively to their context. Benvenuto's statement occurs in the course of his discussion of Dante's famous passage on the transitory nature of fame. The poet says that the renown of Oderisio the miniaturist was short-lived because he was immediately succeeded by Franco, just as Cimabue was eclipsed by Giotto.

> O vana gloria dell'umane posse,
> Com' poco verde in su la cima dura,
> Se non è giunta dall'etadi grosse!
> Credette Cimabue nella pittura
> Tener lo campo, ed ora ha Giotto il grido,
> Sì che la fama di colui è oscura.[6]

It has been suggested that Benvenuto's reference to the great errors of Giotto was simply contrived *ad hoc,* to extend to this painter also Dante's thought about the brevity of fame.[7] But neither the verses themselves nor Benvenuto's comments permit this interpretation. Dante was concerned first of all with reputation and renown, not with problems of criticism and value. Benvenuto himself understood this, devoting most of his commentary on the passage to a discussion of Dante's condition for the loss of fame. The glory of Plato, he says, was dimmed by Aristotle. But since Aristotle was not followed by a philosopher equally as subtle, his reputation survived to the present day.[8] Virgil enjoyed a similar good fortune, for similar reasons, while Cimabue was unlucky enough to find himself not "in aetatibus grossis" but "subtilioribus." Giotto on the

357

other hand, Benvenuto says, *had* no equally subtle successor. Benvenuto would have been inconsistent then if he had supposed a necessary decline in Giotto's reputation; and if he himself had for some personal reason felt called upon to detract from it, would he not have written simply and vaguely that nowadays "some people are no longer unqualified in their praise" rather than the careful statement "he made great errors, as I have heard from outstanding critics"? It seems indeed quite probable that Benvenuto's comment was not provoked by Dante's text alone, but reflected current criticism of Giotto's pictorial style.[9]

Whatever the real meaning of Benvenuto's remarks, a certain kind of adverse criticism of the work of Giotto and his followers was certainly common at this time in the paintings themselves. Every one of the younger masters after 1345–1350 rejected, at least in part, Giotto's most easily imitable accomplishment, linear perspective. None attempted to rival the equilibrium in his art between form and space, or his supple figures moving freely in a measured, easily traversible, receptive world. And which of these masters subscribed without equivocation to his conception of the divine immanent in an exalted and profoundly moral humanity? In all these respects Maso di Banco, of whose activity we do not hear after the early 'forties, was Giotto's last follower. It is striking that the influence of this major master was not dominant in the late 'forties and 'fifties. He had no real succession among the younger painters, who turned unanimously to Orcagna and Nardo.[10]

All of this is indicative of an important change in style and in taste around the middle of the fourteenth century. Variety and change there was of course in the preceding years, too, however dominant the figure of Giotto. The space with which he had surrounded his figures was extended and deepened, the environment made more specific and more familiar. In the hands of Taddeo Gaddi his massive forms became ponderous and rather assertive, in Bernardo Daddi refined and lyric. Maso introduced a marvelous subtlety of color, and gave to the ambience of the figures a wholly new intensity of form and meaning. Other painters, the S. Cecilia Master, Pacino, Jacopo del Casentino, the Biadaiolo Master, whose work has been defined in recent years chiefly by Richard Offner,[11] heeded Giotto's example relatively little, seeking an effect of greater animation and spontaneity, and a more fluid mode of expression. They avoided the grave and the monumental. Unlike Giotto and

Taddeo and Maso they were more effective in smaller works —tabernacles, miniatures, little histories in altarpieces—than in fresco. The departures of the mid-century from Giottesque style, however, are not connected with differences of scale or technique or the conditions of exhibition: they appear in large murals as well as in retables, tabernacles, and miniatures. And whereas some of the masters of the earlier part of the century are un-Giottesque, most of the later ones are, in a sense, anti-Giottesque.

There were similar changes in Siena, too, around the middle of the century. The great styles that succeeded one another during the preceding fifty years—those of Duccio, Simone Martini, Pietro and Ambrogio Lorenzetti—show despite their diversity many related qualities and a certain community of purpose. They constitute a rather orderly development, the younger painter in each instance developing one or another aspect of the older master's style. Around 1350 this continuity seems interrupted. Though the influence of the earlier tradition persists, many of its fundamental elements were rejected, and others were combined in a new and wholly different way. These transformations occurred despite the fact that only one of the painters active at this time, Barna, approximated in stature the great masters of the preceding years. He belonged to an earlier generation, however, and with all his originality he remained in many ways more fully within the tradition of the first half of the century. The younger painters, Bartolo di Fredi, Luca di Tommè, Andrea Vanni, were all less gifted, but they created distinctive forms nevertheless, very similar to one another and related to those of contemporary Florence without being dependent upon them.

Previous accounts of Sienese painting of this period have been devoted less to the analysis of its distinctive character than to its dependence upon the art of the earlier part of the century.[12] It has always, furthermore, been studied separately from Florentine. And when these studies have been part of a comprehensive account of Italian painting, they have emphasized the differences between the two schools rather than the similarities, although they have pointed to the influence upon the Florentines of the earlier art of Simone Martini and the Lorenzetti.[13] Without minimizing these differences, our present purpose is to consider those aspects of the form and content of the two schools that are related.

These similarities between the painting of the two towns are interesting in the light of the remarkably similar circumstances

surrounding their appearance. Though the history of the two city-states had corresponded in many ways from the late twelfth century onward, the resemblances between them were especially numerous just before and after the middle of the fourteenth century. During this brief period, both the Sienese and Florentines lived through a series of deeply disturbing events, which provoked in each a social, moral, and cultural crisis. For what light it may throw on the similarities of their painting, therefore, we shall consider the history of the two people together—their common experience of economic failure, pestilence and social conflict, their fear, their sense of guilt, and the varieties of their religious response.

## THE TWO CITIES AT MID-CENTURY

For both Florence and Siena the first forty years of the fourteenth century had been generally years of great prosperity and of political stability. Already at the beginning of this period the two cities had risen to European prominence as centers of finance and manufacture. Just before 1300 the contest between the rising middle class and the long-established noble landholders had ended in a victory for the former. The middle class acquired complete control of the state. Though many noble families, particularly in Florence, had entered trade or banking and had merged to a great extent with the business groups, they were, like all the members of their class, excluded from communal offices.

As in other late medieval towns, Florentine and Sienese society was organized for political and economic purposes in a series of guilds. Citizenship depended upon membership in one of them. The thousands of workers in the chief industry, the manufacture or refinement of woolen cloth, were forbidden to form or to join guilds, and they thus had no political rights whatever. The guilds of the great merchants, bankers, industrialists, and professional men (jurists and physicians) formed the Greater Guilds, or *Arti Maggiori*. The shopkeepers and artisans were members of the more numerous *Arti Minori*. The state, which shortly before 1300 had assumed the form of a bourgeois republic, was actually administered by a wealthy oligarchy centered within the *Maggiori*. Their rule, as well as the guild structure which supported it, lasted in both cities for about half a century.

*Painting in Florence and Siena after the Black Death*

The great entrepreneurs were engaged in production for foreign more than for local consumption, and with their large accumulation of capital they financed the Papacy as well as many princes throughout Europe. Seeking wider markets in their own regions, they pursued a policy of local "imperialism." During their rule almost all of Tuscany was brought under the domination of one or another of the two cities. As long as the oligarchy succeeded in maintaining a high level of prosperity, it was not seriously challenged in either Florence or Siena.

Though political power was thus highly concentrated, the form of the state reflected a libertarian ideal. The oligarchy sought to maintain the approval of the entire middle class, which believed it had the right to determine the policy of the government, and at times of crisis, as in Florence in 1343, exercised it. The republican principle, which implied the evolution of a nonhierarchical, more horizontal social order, was apparent also in other forms of association—in the guilds, for instance, with their elected captains. It was apparent also, within the sphere of religion, in the confraternities. These societies, formed by laymen for purposes of worship and mutual aid, grew rapidly from the late thirteenth century on. Their members, though subject to canon law, lived in the world without taking vows or adhering to a fixed rule. They were drawn from all classes; priests and friars were admitted too, but they had no special rights or privileges. The fraternities were governed, and their religious services conducted, by lay rectors elected for short periods of time. On the altar of the chapel that each of these societies possessed there stood almost invariably a retable that was the visible center of the cult. There the members assembled periodically, singing hymns to the Virgin before her painted image. No phenomenon of town life was more expressive of its democratic and lay tendencies, and none impinged more directly upon the art of painting.

As in other advanced European centers, but nowhere more than in Florence and Siena, the new competitive economy fostered (as well as it implied) independent individual inquiry and action in all fields of endeavor, and it stimulated a greater measure of individual self-consciousness. The middle class, concerned with the techniques of manufacture and the kinds of calculation required by production and banking on an unprecedented scale, developed increasingly empirical, inductive, and quantitative modes of thought. The burghers emphasized family and civic responsibilities and they val-

361

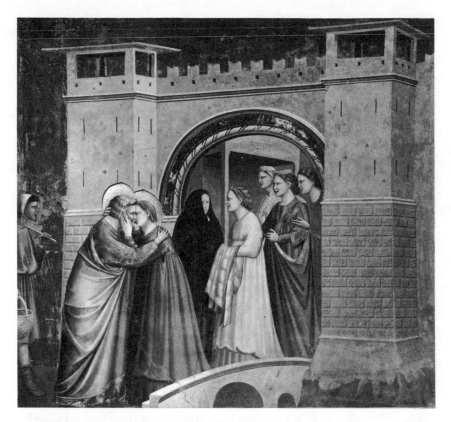

49. Giotto, Meeting of Joachim and Anna, Fresco, 1305–6 (Scrovegni [Arena] Chapel, Padua)

ued circumspection, moderation, and, above all, industriousness.[14] Though they remained deeply pious, they believed with increasing assurance that they could enjoy themselves in this world without jeopardizing their chances in the next. Their optimism seemed to be confirmed by the prosperity and the comparative peace of the first forty years of the century.

The arts flowered as at few other moments in history. The painters and sculptors, developing a more naturalistic style, created an image of an orderly world, substantial, extended, traversable. They endowed the people in it with a new range of intellectual and emotional awareness, and great moral strength. The realm of human values was immeasurably enlarged, the relation of man to man becoming as important as the relation of man to God. It is no accident that the most memorable episodes in the Arena Chapel include the return of Joachim to his sheep, his meeting with Anna

362

at the Golden Gate (Fig. 49), and the lament over the dead body of Christ. These are scenes that had held only a subordinate meaning in earlier Christian art or had only recently been represented at all. In the early Trecento cycle they seem more congenial to the painter and more deeply felt than the episodes involving the prophetic and the symbolical (Last Supper), or the supernatural (Wedding at Cana, Ascension, Pentecost—the last executed by an assistant). Giotto's human sympathy and insight reach an astonishing profundity in the wonderful soldier standing at the left in the Massacre of the Innocents, a wholly unprecedented figure who, though traditionally on the side of brutality and evil, now withdraws in anguish from the bloody work of his men.

### THE ECONOMIC CRISIS

From about 1340 on, the whole of Florentine and Sienese society was shaken by a series of increasingly disastrous events. The persistent and costly attempt of Florence to add Lucca to its domain was frustrated in 1341 by the capture of that city by the Pisans. The expansion of Milan under the Visconti began to present a serious threat,[15] and the burden of meeting this, together with the failure of the English branches of two of the largest Florentine banks, provoked an economic and then a political crisis. In 1343 the great house of the Peruzzi declared bankruptcy, and it was followed by the Accaiuoli, the Bardi (1345) and almost every other bank and mercantile company in Florence.[16] Many of the Sienese houses were brought down also. Throughout the cities workshops and stores closed because commissions were lacking and funds were not available for the purchase of materials or the payment of wages.[17] The crash plunged the towns into an unprecedented depression. Long after it had passed it continued to weigh upon the spirit of enterprise, engendering a more cautious and conservative attitude. For many years, fear of comparable loss tended to divert investment from trade and manufacture to farms and land. The merchant and chronicler Giovanni Villani, who himself suffered severe reverses and who was even thrown into the Stinche for inability to pay his debts, reported that by 1346 the Florentine companies had lost around 1,700,000 florins. No such calamity, he said, had ever overtaken the commune.[18] He wrote this judgment on the eve of a far greater one, in which he lost not his fortune but his life.

POLITICAL AND SOCIAL CHANGE

The ruling merchants and bankers in Florence tried to meet the mounting crisis by the usual method of the Italian communes in time of distress—transference of municipal authority to a dictator. In 1342 the Duke of Athens was called to Florence and given supreme power in the state. But this expedient, which in many other cities had resulted in the permanent loss of republican government, proved unsatisfactory to all sections of the Florentine middle class. Rallying to the cry of liberty, they united to expel the Duke in 1343. The republic was restored, but with new provisions that curtailed the power of the great merchants, industrialists, and bankers who had controlled the state almost uninterruptedly since the end of the thirteenth century. Weakened by the failure in the Lucchese war, the financial collapse, and the necessity of relying upon other groups to expel the *signore* whom they had installed, they were obliged to admit to the priorate representatives of sections of the middle class that had not previously had a voice in its councils. . . .

If the smaller entrepreneurs and the professional men, the *mezzani* of the Greater Guilds, were actually dominant in the government of Florence from 1343 to 1378, this era was not quite so "democratic" as many historians have maintained.[19] But in any event the oligarchy was overthrown, the new priorate was more widely representative, and the lower middle class did acquire a share in the regime. There were, moreover, corresponding readjustments of power within the guilds themselves, so that the consequences of the revolution were felt through Florentine society.[20] The rise to power of the *mezzani* and the necessity for the political recognition of the lower middle class shattered the confidence of the very wealthy, which had already been shaken by the crash. They and all those in the city who depended upon, or sympathized with, the old oligarchy bitterly opposed the new government. In 1345 Giovanni Villani ridiculed the rulers of Florence as "artisans and manual workers and simpletons."[21]

In Siena during these years there was a corresponding series of revolutions, though they occurred at different intervals of time and on the whole the swing to the left extended farther than in Florence.[22] . . .

During the years of lower middle class participation and ascendancy, several Sienese painters—Andrea Vanni, Bartolo di Fredi, Luca di Tommè, Giacomo di Mino—were active in the political parties and in the government, occupying a variety of offices and serving as municipal envoys.

## THE BLACK DEATH

During the 'forties, just after the fall of the oligarchy in Florence and several years before it was overthrown in Siena, both cities suffered seriously from lack of grain.[23] The bankruptcies reduced the financial resources of the cities and weakened the influence of the great Florentine houses of the Accaiuoli and the Bardi in Naples, so that normal imports from that region were not forthcoming.[24] On top of this, crops failed throughout Tuscany in 1346, and they were badly damaged in 1347 by exceptionally heavy hailstorms. Weakened and terrified by these deprivations, which they attributed to divine displeasure, the Florentines and Sienese attempted to appease God. They engaged in collective prayer and public displays of repentance. Giovanni Villani tells of great processions, in one of which, continuing for three days, he marched himself.[25] These had scarcely disbanded when an unimaginable catastrophe struck both towns.

Suddenly during the summer months of 1348 more than half the inhabitants of Florence and Siena died of the bubonic plague.[26] By September only some 45,000 of the 90,000 people within the walls of Florence were still living; Siena was reduced from around 42,000 to 15,000.[27] Never before or since has any calamity taken so great a proportion of human life. The plague struck again in 1363 and once more in 1374, though it carried off far fewer people than in the terrible months of 1348.[28]

The survivors were stunned. The Sienese chronicler Agnolo di Tura tells of burying his five children with his own hands. "No one wept for the dead," he says, "because every one expected death himself."[29] All of Florence, according to Boccaccio, was a sepulcher. At the beginning of the Decameron he wrote: ". . . they dug for each graveyard a huge trench, in which they laid the corpses as they arrived by hundreds at a time, piling them up tier upon tier as merchandise is stowed in a ship . . ."—sights not unfamiliar

to modern eyes. For years the witnesses were haunted by memories of bodies stacked high in the streets and the unforgettable stench of flesh putrefying in the hot summer sun. Those fortunate few who were able to escape these horrible scenes by fleeing to isolated places were, like Petrarch, overwhelmed by the loss of family and friends.

The momentous nature of the experience is suggested by the words of Matteo Villani as he undertook after a few years to continue the chronicle of his dead brother:

> The author of the chronicle called the Chronicle of Giovanni Villani, citizen of Florence and a man to whom I was closely tied by blood and by affection, having rendered his soul to God in the plague, I decided, after many grave misfortunes and with a greater awareness of the dire state of mankind than the period of its prosperity had revealed to me, to make a beginning with our varied and calamitous material at this juncture, as at a time of renewal of the world. . . . Having to commence our treatise by recounting the extermination of mankind . . . my mind is stupefied as it approaches the task of recording the sentence that divine justice mercifully delivered upon men, who deserve, because they have been corrupted by sin, a last judgment.[30]

Though the rate of mortality was doubtless somewhat greater among the poor, about half of the upper classes succumbed. Agnolo di Tura's comments about Siena are significant: four of the nine members of the oligarchic priorate died, together with two of the four officers of the *Biccherna*, the *podestà*, and the *capitano di guerra*.[31] The painters were not spared. The plague carried off Bernardo Daddi, the most active and influential master in Florence, and perhaps also his associate whom Offner has called the "Assistant of Daddi,"[32] It is generally assumed that the disappearance of all references around this time to Ambrogio and Pietro Lorenzetti signifies their death in the epidemic.[33] Undoubtedly a great many minor painters suffered a similar fate. This sudden removal at one stroke of the two great Sienese masters and of Daddi along with numerous lesser painters produced a more than ordinary interruption in pictorial tradition. It gave to the surviving masters, especially the younger ones, a sudden, exceptional independence and a special freedom for the development of new styles.

ECONOMIC AND SOCIAL
CONSEQUENCES OF THE PLAGUE

In the immediate wake of the Black Death we hear of an un-
paralleled abundance of food and goods, and of a wild, irresponsible
life of pleasure. Agnolo di Tura writes that in Siena "everyone
tended to enjoy eating and drinking, hunting, hawking, and gam-
ing,"[34] and Matteo Villani laments similar behavior in Florence:

"Those few sensible people who remained alive expected many
things, all of which, by reason of the corruption of sin, failed to
occur among mankind and actually followed marvelously in the
contrary direction. They believed that those whom God's grace had
reserved for life, having beheld the extermination of their neighbors,
and having heard the same tidings from all the nations of the world,
would become better men, humble, virtuous, and Catholic; that they
would guard themselves from iniquity and sins; and would be full
of love and charity for one another. But no sooner had the plague
ceased than we saw the contrary; for since men were few, and since
by hereditary sucession they abounded in earthly goods, they forgot
the past as though it had never been and gave themselves up to
a more shameful and disordered life than they had led before. . . .
And the common people (*popolo minuto*), both men and women,
by reason of the abundance and superfluity that they found, would
no longer work at their accustomed trades; they wanted the dearest
and most delicate foods for their sustenance; and they married at
their will, while children and common women clad themselves in
all the fair and costly garments of the illustrious ladies who had
died."[35]

This extraordinary condition of plenty did not, of course, last very
long. For most people the frenzied search for immediate gratifica-
tion, characteristic of the survivors of calamities, was likewise
short-lived. Throughout the subsequent decades, however, we con-
tinue to hear of an exceptional indifference to accepted patterns
of behavior and to institutional regulations, especially among the
mendicant friars. It seems, as we shall see, that the plague tended
to promote an unconventional, irresponsible, or self-indulgent life,
on the one hand, and a more intense piety or religious excitement,

on the other. Villani tells us, in his very next sentences, of the more lasting consequences of the epidemic:

"Men thought that, through the death of so many people, there would be abundance of all produce of the land; yet, on the contrary, by reason of men's ingratitude, everything came to unwonted scarcity and remained long thus; . . . most commodities were more costly, by twice or more, than before the plague. And the price of labor, and the products of every trade and craft, rose in disorderly fashion beyond the double. Lawsuits and disputes and quarrels and riots arose everywhere among citizens in every land, by reason of legacies and successions; . . . Wars and divers scandals arose throughout the world, contrary to men's expectation."[36]

Conditions were similar in Siena. Prices rose to unprecedented levels.[37] The economy of both Florence and Siena was further disrupted during these years by the defection of almost all the dependent towns within the little empire of each city. These towns seized as an opportunity for revolt the fall of the powerful Florentine oligarchy in 1343, and the Sienese in 1355. The two cities, greatly weakened, and governed by groups that pursued a less aggressive foreign policy, made little attempt to win them back.

The small towns and the countryside around the two cities were not decimated so severely by the epidemic, but the people in these regions felt the consequences of it in another way. Several armies of mercenaries of the sort that all the large states had come to employ in the fourteenth century took advantage of the weakness of the cities. Sometimes in connivance with the great enemy of the north, the Duke of Milan, they invaded, or threatened to invade, the territory of Florence and Siena. These large marauding bands— the companies of the Conte Lando, of John Hawkwood, and of Fra Moriale, the Company of the Hat and the Company of St. George— hovered in the neighborhood throughout the 'fifties and 'sixties, a continual threat to the peace of the *contado* and a serious drain on the already shrunken communal treasuries. Florence, the stronger of the two cities, was less troubled by them. Siena paid out huge ransoms,[38] in twenty years some 275,000 florins, but even then its lands were pillaged and the people on the farms and in the villages lived in constant terror. For them the story of Job, an old paradigm of trial and affliction, acquired a specially poignant meaning. Not only did Job suffer from a disease whose outward symptoms were like those of the plague; his cattle were driven off and his children

killed. It is not surprising that his history, rarely if ever represented in earlier Tuscan panels and frescoes, should now have been portrayed several times. . . .

The ravages of the merchant companies accelerated a great wave of immigration from the smaller towns and farms into the cities that had been initiated by the Black Death. Most of the newcomers were recruits for the woolen industry, who were attracted by relatively high wages. But the mortality offered exceptional opportunities also for notaries, jurists, physicians, and craftsmen. In both Florence and Siena the laws controlling immigration were relaxed, and special privileges, a rapid grant of citizenship, or exemption from taxes were offered to badly needed artisans or professional men, such as physicians.[39] . . .

In addition to bringing into the city great numbers of people from the surrounding towns and country, the Black Death affected the character of Florentine society in still another way. Through irregular inheritance and other exceptional circumstances, a class of *nouveaux riches* arose in the town and also in decimated Siena.[40] Their wealth was accentuated by the impoverishment of many of the older families, such as the Bardi and the Peruzzi, who had lost their fortunes in the financial collapse. In both cities, too, many tradesmen and artisans were enriched to a degree unusual for the *popolo minuto*. Scaramella sees as one of the major conflicts of the time the struggle between the old families and this *gente nuova*.[41] Outcries against both foreigners and the newly rich, never lacking in the two cities, increased in volume and violence. Antagonism to "the aliens and the ignorant" coalesced with antagonism to the new municipal regime; the government, it was said, had been captured by them. . . .

## THE EFFECT UPON CULTURE AND ART

The painting of the third quarter of the century, more religious in a traditional sense, more ecclesiastical, and more akin to the art of an earlier time, may reflect these profound social changes in Florence and Siena, or rather the taste and the quality of piety that they brought into prominence. For these *homines novi*, the immigrants, the newly rich and the newly powerful, had not on the whole been closely identified with the growth of the new culture in the first half of the fourteenth century. They adhered to more traditional

patterns of thought and feeling, and it may well be that their ideal
of a religious art was still the art of the later thirteenth century—an
art that was still visible almost everywhere in the cities, and even
more in the churches of the *contado*. At other times, less educated,
provincial people have clung to an art that had been supplanted
for as long as fifty years, and we are given hints that this was so
around the middle of the fourteenth century. Writing in 1361 in
his will about a Madonna by the "outstanding" painter Giotto,
Petrarch says that though its beauty is a source of wonder to the
masters of the art, the ignorant do not understand it.[42] Boccaccio
wrote that, as a poet and a student of classical antiquity, he was
regarded as a sorcerer in the town of Certaldo.[43] Elsewhere he
attacked the noisy adversaries of poetry (primarily ancient poetry)
who, ignorant of its character and its true meaning, constantly
opposed religion to it.[44] There is no reason to suppose that these
ready "theologians" or the friars and other groups whom he ex-
coriates for similar reasons were any less antagonistic to certain
aspects of the more advanced style of the Trecento in the figure
arts. We cannot expect them to have proved anything but hostile
to Ambrogio Lorenzetti's fascination with ancient sculpture. One
of the known objects of his fascination, a newly discovered statue
by Lysippus, was broken into bits by frightened members of the
Sienese public. It may be that these same groups were unsym-
pathetic also to the assimilation of ancient forms in the work of
Ambrogio or Cavallini or Nicola Pisano. We cannot then suppose
them to have been much more friendly to all those dispositions and
qualities of the new style that lie behind such assimilations—in other
words, to the essence of the new style itself. Because known com-
ments on painting and sculpture in the fourteenth century are few,
and limited mostly to scholars, writers, and the artists themselves,
such attitudes are difficult to ascertain. It is notable, however, that
Fra Simone Fidati seems to disapprove, by implication at least, the
warm relationship between man and wife in paintings such as
Giotto's. And in the *Meditations on the Life of Christ*, oddly enough
in the very treatise that exercised so great an influence on painting,
we find the old antagonism to the arts themselves reasserted. Except
for their employment in the cult, they are, the Franciscan writer
says, stimulants of a "concupiscenza degli occhi."[45]

Whether or not conservative tastes of this sort were felt by the
painters at the moment of decisive change and innovation around

the middle of the century, their wider diffusion and their prevalence among people who had acquired wealth and influence as patrons at least broadened the acceptance of the new styles and helped to maintain them. A painting such as Giovanni del Biondo's St. John the Evangelist trampling on Avarice, Pride, and Vainglory (Fig. 50)[46] may thus have struck an immediate response because of its older symbolic pattern and the austere frontality of its chief figure. The panel was doubtless widely approved for its subject, too, particularly the representation of the conquest of avarice. At this time avarice was, as we have mentioned, associated especially with the unlimited desire for profit and accumulation that had already

50. Giovanni del Biondo, *St. John the Evangelist, c.* 1370 (Uffizi, Florence)

Detail of above

become characteristic of early capitalism. Neither this motive nor the new economic system had been accepted by a considerable part of society. They were often opposed, it seems safe to assume, by the same people who were conservative in other spheres also, particularly religion and the arts. These people clung to the medieval belief in a just price and the limitation of wealth to the amounts needed for a livelihood by persons in the several stations of life.[47] Their antagonism to the new system and its values was certainly more assured after the bankruptcies and other events of the 'forties. Segre states that in 1354 twenty-one Florentine bankers were fined for usury, and in tracing the fluctuating policy of Florence on the lending of money at interest, he implies a greater opposition to loans in the second half of the fourteenth century.[48] At this time many people undoubtedly took a special pleasure in the sight of a defeated Avarice sprawled on the ground and ignominiously trodden underfoot.

Though the *gente nuova* was doubtless pleased by this portrayal of the triumph of St. John, it is questionable whether any of them played a leading part in the selection of the painter or the determination of the subject. The work was actually commissioned, as we have seen, by the *Arte della Seta*, one of the seven greater Florentine guilds. Though within it, as in all the other guilds, there were during this period certain shifts of responsibility and power, it was still dominated by established merchants and industrial entrepreneurs.[49] These were, in fact, the chief patrons of painting at the time, just as they had been earlier in the century. It was the Tornaquinci who commissioned the frescoes by Orcagna in the choir of S. M. Novella, the Strozzi who employed Orcagna and Nardo for the altarpiece and murals of their chapel, one of the Guidalotti who provided the funds for the frescoes in the Spanish Chapel, though they were executed after his death. But, these wealthy patricians were deeply affected, too, by the events of the 'forties and 'fifties. They had never freed themselves of doubt as to the legitimacy of their occupation. The Church had not explicitly sanctioned either their activities or their profits, and "manifest" usury it strongly condemned. The distinctions between usury of this kind and permissible interest, while precise, were very fine, and in advanced age merchants and bankers quite commonly sought to quiet their conscience and assure their salvation by making regular provision for corporate charity and by a voluntary restitution of

wealth that they judged was improperly acquired. As the most eminent living student of Floretine economic history has written: "Reading the last wills of the members of the Company of the Bardi . . . there becomes evident and dramatic the contrast between the practical life of these bold and tenacious men, the builders of immense fortunes, and their terror of eternal punishment for having accumulated wealth by rather unscrupulous methods."[50]

The guilt of the entrepreneurs and bankers was greatly quickened around the middle of the century. The bankruptcies and the depression struck just as hard at their conscience as at their purse. The loss of exclusive control of the state and the terror of the Black Death seemed further punishments for dubious practices. Giovanni Villani attributed the failure of the companies of the Bardi and the Peruzzi, in the second of which he himself had invested money before he joined the Buonaccorsi, to the "avarizia di guadagnare," and his strictures imply a condemnation not so much of poor judgment in this single instance as of all financial practices that involve great risks. Since few large ventures of the time could be undertaken without such risks, Villani comes close to turning his back on capitalism itself, and he had earlier signified that moneylending was a disreputable occupation.[51]

In the wake of the disasters of the 'forties and 'fifties, then, the established wealthy families of Florence very probably welcomed a less worldly and less humanistic art than that of the earlier years of the century. Their own position seriously threatened, they felt sustained by the assertion in art of the authority of the Church and the representation of a stable, enduring hierarchy. Their taste would have tended to converge, then, with that of the *gente nuova*, who emerged from circles that still clung to a pre-Giottesque art in which very similar qualities inhered.

All sections of the middle class were, in any event, clearly united in their desire for a more intensely religious art. It was not only great merchants such as Giovanni Colombini, with their own special reasons for remorse, who vilified and abandoned their former mode of life. Masses of people, interpreting the calamities as punishments of their worldliness and their sin, were stirred by repentance and religious yearning. Some of them joined groups that cultivated mystical experiences or an extreme asceticism; many more sought salvation through the traditional methods offered by the Church. Several painters—Orcagna, Luca di Tommè, Andrea da Firenze—

373

were, as we have seen, moved to a greater piety or a mystical rapture. Others who were less deeply stirred saw fit nevertheless, as the craftsmen of images for the cult, to adopt many of the new values and the new artistic forms, though in a more conventional way. For the painting of the time this religious excitement, and the conflict of values which it entailed, was a crucial cultural event. . . .

## GUILT, PENANCE, AND RELIGIOUS
## RAPTURE

The years following the Black Death were the most gloomy in the history of Florence and Siena, and perhaps of all Europe. The writing of the period, like the painting, was pervaded by a profound pessimism and sometimes a renunciation of life.[52] "Seldom in the course of the Middle Ages has so much been written," Hans Baron has said recently, "concerning the 'miseria' of human beings and human life." [53] Though religious thought throughout the Middle Ages had dwelt on the brevity of life and the certainty of death, no age was more acutely aware of it than this. It was preached from the pulpits, most vividly by Jacopo Passavanti, and set forth in paintings, both altarpieces and murals (Fig. 51). . . .

The majority of the people expressed their devotion within the traditional patterns established by the Church. In Florence they were inspired chiefly by the great Dominican preacher, Jacopo Passavanti. Passavanti, who was born in Florence at the beginning of the century, became a preacher at S. M. Novella in 1340 after a period of study and teaching in Paris and Rome. From the late 'forties on he was in charge of maintenance and construction, and from 1354 to his death in 1357 he served as prior.[54] During this period the new church was completed, the Spanish Chapel was built, and funds were received for its frescoes. Orcagna, furthermore, painted the altarpiece of the Strozzi Chapel and Nardo its walls, and the former may also have undertaken the mural cycle in the choir. Much of this activity was due to Passavanti's influence, and all of it was under his supervision. The existence of iconographic similarities between the paintings in the Strozzi and Spanish Chapels is therefore not surprising, even though the latter were not executed until some years after his death.

374

51. Francesco Traini, *The Triumph of Death*, Fresco, *c.* 1325–50 (Camposanto, Pisa; Alinari-Art Reference Bureau)

Passavanti's thought has been preserved in a treatise called "Lo Specchio di Vera Penitenza."[55] In it he brought together in a systematic way ideas expressed in his sermons, especially those delivered in 1354. They center on the necessity, or rather the urgency, of penitence, for which he accumulates evidence among the writers of the past, and which he makes vivid for his contemporaries by numerous "esempi," brief but highly colored images or stories interspersed through his more formal discourse. His thought and his mood are closely related to contemporary painting. Man appears a perpetual sinner, hovering in the shadow of death and judgment. His only hope lies in penitence, a mordant contrition that continually torments the spirit. Recalling the common experiences of 1348, Passavanti describes for his audience the frightful decay of human flesh, more odorous, he insists, than that of putrefying dogs or asses.[56] He tells of skeptics who, uttering words of doubt, were struck by lightning and immediately reduced to ashes.[57] He follows them to hell, lingering with their tortures and listening for their anguished shrieks, as though he were under the spell of Orcagna's fresco in S. Croce, where the faces of the damned are torn by the claws and teeth of wildly sadistic devils. Passavanti tries to convey by calculation the incalculable endlessness of their doom. "One day," he says "a French nobleman wondered if the damned in hell would be freed after a thousand years, and his reason told him no; he wondered again if after a hundred thousand years, if after a million years, if after as many thousands of years as there

are drops of water in the sea, and once again his reason told him no."[58]

To Passavanti sin is a demonic power and life a relentless struggle against it, grimly maintained because of fear of something worse. And in many paintings of the time, devils, the embodiments of guilt, become more prominent, more aggressive and more vengeful, attacking the lost souls in Orcagna's Hell, menacing the patriarchs in Andrea's Limbo[59] [Andrea da Firenze, in Spanish Chapel, S.M. Novella, Florence], and the unrepentant thief in Barna's Crucifixion, the most intense image of guilt and fear in the art of the fourteenth century [Collegiata, S. Gimignano]. In the fresco of Limbo one devil munches ecstatically on a human head, and in Orcagna's Hell a group of them lacerate the faces and bodies of their victims. For Giotto, on the other hand, hell is a place more of disorder than of excruciating pain [in *Last Judgment*, Arena Chapel, Padua]. The damned and all the devils except Satan are reduced in scale. Hell is more remote and less substantial than heaven. Indeed Giotto's outlook, serene and assured, differs from that of these later masters in much the same way as Giotto's Dominican contemporary Domenico Cavalca (*c.* 1270–1342) differs from Jacopo Passavanti. Of these two preachers De Sanctis wrote: "Cavalca's muse is love, and his material is Paradise, of which we get a foretaste in that spirit of charity and gentleness which gives his prose so much softness and color. But Passavanti's muse is terror, and his material is vice and hell, pictured less from their grotesque and mythological sides than in their human aspects, as in remorse and the cry of conscience. . . ."[60] Can we avoid thinking of Giotto and Orcagna?

*NOTES*

[1] Sachetti, *Novella* 136.

[2] Orcagna was capomaestro of Or S. Michele from 1355 to 1359, and both Taddeo Gaddi and Alberto di Arnaldo were in Florence at that time (see J. von Schlosser, *Quellenbuch für Kunstgeschichte*, XLVIII [Vienna, 1896], p. 349).

[3] The story has been mentioned by previous writers simply as evidence of the pessimism, the "Epigonengefühl," of all the artists present. See J. V. Schlosser, in *Kunstgeschichtliches Jahrbuch der K. K. Zentralkommission*, IV, 1910, p. 126; P. Toesca, *Florentine Painting of the Trecento* (New York, n.d.), p. 50 (the translation in part incorrect); W. R. Valentiner, in the *Art Quarterly*, XII, 1949, p. 48 (Taddeo's reply incorrectly read).

[4] From 1357 to 1360 and in 1373–1374 (see P. Toynbee, *Dante Studies* [London, 1902], pp. 218–222).

[5] *Comentum super Dantis Aldigherii Comoediam*, ed. (Florence, 1887), III, p. 313.

[6] "O empty glory of human powers! How short the time its green endures at its peak, if it be not overtaken by crude ages! Cimabue thought to hold the field in painting, and now Giotto has the cry, so that the fame of the former is obscured." (*Purgatorio*, XI, 91–95.)

[7] R. Salvini, *Giotto* (Rome, 1938), p. iii.
A later Dante commentator, perhaps under the influence of Benvenuto, also imputed errors to Giotto, but in architecture, where they are far less significant. The Anonimo, writing about 1395, says that he made two errors in the Campanile, of which he was aware and which led him to die of a broken heart. . . . (see Milanesi in Vasari, I, p. 371). Schlosser, *op. cit.*, p. 124, refers to changes in the design made by Giotto's successors as a possible source of the Anonimo's fable.

[8] *Commentum cit.*, p. 311.

[9] It is true that eulogies of Giotto were not lacking around this time. Petrarch spoke admiringly of him in a letter, and in his will of 1361 he referred to the praise of the "magistri artis" as Benvenuto had of the "ingenii." But Petrarch, living far from Florence, may not have been in close touch with the growth of Florentine opinion on the arts. Boccaccio's famous statement in the Decameron was written in 1350–1352, thus at the very beginning of a profound change of taste in Florence. (For the passages in Petrarch and Boccaccio, see Salvini, *op. cit.*, pp. 4–5.)

[10] This statement seems to me essentially correct even though some elements of Maso's style were assimilated by two or three younger masters, among them the author of the frescoes of the Nativity and Crucifixion in the Chiostrino of S. M. Novella (Van Marle, *The Development of the Italian Schools of Painting* [The Hague, 1924], III, Fig. 241), and Orcagna himself.

[11] *Studies in Florentine Painting* (New York, 1927), pp. 3–42, and *Corpus of Florentine Painting* (New York, Sec. III, Vols. I, 1931, and II, 1930).

[12] See for instance C. Weigelt, *Sienese Painting of the Trecento* (New York, 1930), pp. 56–57.

[13] Resemblances between Florentine painting of the period and Bartolo di Fredi have already been observed, however, by G. Gombosi (*Spinello Aretino* [Budapest, 1926], p. 14) and F. Antal (*Florentine Painting and its Social Background* [London, 1947], p. 205). But I cannot agree with Antal's belief that Giovanni del Biondo and several contemporary Florentine painters were influenced by Fredi.

[14] See, for instance, a collection of middle class precepts such as that of Paolo di Messer Pace, *Il libro di buoni costumi*, ed. by S. Morpurgo (Florence, 1921). For burgher modes of thought, see also the comments below on the Villani chronicles (note 17 . . .).

[15] The growth of the power of Milan weighed so heavily upon the minds of the Florentines that a large part of Matteo Villani's chronicle from 1351 on (book II) is devoted to it. For the consequences of the Milanese threat see H. Baron, in *Annual Report of the American Historical Association for 1942* (Washington, 1944), pp. 123–138.

[16] See A. Sapori, *La crisi delle compagnie mercantili dei Bardi e dei Peruzzi*

(Florence, 1926); also A. Doren, *Italienische Wirtschaftsgeschichte* (Jena, 1934), pp. 464 ff.

[17] Sapori, *op. cit.*, p. 140.

[18] "Maggiore ruina e sconfitta che nulla che mai avesse il nostro comune" (book XII, chap. 55). Villani was a *socius* of the Buonaccorsi Company.

[19] This government, furthermore, suppressed as firmly as the oligarchic one preceding it the *sottoposti* of the woolen guilds, who comprised the great majority of the working population of Florence (see G. Capponi, *Storia della Repubblica di Firenze* [Florence, I, 1875], p. 245).

[20] See, for instance, the changes within the guild of the physicians and apothecaries to which the painters belonged, described by R. Ciasca, *L'arte dei medici e speziali* (Florence, 1927), pp. 86 ff., and A. Doren, *Entwicklung und Organization der florentiner Zünfte* (Leipzig, 1897), pp. 51–59.

During these years the painters acquired greater independence and influence within the guild, but this was in part the consequence of special factors, chiefly the greater public esteem won by this craft during the course of the fourteenth century. The painters entered the guild in 1314 as dependents of the *membrum* of the apothecaries, classified simply as men who buy, sell, and work colors. In the guild lists of the 'forties or 'fifties painters of panels and frescoes are called *dipintori*, and differentiated from painters of chests and furniture. Not long afterward the *dipintori* became dependents of the physicians, the only professional group in the guild. Finally, in 1378 the group of painters was authorized to form an independent *membrum* because, as the record states, "aveva conseguito una grande importanza nella vita dello stato, ed appariva già maturo per la vita dello stato" (Ciasca, *op. cit.*, p. 131).

[21] "Signori artefici e gente manovali e idioti" (book XII, chap. 43). In 1340, before the revolution, Villani had advocated a government representative of all classes (book XI, chap. 118).

[22] See G. Luchaire, *Documenti per la storia dei rivolgimenti politici del comune di Siena dal 1354 al 1369* (Lyons, 1906); P. L. Sbaragli, "I mercanti di mezzana gente al potere in Siena," in *Bullettino senese di storia patria*, VIII, 1947, pp. 35 ff.; F. Schevill, *Siena* (London, 1909), pp. 213–228; L. Douglas, *A History of Siena* (New York, 1902), pp. 149 ff.

[23] See N. Rodolico, *Il popolo minuto* (Bologna, 1899), p. 51.

[24] See Doren, *Italienische Wirtschaftsgeschichte*, p. 391.

[25] Book XI, chap. 21.

[26] In a previous epidemic, during the spring of 1340, 15,000 Florentines died, according to Giovanni Villani (book XI, chap. 114).

[27] These estimates of Doren (*op. cit.*, pp. 634–635) are conservative. Others suppose a higher rate of mortality. N. Rodolico, *La democrazia fiorentina nel suo tramonto* (Bologna, 1905), pp. 7, 32, 35, gives an overall figure for Florence in 1347 of 120,000; after the plague 25,000 to 30,000, a death rate of four-fifths. Boccaccio in the Decameron said that 100,000 Florentines died, and the Chronicle of Stefani puts the figure at 96,000. Matteo Villani gives a general death rate of three-fifths (see note 30).

Agnolo di Tura seems to say that 80,000 Sienese died, leaving only 10,000 alive (*Rerum Italicarum scriptores*, XV, part VI, ed. by A. Lisini and F. Iacometti, Bologna, 1932, p. 555) and an anonymous chronicler (*ibid.*, p. 148) asserts that the "grande

morìa" carried off three-fourths of the people. A. Lisini, commenting on this statement (*ibid.*, p. 148 note 2), says that if three-fourths did not die, at least a half did. Lisini estimates as many as 70,000 people in Siena before the plague. Commenting on Siena, Matteo Villani (book I, chap. 4) says "non pareva che fusse persona."

[28] See for Siena, W. Heywood, *"Ensamples" of Fra Filippo* (Siena, 1901), pp. 80 ff., and for Florence, F. T. Perrens, *Histoire de Florence* (Paris, 1888–90), IV, pp. 379 ff. The plague of course became endemic, reappearing in 1400, 1411, 1424, and thereafter, but with a greatly diminished rate of mortality.

[29] *Rerum Italicarum scriptores*, xv, part 6, pp. 555–556.

[30] Book I, end of chap. 1 and beginning of chap. 2.

The entire passage is interesting for its careful, precise account of the spread of the plague through Italy and Europe. Villani is assiduous in the collection of facts and opinions but cautious in accepting them, and he frequently records them with skepticism or with contrary argument. Thus he tells about the reports of a great fire in Asia, and the belief that the plague originated in areas ravaged by it, but adds, "ma questo non possiamo accertare." To the assertion of the astrologers that the plague resulted from the conjunction of three superior planets in the sign of Aquarius, he replies that a similar conjunction had occurred in the past without producing such dire results. He is quick to calculate, and to propose laws and principles: on the basis of reports from many countries, he says that the pestilence may be said usually to last five months in a given region. It normally carried away three out of every five persons.

[31] Agnolo di Tura, *op. cit.*, p. 555–556. One hundred and thirteen of the friars in S. M. Novella in Florence died (C. di Pierro, in *Giornale storico della letteratura italiana*, XLVII, 1906, p. 14), and in Avignon nine cardinals and seventy prelates, despite the great fires which were maintained in the papal palace to purify the air (P. Schaff, *History of the Christian Church*, (New York, 1910), v, part 2, p. 100).

[32] *Corpus*, sec. III, vol. v, p. 119.

[33] Their names are lacking not only in all documents, but in the list of the best Sienese painters compiled around 1349 for the *operaii* of S. Giovanni, Pistoia (C. von Fabriczy, *Repertorium für Kunstwissenschaft*, XXIII, 1900, pp. 496–497).

[34] Agnolo di Tura, *op. cit.*, p. 560.

[35] Book I, chap. 4. A translation of the entire chapter—upon which the above is based—may be found in G. C. Coulton, *The Black Death* (London, 1929), pp. 66–67.

[36] Book I, chap. 5.

[37] Chronicle of Neri di Donato, *Rerum Italicarum scriptores*, xv, pp. 633–636. On the inflation throughout Europe after the Black Death see J. W. Thompson, in *American Journal of Sociology*, XXVI, 1920–21, p. 565, and Kovalevsky in *Zeitschrift für Sozial- und Wirtschaftsgeschichte*, III, 1895, pp. 406–423.

[38] Twenty thousand florins, for instance, to Lando in 1356 (see Neri di Donato, *op. cit.*, p. 585). On the merchant companies and Florence, see especially Perrens, *op. cit.*, IV, pp. 424, 457–470.

[39] See R. Ciasca, *op. cit.*, p. 291. Despite these inducements the number of physicians did not increase as rapidly as the shopkeepers and tradesmen in the same guild (*ibid.*, p. 117). For immigration into Florence see also N. Rodolico, *I ciompi*, pp. 40–42, and *idem, Democrazia fiorentina*, pp. 36 ff. For Siena, see Kovalevsky, *op. cit.*, p. 421 and L. Douglas, *op. cit.*, pp. 155–156. All these writers comment

only very briefly on the immigration. The entire phenomenon, and its consequences for contemporary society and culture, has not hitherto been given adequate attention.

[40] Agnolo di Tura (*op. cit.*, p. 560) wrote that "tutti li denari erano venuti a le mani di gente nuova." See also Matteo Villani (book III, chap. 56); Perrens, *op. cit.*, IV, p. 391.

[41] *Op. cit.*, p. 34. Through Scaramella does not observe it, all references that he cites to the *homines novi* are from the period after the plague (Matteo and Filippo Villani, Giovanni di Paolo Morelli, etc.).

[42] ". . . tabulam meam sive iconam beatae Virginis Mariae . . . cuius pulchritudinem ignorantes non intelligunt, magistri autem artis stupent." See R. Salvini, *Giotto (Bibliografia)* (Rome, 1938), p. 5.

[43] H. Hauvette, *Boccace* (Paris, 1914), p. 464.

[44] See books XIV and XV of the *Genealogia degli dei*, trans. by C. G. Osgood, *Boccaccio on Poetry* (Princeton, 1930).

[45] *Meditations*, chap. XII (see the edition of the Italian text by A. Levasti, Florence, 1931, pp. 46–47): "Cotali cose [i.e. lavorìo curioso, bello, . . . delicato] sono concupiscenza degli occhi, lo quale vizio è uno de' tre peccati, ai quali tutti gli altri si riducono." The author condemns works of craft and of art also because they waste time, promote vanity, and are contrary to poverty.

The passage in the *Meditations* is based on ideas about the *concupiscentia oculorum* expressed by St. John (First Epistle, 2:16) and developed by St. Augustine (*Confessions*, book X, esp. chap. 34), after whom they became part of the medieval tradition. The latter speaks of the "attractions" that men, with the aid of the arts, have added to paintings and other things.

[46] The association of these vices with St. John is probably connected with the passage from this saint cited in the previous note and later interpretations of it.

[47] See Paolo di Messer Pace da Certaldo, *Il libro di buoni costumi*, ed. by S. Morpurgo (Florence, 1921), p. CL (Paolo is mentioned in documents from 1347 to 1370). The writer, son of a jurist, recounts the perils of avarice, and then concludes: "Sia temperato in se, e non disiderare più che'l tuo stato richegha."

[48] A. Segre, *Storia del commercio* (Turin, 1923), p. 223.

[49] A. Doren, *Entwicklung und Organization der florentiner Zünfte* (Leipzig, 1897), p. 71, pointed to the greater recognition given at this time to silk weavers and dyers in a guild that continued to be dominated by silk merchants. See also *idem, Florentiner Zunftwesen* (Stuttgart and Berlin, 1908), p. 199.

[50] A. Sapori, in *Archivio storico italiano*, III, 1925, p. 250. On the subject of voluntary restitution, see B. N. Nelson, in *Tasks of Economic History*, supplement VII, 1947, to the *Journal of Economic History*. Even in the fifteenth century, Cosimo dei Medici sought the advice of Pope Eugene IV on the restitution of money that he confessed had been illegitimately gotten.

[51] Book VII, chap. 147.

[52] See, for instance, the beginning of Sacchetti's *Trecento novelle:* "Considerando al presente tempo, ed alla condizione dell' umana vita, la quale con pestilenziose infirmità, e con oscure morti, è spesso vicitata; e veggendo quante rovine, con quante guerre civili e campestre in esse dimorano; e pensando quante populi e famiglie per questo son venute in povero ed infelice stato, e con quanto amaro

sudore conviene che comportino la miseria, là dove sentono la lor vita esser trascorsa; e ancora immaginando, come la gente è vaga d'udire cose nuove, e spezialmente di quelle letture che sono agevoli a intendere, e massimamente quando danno conforto, per lo quale tra molti dolori si mescolini alcune risa; . . ." (Franco Sacchetti, *Proemio del Trecento novelle*).

[53] *Speculum*, XIII, 1938, p. 12. Baron discusses the diffusion of stoicism and the ideal of poverty in the period following the epidemic.

For the preoccupation with death, see A. M. Campbell, *The Black Death and Men of Learning* (New York, 1931), pp. 172 ff.

[54] C. di Pierro, "Contributo alla biografia di Fra Jacopo Passavanti," *Giornale storico della letteratura italiana*, XLVII, 1906, pp. 1–24.

[55] Ed. by M. Lenardon (Florence, 1925). See also N. Sapegno, *Storia letteraria d'Italia, Il trecento* (Milan, 1942), pp. 505–510; A Levasti, *I mistici del duecento e del trecento* (Rome, 1935), pp. 64 ff.; A. Monteverdi, "Gli esempi di Jacopo Passavanti," *Giornale storico della letteratura italiana*, LXI, 1913, pp. 266 ff., and LXIII, 1914, pp. 240 ff.

[56] *Specchio, cit.*, pp. 307–308.

[57] See A. Monteverdi, *op. cit.*, 1914, pp. 249, 287. The monastery of S. M. Novella itself was struck by lightning several times during the priorate of Passavanti. In 1358 the choir was hit and the frescoes of Orcagna damaged (see Matteo Villani, book VIII, chap. 46).

[58] Monteverdi, *op. cit.*, 1913, p. 305.

[59] Antal, *op. cit.*, p. 202, has pointed to the prominence of the devils in this scene, connecting them with "popular taste."

[60] F. De Sanctis, *History of Italian Literature*, trans. by J. Redfern (New York, 1931), I, p. 123.

# *18.* JAN VAN EYCK AND

# ROGER VAN DER WEYDEN

## *Erwin Panofsky*

### INTRODUCTION

It is fitting that the final selection in this volume should concentrate on
Jan van Eyck and Roger van der Weyden. The art and lives of these two
painters from the Lowlands are particularly resonant in communicating
both the continuity of northern Gothic traditions and the accelerated
conquest of pictorial means that characterized the art of the early fifteenth
century in the north as it had in Italy. Granting that it smacks of mere
academic exercise—however entertaining it may be—to debate the question
of whether Jan van Eyck and Roger van der Weyden are "Late Gothic"
or "Renaissance" artists, the very existence of the question implies a degree
of ambivalence regarding the extension of the idea of a Renaissance to the
Lowlands in the early fifteenth century. It is appropriate, therefore, to
conclude this volume with the late Erwin Panofsky's discerning remarks
on both the social status and the painting style of each of these artists,
for, whatever the classificatory preferences of the reader, Panofsky provides
in the passages that follow numerous indications of the productive interlace
of tradition with innovation in early Netherlandish art.

The new English translation of Max J. Friedlaender's essential fourteen-
volume work, *Die altniederlandische Malerei* (1924–37), will join the same
author's *Early Netherlandish Painting from Van Eyck to Bruegel,* 2nd ed.
(1965), and Erwin Panofsky's *Early Netherlandish Painting,* 2 Vols. (1953)
as the best sources for further information on the early artists of the
Lowlands. Other studies of special interest are Erwin Panofsky, "Jan van
Eyck's Arnolfini Portrait," *Burlington Magazine,* LXIV (1934); Millard

Meiss, "Light as Form and Symbol in Some Fifteenth-Century Painting," *The Art Bulletin,* XXVII (1945); by the same author, "Highlands in the Lowlands: Jan van Eyck, the Master of Flemalle and the Franco-Italian Tradition," *Gazette des Beaux-Arts,* s. 6, LVII (1961); Jules Desneux, "Underdrawings and *Pentimenti* in the Pictures of Jan van Eyck," *The Art Bulletin,* XL (1958); and Karl M. Birkmeyer "The Arch Motif in Netherlandish Painting of the Fifteenth Century," *The Art Bulletin,* XLIII, 1–2 (1961).

Other works relating to these artists are Margaret Whinney, *Early Flemish Painting* (1968), an introductory survey of the fifteenth- and early sixteenth-century painting in the Low Countries; L. Naftulin, "Note on the Iconography of the Van Der Paele Madonna," *Oud Holland,* LXXXVI, 1 (1971), 3–8; Lotte B. Philip, *The Ghent Altarpiece and the Art of Jan Van Eyck* (1972); Ann M. Schulz, "The Columba Altarpiece and Roger Van Der Weyden's Stylistic Development," *Munchner Jahrbuch der Bildenden Kunst,* Series 3, XXII (1971), 63–116; and Sir Martin Davies, *Rogier van der Weyden* (1972).

# JAN VAN EYCK

Jan van Eyck is first heard of as painter and *varlet de chambre* to John of Bavaria, the unconsecrated Bishop of Liége who, after the death of his brother, William VI of Holland, had usurped the territory of his niece, Jacqueline, and established residence in the Hague. He employed Jan for the decoration of his castle from October 24, 1422 (at the latest) until at least September 11th, 1424. And since Jan is already referred to as "master" at the time of his appointment we may assume that he was born not later than *c.* 1390. There is also some doubt as to his birthplace. For many centuries it has been taken for granted that both brothers were born at "Eyck," viz., Maaseyck, some eighteen miles north of Maastricht. Recently it has been proposed that they were natives of Maastricht itself where the name "van Eyck" is not uncommon as a family name. But since the evidence for this hypothesis is as yet inconclusive, I am inclined to accept, for the present, the traditional view.

At the end of his employment in Holland, Jan van Eyck repaired to Bruges, but stayed there for only a short time. On May 19, 1425, he was appointed as painter and *varlet de chambre* to Philip the Good of Burgundy and moved to Lille prior to August 2 of this year. Here he resided, with major and minor interruptions, until the end of 1429, having married, at an undetermined date, a lady of whom nothing is known except that her Christian name was Margaret, that she was born in 1406, and that she presented him with no less than ten children. Soon after, presumably in 1430, he established himself at Bruges for good and spent the rest of his life in a stately house "with a stone front" (acquired in 1431 or 1432), combining the office of a court artist with the normal activities of a bourgeois master painter who would not consider it beneath his dignity to accept such commissions as the coloring and gilding of the statues on the façade of the Town Hall. He died on July 9, 1441.

Throughout the sixteen years of their association the Duke and his painter—the first Early Flemish master to sign his works and,

385

so far as we know, the only one to imitate the nobles in adopting a personal motto, the famous *Als ich chan*, "As best I can," in which becoming pride is so inimitably blended with becoming humility—lived on terms of mutual esteem and confidence. Philip the Good not only admired Jan van Eyck as a great artist but also trusted him as a familiar and a gentleman. As early as 1426 the painter undertook, in the name of his master, certain confidential pilgrimages and "secret voyages," and during the following years he was a member of two embassies to the Iberian peninsula. After two previous marriages, both terminated by death, Philip the Good was still without an heir, and the first of the voyages overseas, lasting from early summer to October, 1427 (when Jan van Eyck received his *vin d'honneur* at Tournai on the eighteenth), was undertaken, it seems, in order to negotiate a marriage with Isabella of Spain, daughter of James II, Count of Urgel. This having failed for reasons unknown, another mission was dispatched to Portugal in order to obtain the hand of the eldest daughter of King John I, also named Isabella. This time the envoys succeeded, though only at the price of two exceedingly rough and dangerous crossings—entailing lengthy stopovers in England on both trips. They started on October 19, 1428, and returned—with the Infanta—as late as December, 1429; the marriage took place on January 10, 1430.

Apart from another "secret mission" in 1436, the Duke of Burgundy honored his painter by at least one personal visit to his workshop, showed him his favor by all kinds of extra payments and an occasional gift of silver cups, exempted him from a general cutback in jobs and salaries decreed in 1426, and acted as godfather by proxy (at the sacrifice of another half dozen silver cups) when a child of Jan's was baptized sometime before June 30, 1434. He even extended his affection beyond the grave. After Jan van Eyck's death his widow received a substantial gratuity "in consideration of her husband's services and in commiseration with her and her children's loss"; and nine years later, in 1450, his daughter Livina (Lyevine) was enabled to enter the Convent of St. Agnes at Maasseyck by a special grant from Philip the Good.

On one occasion, when the bureaucrats in Lille had made some difficulties about Jan's salary, the Duke came down upon them with an order that has the ring of the Italian High Renaissance rather than of the Northern Middle Ages. He enjoined them, under threats of gravest displeasure, to honor the claims of Jan van Eyck without

delay or argument; for he, the Duke, "would never find a man equally to his liking nor so outstanding in his art and science": "nous trouverions point le pareil a nostre gré ne si excellent en son art et science."

What may be dismissed as humanistic hyperbole in Bartolommeo Fazio, who praises Jan van Eyck as a man of literary culture (*litterarum nonnihil doctus*), proficient in geometry, and a master of "all arts that may be added to the distinction of painting," is thus borne out by the testimony of Philip the Good. By the very wording of his reprimand (*art et science,* a phrase not uncommon in the early fifteenth century) he implies that the achievement of an artist, and particularly those of his favorite painter, had to be considered not only as a matter of superior skill but also of superior knowledge and intelligence.

This judgment is confirmed by Jan van Eyck's pictures. Only a keen intellectual curiosity could have devoted so much interest to theological texts, chronograms, astronomical details, cabilistic invocations and even paleography. Only a logical mind could have so thoroughly refined and systematized the principle of "disguised symbolism" that in his world, as I expressed it, "no residue remained of either objectivity without significance or significance without disguise." Only the instinct of a historian could have rediscovered the indigenous Romanesque and recaptured its spirit in all its phases and manifestations. And only an imagination controlled and disciplined by geometry, the "art of measurement," could have determined the impeccable proportions of Eyckian architecture.

That Jan was also an expert in alchemy, as Vasari would have it, is of course an assumption derived from the belief that he was the inventor of oil painting. This belief, we know, can no longer be maintained. Yet the fact remains that he must have devised certain improvements unknown before—improvements which enabled him to surpass both in minuteness and in luminosity whatever was achieved by his predecessors, contemporaries and followers. Whether he distilled new varnishes, driers and diluents—and in this case Vasari's reference to alchemy and his amusing tale of Jan's innovations having started with the development of a quick-drying varnish might, after all, contain a grain of truth—or merely applied the processes of the *nouvelle pratique* with greater sophistication, it is difficult to say. Certain it is, however, that in his pictures the

oil technique, though not invented by him, first revealed itself in
its full glory, the translucency of the colors—"radiant by themselves
without any varnish"—enhanced by an increasingly economical use
of lead white which he employed (apart, of course, from the render-
ing of linen, etc.) for luminary surface accents rather than the
construction of plastic form.

From the sheer sensuous beauty of a genuine Jan van Eyck there
emanates a strange fascination not unlike that which we experience
when permitting ourselves to be hypnotized by precious stones or
when looking into deep water. We find it hard to tear ourselves
away from it and feel drawn back by what Magister Gregorius,
compelled to revisit a statue of Venus again and again although it
meant a walk of more than two miles, described as "some kind of
magical persuasion." Whoever has tried to give a fair amount of
conscientious attention to other paintings hung in the same room
will remember that even a Rubens may strike him as "just a paint-
ing," a mere semblance as opposed to a reality, when looked at
with an eye still carrying the imprint of a Jan van Eyck. In fact,
a picture by Jan van Eyck claims to be more than "just a painting."
It claims to be both a real object—and a precious object at that—
and a reconstruction rather than a mere representation of the visible
world.

The first of these claims is stressed by the very treatment of the
frames which he invariably provided himself and which have come
down to us in at least eight instances. Setting aside the exceptional
case of the Ghent altarpiece, these frames are elaborated into
complex moldings and painted so as to simulate marble or porphyry.
Moreover, this marbleization is carried over to the back of the panel,
and carefully lettered inscriptions are seemingly incised into the
artificial stone. By this legerdemain, which may seem reprehensible
to the purist, Jan van Eyck not only showed off his virtuosity (as
did the Limbourg brothers when they fooled the Duc de Berry with
the wooden dummy of a gorgeous Book of Hours) but also empha-
sized and glorified the materiality of the picture. The modern frame
is nothing but a device for isolating the picture space from the space
of nature. The Late Medieval frame, exemplified by the van
Beuningen altarpiece with its carved rosettes, or, more extra-
vagantly, by the "Carrand diptych" with its elaborate gilt tracery,
is an ornamental setting which compasses the picture as chased
metal does a precious stone. Jan van Eyck's frames are, in a sense,

both. In subduing them coloristically, he stressed the modern idea of the panel as a "picture," that is, as the projection plane of an imaginary space. But in transfiguring them into what looks like marble, he retained the idea of the panel as a tangible piece of luminous matter, united with its frame into a complex *objet d'art* composed of many precious materials.

The impression that paintings by Jan van Eyck confront us with a reconstruction rather than a mere representation of the visible world is more difficult to rationalize. Very tentatively, we may say this: the naturalists of the fifteenth century, avid for observation yet in many ways committed to convention, were plagued by the problem of striking a balance between the general and the particular—between the total aspect of a face or hand and the wrinkles of the skin, between the total aspect of a piece of fur or fabric and its individual hairs or fibers, between the total aspect of a tree and its individual leaves. Before Jan van Eyck, these details, if not entirely suppressed, tended to remain distinct from each other as well as from the whole and give the impression either of a whole incompletely differentiated or of a mass of details incompletely unified. The hand of the St. George in the "Madonna van der Paele," however much detailed, remains a totality so that no contradiction is felt between its complexity and the simplicity of the polished armlet from which it emerges (Fig. 52). The face of the Giovanni Arnolfini in the London double portrait, smooth though it is, seems sufficiently rich in detail to harmonize with the intricacies of the plaited Italian straw hat and fur collar.

This Eyckian miracle was brought about by what may be likened to infinitesimal calculus. The High Renaissance and the Baroque were to develop a technique so broad that the details appeared to be submerged, first in wide areas of light and shade and later in the texture of impasto brushwork. Jan van Eyck evolved a technique so ineffably minute that the number of details comprised by the total form approaches infinity. This technique achieves homogeneity in all visible forms as calculus achieves continuity in all numerical quantities. That which is tiny in terms of measurable magnitude yet is large as a product of the infinitesimally small; that which is sizable in terms of measurable magnitude yet is small as a fraction of the infinitely large.

Thus Jan van Eyck's style may be said to symbolize that structure of the universe which had emerged, at his time, from the prolonged

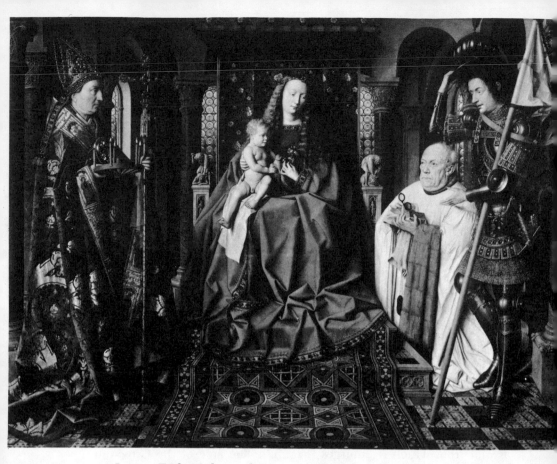

52. Jan van Eyck, Madonna of Canon van der Paele (Musée Communal, Bruges)

discussion of the "two infinites"; he builds his world out of his pigments as nature builds hers out of primary matter. The paint that renders skin, or fur, or even the stubble on an imperfectly shaved face seems to assume the very character of what it depicts; and when he paints those landscapes which, to quote Fazio once more, "seem to extend over fifty miles," even the most distant objects, however much diminished in size and subdued in color, retain the same degree of solidity and the same fullness of articulation as do the very nearest. Jan van Eyck's eye operates as a microscope and as a telescope at the same time—and it is amusing to think that both these instruments were to be invented, some 175 years later, in the Netherlands—so that the beholder is compelled to oscillate between a position reasonably far from the picture and many positions very close to it. And while thus being reminded of the limitations of nature, we share some of the experience of Him

Who looks down from heaven but can number the hairs of our head.

However, such perfection had to be bought at a price. Neither a microscope nor a telescope is a good instrument with which to observe human emotions. The telescopic view tends to reduce human beings to those "figures of diminutive size" which people distant landscapes; the microscopic view tends to magnify their very hands and faces into panoramas. In either case the individual is apt to be de-emotionalized, whether he be reduced to the status of a mere part of the natural scenery or expanded into a small universe.

By nature, Jan van Eyck was by no means an impassive artist, and where occasion demanded it—as in the animated Genesis scenes on one of the capitals in the "Rolin Madonna" or in the truly terrifying "Slaying of Abel" in the Ghent altarpiece—he could be as dramatic as any other artist of his time. But in the "classic," unanimously accepted works of his maturity these dynamic elements are relegated to the background. The emphasis is on quiet existence rather than action, and with the significant exception of the Annunciate in the comparatively early picture at Washington, who retains, in much attenuated form, the emotional *contrapposto* attitude of her Italianate predecessors, the principal characters are nearly motionless, communicating with each other only by virtue of spiritual consubstantiality. Measured by ordinary standards, the world of the mature Jan van Eyck is static. . . .

## ROGER VAN DER WEYDEN

Roger van der Weyden was born, we recall, at Tournai in 1399 or 1400, the son of a master cutler named Henry. Nothing is known of his boyhood and early youth except that he was not at Tournai on March 18, 1426, when the house of his father, recently deceased, was sold without his participation. In the same year he married (as can be concluded from the fact that his first child, a son named Corneille, was eight years old in 1435), and this marriage, too, would seem to have taken place outside Tournai: his bride, Elizabeth Goffaerts, hailed from Brussels. Her mother, Cathelyne, however, bore the same family name, van Stockem, as did the long-suffering wife of Robert Campin, and this very fact lends further support to the assumption that it was the latter, alias the Master of Flémalle,

whose workshop Roger entered on March 5, 1427, and left as "Maistre Rogier" on August 1, 1432.

Where the young master turned immediately upon his "graduation" is unknown. Certain it is, however, that he was most successful from the outset and ultimately settled in the native city of his wife. As early as October 20, 1435, he was able to invest a considerable sum of money in Tournai securities, and on May 20, 1436, the city fathers of Brussels resolved not to fill the position of City Painter ("Portrater der stad van Brussel" or "der stad scildere") after Roger's death—a resolution from which we learn that this position was his at the time and may infer that it had been especially created for him not long before. Whether he was appointed for the express purpose of supplying the courtroom of the Town Hall with the "Examples of Justice" that were to delight eight generations of travelers is not known. Certain it is, however, that these four celebrated panels are not mentioned until 1441, and that the first pair of them was not completed until 1439. It was about this time that he was granted the privilege of wearing the same particolored cloak (*derdendeel*) as did the "geswoerene knapen" of the city of Brussels.

Internationally famed and financially prosperous (further purchases of Tournai securities are recorded for 1436–1437, 1442 and 1445, and in 1449 he gave 400 crowns to Corneille who wished to enter the Charterhouse of Hérinnes), Roger van der Weyden represents, perhaps even more paradigmatically than Jan van Eyck, the novel type of bourgeois genius. Though honored by princes and dignitaries at home and abroad, he lived the dignified and uneventful life of a good citizen charitable to the poor, generous to religious institutions, intent upon the welfare of his community, and solicitously providing for his wife and children. He received splendid commissions from Spain and Italy, yet did not disdain to polychrome and emblazon a stone relief in the Minorites' Church or to attend to the coloring of twenty-four brass statuettes. And except for occasional business trips and a pilgrimage to Italy in the Holy Year of 1450, nothing seems to have interrupted his quiet, laborious life until it ended on June 18, 1464.

Of Roger's personality we know little more than that he was a man of integrity and rare unselfishness. It was to him that people turned as an arbitrator when a dispute arose between a fellow painter and his clients. On May 7, 1463, the Duchess of Milan,

Bianca Visconti, effusively thanked her "noble and beloved master Roger of Tournai, painter in Brussels" for the courtesy and kindness which he had shown to her young protégé, Zanetto Bugatto, and the unstinting generosity with which he had instructed him "in everything he knew about his art." And in 1459 the Abbot of St. Aubert at Cambrai noted with gratification that Roger had improved and considerably enlarged the stipulated dimensions of an altarpiece commissioned in 1455 "pour le bien de l'oeure." These are small things, perhaps, in themselves, but not quite usual at a time when painters were secretive about their methods and even the greatest were paid according to working hours and the cost of materials used.

Happily such scanty records are supplemented, and corroborated, by two portraits which, however inadequately, inform us of Roger's physical appearance. His features are known, first, from an inscribed drawing in the "Recueil d'Arras"; and, second, from his self-portrait in one of the "Examples of Justice" which is transmitted to us through the Berne tapestry. In spite of the indifferent quality of the Arras drawing and the inevitable distortion of the woven copy, we feel at once that we are in the presence of greatness, and this impression is borne out by no less illustrious a witness than Nicolaus Cusanus. In an attempt to describe the way in which God looks at the world, the Cardinal refers to "that face of the outstanding painter Roger in the most precious picture preserved in the Town Hall at Brussels" (*facies illa . . . Bruxellis rogeri maximi pictoris in preciosissima tabula quae in praetorio habetur*). Though a motionless image, he says, this face seems to pursue the beholder with its glance wherever he goes as does the eye of God which observes the human being "wherever he may be" and is fixed on him "as though on him alone." After an established custom of medieval scholasticism, Cusanus endeavored to carry the mind of his readers to that which is divine by means of a *similitudo* taken from human activity. But he might not have chosen this particular simile had his imagination not been stirred by this thoughtful, deadly-serious face and deep, bitter folds around a wide, generous mouth and enormous, visionary, indeed inescapable eyes.

"Jan van Eyck," Max J. Friedlaender once aptly remarked, "was an explorer; Roger van der Weyden was an inventor." Not that Roger was unable to do justice to what may be called the surface

blandishments of the visible world. There are enchanting details in many of his pictures, and in sensibility to color he was second to none. No visitor to Beaune or Philadelphia will ever forget the modulations of blue in Roger's "Last Judgment" or the polyphony of warm, lilac-rose, pale gray-blue, flaming vermilion, drab gray, and gold in his "Calvary." But it is true that Roger substituted for Jan van Eyck's pantheistic acceptance of the universe in its entirety a principle of selection according to which inanimate nature and man-made objects are less important than animals, animals less than man, and the outward appearance of man less than his inner life. One of his contemporaries admired his paintings for *sensuum atque animorum varietas,* and Carel van Mander praised him for having improved the art of the Lowlands by an increase in movement and, most particularly, by the "characterization of emotions such as sorrow, anger or joy as was required by the subject."

Thus Roger's world is at once physically barer and spiritually richer than Jan van Eyck's. Where Jan observed things that no painter had ever observed, Roger felt and expressed emotions and sensations—mostly of a bitter or bittersweet nature—that no painter had ever recaptured. The smile of his Madonnas is at once evocative or motherly affection and full of sad foreboding. The expression of his donors is not merely collected but deeply pious. Even his design is expressive rather than descriptive; it was he, for instance, who discovered how much the pathos of a Crucifixion might be intensified by contrasting the rigidity of the Body with the undulating movement of a billowing loincloth. His iconographic innovations, too, were often designed to create new emotional situations. He permitted donors directly to participate in sacred events and, conversely, introduced contemporary personages into Biblical narratives as *dramatis personae* who, as Leone Battista Alberti would say, "attract the eyes of the beholder even though the picture may contain other figures more perfect and pleasing from an artistic point of view." He combined half-length portraits with half-length Madonnas into diptychs in which the sitter is represented in prayer. And it seems to be he who if not invented, at least reformulated and popularized the subject of St. Jerome compassionately extracting the thorn from the foot of his faithful lion.

When we compare, for example, Jan van Eyck's "Madonna van der Paele" [Fig. 52] with the central panel of Roger van der Weyden's "Columba altarpiece" (so called after the Church of St.

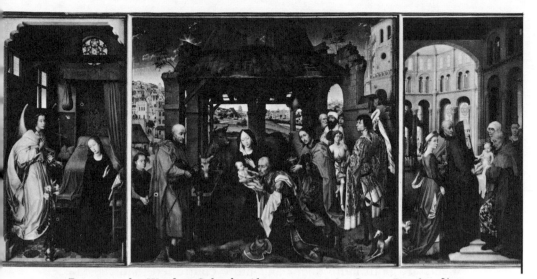

53. Roger van der Weyden, Columba Altarpiece, *c.* 1460; Center Panel, 54⁵⁄₁₆″ by 60¼″; Each Wing 54⁵⁄₁₆″ by 27⁹⁄₁₆″ (Alte Pinakothek, Munich)

Columba in Cologne which was its home from 1493) we perceive what seems to be an irreconcilable contrast. The "Madonna van der Paele" is strictly symmetrical, and its weighty, immobilized figures, receding from the central plane as well as from each other, are painted as though they were crystallizations of light itself. Its style is static, spatial and pictorial. In the Columba altarpiece (Fig. 53) the central group is shifted to the left and the slender, supple figures of St. Joseph and the Magi, all in action, are pressed against the picture plane so as to form a sharply delineated pattern; its style is dynamic, planer and linear. Roger's composition looks almost like a throwback to the fourteenth, if not the thirteenth century, and he has often been said to represent a kind of Gothic counterrevolution against Jan van Eyck. However, while it is true that Roger's style has fundamental characteristics in common with what we call High Gothic and that he revived a number of motifs and devices nearly forgotten for half a century or more, he was not, as has occasionally been said, a "reactionary." He arrived at his apparently archaic solutions not only from an entirely "modern" starting point but also for a very "modern" purpose: far from simply opposing to the ideals of Jan van Eyck and the Master of Flémalle those of an earlier period, he attempted to break new ground by the old device of *reculer pour mieux sauter.*

Jan van Eyck had not so much resolved as negated the problems posed by the great painter of Tournai; he had eliminated the ten-

395

sions and contradictions characteristic of the latter's manner by abolishing their very *raison d'être*. Where, as in Jan's mature style, all physical and emotional action was absorbed into pure existence there could be no conflict between movement and rest. Where all surface relations were transposed into space relations there could be no conflict between two-dimensional design and composition in depth. Where all details were perfectly integrated with total form there could be no conflict between a pictorial and a linear mode of presentation. Roger van der Weyden, however, set out to develop the expressive and calligraphical possibilities inherent in the style of the Master of Flémalle without forfeiting the consistency and purity attained by Jan van Eyck.

While Roger's figures are more dynamic than Jan's their movements are both more fluent and more controlled than the Master of Flémalle's. And while their grouping is denser and more diversified than in an Eyckian composition it is less crowded and more coordinated than in a Flémallesque one. It is as though a living chain of figures were thrown across the picture plane—a chain whose links remain distinct though conjoined by artful repetition and variation. And the component parts of every figure, body and garments alike, are both articulated in form and function and unified by an uninterrupted flow of energy. In short, Roger van der Weyden may be said to have introduced into Flemish fifteenth-century art the principle of *rhythm* in contradistinction to meter—definable as that by which movement is articulated without a loss of continuity.

This rhythm unfolds within a kind of foreground relief neatly divorced from the space behind it. But both foreground relief and background space are what I should like to call "stratified" into a series of planes deliberately frontalized yet interconnected in depth. The entire picture space is thus made to obey a common principle analogous to the "rhythmical" organization of figure movement: articulation is accomplished without destroying continuity. In the central panel of the Columba altarpiece this system of interlocking frontal planes is particularly evident, not only in the general disposition of the figures, the succession of piers, arches and posts in the building, and the stratification of the landscape but even in inconspicuous details. The donor on the extreme left looks on from a plane located between that of the St. Joseph and the pillar behind him. The little greyhound on the extreme right attaches the figure of his master to the very front plane (the hat in front of the

oldest king, incidentally, fulfills a similar function) and the rigidly frontalized animals behind the Virgin Mary obligingly bend their heads into the planes in front of them.

As the principle of rhythm overcomes the tension between movement and rest in the behavior of the figures, and between surface and depth in the organization of space, so does it overcome the tension between the pictorial and the graphic in the presentation of plastic form as such; and this, I believe, is the very essence of Roger van der Weyden's "linearism." As in all Early Flemish painting, his lines are not abstract contours separating two areas of flat color, but represent a condensation or concentration of light or shade caused by the shape and texture of the objects. However, in Roger's paintings these forms assume a linear quality without relinquishing their luminary significance. Eyebrows or eyelids, the bridge of a nose, the edge of the lips, strands of hair, or, for that matter, the borders and folds of a garment are indicated by lines designed with the precision of an engineering drawing yet innervated by a vital force that sharpens their angles and intensifies their curvature. While never disrupting the unity of plastic shapes and color areas, they achieve a purely graphic beauty and expressiveness.

# Index

Page numbers of illustrations appear in boldface.

Accaiuoli family, 363
Acropolis, 44, 89, 93–94
Adulvesnasa, Essex, barn at, 203–4
Aeschylus, 37–38
Agnolo di Tura, 365, 366, 367
Alaric, 329
Albert the Great, 334
Alberti, Leone Battista, 328
Alberto di Arnaldo, 355
Alcamenes, 44, 82
alchemy, 387–88
Alexander the Great, 16
Alexandria, lighthouse of, 92
Amenemhat III, 11, 16
Amiens Cathedral
  bays of, **209**, 210
  interior of nave, 332, **333**
amphoras
  Attic, by Exekias, **65**
  Attic, Late Geometric, **56**
  "Nessos" amphora, **59**, 60
Andrea da Firenze, 373, 376
Anzy-le-Duc, 255
Aquinas, St. Thomas, 273, 275
Archaic Greek art, 51, 53, 56–70
  compared to Geometric, 57–59
  Early and Middle periods, 60–66
  Oriental influences, 56–60
  sculpture, 60–63, 66–67
    kouros and kore, 61–63, 66
    reliefs, 63
    temple pediments, 66–67
  vase-painting, 57–60, 64–66, 67–70
    black-figure, 57, 59, 64, 66, 67
    red-figure, 64, 66, 67–70
architecture
  bay system, 187–220
  Byzantine, 178–81
  Egyptian, 10, 11–12
  Gothic church, 336–40
  Greek, 87–103
    interior space in, 101–102
    numerical aspects of, 96–100
    Orders, **91**, 94–99
    parallel planes in, 100–101
    space division in, **209**
    temple plan and, 89–94
  Roman, 125–48
    building materials of, 128–32
    construction process of, 132–36

design characteristics of, 139–43
economy of construction of, 127–38
Imperial, 143–46
"new" architecture, 138–39
pozzolana mortar, 130, 131, 135, 136
structural features of, 136–38
vaulted style of, 143–44
Arena Chapel (Padula), 362–63, 376
  Giotto's frescoes in, 362–63, **362**
Aristotle, 357
Arnessysla, Iceland, timber church at, 191–92
*Arti Maggiori*, 360
*Arti Minori*, 360
Assisi, Upper Church, frescoes in, 315
Assurbanipal, 28
Assurnasirpal, palace reliefs of, 25–27
*King Assurnasirpal II's Chariots Passing a Fortified City*, **27**
Assyrian art, 21–34
  naturalism in, 23, 30
  palace reliefs, 25–33
    draughtsmanship of, 26–27
    historical epic in, 25–26, 31–32
    human figures in, 27
    spatial rendering in, 27–32
  religious beliefs and, 24–25
  seals, 23–25
  secular scenes in, 24
  winged monsters in, 24–25
Athena of Phidias, 44
Atley, Bishop, 201
Augustine, St., 270–71

Balawat, palace gates at, bronze reliefs, 27–28
Bardi family, 363, 369, 373
Barna, 359
Barnabei, Felice, 151
Baroque art, 112, 229, 389
Bartolo di Fredi, 359, 365
basilicas, Romanesque, building of, 235–36
Basilica Ulpia, 128
bay system, 187–220
  Carolingian, 192, 193, 198, 210
  Continental churches, 189–93, 195–98

development of, 209–13
Gothic architecture and, 211–13
hall and barn (in England), 198–204
houses and barns, 193–95
Iron Age, 195, 211
Leicester Castle hall, 198–200
origins of, 187–220
Plan of St. Gall, 195–98, 203
space-division, 190–91, 209–11
Beauvais Cathedral, 340
Benedictine scheme (Berry plan), of church architecture, 236
Bernard, St., 260
Berne tapestry, 393
Berry, Duc de, 388
Biadaiolo Master, 358
Biondo, Giovanni del, 371
Bishop of Hereford, palace hall of 200–202, **201**
Bisse, Bishop, 201
Bissos Church at Ruweha, 214
Black Death, 365–66
economic and social consequences of, 367–69
effect of, on culture and art, 369–74
guilt, penance, religious rapture and, 374–76
Boccaccio, Giovanni, 365, 370
Bonaiuti, Andrea, 356
Boscoreale, wall paintings from, 149–66
Second Style, 152, 153, 154–55
Villa of Publius Fannius Synistor, Cubiculum, 153–61, **154**, **156**
Bramante, Donato, 212
Breberen, Carolingian timber church at, **193**
Brunelleschi, Filippo, 327, 328, 335, 336
Buffalmacco, 355
Bugatto, Zanetto, 393
Byzantine art, 167–86, 225
architecture, 178–81
cross-in-square church plan, 181–83
compared to Hellenistic art, 107, 117, 119–20
contribution of, to Western art, 293–324
channels of transmission, 304–7
conflicting assessments of, 295–97
"damp fold" style of, 307–8
"dynamic" style of, 308–10

Italian "proto-Renaissances" and, 315–18
manuscript illumination and, 305
neo-classicism and, 312–13, 317
parallelisms between East and West, 310–12, 313
in twelfth century, 298–300
use of various media in, 302–4
"volume style" of, 302, 314–15, 317
icons, theory of, 171–78
mosaics, 167–86
architectural and technical conditions of, 178–80
frontality in, 173–75
movement and gestures in, 176–78
similarity theory of, 172–73
subject matter of, 170–71
three zones of, 183–85
"Byzantinische Antike," 312

Carolingian art and architecture, 192, 193, 198, 210, 226–28, 236, 312
ivory carvers, 228
sculpture, 227–28
Casentino, Jacopo del, 358
Castelseprio frescoes, 297
cathedrals
Amiens, **209**, 210, 332, 333
Beauvais, 340
Chartres, 334
Cologne, 340
Ely, 334
Gloucester, 334
Lincoln, 334
Maastricht, 192
Narbonne, 340
Prague, 340
Speyer, 209, 213, 214
Spoleto, 305
Strassburg, 340
*See also styles of architecture*
Catullus, 160
Cavalca, Domenico, 376
Cavallini, Pietro, 317, 370
Cennini, Cennino, 356
Cesariano, 328
Charlemagne, 209, 328
Chartres Cathedral
flying buttresses of, 334
tympanum, *Christ as Judge and Ruler of the Universe with Symbols of the Evangelists,* 269–70, **270**

INDEX

Châteaumeillant (church), 236
chiaroscuro, 115
*Christos Paskon* (Byzantine drama),
 240
churches
  bay system, 187–220
  Carolingian, 192, **193**, 198, 210
  cross-in-square, 181–83
  Gothic, 336–40
  Ottonian, 210
  Romanesque, 221–64
  *See also* cathedrals; *names of
   churches*
Church of the Virgin at Studenica,
  wall paintings in, 301
Cicero, 151, 153, 327
Cimabue, Giovanni, 315, 355, 357
Clairvaux, Abbey of, 204, 206
Cluny monastery, 231–32
Cologne Cathedral, 340
Colombini, Giovanni, 373
Columba Altarpiece (van der Weyden),
  394–95, **395**
Company of the Hat, 368
Company of St. George, 368
Conte Lando, 368
Corinthian Order, 89, 91, 95, 243
Correggio (Antonio Allegri), 115
Council of Clermont, 260–61
Cubiculum (villa of Publius Fannius
  Synistor) at Boscoreale, 153–61,
  **154, 156**
  architectural scheme of, 153–59
  wall paintings, 157–61
Cusanus, Nicolaus, 393
Cyrus the Great, 153

Daddi, Bernardo, 355, 358, 366
"damp fold" style, 307–8
Dante Alighieri, 273, 356, 357
Daphni, mosaics of, 297–98, 300, 304
de l'Orme, Philibert, 328
Demetrius, 45
Desiderius, Abbot, 306
Didymean Apollo, temple of, 89
*Discobolus* (Myron), 82
Domitian, 127
Domus Aurea, Esquiline Wing, 132–33
Doric Order, 89, **91**
  evolution of, 74
  generative ratio of, 97–99
  proportions of, 94–95

Duccio di Buoninsegna, 295, 315, 359
Dugento painting, 295, 303, 314
Durandus, Gulielmus, 268, 274

eclecticism, 90
Egyptian art, 7–20, 25, 32
  architecture, 10, 11–12
  cubical forms in, 10
  depiction of historical events in, 14
  hieroglyphs, 14
  naturalistic elements in, 9–10, 12
  paintings, 12–15
  reliefs, 12
  religious beliefs and, 17–20
  sculpture, 9, 11–12, 39–40
  style characteristics of, 16–17
  tomb art and architecture, 11–12
  wall paintings, 12–16
   brush-strokes, 13
   subject matter of, 14–16
Eleusis, Hall of Mysteries at, 98
Ely Cathedral, 334
Ephesus, temple of Diana at, 89, 92
Euphronius, 67, 68
Eutyches, 172
Exekias, 65
Ezinge, cattle barn, 193–95, **194**

*Fallen Wariror,* from pediment of
  Temple of Aphaia, **77**
Fazio, Bartolommeo, 387
Fidati, Fra Simone, 370
Filarete (Antonio di Pietro Averlino),
  328, 329
Florence Baptistery, mosaics in dome
  of, 315
Florentine and Sienese painting, 353–
  81
  Black Death and, 365–67
   economic and social consequences
    of, 367–69
   effect of, on culture and art, 369–
    74
   guilt, penance, religious rapture
    and, 374–76
  economic crisis of 1340's and, 363
  in mid-fourteenth century, 360–63
  political and social change and, 364–
   65
  *See also names of artists*
Foigny, Abbey of, 206
Forum of Trajan, **140**
Franco, Battista, 357

400

Franks, 225
Fulcher of Chartres, 260–61

Gaddi, Taddeo, 355, 356, 358, 359
Geometric Greek art, 51, 53, 54–56, 57, 58
  compared to Archaic art, 57–59
  decorative style, 55
  Early period art, 53–54
  metalwork, 55–56
  pottery, 55, 56
Ghent altarpiece (H. and J. van Eyck), 388, 391
Ghiberti, Lorenzo, 295
Giacomo di Mino, 365
Gibbon, Edward, 296–97
Giotto di Bondone, 295, 317, 355–56, 357, 358, 370, 376
Gloucester Cathedral, 334
Gothic style, 73, 190, 209, 236, 295, 296, 303, 313, 325–51
  bay system and, 211–13
  church architecture, 336–40
    altar styles, 337–38
    chapels and ante-rooms, 339
    rood screens, 338
  development of, 331–36
  Late period, 335–36
  symbolism in, 340–50
    doors, 342
    double choirs, 343–44
    of form, 346–50
    of meaning, 340–46
  windows, 334, 347–48
Goths, 225, 328, 329
Greek art, 14, 32, 35–123
  Archaic, 53, 56–70. See also Archaic Greek art
  architecture, 87–103
    interior space in, 101–2
    numerical aspects of, 96–100
    Orders, 91, 94–99
    parallel planes in, 100–101
    space division in, 209
    temple plan and, 89–94
  Geometric, 53, 54–56. See also Geometric Greek art
  Hellenistic, 105–23. See also Hellenistic art
  influence of environment on, 38–39, 40
  sculpture, 35–49
    Archaic period, 60–63, 66–67

  architectural uses of, 43–44, 47–48
  chief uses of, 43–49
  commemorative groups of, 44–45
  contour and, 43
  genre art, 48–49
  grave monuments, 45
  human form in, 40, 43, 44–46
  idealism and, 40–42
  proportions of, 42–43
  relief, 43–44
  religion and, 37, 43, 46–48
  simplification of form in, 42
  subjects represented in, 45–48
  temple pediments, 43, 47–48, 71–86
    Aegina figures, 77–78, 80
    Aphaia, 77
    bronze-caster's technique and, 77, 79
    orientation of, 79–80
    origin of, 73–74
    narrative quality of, 83–84
    realism in, 76, 78
    reason for, 74–76
    roof construction and, 77–78
    spatial structure of, 84–85
    Zeus, temple of, at Olympia, 80–82, 83
Gregorius, Magister, 388
Grenoble, crypts of, 225

Hagia Sophia, mosaics, 299
Halicarnassus, Mausoleum of, 92
Harmondsworth barn, 206–7
Hawkwood, John, 368
Hellenistic art, 48, 95, 102, 105–23
  assessment of, 118–20
  compared to Byzantine art, 105, 117, 119–20
  emotion in, 117–18
  eroticism in, 108
  essential traits of, 105
  genre, 109–10
  humor in, 109
  illusionism in, 114–16
  landscapes and architectural settings in, 110–16
Henry VII, Chapel of, 336
Hereford Castle, England, interior of Great Hall, 200–202, 201
Hermogenes, 89
Hesiod, 37
hieroglyphs, 14
Holmes Chapel, Cheshire, 191

Holy Trinity, Church of, Sopoćani, wall painting, *Patriarch,* **303**
Homer, 37
Horace, 151
House of Amandus, wall painting from, **113**
House of the Little Fountain, wall painting from, **114**
Hugh, St., 231
Huns, 328

iconography
accepted symbols of, 267–68
controversy of 800–900 A.D., 171–72
Gothic symbolism, 340–50
of form, 346–50
of meaning, 340–46
*Mirror* (Vincent of Beauvais), 273–86
position, grouping, symmetry, and number, 268–71
Romanesque, 238–41
quality of, 241
tympanum at Vézelay, 251–64
as symbolic code, 272–73
icons, theory of, 171–78
idealism, in Greek art, 40–42
illusionism, 114–17
Imola, Benvenuto da, 356–58
Ingeborg Psalter, miniatures in, 312, 313
Ionic Order, 76, 89, **91**
column-base development of, 95, 96
Irish manuscripts, 226–27
Irish monachism, 231
ivory carvers, Carolingian, 228

John II Comnenus, votive panel of, 298–99, **299**
Joshua Roll, miniature in, 297
Jouarre, crypts of, 225

Ka-aper, called "Sheikh-el-Beled," statue of, **10**
Kariye Djami, mosaics of, 302, 315
*The Temptations of Christ* (detail), **316**
Klitias, 66
Klosterneuburg, Altar of 1181, 309, 311
Knossos, Cretan palace of, 13
kouros and kore, 61–63, 83
*Kouros of Sounion,* **39**
krater, by Euphronius, 67, **68**

La Lande de Cubzac, 239
*Lamentation of Christ,* wall painting, Church of St. Panteleimon, **300**
landscapes
in Hellenistic art, 110–14
in Roman art, 153–61
Languedoc, tympana of churches in, 239
*Laocoön,* 117
La Tène style, 223
Leens, timber house at, 195, **196**
Leicester Castle, Great Hall, 198–200
reconstruction of, **200**
Limbourg brothers, 388
Lincoln Cathedral, 334
*Lion Facing Horseman,* relief from Nineveh, **33**
Lombards, 328
Longchamp, Abbey of, 206
Longhi, Roberto, 295
Lorenzetti, Ambrogio, 359, 366, 370
Lorenzetti, Pietro, 359, 366
Louis XI, King, 208
Louis VII, King, 260
Luca di Tommè, 359, 365, 373
Lysicrates, monument of, 95
Lysippus, 370

Maastricht Cathedral, 192
*Madonna of Canon van der Paele* (van Eyck), **390**, 394
*Maestà* (Duccio), *Christ in Gethsemane* (detail), **316**
*maniera greca,* 295, 296, 302, 304, 314–15
manuscripts, illuminated, 305
Martini, Simone, 359
Maso di Banco, 356, 358, 359
Master of Flémalle, 391–92, 395, 396
Mattingly, Hampshire, church in, 191
*Meeting of Joachim and Anna* (Giotto), 362–63, **362**
Mene-na tomb of, wall painting in, **15**
Méréville, market hall at, 208
Middle Ages
architecture, bay system, 187–220
Gothic style, 325–51
iconography, 265–91
Romanesque art, 221–64
tympanum at Vézelay, 251–64
*See also* Florentine and Sienese painting; *names of cathedrals*
Milesevo, frescoes of, 301–2

Mino, Giacomo di, 365
*Mirror* (Vincent of Beauvais), 273–86
  background of, 273–76
  of History, 283–86
  of Instruction, 279–81
  of Morals, 281–83
  of Nature, 277–79
Mnesicles, 94
monasticism, 230
Monreale, mosaics of, 309
  *Expulsion of Adam and Eve from Paradise,* **310**
Montecassino, 306, 308
Montereau, Pierre de, 341
Morgan Library Triptych, 304
Moriale, Fra, 368
mosaics, Byzantine, 167–86
  *Annunciation,* Church of the Dormition, Daphni, **177**
  architectural and technical conditions, 178–80
  *Empress Irene,* from mosaic panel of *Virgin and Child between Emperor John II Comnenus and Empress Irene,* Hagia Sophia, **299**
  frontality in, 173–75
  magical identity in, 173
  movement and gestures in, 176–78
  similarity theory of, 172–73
  subject-matter of, 170–71
  theory of icon, 171–78
  three zones of, 183–85
  Venetian, 315
  *Virgin and Child with Saints,* Torcello, Cathedral, **174**
Myron, 82

Narbonne Cathedral, 340
Nardo, 356, 358, 374
naturalism
  in Assyrian relief art, 23, 30
  in Egyptian art, 9–10, 12
Nerezi frescoes, 118, 298–99, **300**
Nero, 135
"Nessos" amphora, **59,** 60
Nicholas of Verdun, 309–10, 311, 312, 313, 317
Nike of Paionios at Olympia, 44
Nike of Samothrace, 107, **108**
Nyeven, Province Drente, Holland, church in, 191

Oderisio, 357
Odo, St., 231
Odyssey landscapes, 111
Orcagna (Andrea di Cione), 355, 356, 358, 372, 373, 374, 375, 376
Ottonian art, 210, 311, 312

Pacino, 358
Paeonius, 81, 82
Pagasai stele, 117
painting, 295, 296, 353–97
  in Florence and Siena, 353–81
    Black Death and, 365–67
    consequences of plague, 367–76
    economic crisis of 1340's and, 363
    in mid-fourteenth century, 360–63
    political and social change and, 364–65
  Greek (Archaic period), 63–66, 67–70
  in Lowlands, 383–97
    van der Weyden, 391–97
    van Eyck, 385–91
  *See also* wall painting
Palace of Amenhotep III, at Tell el Amarna, 11
Palace of Domitian, 132
panel painting, 303, 304, 306
Pantaleoni family, 305
Pantheon, 132, 133, 138, 139
Parçay-Meslay, Abbey Grange, 204–6, **205**
Paris Nicander Manuscript, miniatures in, 297
Paris Psalter, miniatures in, **113**
Parler, Peter, 334
Parthenon, 44, 47–48, 73, 76, 80, **91**
Passavanti, Jacopo, 374, 376
Perrecy-les-Forges, tympana at, 239
Persepolis, columns of, 98–99
Peruzzi, Baldassare, 212
Peruzzi family, 363, 369, 373
Peter the Venerable, 261–62
Petrarch, 327, 366, 370
Phidias, 44, 48, 81
Philip the Good, 385–87
Philip II Augustus, 260
Philon, 98
Pisano, Niccolo, 315, 370
Plan of St. Gall, 195–98, 203
Plato, 39, 40, 41, 46, 47, 327, 357
Pliny, 115
Plotinus, 42

Polyclitus (the Younger), 44, 73
Pompeii, wall paintings from, 113, 114, 116
*Poseidon,* 45
Prague Cathedral, 340
Priene, Athena temple at, 89
Pythius, 89

Ramesside temple reliefs, 16
Raphael Sanzio, 212
realism, in Greek art, 76, 79
religion
    Assyrian art and, 24–25
    Egyptian art and, 17–20
    Greek sculpture and, 37, 43, 46–48
    *See also* iconography
Rembrandt van Rijn, 115
Riccobaldo, 356
Richard I, King, 260
Richard II, King, 202
Richards, Raymond, 191
Rochecorbon, Abbé Hugue de, 205
Roger of Tournai, 393
Roman art, 125–66, 225
    architecture, 125–48
      building materials of, 128–32
      construction process of, 132–36
      design characteristics of, 139–43
      economy of construction in, 127–38
      Imperial, 143–46
      "new" architecture, 138–39
      pozzolana mortar and, 130, 131, 135, 136
      structural features of, 136–38
      vaulted style of, 143–44
    wall paintings, from Boscoreale, 149–66. *See also* Boscoreale, wall paintings from
Romanesque art, 73, 189, 192, 209, 221–66, 331, 332, 337, 343
    church architecture, 221–49
      art of building, 232–37
      background of, 223–28
      Baroque phase of, 229
      Benedictine (or Berry) plan, 236
      conformity and geometric schemes of, 245–46
      creation of, 260
      decoration of, 238–47
      iconography of, 238–41
      moulding decoration of, 243–44
      ornamental motifs in, 246–47
      religious feeling and, 260–61
      sequence of development of, 229–32
      technique (architectural and ornamental), 242–47
    sculpture, 226, 253
    square schematism of, 210
    tympanum at Vézelay, 251–64
      conflicting interpretations of, 253–60
      contribution of Peter the Venerable to, 261–62
Romanticism, 296
*Royal Commission on Historical Monuments,* 191
Rubens, Peter Paul, 388
Ruccellai Madonna (Duccio), 315
Rufus, William, 202

Sacchetti, Franco, 355
*Sack of the City of Hamanu in Elam,* relief from Nineveh, 31
Sacramentary of Gellone, 241
*Sacrifice of Iphegeneia,* 117
St. Aubert, Abbot of, 393
St. Catherine's, Church of, at Honfleur, 190–91, 190, 192
Sainte-Madeleine, Abbey Church, Vézelay, 239, 244, 245, 251–64
    *Mission of the Apostles,* tympanum, 253, 254
St. George, Curbevino, wall painting, *Angel of the Annunciation,* 301
St. Gereon in Cologne, Church of, 305
St. James and St. Paul, church of, at Marton, England, 191, 192
*St. John the Evangelist* (Biondo), 371
Saint-Maurice d'Agaune, Valais, 240
St. Panteleimon, Nerezi, wall painting, *Lamentation of Christ,* 300
St. Pierre-sur-Dives, market hall, 207–8, 207
St. Sergios at Rusafa, basilica of, 214
Saint-Sernin, Toulouse, 236
    aerial view, 237
    plan, 234
St. Werburgh, church of, at Warburton, England, 191, 192
San Croce, 375
Sandrart, Joachim von, 329
San Michele, oratory of, 231
San Petronio, Bologna, 338
Santa Maria del Fiore, 336

Santa Maria Maggiore, 317
Santa Maria Novella, 372, 374, 376
Santiago de Compostela, 231
Scaramella, 369
Scopas, 73
Scotus Eriugena, 240
sculpture
  Carolingian, 227–28
  Early and Middle Archaic Greek (to
    520 B.C.), 60–62
  Egyptian, 9, 11–12, 39–40
  Greek, 35–49
  Late Archaic, 66–67
  Middle Ages, 224–25
  Romanesque, 226, 253
seals, Assyrian, 23–25
Sennacherib, reliefs of, 28–30
Sesostris III, 15, 16
Sesostris III (Se'n Wosret), fragment
  of head, 15
Seti I, reliefs of, at Karnak, 26
Shrine of the Three Kings, Cologne
  (Nicholas of Verdun), 311
Siena. See Florentine and Sienese
  painting
Siphnian Treasury at Delphi, 74
Socrates, 41–42
Sophilos, 66
Sophocles, 38
Sopoćani frescoes, 297, 303, 314, 315
Souillac, monastery church of Notre
  Dame, sculpture, 246
Spanish Chapel, S. M. Novella, Flor-
  ence, 376
Speyer Cathedral, bays of, 209, 213,
  214
Spoleto, Cathedral of, 305
"square schematism" of Romanesque
  architecture, 210
stained glass, 303
Stavelot, Monastery of, 304
Stefano, 355
Strassburg Cathedral, 340
Street Musicians (Dioscurides of
  Samos), 109
Strozzi Chapel, 374
Strozzi family, 372
Strzygowski, Joseph, 189, 193, 209
Styppax, 48
symbolism, medieval, 330, 340–50
  of church architecture, 336–40
  of form, 346–50
  of meaning, 340–46

Synistor, Publius Fannius, 149, 153

Tell el Amarna, 11
temple pediments, Greek, 43, 47–48,
  71–86
  Aegina figures, 77–78, 80
  Aphaia, 77
  bronze-caster's technique and, 77, 79
  orientation of, 79–80
  origin of, 73–74
  narrative quality of, 83–84
  realism in, 76, 79
  roof construction and, 77–78
  spatial structure of, 84–85
  Zeus, Temple of, at Olympia, 80–82,
    83
    Apollo and Lapith Women Strug-
      gling with Centaurs, 80
Temptations of Christ, detail, mosaic,
  Kariye Djami, Istanbul, 316
Tibullus, 151
Tournai Shrine reliefs, 312
Traini, Francesco, 374, 375
Trajan's Forum and Markets, Rome,
  140–41
Très Riches Heures du Duc de Berry,
  Les (Limbourg brothers), 388
Triumph of Death, The (Traini), 374,
  375
Tukulti-Ninurta, Assyrian palace of,
  paintings in, 13

Unro of Verden, Bishop, 193
Urban II, Pope, 260–61

van Beuningen altarpiece, 288
Vandals, 327–28
van der Weyden, Roger, 391–97
  background of, 391–92
  personality of, 392–93
  style of, 393–97
van Eyck, Jan, 385–91, 392, 394, 395,
  396
  and alchemy, 387–88
  association with Philip the Good,
    385–87
  background of, 385
  frames of, 388–89
  style of, 388–91
van Mander, Carel, 394
Vanni, Andrea, 259, 365
Varro, 151

Vasari, Giorgio, 212, 295, 296, 297, 302, 328, 329, 387
vaulted architecture, 143–44
Vergil (Virgil), 327, 357
Vézelay. *See* Sainte-Madeleine, Abbey Church, at Vézelay
*Victoria History of the Counties of England,* 191
Villani, Giovanni, 363, 364, 365, 373
Villani, Matteo, 366, 367, 368
Villard de Honnecourt, 245, 327
*Virgin and Child with Saints,* mosaic, Torcello, Cathedral, 174
Visconti, Bianca, 393
Visconti family, 363
Visigoths, 225, 241
Vitruvius, 129, 130
von Hall, Burckhard, 327
Voragine, Jacobus de, 273–74

wall paintings
    Egyptian, 12–16
    Hellenistic, from Pompeii, 110–17
    Roman, from Boscoreale, 149–66

Westminster Palace, 202
Westminster Psalter, miniatures in, 312
Wibald, Abbot, 304
Wilhelmshaven-Hessens, house-type discovered at, 195, 197, 198, 200
William of Auvergne, 212
William of Sens, 327
William of Tyre, 260
Wimpfen, church at, 327, 335
Winchester Bible, miniatures in, 311–12
winged monsters, in Assyrian glyptic art, 24–25
*Woman and Shepherd* (Hellenistic genre painting), 109

Yellow Frieze in the House of Livia, 111

Zackenstil, 314
Zeitstil, concept of, 311
Zeus temple of Acragas, 94
Zeus temple at Girgenti, 92
Zodiac, represenations of 245, 259
Zoser, limestone statue of, 10